Savage Messiah

A biography of the sculptor
Henri Gaudier-Brzeska
by H.S. Ede

with new texts by
SEBASTIANO BARASSI, EVELYN SILBER
and JON WOOD

2011

CAMBRIDGE | Kettle's Yard

LEEDS | Henry Moore Institute

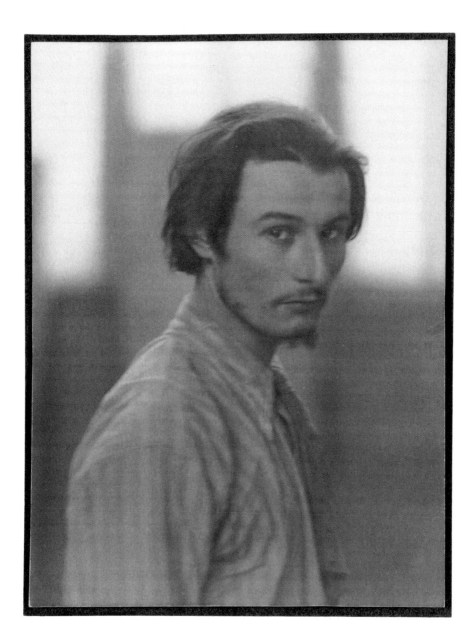

Contents

Foreword

The names of Henri Gaudier-Brzeska and H.S. 'Jim' Ede have long been closely associated. Although they never met, Ede's encounter with Gaudier's work in 1926 represented one of the turning points in his life, and later played a crucial part in the creation of his own 'masterpiece', Kettle's Yard.

Gaudier's legacy benefited much from Ede's interest in his work. The very fact that Ede was able to acquire the sculptor's estate in 1927 signals that by then Gaudier was slowly fading into obscurity. Following the acquisition, Ede took it upon himself to establish the sculptor in the place he believed he deserved in the history of modern art.

The publication of *Savage Messiah* was arguably the most important step he took. Through Henri's and Sophie Brzeska's correspondence and writings, Ede immersed himself in their innermost world. Their troubled relationship, the hardships they faced but above all the tenacity with which they pursued their artistic dreams made their story irresistible. With such personal material at his disposal, and Ezra Pound's memoir as an important but constraining precedent, Ede decided to concentrate on biography rather than art history. Yet eventually the book played a major role in establishing Gaudier as one of the key figures shaping a modern sculptural language.

Eighty years after its first publication, and with all previous editions out of print, Kettle's Yard and the Henry Moore Institute have joined forces to re-present *Savage Messiah*. The collaboration stems from our shared interest in the book, which played a very important role in the genesis of Kettle's Yard and whose original manuscript is now in the archive at the Henry Moore Institute in Leeds. This manuscript has guided the editors and designer in the layout of the new edition, and most of the original illustrations from the manuscript are reproduced in it. Our new edition is also published one hundred years after Gaudier arrived in London, in 1911.

We have chosen to publish the most recent version of the text, approved by Ede in 1971. It differs only very slightly from earlier versions, with

alterations that do not affect in any significant way the narrative or the quality of the writing. In the editing process we have corrected a small number of Ede's spelling and transcription errors (mostly of foreign words).

A scholarly apparatus has been added to set the book into its historical context and highlight its lasting relevance for the study of Gaudier's life and work. The apparatus includes notes to Ede's text, essays outlining its genesis and post-publication history, and appendices with omissions from the letters, a comprehensive list of the book's sources and other unpublished material.

The selection of images reflects closely that made by Ede for the very first, deluxe edition, entitled *A Life of Gaudier-Brzeska*. Ede considered this the 'real' book and regarded the illustrations essential to put across the quality of Gaudier's work.

We are indebted to The Henry Moore Foundation, the Paul Mellon Centre for Studies in British Art and the Gordon Fraser Charitable Trust for their support, which made this publication possible. The book is in memory of Gordon Fraser, the last publisher of *Savage Messiah* (London, 1971).

Our special thanks go to Evelyn Silber for her expertise and her invaluable contribution to the editorial work. We would also like to thank for their assistance and encouragement: Barbara Adams (Archive of Modern Conflict, London), Patrick Baty, Jonathan Black, Richard Calvocoressi (The Henry Moore Foundation), Roger Cole, Richard Cork, Penelope Curtis (Tate Britain), Rob Crow, Roger Eastman, Stephen Ferguson (Princeton University Library), Anne Garner (New York Public Library), Kirstie Gregory, Karen Atkinson, Lisa Le Feuvre, Sarah Hanson, Jackie Howson, Claire Sawyer and Ann Sproat (the Henry Moore Institute, Leeds), Michael Harrison and Mark Searle (Kettle's Yard, Cambridge), Julia Kelly, Wiesia Kelly, Isabelle Klinka-Ballasteros (Musée des Beaux-Arts, Orléans), Doïna Lemny (Musée national d'art moderne, Paris), Tim Llewellyn, Peter McGrath, Ed Maggs, Jane Morgans, Alex Parigoris, Christopher Phillips, Gillian Raffles, Rowena Smith, Mrs. Anthea Stewart, Elisabeth and Harold Swan, and Anne Wagner.

SEBASTIANO BARASSI and JON WOOD

205

statue, which looked splendid under the airy lights between the big walks.

Yesterday evening I delighted my heart with the 'St Jean Baptiste', this afternoon with Beethoven. I also had a superb pomegranate, pink large and bean-
... which I kiss
... I have my
... the Library,
... walk, and

Tysięcy pocałunków dla
mojej ukochanej, biednej
drogiej Zosii

žišik piṣik

... ar Zosik, all over
... recommend her
... -icent sun. I
... as in, it would
... ey. 5/15 lb. 2/-,
... it was almost
... next time I will
... things: the old
... that you would
... y.
... kisses full of
... oes, kisses, kisses-
... The Bulgarians
... le - good-night
... ik

Savage Messiah

H.S. EDE

Preface

I have personally met very few of the people mentioned in this book, and any remarks about them in no way denote my own feeling, but entirely those of Henri Gaudier and Sophie Brzeska.

My authority for what I have written has mostly been a Diary kept by Miss Brzeska, whose statements I have checked both with letters from Henri Gaudier and by conversations with people who knew them both. Where it has been possible, I have used Miss Brzeska's own words, putting them between quotation marks; but usually the Diary is too diffuse, and too personal to Miss Brzeska, to allow of a direct translation.

All Henri Gaudier's letters were written in French, with the exception of two early letters to Miss Brzeska, pages 20 and 36, and the rough draft of one to Middleton Murry, page 112, and these are printed in their original language. In translating the letters I have occasionally left out passages which are mere repetitions, or of no general interest.

Several works by Henri Gaudier-Brzeska, and Miss Brzeska's papers, passed at her death to the Treasury. These were purchased by Mr. McKnight Kauffer, from whom I in turn obtained them.

H.S. EDE

Preface to the 1971 edition

In the fifty-six years since Gaudier's death his reputation has grown from that of being simply 'an illustrious unknown' and moves towards his recognition as perhaps France's greatest sculptor.

Until a few years ago his name was known only underground, chiefly to other sculptors. Henry Moore, speaking of him as one of his formative influences says: 'He made me feel certain that in seeking to create along paths other than those of traditional sculpture, it was possible to achieve beauty, since he had succeeded.'

Today a large number of his works may be seen at The Tate Gallery in London, Kettle's Yard in Cambridge, the Musée National d'Art Moderne in Paris and the Bielefeld Art Gallery in Germany. His reputation continues to grow.

H.S. EDE

1 | The meeting

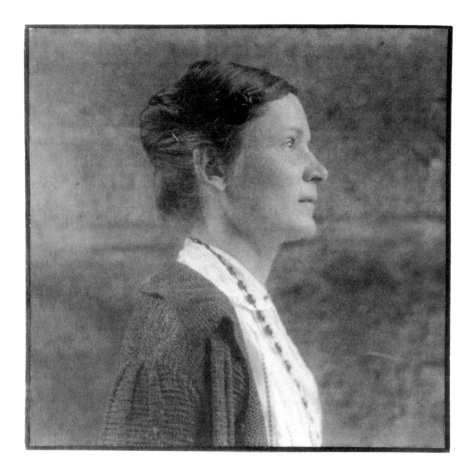

Sophie Suzanne Brzeska and Henri Gaudier met for the first time at the St. Geneviève Library in Paris[1] during the early part of 1910. It was the strange meeting of two people with violent temperaments, widely different in age and experience, utterly unsuited to each other, and yet destined to live together for the next five years, and in the end to die violently as they had lived, the one on the battle-field, the other in a madhouse.

Miss Brzeska, a highly-strung Polish woman, already thirty-eight years old, was working, or fancied she was working, at German: she was interested in languages and in the literature of different countries, but owing to her hate of the Germans she had not studied their language before. She was small, flat-chested, with a pointed chin, thin lips, tilted nose, sensitive nostrils, and high cheek-bones, which rose up to meet the large eyelids sheltering strange tired eyes, eyes that often stared big and vacant, and then of a sudden melted into roguish intimacy. Her movements were rapid, abrupt, and angular; her student's paraphernalia, which she set about her on the table with neurotic precision, were extensive, and often attracted the attention of the young men who sat and worked at the same table, and to whom her eccentricities and seeming independence were the cause of much speculation: a speculation not to be wondered at, since she was a woman who was bodily ill and mentally diseased, whose life had been a succession of continual emotional crises; of terrors, intuitions of evil, forebodings of madness, outbursts of rage, meditations of suicide, and intimations of her own greatness. She was extremely poor and absolutely alone, without a friend to speak to; she had come to Paris, a few months before, with the firm intention of killing herself to escape from the fine torment of life into those vast spaces of rest and forgetfulness which she believed to be the reward of death; but life in Paris, with its keen student energy, and the thought that if she were buried her body would be eaten by worms, had weakened her resolve, and she was again making frantic efforts to conquer her depression.

Sitting by her, in the Library, was a young boy who often looked at her furtively, almost timidly. He was about eighteen, with dark, finely-chiselled features and sparkling eyes, and his attentions occupied much of Miss Brzeska's thought; he was an artist, she supposed, since he was studying anatomy; he looked poor and tired, indefinably gentle and yet somehow alert and cruel, like a panther. This incongruity fascinated her, for it had much in common with her own swift outbursts. She wondered why he looked at her with such interest: he was so young and she — she might be his mother. Why had she never had a child, she whose experience of life was so vast? She could have protected and helped a son, studied the growth of his ideas, and found satisfaction in his turning to her for support; such were the thoughts she noted in her diary as she watched Henri Gaudier,

and as she felt his young presence near her. She even wondered if he might love her; but no, that was impossible: love did not exist, she had been too often mistaken to fall a prey to that deception.

In order to break the monotony of her daily life she was prepared to do anything, even to give up her eternal search for an experience in which love and friendship would be united, and just to give herself quite wantonly, asking for nothing but to be possessed by the deep-reaching abandon of physical love. But it was quite clear to her that it must not be with Henri Gaudier. Such an action could only bring her shame and remorse; she wished to revenge herself on men, but to break into his life would be like torturing a baby. She wanted to be happy, to laugh and to be free, to forget her grinding pain. She would like to smile at Henri, to take his hand, no more. They might be companions and help each other; but then her heart cried out to her that she was old, in the autumn of her life, and that she could never play so austere a part, for she would need to be strong enough for two, since he was so young, and young people were so easily excited. Besides, she felt that he was far too good for her, she needed someone cast in a rougher mould.

She chose a Russian, a largely built, pale-faced man with small, penetrating eyes, and she threw him a significant look which he smilingly received; he seemed to set no barrier between them, and already, as she looked at him across the table, she felt herself in his arms. But Miss Brzeska's temperament was not of the kind which made her able to give herself easily; she was spirited and proud, so she drew back again into herself, and hid behind her provocative air of listless gaiety.

At the end of a couple of weeks she no longer wanted to abandon herself to this Russian: her immediate excitement was allayed, and she felt that perhaps after all she would find somewhere a real friend. She continued, however, to play with the Russian, who, after making many vain attempts to come to an understanding with her, to meet her when she came to or from the Library, would decide to give her up, but then returned to the attack only to disappear again beaten. She did not care for him, but the game amused her, though her conscientious nature began to give her serious pangs of regret; what right had she to make the poor fellow suffer? The other students at the table followed the flirtation with great interest, and some of them gave her encouraging looks, hoping that they, too, might

be drawn in, but on their own account; thinking themselves more able to gain a victory than their fellow-student.

Henri Gaudier was the most assiduous of these. He always managed to sit by her side, putting his books quite close to hers. This often upset her plans with the Russian, but she had never the heart to look at him severely. One day she asked him to show her his book of drawings, which he did with evident pleasure, trying to draw her into conversation; later he waited for her at the exit, and they walked a little way together. He evidently wanted to talk to her, and she allowed her interest to ripen for this young life, which thought only of Art and the big work it would accomplish. One night Sophie let him walk with her as far as the door of her hotel. He complained of his loneliness and of his desire to know someone who would understand him and encourage him in his ambitions. Sophie was immediately touched to the finest fibre of her nature; spontaneously she replied: 'I am too old for you really, but I will be a mother to you, if you agree.' Henri said he would be enchanted, he had wanted to know her for so long, he thought her beautiful, and she pleased him. Sophie looked at him with surprise; no one had ever felt like that about her before, and at home since her childhood she had always been spoken of as ugly. Henri explained that that was because people did not see true beauty, the beauty which lay in the heart and in the expression. What was more, he loved her concentrated energy and was intrigued by its changefulness; at times she would be completely absorbed by her work, and then she would stare at the ceiling with eyes full of tragedy.

'Sometimes you look as if all the devils in hell possessed you — for instance, when you look at the Russian.'

'Aren't you then frightened of me,' said Sophie 'seeing how wicked I can be?'

'On the contrary, I hate those mincing beauties whose expressions never change — they are no more than mummies.'

So for a long time they walked and talked in the Rue Cujas,[2] hours filled for them with breathless excitement; what did it matter what they said, since to be talking at all meant that they were no longer lonely, and before they separated they arranged that on the next day they would visit the Louvre together.

2 | Miss Brzeska[1]

Sophie Brzeska was born in a large house in the heart of the country, not far from Cracow. Her father, a solicitor, had, according to her own report, only two interests — wasting his inheritance, and entertaining women of all stations in life, provided they were young; and so long as he was left quietly to this occupation he was a pleasant enough man to live with, but it kept him much from home.

Mrs. Brzeska, on the other hand, was always at home. She gave birth to nine children, of whom Sophie was the only girl. Her parents were constantly irritated and humiliated by this, and kept telling her that she was a useless encumbrance who would remain on their hands and give them no return.

During her early childhood she was alone with her mother, who was continually pregnant, often bearing still-born children; Sophie watched the funerals of four of these. There were young brothers growing up entirely neglected by their mother, who read and studied all day without any system, and they naturally joined in their parents' abuse of Sophie. Mr. Brzeski shut his eyes to all the disharmony of his family so long as his own pleasures, which were the cause of many objectionable scandals in the house, were not interfered with.

Sophie tried, when she was sixteen, to escape from the miseries of her home; she wished to work, and already felt a desire to write; but her parents told her that there was no money for so stupid a person, and that the only thing she could do was to find a rich man as stupid as herself, and persuade him to marry her.

The only subject of conversation on her account seemed to be of arranging such a marriage, and after several attempts, an elderly Jew was found who consented to become engaged to her, much against her wishes. She even thought of escaping from her troubles by suicide, only the fear of her mother forced her to accept the Jew's proposal. Happily the Jew expected a dowry with her, and this infuriated Mr. Brzeski, who felt that anyone of such obscure origin should think it a sufficient honour to be given his daughter; so the engagement fell through with insults on both sides.

During the next four years there were three incidents which might have led to marriage, the first two with men as little to Sophie's taste as the Jew. The third was a young man, of shockingly poor physique, but universally spoken of as a decent fellow. He had a rich mother who wished him to make a brilliant marriage, but who for a time countenanced his attachment to Sophie. One day Mrs. Brzeska made a dreadful scene with him over a game of cards, and without consulting Sophie's feelings turned him out of the house. His own mother was in her turn furious, and made him promise never to see Sophie again; but he wrote to tell her that he would always love her, and that they must trust in the future. Then came Mr. Brzeski's bankruptcy, and a little later, his death.

Miss Brzeska, who suffered much from gastric catarrh, had saved a little money out of her dress allowance, and driven from the house by her mother's ill-treatment, went to study in Cracow. From there she moved to Paris, where she worked for a time as a nursemaid, but was made miserable by the gibes of her fellow-servants. Then she obtained a succession of posts, often only for a fortnight at a time, until her health entirely broke down. She was obliged to take a short rest, after which she found a position with a family who were going to Philadelphia. There was a little boy of ten years old and a girl of sixteen. Sophie became deeply attached to the boy, but after a few weeks he died, leaving only his sister for her to take care of. This girl kept asking for indecent stories, and because Sophie did not tell her any, she complained to her mother that Sophie was dull. The mother told Miss Brzeska that she must try to entertain her pupil better; so in fear of losing her job, and because the child was already more worldly-wise than she, Sophie invented scandals about Parisian actresses, much to the delight of her pupil. One day the mother and father overheard their talk, and Miss Brzeska was dismissed.

She now went to live in a French 'Home' in New York, kept by nuns. From that time on there came more and more detestable children and impossible parents, and each year she became more painfully nervous. Her whole aim was now to get back to her own country, particularly as she had heard from her cousins that her young man was still faithful to her. She must economize, make money; but she must make it honestly. Many a time, from fathers in whose families she worked, she might have earned in a week, had she been amiable and complying, more than she could

otherwise do in four years; but she had a profound belief in the sacredness of love.

In the meantime she longed for human affection, and felt so much the need to forget herself in her love for someone else that she began to fall in love with other women. In this she met with nothing but disaster. For all her affection and her generosity she got only deception and abuse. Miss Brzeska felt at this time that she had reached the acme of suffering, that life could hold no bigger trials for her; and it was only want of money that prevented her from returning to Poland, which she now felt to be her only escape.

Little by little she saved enough for her return, and then heard from her eldest brother that he wanted to come to New York. She was fond of him, for he was sensitive and delicate, and she pitied his being under the maternal roof. She sent him enough money for his journey, and so gave up her own chance of returning. For five months her brother could find no kind of work, and finally had to accept a post as kitchen boy in a large hotel. He began to accuse Sophie of having persuaded him to come to America, and finally he refused to see her. To add to her troubles, she was out of employment herself; so when suddenly a chance offered of getting to Paris, she accepted it with alacrity.

She had planned to stay in Paris, and make a position for herself, in preference to returning home; for she was now thirty-six years old, and feared that the man who had promised to wait for her might think her too old and too battered by the life she had been forced to lead. However, in Paris she could get no work, and thus was compelled to return to her mother's house, where another severe blow to her pride awaited her. She had an uncle, aged seventy, of whom she was tremendously fond; she had always treated him as a father, and felt him to be her one stay in life. She found that on the death of his wife he had persuaded a shameless cousin to come and live with him; and although there was no need of arguments to accomplish her seduction, he told her that Sophie, the refined and correct Sophie, had been his mistress, and that in order to avoid a scandal he had sent her to Paris. This discovery so shattered Miss Brzeska that she felt its effects for the rest of her life.

Her family ridiculed her for having only saved a thousand francs during all her years in America, and they laughed at her ideas of virtue. She then

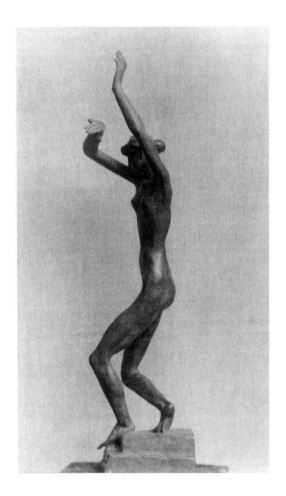

heard that her friend had become engaged to an heiress, and she wrote to him imploring him not to ruin his life, saying that she was prepared to wait for him as long as it was necessary: he replied, coldly polite, that he loved and respected his fiancée.

By such blows Sophie was turned sceptical, and believed that she no longer desired the love of men. To deaden her distress she forced herself into a life of dissipation. Her health soon broke down and she went to Baden for a cure.

It was here that she met Monsieur M., a rich manufacturer aged fifty-three, with whom she had her most serious love affair. Now was her

chance to show her relations that when she chose she could make a good marriage; but again she was caught. Monsieur M. proved to be amusing, intelligent, a lover of nature and full of kindness, understanding quickly all the pent-up troubles of her heart; and before she knew where she was, she was passionately in love with him. He assured her of his love for her, and she believed him, her nature needed so intensely to believe him; but he did not ask her to marry him.

Their friendship lasted for over a year. During this time Monsieur M. encouraged her and to a great extent used her, but never gave her the complete satisfaction for which she craved. Ultimately, after a dreadful scene which nearly ended in the death of both, he told her that he had a son, and that he had promised always to remain free in case the boy's mother wished to marry him – that he adored his son, and that his one ambition was to make him a home.

Poor Sophie, she who was so famished for love, who had guarded herself so carefully until she felt that she had found someone who was worthy of her love, who wanted love to be eternal, how was she now distressed! She felt her senses leaving her, and for some time she was on the verge of madness. She wrote to Monsieur M., imploring him to kill her if she went mad; and he replied that she had upset his nerves for nothing, that she had better go to the country to cure her hysteria, and that he was quite willing to pay. After heart-rending scenes she returned in despair to her home. Her allusions to madness had decided Monsieur M. to have no more to do with her, and he left her numberless letters unanswered.

At home she would lie for hours on a sofa wondering how best she could kill herself. A fat aunt, who was there, occasionally indulged in vulgar pity. 'Poor girl – you evidently want something – it's a pity, all the same, that you did not marry that old man your mother found for you – he was certainly stupid, but he seemed to have a kind nature.' Then Sophie would stamp and shriek with rage, flinging invective and injury upon her aunt, while her mother would stand by smiling. 'You see what a toad she is – what a scorpion; didn't I tell you? But you would never believe it. You can see for yourself now.'

It was less than two months after this that Miss Brzeska saw Henri Gaudier for the first time in the St. Geneviève Library.

3 | Henri Gaudier

When Henri visited the Louvre with Miss Brzeska he was very attentive to her, explaining everything most vividly. He enjoyed so much being able to enlarge on his ideas to his enthusiastic companion, for he had never met anyone before who cared to listen to him. He was particularly attracted by the sculpture, and endeared himself to Sophie by taking off his hat in front of the Samothrace 'Victory'.

Henri was very poor, his clothes were torn and dirty and his shoes full of holes, but Sophie felt proud to be with him, although usually she would have been much put out by such things; for several years she had not followed the fashions, but she had always been scrupulously clean in herself and her linen.

Slowly but surely he entrenched himself deeply in Sophie's heart; he gave her his diary, in which he complained of being 'without love and without friends', and he told her that he was fully satisfied with her motherly love.

She herself was in a seventh heaven: it was, I think, the happiest time in her life, perhaps also in Henri's. Once or twice a week she would go to his tiny room at 14 rue Bernard Palissy[1] and he would draw her portrait while she told him of her ambition to be a writer, and read him several of the short stories she had written. Henri used to talk to her in English, and they learnt together Shakespeare's sonnets and discussed the literature of many nations; for Sophie was widely read, and they were both intensely keen on searching into the manifestations of human development. Many were the delicious moments which they passed together, he with his head on her shoulder or she resting on his; the solace of kisses was not allowed, but their spirits were united in a radiant joy. They had their own troubles to talk about, and they discovered that they were both suffering from the same ills. Miss Brzeska had been a short time before to a specialist, thinking she had caught some disease in the hotel where she was living, and the doctor had told her that her state was one of nervous prostration due to lack of food and over-anxiety. Henri was in just the same position: his

weakness was extreme, his hands were always moist, his cheeks hollow. For some time he would not confess to being short of money, and when he did, it was with the greatest difficulty that Sophie persuaded him to accept a few francs. Often she would buy food and come to share it with him in his room. Once when she had to keep to her bed, he bought her a fine rose. 'But I won't leave it,' he wrote,* 'lest the old mufflers at your hotel give a false meaning, and profane the idea I have and which you share. Anyhow, I shall not have bought it for nothing, and I enclose some of the petals — you won't get this letter before to-morrow, which is a great pity. I am sure you would have much more pleasure in reading it to-night. Good-night, with love. Syn.'

In a letter to Dr. Uhlemayr,[2] with whom Gaudier had lived at Nuremberg during part of the previous year, he tells of his meeting with Sophie Brzeska:

Paris
18th June 1910
I have such a lot of things to tell you, but things quite different from those I have already talked about — I refer to the effect of love on one's working power. Would you believe it, I am in Love! I see that you already picture me with some *backfisch* strolling in the *Boul Mich*,[3] or whispering sweet nothings in secluded corners around the Panthéon. You are wrong; the woman I love is thirty years old† — you smile — I love her with a purely ideal love, it is flow of sensation which you must feel, since words are too coarse a medium to convey it. She is Polish — Brzeska is her name. I met her in the library where I go to work each evening. I've done several sketches of her, and thus we got to know each other. She is a poet, and her ideas on the family, society, and Western civilization are the same as ours; she has an entirely independent nature, is an anarchist — simply and naturally, has a beauty *à la Baudelaire* — and might have stepped out of 'Fleurs du Mal'. She is lithe and simple, with a feline carriage and enigmatic face, the fine character of which reflects her most intimate thoughts — planes combining in the most surprising manner, impressions of age and of youth in alarming contrast. In a word, we are both as mad as hatters. Would you

* This letter is written in English.
† Miss Brzeska was thirty-nine.

believe it, last Sunday we talked from eight in the morning until three in the afternoon without noticing how the time had passed. I told her of my ideas about Art for Art's sake, and she explained hers on the basis of a society founded on motherhood undertaken freely and with open eyes. We parted about four o'clock, and I came home and at once set to work. I was so thrilled that I did a great bust that evening to give her next morning, as she had asked me for a bit of sculpture. Since then I have been like a man bewitched, and I would work like a machine, only that I have forced myself, with some success, to be reasonable. All the same, I am happy, and I only hope that the fever of work which possesses me won't as suddenly leave me. I am also very pleased to know this Pole, particularly because she is a Slav and I know nothing about Slavs. She is going to teach me her language so that I may steep myself in the Slavonic spirit. I hope that I shall profit as much by it as I have by meeting with German culture, and that it may open for me the great gateway of the East. You mustn't be annoyed with me for telling you all this, since it is only natural that men and women should love each other, and that the nearness of one should cause happiness in the other.

I don't know what my fellow-countrymen must think of me, for in the Latin Quarter I know only Russians and Germans – there is one who looks very like you and another who takes opium, he's a very interesting subject; he wished to hypnotize me the other day, but couldn't.

I begin to understand the Greek and pagan antiquity, which I now prefer to the Gothic. For a long time I have been obsessed by Ruskin and the English; now I have finished with them, as with Christian philosophy, that hysterical egoism which contemplates the material sufferings of a material body and says: 'I have no wish to be crucified. I thank you, Christ, for having suffered in my stead, to save me from Hell where my body would have burned eternally.' This now seems to me only a repugnant sadism, and I much prefer the pantheistic idea. What pleases me most of all is the Buddhist philosophy, with its 'Nirvana' as the highest form of thought. ...

Henri had arrived in Paris from Germany in October 1909; he was eighteen years old, and became an enthusiastic admirer of Puvis de Chavannes, Rodin, and Whistler's 'Portrait of his Mother'.[4]

Through the help of Monsieur Simonet, a professor at the Sorbonne,

he obtained the work of translating books and letters in a bookshop;* this occupied the whole of his day, while his evenings were spent in studying anatomy and his Sundays in drawing. His letters to Dr. Uhlemayr, written during these first few months of his stay in Paris before he met Miss Brzeska, show clearly the nature of his life and interests, and parts of them are worth quoting:

Paris
October 1909
(To Dr. Uhlemayr)
Now that I have definitely begun to live I find myself more and more convinced that civilization with its trappings and artificialities is not so good as nature. By nature I mean a natural culture — the kind you and I used to discuss in the forest of St. Gebald.[6] But that was no more than a dream, and the present reality seems the sadder for it. Ten hours of each day I have to do translations and letters in a bookshop, which you will agree is a pretty poor lookout; the rest of the time I work for my own pleasure — I am trying to perfect my drawing, and hope to succeed. I've made immense strides since I was with you, but how small they seem beside those I must still make! Every evening† I work in the St. Geneviève Library — crowds of foreign students fill the place, and at the table where I usually sit they are all Slavs and Germans. …

Paris, 14 Rue Bernard Palissy
1st January 1910
(To Dr. Uhlemayr)
We shall never see a greater sculptor than Rodin, who exhausted himself in efforts to outvie Phidias, and did outvie him in his 'Penseur',[7] which reaches heights he can never surpass. Rodin is for France what Michelangelo was for Florence, he will have imitators but never rivals. … It is fatal, for these men by their monstrous personality bleed a nation to death and leave others only the alternatives of imitation or veneration. …

* Mr. Ezra Pound says this was the Librairie Collins. *Gaudier-Brzeska*, by Ezra Pound, p. 43.[5]

† His evenings in the St. Geneviève Library were mostly occupied in studying anatomy.

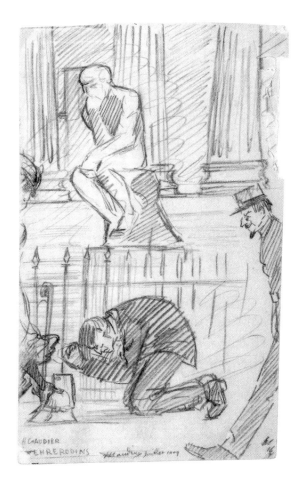

Paris
5th March 1910
(To Dr. Uhlemayr)
I have been, during this last week, the stage of a great battle. One of my friends has a little house and garden in the country, and I often go there for Sunday. Last Sunday I dug in the garden all day long, and a happier man than I could not have been found. My friend, who had to go to town on some business, left me alone in his house. I started to dream and to think, and so the battle began, and these are the opposing forces. On one side happiness and nature, represented by the simple life of the fields, and on the other the sadness and artificiality of business and town life. The

La Main

La Main se compose de 3 parties qui sont : de haut en bas : le *carpe* le

métacarpe et les *doigts*.

Le Carpe : est composé de 8 os qui s'alignent sur deux rangs et qu'on nomme :

1º le scaphoïde - 2º le semi-lunaire - 3º le pyramidal
4º le pisiforme pour la rangée supérieure.
5º le trapèze - 6º le trapezoïde - 7º le grand os 8º os crochu
pour la rangée inférieure.

Les deux rangs ne sont pas également superposés, l'inférieur dépasse en dedans et le supérieur surplombe un peu en dehors.
La face antérieure du carpe est concave et forme une gouttière convertie en canal par une bandelette ligamenteuse allant des os internes (pisiforme et os crochu) aux os externes (scaphoïde et trapèze). c'est le ligament annulaire antérieur du carpe. (Dans ce canal passent les muscles fléchisseurs des doigts, qui y disparaissent et ne donnent lieu à aucun modelé extérieur)
Les os du carpe les plus remarquables sont : le pisiforme, le trapèze dont la face inférieure concave transversalement s'articule avec l'os du pouce, l'os crochu muni d'une apophyse en forme de crochet.

La face postérieure est convexe, le bord supérieur est convexe et se met en rapport avec les os de l'avant-bras et le ligament triangulaire qui les réunit.

ligament triangulaire

Le Métacarpe : forme le squelette de

la paume de la main, et est composé de 5 os - longs on les nomme métacarpiens et on les numérote du pouce vers le petit doigt.
Caractères généraux des métacarpiens : Ce sont de petits os longs à corps prismatique légèrement concaves en avant ce qui contribue à donner à la paume sa forme excavée.
Extrémité supérieure ou base : forme cubique, s'articulant avec les carpiens correspondants et par des facettes latérales avec ses voisins métacarpiens - présente en haut et en bas des rugosités correspondant au dos et à la paume de la main.
Extrémité inférieure ou tête : arrondie, articulaire, sur la partie postérieure des faces latérales se voient des tubercules destinés à donner attaches aux ligaments réunissant ces ~~carpiens aux~~ métacarpiens aux 1ères phalanges

Caractères particuliers des métacarpiens : ils diffèrent par leur longueur et des modifications résidant dans leur partie supérieure ou ~~tête~~ base - le premier qui correspond au pouce, est court, épais moulé sur la face inférieure du trapèze à laquelle il s'articule (configurée en selle) Le second est long son extrémité supérieure possède une encoche qui reçoit le trapezoïde le 3º est un peu plus court et muni en haut et en arrière d'une apophyse pyramidale ou styloïde. 4º plus court que le précédent, 5º encore plus court mais moins que le premier légèrement saillant à sa partie interne de son extrémité supérieure, sur laquelle s'attache le cubital postérieur.

pleasure of the fields is clouded by bad weather, by danger to the harvest; but, in spite of this, happiness remains, no less truly. The misery of the office, though tempered by art, is the enemy of pleasure. The two main things: nature, a superhuman and beautiful creation, and the town, human and ugly – these will always keep their peculiar characteristics.

The exigencies of life compel man to obtain money. A commercial life provides this, but I cannot face it, and since art doesn't bring money, I am inclined to abandon this life of a middleman robber which repels me, and will do all that I can to learn some handicraft which will dispose of the idea that to produce nothing during the day is to waste my time.

But I have decided nothing, the town and the fields sit opposite each other – and if I have a trade, I shall still need art. Only a country life can give me pleasure, and I have begun to feel that farming is one of the most lovely of the fine arts. But since I am an anarchist in my soul and a friend of great solitude, if I wish to have done with it once for all – I should go to Canada, there they will give me land and I shall be free and happy.

If this were all, life would be easy, but my principles are to a certain extent in opposition. I am the friend of the producer, of the worker; I support him against his masters. Would it not be a horrid cowardice, a profound egoism, to go to the colonies instead of fighting at the side of my fellows? Land – Canada, these are my personal happiness. In trade, suffering, art, the town, the battle, I seek a collective happiness. I uphold the creative spirit of mankind, maintain it and make it triumph over the middle-class man who seems to deny its existence. If I abandon the workman, I take sides with the fat-bellied, flabby-faced plutocrat – a hideous idea. All the same, it is rather beauty than a selfish satisfaction which attracts me to nature – and there I come round again, and can arrive at no decision. One thing I can absolutely decide, it is the only thing I can cut off at once, namely, to give up business for some craft. I am going to learn the technique of sculpture in wood for cabinet-making. I shall give next month to this, and it is with this I hope to earn my daily bread, and not by fleecing the masses. When I face the beauty of nature, I am no longer sensitive to art, but in the town I appreciate its myriad benefits – the more I go into the woods and the fields the more distrustful I become of art and wish all civilization to the devil; the more I wander about amidst filth and sweat the better I understand art and love it; the desire for it becomes my crying need. …

Paris
24th May 1910
(To Dr. Uhlemayr)
I have taken a great decision – I am not going to do any more colour work, but shall restrict myself entirely to the plastic. I have never been able to see colour detached from form, and this year, after doing a few studies in painting[8] I noticed that the drawing and the modelling were all I had been concerned with. I have put by the brushes and tubes and have snatched the chisel and the boaster – two simple instruments which so admirably second the most wonderful of modelling tools, the human thumb. This and clay is all that I now need, with charcoal or red chalk and paper. Painting is too complicated with its oils and its pigments, and is too easily destroyed. What is more, I love the sense of creation, the ample voluptuousness of kneading the material and bringing forth life, a joy which I never found in painting; for, as you have seen, I don't know how to manipulate colour, and as I've always said, I'm not a painter, but a sculptor. It may surprise you that I can be content with confining myself to this one branch of art, leaving all others untouched. Yet sculpture is the art of expressing the reality of ideas in the most palpable form. It makes plain, even to the eyes of fools, the power of the human mind to conceive ideas, and demonstrates in cold lucidity all that is fervent, ideal and everlasting in the soul of man.

You will have noticed that civilizations begin with sculpture and end with it. Painting, music, letters, are later refinements. ... For my part I see quite clearly that I don't wish to wield the brush any longer, it's too monotonous and one cannot feel the material near enough, paint sticks well to the hairs of the brush and sings on the canvas, one appreciates its fertile texture; but the sensuous enjoyment is far greater with the clay slipping through your hands; when you feel how plastic it is, how thick, how well bound together, and when you see it constantly bringing forth.

I am now right in the midst of Bohemia, a queer mystic group, but happy enough; there are days when you have nothing to eat, but life is so full of the unexpected that I love it as much as I used to detest the stupid and regular life of trade. ...

Henri's boyhood had been lived at St. Jean de Braye, near Orleans, where he was born on October 4th, 1891. His father was a carpenter, a clever

workman interested in what he was doing, and it was from him that Henri first learnt his love of materials. There was a family tradition that one of his ancestors had worked on the cathedral at Chartres, and Henri was very proud of this legend.* He was a very sensitive child, delicate and frail-looking, but beneath all this lay a deep assurance and strength of will.

His father used always to encourage him to defend hotly what seemed to him to be right until the contrary was irrefutably proved; and as he grew in intelligence his disputes with his father became more and more intense. Already at the age of fourteen he had become the master in argument, and when he was older he would often tell how his father *a essayé de me battre, mais je lui ai donné de tels coups de pieds, qu'il n'a pu réussir.*[9] †

At six years old he began trying to draw the things which interested him, and it is curious that already these should have been insects and the lovely patterns of which they are composed. He used to tear up all his drawings,[10] and when his father protested he would say: 'I have done them, and that is sufficient; if I keep them I should be tempted to do them again, and that would be worthless.' This was his attitude all through his life; he always counted on fresh inspiration, and never surrounded himself with the past as a support to the present.

At his school in St. Jean de Braye he did very well, and at the age of twelve he went to Orleans, where he won at fifteen a scholarship which took him to London for two months.[11] This visit, in 1906, was his first experience of travelling; it gave him a decided pull over his school companions, and at the beginning of 1908 he won a second scholarship, this time of 3000 francs, to be spent on studying business methods abroad. His parents were very anxious that he should take to business. Some friends of theirs at St. Jean de Braye had a son who was already launched in Paris, and it was hoped that Henri might be able to join him; but Henri could never bring

* Once in 1913 when he was to visit Miss Brzeska in the country, and was to pass as her brother, she asked him not to mention his Chartres ancestor, as she was considered by her landlady to be of gentle birth.

† This is a Beauceron proverb, not to be taken literally: but Gaudier sometimes amused himself by using it for his story, and watching the effect on his audience, who were generally horrified: and so the legend arose that his nature was so violent that he used to kick his father.

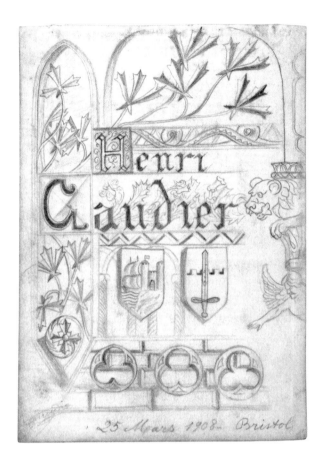

himself to show any zeal for a financial life, though for the next two years he still fluttered around the idea.

He went from Orleans to University College, Bristol, where he lived with Mr. Smith, one of the professors;[12] and from this time on he was engrossed by his desire to draw. Already he felt that an artistic future lay before him, and he signed and dated all his drawings with meticulous care. His first sketch-book[13] begins with a page of heraldic design, circling the name of Henri Gaudier; he saw his name repeated through the ages, it stood for the glory and honour which would be his; and this feeling was with him still in 1914, when he dreamt he had a studio with his name written up in letters of gold over the door. His continued interest in animals and flowers shows itself in this sketch-book, which he took with him on a holiday in

Devon and Somerset, but of his swift certainty of line there was as yet no trace whatever. He holds his pencil with a bourgeois closeness, and it is astonishing how commonplace several of his drawings are. Two illustrations for 'Omar Khayyám',[14] done about this time, are almost shocking in their lack of taste, and yet even in these there is no disguising his ability to convey with his pen a visual impression. He had become a square-shouldered young man, with short hair parted in the middle, and wore an upright collar, a small made-up bow tie, and clothes suited to a man of thirty.

By August of 1908 he was back in Bristol, and had begun a series of highly-finished architectural drawings;[15] and in these, particularly in the signing of his name, the easy flow of his pen first shows itself. After a short visit to London in September he concentrated on copying the antiques in the Bristol Museum.

Towards the end of 1908 he was placed in the firm of Fifoot, Ching & Co., coal contractors in Cardiff, where he lived at No. 29 Claude Road. Mr. Ching writes of him in 1928: 'He was one of several students who came to us, and while he excellently fulfilled the duties allotted to him, one could easily notice that his mind was not altogether in his work. Art undoubtedly occupied the greater part of it, and in his spare moments he was everlastingly, pencil or pen in hand, sketching some little incident that appealed to him. During his lunch hours he periodically walked across to the docks, and brought back with him a small sketch of, perhaps, the bow of a boat, or the elevation of a crane or tip, all of which showed genius. I encouraged him in this work because I felt that commerce was not his forte, and that he would be bound to leave it at the first possible chance. ... In character he was somewhat Bohemian, and just a little casual, which was natural, but he was the kind of boy that one would have expected, if necessary, to have lived in a garret while he got on with his life's work as he felt it to be, and therefore you can imagine how disappointed I was when I heard nothing more of him (until you wrote) after he left our employ.'

Not only did he sketch at the docks, but he made the most elaborately finished drawings of birds, which he studied in the museum, or in Victoria Park, Canton.[16]

On the 15th of April 1909, he left England for Nuremberg via Holland, where he went to stay with Dr. Uhlemayr; in his first letter to his mother and father he speaks of his arrival.

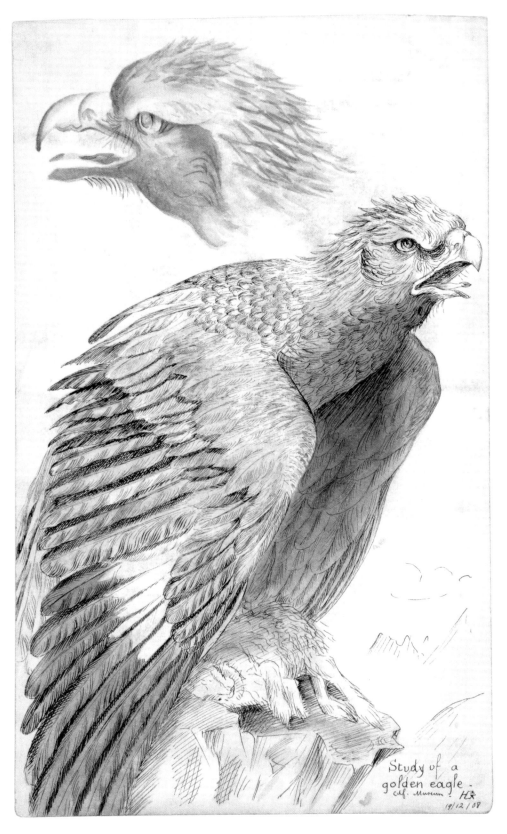

Study of a
golden eagle.
Cdf. Museum
19/12/08

30

9 Schlüsselfelderstrasse, Nürnberg
20th April 1909
Dear Parents,
Here I am at last, after three days of continuous travelling, and not a bit tired. Dr. Uhlemayr and his wife are very nice people, and are a pleasant change after Cardiff. I sent cards to Henriette and to Renée* from Brussels, Cologne, and Frankfort, I wonder if they got them.[17] Nuremberg seems to me to be a very lovely town, but I like England better than Germany, and if ever the English go to war with the Germans, I shall be on their side and will be delighted every time these 'pointed helmets' get the worst of it. Everything seems to be moving that way, and only last month, when Mr. Haldane[18] said that the country was in danger, in less than fifteen days they had more volunteers than they wanted. All the same, perhaps I'm not very just towards the Germans, although they do deserve a big defeating to the tune of 'Rule, Britannia, Britannia rules the waves'.

Dr. Uhlemayr speaks French very well, which is a great comfort, for I can speak hardly any German yet; but soon I will.

H. Gaudier.

Dr. Uhlemayr and his family were among Gaudier's first sitters, and he did several sketches of the Doctor with his violin, and one of the violin alone,[19] which is curiously sensitive, and very reminiscent of Dürer; and it is characteristic of Henri's mind that the titles of all his sketches done at this time are in German script, a small instance of his thoroughness in acquiring knowledge: he always liked to know about everything, and by the time he was twenty-one was extremely well informed. He would instantly pretend to full acquaintance with things quite new to him, and it was this kind of 'boastfulness', as Miss Brzeska used afterwards to call it, which in 1911 prompted his reply to Epstein. He was introduced to him at an exhibition, and Epstein asked him if he cut direct in stone. Gaudier, who had never yet worked in stone, replied, 'Most certainly'; upon which Epstein said that he would visit him on the following Sunday. Gaudier rushed off, got three small blocks of stone, worked furiously all night, and had three original works lying casually in his studio by the time Epstein arrived.

* Henri's sisters.

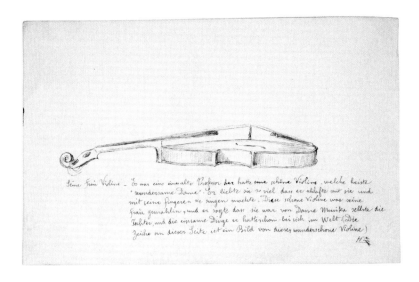

Gaudier's sketches in Nuremberg and its environs are still of an architectural nature, but not so minutely expressed as those he did in Bristol – there is in them an obvious desire to be painting.[20]

One day a Zeppelin came over Nuremberg, and Henri describes it to his father in a letter:

9–3 Schlüsselfelderstrasse, Nürnberg
31st May 1909
Dear Father,
Herr Doctor, Herr Gaudier, Der Graf Zeppelin mit seinem Luftschiff![21]
Thus we were interrupted yesterday, bang in the middle of our lunch, by Marie. In the twinkling of an eye we snatched up the glasses, which mercifully were near at hand, and with one leap we were out on the balcony. There the most wonderful spectacle awaited us.

This balloon, floating in space, like the frieze and metopes of the Parthenon, defies exact reproduction or description. Picture an enormous long polygonal-shaped mass of a startling whiteness sailing two thousand feet above us. The propellers, murmuring like innumerable bees, made the canvas shiver along its rigid structure. The aerostat tacked about against the north wind, but unlike sea ships, which tack on a horizontal plane, it tilted itself upwards. It was all so full of life, vibrating with so joyous a sound and so harmoniously lovely in its setting that one could scarcely believe it a man-invented thing, but thought it some strange animal come from the higher regions of the air, prompted to look at us by contempt or curiosity. With the help of glasses I counted fifteen people in the front gondola and five in the back one; the last, mechanics no doubt. It had come from Friedrichshaven to the Alps, and so had done two hundred and twenty-five kilometres when we saw it here, and it went like the wind – only a few seconds and it was gone. We put on our shoes and rushed downstairs, where we joined a great throng of people, half-dressed, who also hoped to see the Zeppelin a little longer. At last we caught it again just in time to see it sail over the mountains, a truly lovely sight. Its white, which had been so alive and gay, had changed to a mist, blue and airy, on which the elegant forms of its framework were delicately shadowed, the colour of light blue violets, so simple that it was one with the mountains over which it hung – and then it vanished in the air.

A memory remained, already faded; was it towards Bayreuth and Bamberg that it was going, on its course towards the north? I don't know yet, but, with Dr. Uhlemayr, we hope it will come back. It was so beautiful; not pretty, but beautiful, agreeing with the laws of Greek art and with nature, and what fun if only it would take us for a trip!

The children, Gunther and Walter, were delighted, and Walter, the younger one, aged five, hasn't ceased to look for it. After it had gone, he came to find me on the verandah, and said so sweetly, 'Mr. Gaudierlé, you must fly to catch the Zeppelin, to ask it to come back — I want to see it again.' 'But Walterlé, I can't, I haven't any wings.' — 'Ach! You are a naughty Mr. Gaudier!'

We walked yesterday through the woods, which remind me very much of the forests around Orleans, to a fortified church at Gratshof,[22] where a venerable *pasteur* was preaching. His hair and his long beard were pure

white, his face beautiful and austere, and so religious a calm enfolded the peasants who were met there that it would have made a wonderful subject for a painting.

My German is getting on quite well, and I am very friendly with the people of the house. I frequently discuss art and civilization with the Doctor; *Kultur* they call it here. He is a good and simple man, son of a mountain peasant; was born in 1871, while his father was at the war, leaving twelve sons and daughters at home. His father-in-law got a bullet in his left arm at Bazeilles, and has never been able to use it since, so you see that the war wasn't all rose-coloured to the Germans either.

I kiss all the family – my love to you.

<div align="right">*H. G.*</div>

Ezra Pound says that after he left Nuremberg he went to Munich, where he was employed on the manufacture of faked Rembrandts.*

Gaudier's stay in Munich made a great artistic impression on him; he started two large series of drawings relating to Munich life,[23] and worked so hard (among other things he was learning Russian) that he began to have serious trouble with his eyes. He then returned to Paris, which, as we have seen, became the stage of his revolt against business life, and his new-found friendship with Miss Brzeska must have contributed very considerably to his ever-growing discontent with a life so little suited to his nature. To have someone to whom he could open his heart, someone who encouraged his strong desire to devote himself to art, gave him the extra confidence which he required; and he threw up an irksome job which he had taken with the firm of Goerz,[24] after leaving the bookshop where he had been placed on his first arrival in Paris, and, as is described in the following letter to his parents, accepted temporary work of a more congenial kind.

22nd June 1910
Dear Parents,
I have just seen Mr. Maurice – it seems that you are anxious about me, and you think that I have run away abroad. I am safe and sound in Paris, and hope to be here for some time yet. I've only changed my job. I went away from Goerz without giving notice because they would have made me stay

* *Gaudier-Brzeska*, by Ezra Pound, p. 49.

fifteen extra days. I have now got a job as a draughtsman for materials and carpets. I work ten hours a day and get sixty centimes an hour [five shillings a day at that time], I believe, I haven't been told yet, and even if I only get two francs a day I am relatively happier, and I can no longer think why I was such an ass as ever to go in for trade. I know that you will be annoyed by this, but do for goodness' sake get it into your heads that I am an artist and that nothing else holds any interest for me. At figures I am an absolute nincompoop, and in a commercial life one must be interested in figures and in money. I shall stay here long enough to learn the tricks of the trade, and then I think I shall go and work in Poland or in Russia. Please don't write me nasty letters about this. With all the will in the world I cannot conscientious-ly do any kind of work, other than that of a sculptor of wood. Apart from this job I work very hard at my modelling; the drawing here doesn't require any intellectual energy, and when I get home I am still fresh and keen. I am free on Saturday afternoons and Sundays, which is excellent. Love to all.

H. Gaudier.

In the meantime, Henri's and Sophie's health, far from getting better, got worse, and Sophie went into the country to Royon.[25] Henri was not very assiduous with his textile firm, and often left it to wander the streets, to observe people, to visit museums. He did odd jobs here and there, and for some time earned a few francs a day as a servant in someone's studio, but as these francs mostly went in the purchase of prints and engravings, he soon became seriously ill for want of food. He wrote to tell Sophie that he would come to her on foot, that his nose had taken to bleeding and that he was utterly run down. Sophie was afraid to encourage him; she had so often before been deceived in her affections and felt that closer familiar-ity might breed contempt between them. Apart from this, her own savings were so small, and her health so poor, that she could not contemplate looking after him at her expense.

His mother and father, who had a comfortable house by the Loire, were trying to persuade him to come to them, but he was stubborn. He writes to Sophie:* 'I told them I would not go, I would rather stay in the hospital than receive help from anybody whatsoever. I shall go and see them on Sunday week and let them understand I am going to stop a week, but I will

* Gaudier writes this letter in English.

not. I am quite decided not to give way. When I am with them they will try to get me into commerce again, and I would rather die than go again type-writing and making parcels – don't you think so? They seem to do it for love, but I cannot believe it. Anyhow, the matter is over, and I am in Paris, and will remain here, since you tell me not to go to you. I shall rather fight with the *harakiri* than to be stirred a foot out of my doors.'

Paris
4th October 1910 [26]
(To Dr. Uhlemayr)
Yesterday was festivity – to-day comes depression – I profit by it to write you a letter, for that will ease my heart.

The day of the *Mi-Carême* I carried on like a character out of Zola. I went on the razzle, and now to-day I repent and wish to be pure. After those violent joys – after such monstrosities I find myself in the most pessimistic state of mind, just ripe to deny that life holds any interest or happiness. My circumstances, which only yesterday seemed not at all unjust, appear to-day as bitter as one of those good wines turned rancid. I suppose that will make you laugh, but I assure you it's horribly true. This is what I have always noticed for the last few years since I learnt to look at life in a fairly abstract way, and became able to analyse my own feelings: with me every big pleasure, or rather, every big deviation from my usual life, is followed by a deviation in the opposite direction, and this is the reason for the pessimism and optimism which I hold in spite of myself. My natural state, my every-day feeling, is between the two. It is a succession of little variations, tiny contrasts, perhaps, but which all the same exist. I am never without a little joy and a little sadness. These small moments stretch out for several days, some cause or other favouring the intensive development of one of these two states, and this is what happened this morning after I had come home.

As a rule, when I go to sleep I am glad to wake and see the day and look at a lovely engraving by Steinlen or a poster by Toulouse-Lautrec which I have, then I quickly get to work before I have to start for the office and the translations which prolong my material existence.*

To-day, nothing of this.

* Gaudier had gone back to work in an office.

I got in at six, tired, weak, annoyed with myself for having shouted all the afternoon in a 'rag', and for having wallowed all the night. I felt phenomenally lazy and depressed in spirit. Tomorrow, however, that will be all right. Already I feel the change coming over me.

I have been reading Taine's 'Philosophy of Art'. His theory does not seem to me to be very sound. It is true that environment does have an influence, but what has a much greater effect on the artist is love or hatred. He uses his settings to express these things – that is how I see it. Take, for example, Forain – the best of draughtsmen, in my opinion. This man has been made spiteful by the misery of his early years; he began his work in a spirit of implacable raillery against the customs and manners of his contemporaries; to-day the influence of his surroundings is modified enormously – he is rich. The setting has changed, but the artist has become even more intransigent and malicious than before. His drawings breathe the strength of a perfect anarchy. This powerful personality dominating its surroundings is a thing which Taine never explains. I do not believe that it is possible or useful to describe art in so rigorously scientific a way. To begin with, you lose the whole of the pleasure when you only look at a work to discover all the causes which went to its making – then art is so subtle and capricious a thing, so different in the hands of people who have developed together, that, considering the rarity of good work, one should find the pleasure it gives a sufficient justification for it.

I have started to read Bergson's 'Evolution Créatrice' – it is an entirely abstract work, and so profound that I must study it carefully, and, above all, meditate about it before I can discuss it with you.

You will remember that last summer I deplored the lack in France of an illustrated anarchist review which should equal *Simplicissimus* in artistic value. This review now exists – it is *Les Hommes du Jour*, which for Art and Literature does what the *Guerre Sociale* does for Politics.[27]

We are forming an anti-parliamentary insurrectional committee, who have in view a revolution only possible by force. Young people will come to us, and it is all that we need. ...

You will think me very revolutionary. I am. Each day I grow more convinced of the necessity of a radical sweeping away – especially of machines, which must be utterly destroyed. It is mechanism which is now our master. To make matter obey him, man must abandon the wish to do colossal

things. The other day I visited an exhibition of Japanese prints and sword-hilts. Since then I have not stopped proclaiming, in the teeth of opposition, that the yellow civilization is better than our own. Had it not been so they would not have so adeptly appropriated our infernal machinery for our own destruction. …

Miss Brzeska now persuaded Henri to leave Paris, and a month in the country brought back most of his natural vigour. Sophie was better, too, and decided to stay on in Royon all the winter. Henri, whose doctor would not allow him to paint, and advised him to stay in the country for another two months, implored her to come to him. He found her a charming little cottage not far from his parents' house,[28] and after much deliberation and with many forebodings Sophie decided to go. There Henri came to see her every afternoon. He would arrive early while Miss Brzeska lay on her bed, a practice which helped her to digest her dinner. One day he told her that his mother was beginning to be annoyed by his daily visits; that she had accused Sophie of debauching Henri and so making him ill, and had added that soon there would be evil gossip among the neighbouring farmers. Sophie felt that there might be some reason in Madame Gaudier's vexation, and persuaded Henri not to come the next day, particularly as his visits occupied much of her time, and she was anxious to get on with a book which she was writing.

Next day Henri came as usual and said that he could not stay away, that it was so dull at home, that no one understood him, and anyhow, why should they be separated? Sophie was lying on her bed, and Henri, who sat in a chair by her side, got up every now and then tenderly to caress her mouth or her forehead with his lips. Although Sophie had never allowed him the passionate kisses of a lover, she did not feel that she need refuse him the indulgence of this small caress which he seemed so much to need.

While they were thus together there was a knock at the door; Sophie expected no one, but without getting up called out, 'Come in.' It was her landlord out of breath and red in the face. 'Come downstairs quickly,' he said, 'the police have come with an anonymous letter'; and before she understood what he meant, the police were in the room. With furtive glances at the bed, they asked her to read the letter, which accused her of using her house for the improper reception of men.

It seems that some farmer,[29] who had unsuccessfully tried to rent the house in which Miss Brzeska was living, had started this scandal in order to revenge himself on the landlord. Henri and Sophie were very much upset by this incident, and spent a great deal of time and energy, though without any satisfactory results, in trying to have the originator of this slander punished.

Henri's reaction expresses itself in a letter to Dr. Uhlemayr:

St. Jean de Braye
11th November 1910
You will be surprised to see that I am in the country. I have been ill — anaemia — the result of all the energy I've put into this hateful battle for existence. All the same, I have won, for from the muddy channels of commerce I have risen to the less seamy realm of *Kunstgewerbe*.[30] It is as a designer of fabrics that I now earn my living, and it is in this way that I shall continue through a long and tempestuous future.

But enough of myself — I want to speak of *la belle France*. It is indeed a lovely country, but the people who live in it are utterly degraded. Men more malicious, more treacherous, more miserly and grasping, you will find nowhere. I begin to establish certain maxims for my personal use: 'Beautiful countries are given over to savages.' 'Religion is a necessity to frighten ferocious beasts.' If our peasants feared an imaginary God, they would not act so wickedly. I have got mixed up in the most abominable affairs,* of which I will tell you later, and I have been able to judge for myself the value of a pure republican justice. I believe that my country has never before been in so advanced a state of decadence. The Latin race is rotten to the core. Its flag has become violet, yellow, and green, the colours of the putrescence which fills the romantic paintings of Delacroix, presaging storms, wind, destruction, and carnage. The French disgust me more and more by their idleness, their heedlessness, and their excess of bad taste — I have irrevocably decided to leave them to the Furies and to get quickly to the frontier.

I have tried to place caricatures in the Parisian papers; they took a few for *Le Rire* and *Charivari*[31] — I don't know if they published them, but they paid well. I shall try again, particularly since my ideas become more crisp

* The slander against Miss Brzeska.

and precise, but there's the rub — at nineteen one is scarcely more than a child, and the battle is hard. One's line lacks snap and vigour, and one's outlook is narrow, there is a want of cohcrence. There are parts which seem free and original, and others which are full of outside influences and childishness. The editors see this clearly enough, and it is better for their papers, but it sometimes drives me to despair. Still, one has to sacrifice oneself a bit. One only has to take three vows; poverty, chastity, abstinence, and everything goes well. One leads the life of an ascetic, and art becomes the sole inspiration — and that is the only way to development — by cultivating one's own innate powers. ...

Worn out and disgusted by persecution and injustice, they decided to leave France, particularly as it was almost time for Henri to start his military service; a duty he was determined not to do, his convictions as well as his character not easily submitting themselves to these years of slavery.

England seemed to be the most suitable country; for Henri, because he had already spent two years there, thought that with the help of friends he would be able to find work. Sophie, who believed in his glowing accounts of the English, agreed to accompany him. First of all, however, they went back to Paris, where they stayed for two months.

Henri looked for work without success, and Sophie had to provide rooms, clothes, and food, since he would accept nothing from his parents after the way in which they had behaved about Miss Brzeska.

They were not peaceful, these two months; Henri was nervous and irritated, and Sophie was frightened to find her small savings rapidly decreasing. There were many angry quarrels, with as many reconciliations, until at the end of 1910 they crossed over to London, where for the next four years, until Gaudier's death, these two were to live together under the name of Gaudier-Brzeska,* as brother and sister; each in his or her way passionately fond of the other, but seldom rising sufficiently above the daily grind of poverty to be able fully to appreciate each other's friendship.

* So far as I know, the linking of their two names into one was never more than a personal arrangement.

4 | The first months in London

Part I

In London, Gaudier did not find work so quickly as he had hoped; his poverty-stricken boots and frayed collars frightened the few acquaintances on whose help he had counted. Sophie had drawn heavily on her savings for the expenses of the journey, and had to continue doing so to pay for the necessities of their daily life; this naturally alarmed her, because the precarious state of her health always made her desperately anxious to keep by her a small fund in case of need.

At one moment they were reduced to such poverty that while Henri was out, Miss Brzeska made a doll, took a shawl, which she wrapped round herself and 'her baby,' and went to the street corner to beg. She collected sixpence in pennies, and with it she bought some bread, margarine, and tea; because Henri was fond of cakes, she also bought one small cake. When Henri got home he found an excellent tea all ready for him, and he asked Sophie how she had done it; she told him, and to her surprise he was very angry, saying that she must never do such things again. Instead, they visited the various public-houses of the neighbourhood, and Henri did drawings of the customers at a penny each.

At last, after two months of searching, during which they came very near starvation, Henri found work as a typist and foreign correspondent with a Norwegian in the City at a salary of six pounds a month.[1] A month later Sophie got a temporary post as a governess at Felixstowe, in exchange for board and lodging.

The two months in London without work for either of them, and the consequent poverty and worry, had exhausted her, so it was a relief to be in the country, though at the same time she was very anxious about Henri's health. He had no idea of the value of money, and quickly got through the six pounds he was earning, which left nothing for food; he had little rest, since his business occupied him all day, and his evenings were spent in drawing and study, so that he became enervated, underfed, hollow-eyed, thin in the face, and subject to dreadful fits of crying and anger. The doctor

he had seen in France had told him that he would find it good for his health if he went occasionally to prostitutes; and Sophie encouraged this idea, even though it cost five shillings every time; but her economical sense was outraged, though her heart was touched when Henri returned, having given the woman five shillings, and then been too disgusted and horrified to have anything to do with her.

He was very lonely when Sophie went away, and wrote her long letters full of love and affection. These letters give a very true picture of his life during the next month.

C/o W. and Co.
22nd April 1911
Mamusin Dearest,
I expect you are feeling better by now – I know Pik is; he was very miserable yesterday, but he slept for ages the night you left, and last night, too. Wulfs*only came back yesterday evening at five o'clock, so you see I have had a quiet time.

I have disobeyed Mamus! I didn't go to the Park, but went to the Museum instead, where I found some marvellous casts of Michelangelo's study of a slave.[2] I only worked from five till nine, and half an hour afterwards I was in bed. Yesterday evening I bought the frames (eightpence three-farthings each) and also a little brooch for sixpence – it is silver with blue enamel. I didn't choose one with brilliants, because they were very small and badly made – no use at all.

I have something very amusing – comic, rather – to tell you; the love affairs of the Jewess Rachel, the celebrated actress.[3] It relates to the first time she lost her virtue. The Prince of Joinville, son of Louis Philippe, Admiral of France, had just brought home Napoleon's ashes. At a gala night at the *Comédie Française,* given in his honour, he saw our Rachel. He at once sent a message to her box with the words: *Ou? Quand? Combien?* to which the actress replied, *Ce soir, chez toi, pour rien,*[4] and our two had a gay time.

And now for our own affairs. This morning I received replies [from J. A. Dickinson & Co.][5] to my advertisement of last week. They ask me to send them specimens of my work, and if it is suitable, they will give me a

* Wulfsberg was his employer.

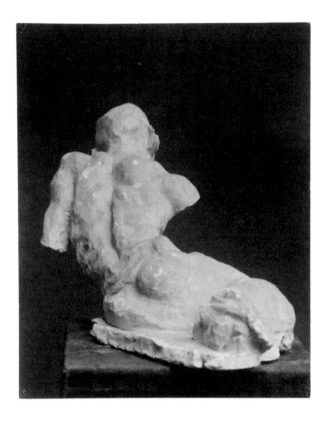

commission. So I am again going to disobey my Mamus. I shall work all
this afternoon, this evening, and all day to-morrow, without taking much
of a walk, just as far as the river, perhaps. You must forgive me, Mamus,
because it would be stupid to miss a good opportunity. If I am successful
it will be a help to you — so you see, you stupid little Madka! I won't write
any more now, it excites me too much, and I must keep very quiet. I wish
you the best of luck and health, and send you my blessing. Every day I say
our prayer to the great sun, and he shines splendidly. I ask him always for
endless benefits for Zosienka — that she may be happy, contented, sweet,
and beloved. I send you a copy of the letter which I'll send to-morrow with
the drawing in reply to the advertisement, and also a Polish study.

Pipik.

P.S.–Dickinsons addressed me as 'H. A. GANDER'–*Mr Jars, mâle de l'oie
en français*.[6]

Horsden Hill, Berks
Sunday, 23rd April 1911
Zosienka Darling,

I am always the *p'tit blagueur français*.[7] Having proposed to work all yesterday afternoon and all to-day, I only managed to draw from five a.m. till one to-day. I was dreadfully upset with Mamus's departure, and the move to new rooms, and then here I wasted ages hunting after subjects none of which pleased me. I have come miles out, far into the fields, and the lovely sun blazes. I have been very lonely since Mamus went away so quickly, but I am keeping myself well in hand. When I am in my new rooms, everything will change, and as I have heaps of work to do, I am sure to forget a little. What a curious thing life is: in order to have any peace at all, one must always forget. Don't you think, little Mother, that life would be marvellous if one were always allowed to remember? But for the moment we must work, and knowing this, I am sticking at it.

I went on with the study of form and the arrangement of Michelangelo's noted planes, but without discovering anything new; I only convinced myself that what I felt yesterday was true. There are always a dozen little 'kids' around me when I draw the Slaves. They are, no doubt, astonished by my methods, because I write as much as I draw; for a long time I look at the thing I want to understand, and then draw by system. What intrigues them beyond anything is that instead of drawing the fellow straight off, as they are used to seeing everyone else do, I draw square boxes, adjusting the sizes, one for each plane, and then suddenly, by joining the boxes with a few little lines, they see the statue emerge. They look at me with terror – with respect, perhaps – I don't know if it is because they find me so severe, or because of the drawings. Whatever it is, they amuse me highly. I believe, in the end, it is the drawing, because men respect and reverence, or rather fear, what they don't understand, and consequently what astonishes them.

When I tired of drawing Michelangelo – about eight o'clock – I went to see the Goyas. He is a Spanish painter – the first since Rembrandt who knew how to use aquatint with mastery. He did three series of engravings: 'Los Caprichos', 'Los Desastres de la Guerra', and 'La Tauromáquia'.[8] Last night I only looked at the first two series. Mamus would delight in them, because although they are, for the most part, very scrupulous studies of

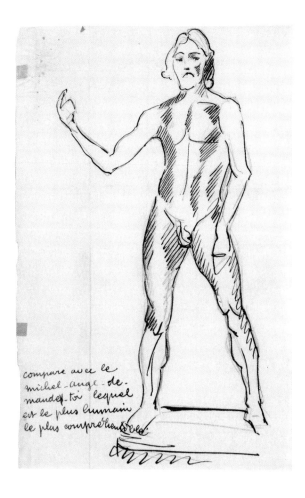

life and movement, they are, at the same time, real drawings, and are all impregnated with a very strong philosophy and sarcasm. In the 'Caprichos', for instance, he has drawn the most outrageous things: an old woman, fat, abominable, naked, held by devils, who carry her in the air, and underneath he has written: *Donde vá mamà?*[*9] ... The words he uses are so short, so strong, and so intimately connected with the drawings that it is impossible not to be bowled over with admiration. I tell you this, dear little Mamus, thinking that it will interest you, for it has thrilled me – I am quite

* The letter here contains many detailed descriptions of Goya's engravings.[10]

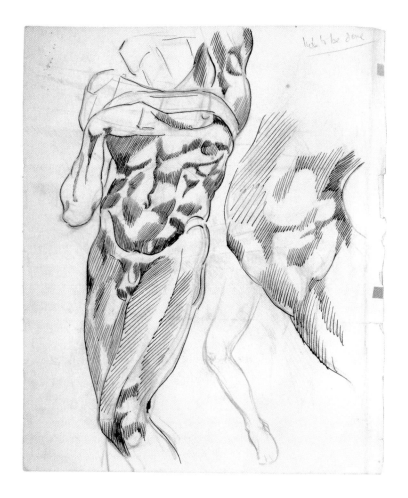

captivated by it. The drawing is magnificent, and I believe that the best draughtsmen in this manner – Goya, Daumier, Gavarni, Toulouse-Lautrec, Phil May, Keene, Forain, Belcher – have been, or are still, the profoundest thinkers. So you see, we have heaps of lovely things to look at when we are together again in the winter: Japanese prints, French paintings, Belgian and German engravings, Goya, and many other things which I shall no doubt find. You will be quite confused by hearing of so much all at the same time, funny little Mamus; what with the orchids, the palm-trees, the drawings, you won't need Pipik any more, and to think you didn't want to come to London!

It is very annoying that I should have to reply to the advertisement just now, when I never felt so good for nothing, so empty-headed, jumpy, over-excited, and *zweifelhaft*.[11] All the same, I have done a drawing, but as I have already told you, it took me from five this morning until one o'clock this afternoon. The little larks are singing all around me, and that makes me live in company with my precious Zosienka. You will see, little Mamus, we shall be happier soon, so have courage – for me particularly, as I am so easily depressed. I soon pick up again, but these sudden changes make me suffer physically very much.

<div align="right">*Pik.*</div>

Still at 'Fifille'
25th April 1911
Pickna Zosienka,
You will scarcely be able to imagine the tremendous joy I had last night, when I found your dear letter in my room; just like my beloved little Maman, I have been terribly over-excited and ill – although I feel a bit better now. It is strange that we should influence each other to such a degree.* Knowing this, I do everything in my power to be very quiet at these moments, I study the old masters, and so straighten out all the stupid ideas which upset my mind. The *zweifelhaft* worried me dreadfully yesterday. After taking all the morning over a drawing, I decided that I would go out somewhere in the afternoon. But where? To the Tate Gallery? No. Museums make me sick. I should see nothing. To Kew? No, there would be such crowds there. Then where on earth? Perhaps to the Tate after all – no, I'll decide on Kew. All this took an hour at least, until, furious with myself, I took my head in my hands and shook it to bring back my wandering wits. I left for the train, and only at the station decided to go to Sudbury Hill, far away in Berkshire, in the west.

I saw the most magnificent country from the top of the hill – all central England, even the good old Blagdon Hills that I loved so much in Somersetshire; the South Downs as far as Portsmouth and, close up in the valley, Windsor Castle. Beyond all this, I imagined France lying far behind the Downs which fell away in front of me, and I was comforted, alone with

* See letter of 19th May 1911, p. 55

the memory of Zosia, and with the phantasmagoria of Goya y Lucientes. The great beautiful sun sank to rest behind all the expanse of meadows and trees, and I prayed to him, the great artist, to make us prosperous. I should never be happy all day if I did not, each morning when I get up, kneel down before him and communicate with you, good little Mamuska. I am always very enthusiastic, but very weak, and this is why I need a beloved Maman, and a beautiful great God. We only follow the fine and natural religion of the ancients, and no one can laugh at us, for our prayers are addressed to a Being, true and real.

Do you know what I saw yesterday in the City? An old book by Emerson, in German, and the title was *Die Sonne regiert die Welt*.[12] If Matuska will allow me, I will buy it later, but only if I can't find it in one of the libraries, for I already possess too much. I notice this particularly during a removal, though I am getting on all right with this one. Already I have half my things at Sterndale.* The rest are tied up here, and after three more journeys there will be nothing left. To-night I will sleep in your bed, and this will pleasantly crown the memories of this happy week. I shan't need a man to help me move the box, which we are destroying, and I shall have enough pennies to last me until April 30th, which is Sunday. I shall be bucked if W. pays me on the 29th. He probably will. I put myself out for Wulfs much more than I have done in other places, because I am fond of him, and so I work conscientiously for him. He is trying to get a certain job in order to do in a filthy pig of a 'business man', a hideous liar, woman-hunter, and rotter; so, sweet Mamus, you will pray for Wulfs success, won't you?

Don't be too disappointed that I haven't been learning Polish, and that we haven't spoken much. We will discuss all these things in our letters. We have been together for so short a time that we are quite justified in letting ourselves go a bit. We have so many things to talk about. At Kew, for instance, we could only talk of the flowers and the trees, and when we stayed at home there was so much to say – Mamus had to tell all that happened to her at Felixstowe,† and since that Tuesday Pik has seen little of her; so you see, sweet dear, you must not get anxious.

* 39 Sterndale Road.[13]
† During her visit for an interview.

I promise you, Mamus, to look after myself better next month. In addition to the two pints of *lolo*,[14] I will eat raw eggs every day, and if I can get it, some raw meat too. Although I may control myself ever so much, I can't possibly promise not to be an enthusiast – it would be impossible. For that, I would need to see nothing, to read nothing, and never to think. I must get stronger, I agree, but it must be a relative strength, don't you see, my little Mamus? For certain things I shall do, as I have already told you dozens of times, I shall follow my instinct, and think as little as possible about them; and, little Mother, don't worry about the drawings, nor about your writings. You see that advertisement may easily lead to something, and now that I am feeling better and have not got to think again about changing my lodgings, I shall, through the help of the *Architect*, get to know other people, so that, without having an Abbey – you greedy kid – we will at least have a little house, or even a little flat for the two of us. The little Mother is, of course, an excellent housewife, and she must have her little nest. Is it in order to powder her nose? Pik isn't so ambitious on that head, although it is true he is just as keen – for his greatest joy would be to have a studio, also for powdering – people – in plaster!

Let's keep up our spirits with the big sun as our guide. You know Pik is very, very young, and Mamus is young too – we will have time to do such a lot.

Heaps of love, kisses, and sweet things to you, poor love. I will get better all the time now, little Zosienka.

Pik.

Tes énormes fautes
horrible petite gribouilleuse

'lui laissant la charge *de* gosses' – des gosses.
　　un nombre vague, indéfini (il peut en avoir 10 comme 20, 30).
　　Par contre, *de* 3 gosses – *de* quelques gosses, *de* plusieurs gosses.
'je suis forcée d'avoir des mioches':
　　c'est très bien là – pourquoi pas dans le l[er] cas? *étourdie.*
la nature n'est pas *magnanime* mais *magnifique*:
　　magnanime – seulement pour les individus.
'loin *de* méchants h...,' *des* – comme pour gosses.
abaye – abbaye.[15]

39 Sterndale Road
13th May 1911
Beloved Maman,

First of all, I must give you a good spanking for having wished to go away from Pik so soon. She doesn't want him to work for her, she would like to earn her own living – stop there! Madama, it is high time that you settled down; you have collected quite enough material by now to construct something, and it is impossible that you should go on any longer dragging from place to place. I am very young, and I ought to study, but while doing so, I will earn a little. If Mamus would only consider her Pik as part of herself, she would not talk of being 'kept' – as if it were a question of two different people, of a fellow who had a woman for his kitchen and his bed. No, it is a question of art, and I'm your Pikus, as you know. I shall be desperate if you really wish to do what you say in your letter.* It is this splendid sunshine that has puffed you up with enthusiasm and recklessness. At heart you are still poor little Madka, who needs a good Pik to do all in his power to aid her to realize her wishes; he will do it, so give him your promise. Pipik takes your advice, you know, whenever it is possible, and today he took his first sunbath. We are a couple of miserable little insects – for I also thought he would shine just because we worshipped him – who is going to whip us for our presumption? Between you and me, I think it is the only way, all the same. It is lovely weather – magnificent – a most delicious springtime. The lilac is in flower in the gardens, and each evening I inhale deep marvellous scents which put me in a frenzy. You are quite right about my eyes; they used to say to me in France – mother in particular – 'Why don't you look like everyone else? You have the eyes of a wicked madman. People will think that you want to steal something,' etc. And, certainly, it is true – and it is the Soul that I wish to capture.

Now let's talk about art. You say that it is monotonous to see [single] statues standing or seated.

* Miss Brzeska was looking for a permanent position as a teacher in a school.

We have:

Victory:	standing
The Slave:	„
St. John:	„

and these are the best.[16]

You are bungling the whole thing when you say that design and colour do not require much thought. It is only as a result of knowledge and ability that simple things are discovered. Philosophy is inherent in man. It comes long before these exact expressions. We always come back to the same thing, belovedest, that beauty can only be arrived at through truth of form and colour. It is not a scrap of use theorizing in front of a mass of modelling clay. Life must come out of the clay by means of its external surface, and this is the *design*. If you discover fine design, it will bring with it life, and herein lies Art. No one will shake my belief in this. Conceptions, subjects, are but the frames of pictures – secondary things on which one should not count.

It is true that before beginning even a portrait I should know what the work will be, but if I am unable to render what I conceived, people will say

that I am not an artist – thus art does not lie in the dream, but in the marriage of the dream with the material. Work, always work. And in order to work well you need a big intelligence, and that is all I can tell you, little Mamusienka.

I have been reading about the Neo-Impressionists. They are, like all artists, very idealistic: too idealistic I think – mystical and not at all independent. They are like Christian savages of the Middle Ages. Their principle is that drawing (painting, sculpture, architecture) should not represent such and such an object, but by means of some indications should convey to the mind the memory of a form, heighten the imagination and make you think of the thing represented. Example: a laughing man: they would not draw the features, but only make you think that the man laughs. This is a decadence, because they are mixing painting

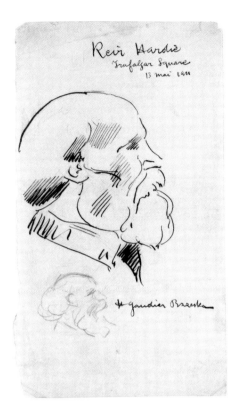
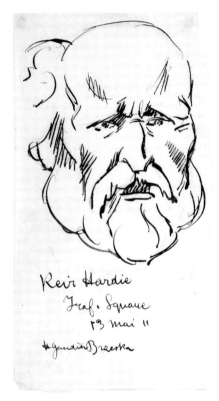

with music — an art altogether idealistic, since it exists to evoke, nothing else — while the role of drawing is to be pleasing to the senses in giving them something palpable, solid; in other words, in giving a representation. If the representation is of a living thing and if it is true, it will be alive, but under no consideration should one imagine that it belongs firstly to the soul — that is a false trail. One's fingers should feel delight in touching the undulations of a statue, the eyes in beholding a painting. Philosophize after, to satisfy your humanity, but not before. In Art one must absolutely respect its limits and its logic — otherwise one arrives at nothing worth doing. The great masters are there to instruct us, and I wish to remain faithful to their tradition.

I heard Keir Hardie, the great English socialist — a magnificent old man — very enthusiastic. He was holding an open-air meeting in Trafalgar Square, and spoke of the exploitation of the miners by the owners of the

mines.[17] I'll send you the sketches I did of him and a little revolutionary pamphlet, copies of which were distributed.

I write in haste this evening so that you will get it to-morrow morning.

I beseech you, little Mamus, to forget what you said about plans for next winter. I do absolutely wish to help Mamus, and she ought to accept, otherwise it will be I who can do nothing because of the torment I shall be in on your account. Be a good little Madka, and since we so affectionately promised to live one for the other, you *must* accept. Poor little Mamusienka, you have made me very sad and I shall worry myself all to-morrow, poor devil that I am, and shall be able to do nothing.

Pik.

14th May 1911

I write again, little Maman, because my heart is very full. I feel very discouraged by your queer tone of independence. Up till now I have gone happily to business with the delightful vision in my mind of making it possible for little Madka to work quietly during the next year, of making her happy and of finally giving her this miserable little home that she covets. This evening she herself upsets everything.

Why, oh why, do you say such things to me?

I can't prevent myself from crying and upsetting myself dreadfully. I won't feel light-hearted in the City any longer, for I shall regret the sculptor's chisel so much more. Anyhow, everything looks black at this moment, when outside all is so beautiful, and I ought to be feeling stronger; it is another gift of the moon, I half expected it – the thirteenth of the month – a pinch still of superstition! I don't care much for myself – for my poor, broken carcass, so that it requires something more than my own personal comfort to enable me to sacrifice myself to office work. For this I had my darling Zosienka, and now she won't allow it any longer, becomes disagreeable, and, for low-down, shabby questions of money, capable only of interesting hideous middle-class people, she gives me pain. I implore you on both knees, dear Maman, as the only creature who loves me, for the good of us both, to promise to think of yourself as a part of your Pik; otherwise, in spite of himself, he will go to the dogs through depression and disgust, and through all the devilish horde of troubles which upset his health. So for your own sake, you must absolutely stay, Zosienka. You can't go away

from Pipik, I implore you, darling. I am an ass to upset myself like this, I know it; but these things make such an impression on me at the moment. I forgive poor Mamus, because she hasn't done it on purpose. Perhaps it was only by a kind of modesty or politeness – I understand my little Zosik – but she ought to be my own madka, for I am nothing but her pik, belong only to her, and am ready to sacrifice everything in order that she may feel better and be able to work – if she fails me I shall fail too, for I shall be incapable of doing anything. She will call me capricious – but I am not, Maminska, it is because I love you and I don't want to suffer for nothing. If I make myself stupid at a typewriter, I desire at least that Mamus shall profit; unless she does, I shouldn't have the strength to keep it up.

I got too upset last night, for I was very tired. My English colleague has gone away on his holidays and I have to do all his work – that is why I have written this sentimental tirade to-day. As it is wet, I have stayed in my room, reading and resting, and I understand better now what little Madka means – but Mamus, you must not compare yourself with Sarah Bernhardt,[18] for she is stronger, she does not suffer as you do, and is not tormented by illness every month. Already this week you have had to stay in bed three days: Friday, Saturday, and Sunday. Think it over. I will be very quiet for your sake, poor little soul, and don't refuse Pik's aid, because he is your own boy and not a vulgar outsider. Darling, do write to me as soon as you can, for I shall be frantic, what with this and the awful heat that we are now having in London.

Pik.

Friday, 19th May 1911
Adorable Maman,
Surely poor Zosienka is in pain, for since mid-day to-day Pik has suffered from every ill. What with a headache and a hideous stomach ache I listened so badly to what Wulfs was saying that I have had to do over again a third of my correspondence, which isn't exactly a help, since I am all alone to do everything. I've been upset since about two o'clock yesterday, when things started going wrong, and this morning I broke the big white jug from my room. It happened when I was in the bath: the old fools have turned out the bathroom, and taken out all the planks, leaving only the bath. It's been like that for a week, and Pik has refrained all this time from having

a sponge down. But this morning, because he felt more rotten than usual, he went into the bathroom – the beastly affair gave a great shake while he was pouring water down his back, and it made him jump out of his skin.

I dropped the jug, which broke into atoms, but happily did not cut me. What would have continued this litany of accidents would have been the second print in the Goya book – 'The Pig has broken the Pitcher' – but there was no Mamus to beat Pik's bottom with a slipper. I shall keep very quiet for the rest of today, to-morrow and Sunday, for since there is such telepathy between us, we must be sensible, mustn't we, Mumsie dear? We so often gain by it, that when we don't, we mustn't complain; it shows that we love each other in a perfect way, that our souls and bodies make one – Mamuspikus – so let's be happy, very happy; Pipik never expected to be so loved, and neither did little Mamuska.

For several nights I've dreamt about my beloved Maman – such lovely things, like the dreams of quite little children: little Mamus, magnificent, radiant with great suns all around her, bending low over Pik to bless him – and the sentimental Pikus, who always takes the mask to bed with him, wakes in the morning kissing it, in the belief that it is his real Maman. He gets up at once, washes and then says his prayer for Mamus and himself – with the sun so pure, he can only pray after having purified himself of dust and dirt, and then, naked, he adores; clothes are not creatures of the sun – only our bodies. I love to pray thus before so great a god, for I become one with my beloved and that fills me with voluptuousness.

Before that I had several nights of ugly dreams – that is, ugly afterwards, for I had 'enjoyment' during these nights. Pik had horrid temptations with stupid women, and once with men: he even committed the act with them, but he doesn't remember if that gave him pleasure. He was always very annoyed with himself when he woke, and washed three times as hard as usual, for all these things are repugnant horrors sent only by the moon.

All the time and quite regularly I am learning Polish, and by next winter I shall be able to read, for already I can manage without difficulty little things on the history of Poland and those stupid conversations at the end of the exercises. ...

Evening

Dearest, if I said that you must come to me while you are writing the 'Trilogy',[19] that was only so as not to shock you, because you would never let me say 'for always' on account of my sculpture; but I desire, and absolutely must see, that this 'Trilogy' is written and written well. Even if for that I have to sacrifice art, study, everything, in order that Matka may work, I will do so — that's all I wanted to say to my precious Mamusin.

Now it's understood that when little Mamus grows old Pik will look after

her as if she were his daughter, and will always adore her. While he has a drop of blood he will fight for his Mamus, just as his Zosienko will do for him – so don't let's torment ourselves any more – anyhow, I wrote that *tartine* because I was enormously tired and these obscenities all came to upset me, but last Sunday's letter has put all right. I am much too sensitive a chap, have too much the characteristics and manners of a schoolgirl, and Mamus must often scold me – but you see, Matka, it is being obsessed by art which leads to these stupidities, for art leaves no room to cultivate secondary ideas – so give me many 'thrashings'.

I am very sad also about Delannoy's death.* I am very fond of his way of drawing: it is strong, and now I understand why his latest things weren't so good as the first ones, it's because the poor devil was ill. I have most reverently put by the portrait; it's rather weak, but all the same one can see that he had character. You see Mamus I'm right again: that a fine and noble artist must also be a simple, good, and beautiful man. I will never give this up, and you can cry out that it is presumption to judge by a face, quoting the proverb *il ne faut pas juger les gens sur la mine*.[20] It isn't presumption, but knowledge and judgement – humility is no good, you know that quite well, and preach it yourself, poor old Mamusin. Let's pray to the beautiful sun for Delannoy.

Dearest, the mistake you make is to confuse 'expression' with the successive appearances of the face. Expression, as I tried to say, is the sum total of the vices and virtues of the whole [inner] life which shows in the aspect of each individual. I might no doubt say that one person has more expression than another if his enthusiasm, his anger, his passions are more lively in his face, if there is more sarcasm or gaiety in his laughter and more sadness in his tears; but that laughter and those tears are mere accidents caused by nervous excitements, in the course of which the whole expression is not changed, but coloured, or, if you like, veers towards a note of gaiety or sorrow. When I say that Mamus changes her *expression,* I only mean that her gayest laugh follows her blackest woe without transition, that her nervous excitements are so great and so varied that her real, innate, unchangeable expression, that of a good and energetic little mamiska, is constantly taking a different *colour.* When you laugh or cry you do not cease to be the little mamus.

* Aristide Delannoy, born 1874, died 5th May 1911.

58

A loathsome personality – like that pupil of yours for instance – can laugh, make pretty faces, or work herself up as much as she likes, her *expression* doesn't change, you still see her filthiness show through her coarse lips, her vileness through her low forehead or her ill-shaped nose, her stupidity and malice through her eyes. That is what expression is, and it can certainly no more be distinguished from features than the soul from the body. Now little Mumsie speaks without really thinking of all these enormous possibilities. It is true that a man can and does change the appearance of his face, as also his body – unconsciously in most people – and that this change directly follows his ethics. When Nero was young he was attractive to look at, but through debauch, slaughter and cruelty, he developed a bull's neck, hideous eyes, and a wicked mouth, thereby stigmatizing on the outside all that was within. How is it that depraved men and women develop these eyes, lips, and noses? They weren't like that when they were young, and if they had kept themselves from vice they would not have grown like that. One sees this side chiefly, as more people go from virtue to vice than from vice to virtue.

Now for statuary, I like best the 'Jean', I admire Michelangelo's 'Slave' for its magnitude, because heroism, creative energy, astonishes me; the Samothrace 'Victory' because its poetry pleases my senses; but I don't really understand one or the other, although I often make out that I do. I can't look at them for long without getting tired; but Rodin's 'John the Baptist', on the other hand, would hold me for days on end.

My aim has always been to convince you that a chosen subject may be very well executed, but, for all that, doesn't make a work of art. I agree, Mamus, absolutely agree so long as this subject has been lived – like your Trilogy, for instance – which is a very good subject into which you can weave many sensations; but never introduce purely legendary incidents. Beware of your imagination – make it serve you to a good end by mating it with your observation, your knowledge of real life, true things that are beautiful because they exist. As I have told you, its conception is natural, it stands by itself as a portrait, so that's that. A St. John by Rodin is a subject, an old woman is a subject, a man with a broken nose is a subject, everything is a subject; but it has no need to be an old woman dressed up in the garb of mythology; indeed, it ought not to be; *finita la commedia*.[21]

You are certainly right in saying that the beautiful and good are innate in

the Primitives – yes, but they are very weak, and civilization must develop them so that ethics and aesthetics become their product. We find the truth of this not in savagery but in civilization. The savage acts by rage, vengeance, hatred; in a word, he is natural and spontaneous, he has no laws, it does not matter to him that his daughter should do as she likes, she is probably his wife and many other people's too. The rich Greek makes a law – he thinks of his fortune, his power, which he does not wish to lessen, and so he forbids his children to ally themselves with others, on pain of death, since this is the only thing which will stop them. This is criminal, not savage – it is criminal not because the death penalty is brought in, but because a man takes it upon himself to dispose of the liberty of many others. There you have civilization, and just as I hold no brief for a civilization which admits slavery, human sacrifice, etc., I do not wish a system of aesthetics, equally false, based on so absurd and illusory a thing as line. Line is a bar, a limit, an infraction of liberty, a slavery – while mass is free, and can be multiplied infinitely, treated in a thousand ways. It leaves me free, and on top of all that, it is true, it exists.

Aesthetics are certainly a product of civilization because one judges an epoch as much by its Art as by its customs; one wishes to see the level certain people have reached in their rendering and their comprehension of the beautiful. Our taste in all this has been falsified by a badly understood tradition which has always taught blind adoration of the Greeks and the Romans. Certainly they reached a high level, but we can and do arrive at an equally high degree without imitating them, *sklavisch nachhamen*.[22] In my opinion the 'St. John' is more beautiful than the 'Venus of Milo',[23] for I understand beauty differently from Phidias and his followers. He is a beggar who walks along, who speaks and gesticulates – he belongs to my own time, is in my epoch, he has a twentieth-century workman's body just as I see it and know it; in a word, it's a lovely statue. I like it better than the others, because I believe that Art should be seen in the present, looked for in the present, and not in the past. I keep my head high before anyone who reproaches me for not having 'seen' the Greeks. 'Sir,' I would say, 'had you made me then I would have been able to see them'; but it would be my greatest shame if anyone could accuse me of not being able to see what was around me. I should have no excuse.

Mamus feels all that instinctively, and she has never asked herself why

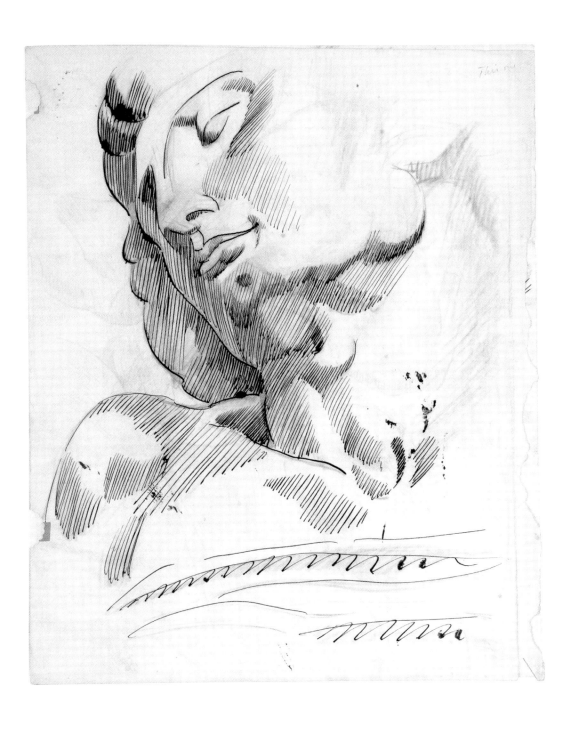

she does not place her novel among the knights of the Crusades. It would, of course, be ridiculous, and it would be equally stupid for me to draw according to ideas which came from the minds of antiquity, and which were brought into life by circumstances which are not in force to-day. That's what I want to arrive at and to hold until the end – that in art the sentimental subject has no place, and any imitation of a past time is an enormous fault. Flaxman added nothing to the human collection, for he imitated Phidias. Stevens nothing, for he imitated Michelangelo. If to-day we have only beggars, let us only sculpt beggars; if subjects suitable for gigantic paintings no longer appear, don't let us do gigantic paintings, for our successors should not be able to accuse us of having falsified our age. My belief in the eternity of life (but on this earth, in the breaking-up of life's forces to renew itself) makes me count it a crime to lie in this way, because I am surely also made of the past which I must respect, and of the future which I should venerate, since it is more important.

Artistic vision, sensation if you like, is not called forth because some picture is labelled 'The Battle of Hermann', in which Romans and Germans kill each other, but by some beautiful form which it contains. Now what I object to in such representational subjects is that the artist, not having been in it, cannot convey all the artistic feeling; his work lacks interest, and to gain ground he indulges in theatricalities and sentimentalities: in fellows who bleed, in children with torn throats, in women who cry, etc., not to mention the sweeter sides. Imagination exists to help us understand the present, not to create things of herself. I talk now like Mamus for the pleasure of talking, not to convince her, because at heart she is already convinced. If she had not this sense of the contemporary, this appreciation of art in immediate things, this working from the present in which alone I believe, she would not write a novel which is beautiful and vibrating with life though tragically true, but one full of soft beauties (of a knight Jehan who kills another knight at a tournament for the hand of a *damoiseau beau et gente que sera son noble épouse*[24]). She can speak thus of mythological things, stories which are in other people's worlds, but in her own world she would not dream of doing so, and in Pik's it is utterly forbidden to express anything other than that which is real. That, little Mamus, is what makes the greatness of Phidias and of Michelangelo, they did not represent Egyptians nor Gauls but their contemporaries. Rodin will be as

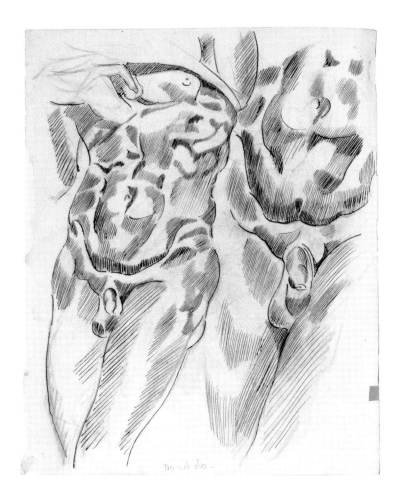

big a man for the twentieth century as Michelangelo is for the sixteenth – but you must not compare one with the other – do you see, Mamuska? Yesterday I drew 'St. Jean' for you, and here it is. I would certainly prevent Mamus from writing rot; that is to say, things without sense because unreal and out of date; and on her side she should save me from presumption (since she finds it in me) and from unreality.

I enclose you a drawing* which is worth ten thousand times all the Prometheuses because it is alive, its forms are right, as I have seen with my own eyes and felt in my own soul.

* Drawing of little old seated woman, since lost.

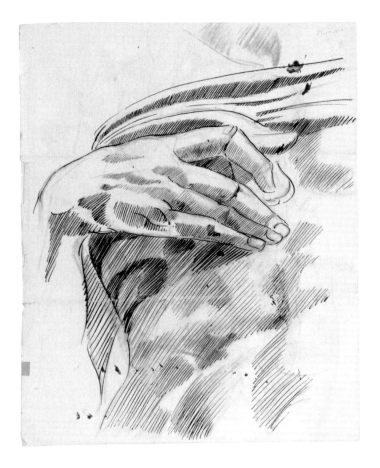

I need to discuss; but little Mamus is always saying to me: 'Modesty, modesty.' I am modest, but not humble; that is a Christian stupidity; I know what to do, and when I do something really good, or even fairly good, I say so without hesitation; but I see my faults, and the proof of this is that when I do something bad I burn it. Mamus jumps with rage during these *autos-da-fé*, but they must be, for none of this piggish trash must remain. You say, 'Pipik, perhaps you may make a mistake and believe a bad thing to be good.' Impossible in a drawing, though not in science. I may make a mistake in a calculation, but I see at a glance if the completed thing is good or not; there is an instinct inside me. To be modest is not to be puffed up — tell me, Mamus, have I ever boasted of myself as an artist? Never any more than you — this thing is so sacred that we would not dream of sullying it. I

draw firstly out of love, then from egoism, and I wish that it should be good out of dignity, so as not to offend myself first and afterwards others, but so long as I do not offend myself I'm blest if I really care.

Beloved,
I don't want to accuse Uhlemayr before being quite sure that he hasn't replied.* I haven't yet been to see at South Kensington. Usually Uhl. does not write more than once every two or three months. I don't think he would be so rotten, and I hope for the best. ——, ——, and —— are idiots[25] and I shall give them a miss, and if others act in this way I shall ignore them also – but always and in spite of everything I shall be pik to matus, just as she will be matus to pipik, although he is capricious, unstable in his thoughts, changeable in his ideas, but only superficially – at heart he is solid, about art in particular.

It is already eleven o'clock, and I have been writing and drawing for you during four hours, dear Zosienka, and I am happy, content, and quiet, although ill; but since you, poor dear, are ill too, I will not make things worse by grumbling – if the 'old boy' wishes to *couler qu'il coule, 'et l'on s'en fout la tire re lire re lon'*,[26] etc. Just as at the Panthéon – you remember those 'rags'!

I will bring anything you like, and I will have enough cash at the end of the month to come to you! Pik must be economical; since the most stupid fools can manage on tiny means, why shouldn't we, who are more intelligent than all of them?

There is a market in Leadenhall Street where they sell dogs, cats and birds. I go there, and I love to see the tiny dogs amusing themselves; it is much pleasanter than the heart-rending slaughter-houses of Whitechapel, with hideous Jews. When you write on Monday tell me what you think of Keir Hardie and of the pamphlet I sent. I hate those swine who upset you, and I pray the lovely sun to send them to sleep by its heat, so that you shall be left for a little in peace, poor darling.

Your own Pik.

* Dr. Uhlemayr had not written to Gaudier for a long while because at this time he was extremely busy. Gaudier feared that he might have been offended by the Gaudier-Brzeska arrangement.

Part II

Sunday, May 1911 [27]
Beloved little Mamus,
It's you who are a stupid old boaster — what paradoxes you do fling at me!

'The true artist neither desires to be nor is aware of being one.' That is equivalent to saying that Michelangelo, a great artist, never knew that he was a better sculptor than Desiderio da Settignano or Giovanni da Bologna, who were his contemporaries, and that he could only do his Slaves well 'without being aware of it', and this after he had spent years in making studies to get into them the greatest possible amount of life, of rich modelling — or that Shakespeare never knew that he wrote far better than Marlowe or Milton,* and that his arrangement was always unconscious — or again that Rodin doesn't know in his heart that he is bigger than the others. Blast it all, if he hadn't known this he would never have struggled for so long. The truth is that a great artist is conscious of the talent and the power he possesses, otherwise he would not see his faults, and so would not be able to improve.

You ascribe strange laws to beauty — that's because, like the early Christians, you believe that the soul is separate from the body, and that pushes you to say that expression is a different thing from features. You give the paradoxical example of two people who have similar features but different expressions. What are features — what is expression? The features are a certain composition made by the nose, the mouth, the eyes of an individual, the expression is the sensation which is thrown off by these features; now if two people have practically similar features, their expressions cannot certainly vary as much as if one was beautiful and the other ugly. It would only be possible if the features, although apparently similar (that is to say, the form of the nose, of the mouth and of the eyes), were *really* absolutely different (composition). The profane would say: 'See two people curiously alike,' and the 'wise man' would deny it to the last. As I have told you and will always maintain, the expression is inherent in the form and colour, and made by them; to arrive at it one must model and colour *truthfully*.

You say that Rodin's 'Old Woman'[28] is ugly because shrivelled. It is age,

* Sic. Shakespeare died before Milton had published anything.

and it seems to me vicious to generalize over life and beauty. A strong, vigorous man whose arms have been cut off is ugly; a tree fallen in the full plenitude of its life is ugly; a slaughtered lamb is ugly — because all that disturbs the design of life is ugly. An old man, decrepit (not disabled, for that is unnatural, a man with a wooden leg or crutches being ugly), is beautiful; a body, which has died naturally in old age, is beautiful, a well-set-up child, a sound man is beautiful, and Rodin's 'Old Woman' is beautiful – for beauty is life and life has three phases: Birth, Maturity, Death, all of which are equally beautiful. The forms of this Old Woman are lovely because they have character, like your hands, which are lovely; and just as you cannot see your hands as other than having character, it is impossible for you to speculate on what the statue might have been had it been void of character.

You talk of an artist's 'aim' and 'pleasure', *Life,* you say. But it is so in the essence of man, in his being, that in truth he has neither aim nor pleasure, but a *passion* to accomplish in order to accomplish, and where look for subjects if not in *'Life'* (since as I understand it there is no opposition between life and death), since only life surrounds us?

Now to get back to the Greeks and the beauty of the Greeks. I see that you won't give up your blessed lines. The 'Victory' is beautiful, not because its silhouette is abominably weak and monotonous, but because the masses of which it is composed have sufficient truth in their disposition to give the sensation of many rhythms: life, movement, wind, water, which are pleasing to the eyes. Phidias' statues are beautiful because the planes are well disposed, but the manner in which the work is done, the insipid draperies on the 'Three Fates'[29] with their mawkish lines, are absolutely beneath consideration. Phidias' most beautiful statue is the 'Ilissos',[30] and he at least has not got sweet lines, concession to an animal voluptuousness of the basest and most barbaric kind. True voluptuousness springs at the same time from the soul and from the body, and two people who love, and perform the act, will naturally have more pleasure if they have bones, muscles, nerves, furrows of skin to caress, than those who have soft contours to press against, for in this latter case the human body would become mixed with the cushions on which it reposes.

Line is nothing but a decoy — it does not exist, and although the Greeks are praised for having put it to so good a use, I — and you can call me presumptuous — am sure that it has nothing essentially to do with beauty.

There are few things so detestable as the 'Venus of Milo' – and exactly because she is no more than a line enjoyed by pigs – an enormous stomach if you like, without lumps, without holes, without hardness, without angles, without mystery, and without force – a flabby thing made of wool, which goes in if you lean against it, and, what's worse, makes a fellow hot. Then in God's name tell me what hands could be more abominable than those of the 'Venus of Cnidos':[31] tapering hands, butter fingers which flow without joints, without phalanges, without tendons, and with which she hides her *cucu,* that marvellous thing, that wonderfully divine delight? I loathe Praxiteles, for he, better than any other, has rounded the angles and levelled the depressions: stumps of marble very polished, very sweet, Mr. Praxiteles, Sir Scopas idem. But these are not men, only well-oiled corpses which one has set up; and they give pleasure because they are corpses, they are not forms which can give a local rhythm, do not evoke the base or the sublime, have no vibrating life-force; and that is why all the Greeks, with the exception of Phidias, Polycletus and Lysippus, are nothing but vulgar hewers of marble.

Your code for an honest life is conventional and was acquired by legions of individuals in the past, a perpetual adaptation to the needs of the moment. For Plato it is perfectly right for a father to kill his daughter if she does not wish to marry a particular person, or his son if he does not obey him: to me this is odious, and in the same way why should I, in aesthetics, necessarily be obliged to accept certain parts of their laws which to my senses are equally horrible and seem to me to be nothing but relics of barbarism?

That the Greeks were entirely right in balancing the masses, in studying planes and rhythm, yes, it was in this their grandeur lay; but that they were equally right for form in general, sweet lines, suave mouths, little feet, big breasts, no; there was their mistake, and I see no reason why I should adopt such ramblings. I understand beauty in a way which I feel to be better than theirs, and history and observation convince me that I am right; that is why I am so enraged against their damnable lines which have falsified people's taste, even that of my own little Mamusienka. Michelangelo has not manifested life in all its aspects, far from it. He has taken one aspect, and that without *desiring* it, but because it admirably served his technique – that is to say, the latent life of a man who thinks before acting: 'David',

'Night', 'Dawn', 'Evening', and 'Day', the 'Slaves',[32] all without a definite and positive movement, all undecided. Rodin has put into the 'St. John' what he saw in his beggar, with less certainty it is true, because he is not perfect, and life is.

The single statue is the only true way, standing or seated, whatever you may say about its monotony. The greatest masters have only made single statues, groups are always inferior; that is why Carpeaux, big though he was, is less so than Rodin, for he never knew how to make single statues. He did not know how to find his rhythm in the arrangement of the shapes of one body, but obtained it by the disposition of several. The great sculptors are there to prove this. Think of the masterpieces which we like most, all standing or seated, and one at a time, and they are not in the least monotonous. The connoisseur loves one spicy cake, but the glutton requires at least six to stimulate his pleasure.

The great thing is:

That sculpture consists in placing planes according to a rhythm.

That painting	,,	,,	colours	,,	,,
That literature	,,	,,	stories	,,	,,
That music	,,	,,	sounds	,,	,,

and that movement outside any one of these is not permitted, that they are severely confined and limited, and that any incursion of one into the domain of another is a fault in taste and comprehension.

Now Matka is far more presumptuous than Pik, for she will never admit herself to be in the wrong. Although the stories would never have been published in February, she still repeats to Pik that if he had subscribed, as she advised him to, she would have seen in the January number the advertisement which she has just read, asking for contributions by the end of May; yet if, having subscribed, she had seen it, she would have sworn the most foul oaths; for she would no longer be receiving the paper when the stories were published in July. Oh, you wretched little Matulenka, I did very well not to subscribe from January. I have always believed and thought that it would take at least three or four months to correct the answers and to distribute the rewards. Mamus has always mocked at me about this, we

even had a row over it at Edith Road; I remember only too well, and in the end who is right? Mamus, naturally! Eh, you beloved old stupid! Prepare yourself to receive a spanking at Pentecost – learn from to-day how to lift your petticoats properly. Apart from that, I pray the sun, most fervently, to help us and to bring us a prize, even if it is not the first, in July when the results are published.

To criticize your work: Mamus is too bitter against men – males in general. The really intelligent have always taken women into their confidence, it is only the vulgar who have despised them – see Julius Caesar, Napoleon, Ulysses (if one is to believe Homer), Michelangelo and Colonna, and nearer to us, Curie.

Tell me that you will be pleased that Pipik should earn some money so that you can write your Trilogy, and tell me what you think about the question of Line – think it out logically and you will see that beauty doesn't depend on it in the least.

Devotedly, Pik.

Saturday, 3rd June 1911
I am at the Museum, Mamus dear, and here is a sentence by Rodin himself which exonerates the presumptuous Pikus, and plunges the poor *vieulle*[33] into outer darkness: 'only one thing is important in sculpture – to express life', etc. …

I have just got your letter, beloved. I must speak of Rodin first. You – you do nothing but blaspheme – that's the worst of you literary fellows: you judge everything by your own little standards.

I shall always maintain tenaciously that Michelangelo was wrong in his mannered proportions which make 'supermen'. That's an unfortunate word which I don't like. If a man is imperfect you qualify him according to his merits, base, brutal, false, otherwise he is perfect – but if he is a 'superman' it must be that he is inhuman.

Paradox – you reproach me with it, but little Mamus, it's a way of amusing oneself which is no worse than wit and lying, and is more cultivated and with Pik quite natural, he curbs himself tremendously, but all the same it often darts out. It is funny, Mauclair[34] is worried by just the same thing in Rodin, he says that all aspirations of the sculptor to be simply realistic are paradoxical – but my only feeling is that you idealists, with

possibilities stretching before you as wide as the universe, take immediate fright at the idea of limitation and combat it. Our sculpture is limited – it is a mathematical art – if we take off a millimetre from ten there only remain nine; if you take a line out of a chapter it wouldn't be missed. To make reliefs *tell* you must exaggerate the forms – that is the logical upshot of our discussions and it shocks you – you say that it's a paradox. Poor little Mamus will again say presumptuous little ass, lunatic who is always reverting to old ideas, etc., but, Mamus, I cannot possibly get away from them, they are instinctive and necessary. I must deduce things mathematically, for in my head everything unconsciously takes the form of a cube so many centimetres wide, while in that of my little Mamus everything is a long vaporous trail. That sets up a balance; beloved Matka must always strain after ideas and be cooled down by the concrete outlook of her Pikus; Pik should sedulously force himself into form and be warmed by the ideas of his good little Zosienka.

So I'm very pleased with this *Wortstreit*,[35] it does us both good. Matka is on the side of Mirbeau (sometimes), of Mauclair always, and of Anatole France, Marx, etc. – they are great in literature, Pik is on the side of Rodin, and asserts that sculpture is far simpler than what these vain theorists?????!!! keep repeating over and over again.

I was in bed, and got up to shout you down. Will you please understand, dearest, once for all, that beauty does not lie in oily lines nor in the sugared accents of the voice. It's a mannerism in Mamus to find everything in herself ugly 'because people have always said so'. You must judge for yourself and let others be damned, but I know that deep down you don't really think yourself ugly. I don't know enough about music to be able to say whether or not your voice is true – but I love the dear voice of Maman, it is rugged and tempestuous, but alive and full of feeling, it expresses all the loveliness held in her dear heart and all the ideas in her little head – it is infinitely varied, as are all beautiful things, it changes completely with her changing moods, with her pleasure in Pipik or her rage against him, but above all it is sincere, and sincerity and truth are beauty – that is why in statuary the true copy of nature (not the servile one) is beautiful. Leave me in peace, you, with your oils and your flabby flesh of reverend academicians – remember that on their side is the woman with big breasts, and that on mine you will see her bones and her muscles. Beauty is character,

truth, nothing else. This *bura*[36] is now finished!

I have thought a great deal about *The Studio*[37] and you will rant against my want of courage, but it is childish to waste one or two hours of one's precious time, and a penny, which is the important thing (we are poor and already my little toothbrush hasn't any hairs left), and to fuss oneself to death for fools that I have never seen. I'll have the most fulminating rows with fellows who know me, people who may be moved, but with *The Studio* ... who will read what I say? Some kid who opens the letters, and it will only make him laugh – it isn't worth it. The world is corrupt, and the way for me to make it better is not writing letters, but joining my efforts with those of others to produce a work of beauty. If Mamus wishes to write herself, let her, for she is better at cursing than I am; also it will give her practice, it's part of her job. To me it is most profoundly repugnant.

I shan't be sending any more German exercises, we will do them next winter; at present Polish is as much as my head will stand, and as I've been pretty poorly I've not even done this since Thursday. It's most regrettable that this disgusting moon drives me to all sorts of things.

Yesterday I bought two little copperplates for engraving, 3 frs. 50, but if I had had your letter I should have spent the 3 frs. 50 in quite another way – I should have sent them for Delannoy's portrait. But all is not lost. Instead of going to Richmond on Sunday, I will only go to Battersea Park, and so save about 2 frs. 50. On Tuesday I will post the order and tell them to send the portrait direct to Mamus – it will be a souvenir of the anniversary of our love, and of the birthday of the charming Zosienka. I want this letter to bring you every tenderness, specially distilled in my heart for the 6th of June, the day which gave you birth.

The beastly moon is up, as I have already told you, and it has scarcely brought me luck: on the contrary everything is rotten. Not only the 'old boy' comes into the game, but also my nose has been bleeding ... Anyhow I do practically no work, eat very well, have a bit of a headache, am as irritable as the devil; but all the same happy, since the sunshine is lovely and Matuska beloved and good. She must not get at all worried because of these accidents – it will probably get better bit by bit.

You write in your story, *Qui sait si à un moment donné elle n'aurait pas pris un gros bonhomme ... et qui sait si à un moment donné elle ne s'est pas fait immensément de mauvais sang à cause de cela.*[38] Poor dear

Matka, you must indeed have suffered to have let yourself go so completely – but you must not think of it any more now – you see you have a rotten little Pikus, and the warm sunshine caresses us.

I must impress on you once again the mathematical side of sculpture. Take a cube – it is beautiful because it has light and shade – now here is a collection of cubes which delights me – I can inscribe the body of a woman. It is not beautiful because it's a woman of such and such a type, but because it catches the light in certain ways. If you want to dream in front of it so much the better, but you must on no account tax the sculptor with having primarily wished to express vice or virtue. His first wish has been to make a beautiful statue, from a material point of view. What puts you people wrong is that the most characteristic types are represented by the most beautiful statues, and for this reason. Christians and Pantheists may insist that the soul is separate from the body, but this is not true. There is a live body, that is all. Now if the forms are fine in the sense of refined it is because they are allied to a fine and refined moral life, and these exquisite forms reflect an exquisite light; and the result is a beautiful statue. You are the compiler not I.

I long to make a statue of a single body, an absolute, truthful copy – something so true that it will live when it is made, even as the model himself lives. The statue has nothing to say – it should only have planes in the right place – no more.

You make a dreadful mistake in trying to compare Shakespeare with Rodin, it plunges you into an inextricable confusion, for one is a writer and the other a sculptor. You are wrong too, because Shakespeare didn't invent his subjects, he took them as settings for his contemporaries, *überzeugt*[39] that man does not change throughout the ages. Queen Elizabeth might well have served as model for Macbeth, and when you read 'Hamlet' or 'Othello' you don't for one moment ask when or where they take place, because they are true for eternity; and why? Because they are pure, they aren't muddled by painting or music – they are nothing but literature. It is only these adulterations which are dull. One quickly tires of Zola because he has mixed them all up, and his work only applies to a certain class of people, to a given period, and is not eternal. In the same way a man is disgusted with his body after sexual relations, or with his entire being when he is morally diseased.

Now for Baudelaire – I like him just because he has sacrificed the fugitive to that which endures. He encloses his idea in a severe form, the sonnet, and puts nothing but the essential, that which will remain for ever. When the principal features are expressed the secondary ones are easily imagined; if only the secondary are given, the principal ones are lost. If they are both given, then they lose in intensity and one can no longer distinguish. It is a law of art which applies to all its branches. To the first group belong Michelangelo, Rodin, Shakespeare, and Baudelaire, to the second all bad artists, and to the last, devils like Dickens and Walter Scott. Now I like Baudelaire and Chopin, for as I have told you music should only express those mysteries which sleep in the deep recesses of our hearts; and if I am a complete being I am satisfied, for I have different pleasures. I am sensual, voluptuous, materialistic in front of a statue, drunk with the play of light and with the harmonious or discordant colouring before a painting, I think profoundly when reading a book, and when listening to music I dream and am exalted. You, you don't know how to enjoy, for you don't recognize differences, and judge always on a basis of your literary idea – which is fundamentally impossible, for whatever you may say, your sensations are different when you read or when you listen to music or when you look at statues – different at their root, of a different species if you like; and these differences form our taste, which will be proportionately heightened in accordance with the profundity of our differing sensations.

It is no use for Mamus to waste herself in theories, for she lies to herself all the time. All that she says consciously is at war with her talent, which comes from her unconscious self. It's of little use for you to bewail the periods which have gone by without art; and here let me tell you, if there are periods without great artists it is that they were not sufficiently interesting to come into the history of art, and we ought not to worry our heads about them. You write what you know about, what you have lived – you blame yourself for only writing your 'Trilogy' because you have suffered, and because that so burns within you that you cannot choose but tell it. So much the better, for had you not this living idea you could do nothing, you would write historical stupidities without any life. Notice a point though – in your 'Trilogy' you could call the characters by Greek names, place them in Aulis if you liked, that wouldn't alter it at all; that is only setting, as in the case of Shakespeare; it is the fugitive, the famous 'local colour' which

should be sacrificed to the universal colour, inspired genius?????!!! ...

In Art one must exaggerate; as the sculptor deepens a depression, or ac-centuates a relief, so the writer accentuates a vice, diminishes some quality, according to his needs; and it is only here that the imagination comes into play. Grandiosity, sublimity and luxury with which you overwhelmingly re-proach me go with that necessary exaggeration of the facts which helps to secure greater truth, and that is what I mean by a well-thought-out copying of nature.

Mamus really must think more deeply, she is too superficial in all that she says, it's because the poor little one has never grown accustomed to

look at different things in different ways – she muddles them all together, and that's why I ask her to be more careful about her style. ...

Monday, 5th June 1911

I went to Kew yesterday afternoon and had an absolute orgy of beauty, and was happy that Mamus was seeing things even more beautiful. It is very hot, and I have but little courage. I'll do some drawings in the morning, and in the afternoon I'll go out again – probably to Kew, for I can make sketches of lovers who roll in the grass – you know how. I've been very lucky lately, for I've seen some lovely creatures – two superb women dressed so lightly that one could see their big bodies without corsets and their breasts small and well-placed on either side of their chests. One was a Hindu and the other, I don't know, probably a Russian, but certainly not English; and for a man, again a beautiful Hindu. He had a mouth so delicate and voluptuous that it looked like a ripe fig burst open in the sunshine: he had scarcely any clothes on either, and only the thinnest of vests covered a most marvellous chest. He walked like a tiger, proud and haughty, with eyes that flashed like steel. I think he was the most lovely man I have ever seen, the sight of him made me wild with pleasure; and, would you believe it, the English, with their hideous mugs, laughed like idiots as he went by. In this country it's a kind of crime to be beautiful. Pik would have loved to kiss that lovely mouth.

I have found some more coincidences with Rodin – he sees statues in the clouds, in the old trunks of trees, in flowers, vases, insects and birds, in the bodies of women – just like the Mamus! Now, don't be too proud, you rotten little Matusienka.

Pik.

Wednesday evening, 14th June 1911

Dear adored Mamuska,

I will arrive on Thursday morning, 22nd June, 11.01 a.m., at Felixstowe Town (I'm getting a five days' ticket, costing 7/6) and will leave on the following Sunday evening at 7.33, so that I shall have three nights and four days with you, my own beloved. It was thanks to you that I got four days. I was going to ask my boss for them bang out when a good wind filled with *kruczki polskie Zosienkie Brzeskie*[40] blew in my ears; and without showing it, but

looking a picture of innocence, I asked Wulfsberg if we were going to have Friday 23rd, the day after the Coronation.[41] I knew quite well that we should, but I wanted to make him speak, and I fully succeeded – 'Oh yes, Gaudier, it's only a question of Saturday – we will shut on the 22nd and 23rd – are you going to the country?' 'No, Mr. Wulfsberg, I ought to go to Paris, and you see if we have Saturday it will give me four days, otherwise only two.' 'Well you know I'm very pleased with you and you've worked well, so I'll give you from Wednesday evening until Monday morning.' I said thank you, and off I am to Paris – Felixstowe – to see the Mamusi – it's all the same so long as it contains the Mamus. I'm so pleased, for the air will do me good – I'm about in the same state as I was last year when you came to Combleux. I couldn't get out this evening, for yesterday I caught a cold coming back from the country, or perhaps it was only because I am so run-down, and to-day I've been very unhappy – always *là bas*[42] – I smelt bad and was afraid the others would notice it. I often went down to the washroom and upset myself thoroughly. I'll go to bed at 9 and will get up and go for a walk from 5–8 to-morrow morning like Mamus' good little Pikusik. I've got lots of things to tell you about Mrs. Harriet Beecher Stowe, whose centenary is to-day – also about modern Tokio. I'll write all that to-morrow. Goodnight, Mamusin – I'll have a long sleep, and rest in your arms for the night.

Thursday morning
I haven't gone for a walk, for I have only just woken up, and it's 7.30. It was little Mamus who put me to sleep, dear gentle Zosia, and I feel much better than yesterday, fresh and rested, and I'm in a delirium of joy that in a week from to-day I shall press to my heart the real little Mamus of flesh and bone. I'll pamper her no end and make her very happy – we will wander along by the edge of the sea, we will bathe in the swift waves – at least Pik will, very early in the morning when there is no one about – what orgies of nature we will have together! It is so beautiful that it is almost unbelievable after the sordidness of this dirty old town. ...

'People still recall Mrs. Stowe during her visits to England as a pleasant little lady with corkscrew curls and a quiet dignified manner. She had an earnest religious manner, and took her mission as a writer very seriously and had little taste for the lighter social graces. Her highly-strung nervous temperament and habit of absent-mindedness made her adverse to crowded

receptions, and she was content to leave most of the talking to her amusing and jovial husband, who had a fund of racy New England anecdote.' There is a strong analogy with Matka in her face and in her constitution too; see how she writes of herself: 'a little bit of a woman somewhat more than forty, about as thin and dry as a pinch of snuff – never very much to look at in my best days, and looking like a used-up article now.' This was at the moment when she wrote *Uncle Tom's Cabin,* one of the most decisive books of all times, for it played an eminent part in bringing about the War of Secession and the emancipation of the American negroes. You see Mamus is just the right age, '40', and the right appearance, 'thin and dry', to write a book just as decisive, but better literature, more beautiful than hers. Have courage, little Mamus, it will come, work hard and I pray the good sun every day to bless you.

I will talk about Modern Tokio another time, for it's already late this morning and it would take too long. With regard to my making up to the old women, arrange just what you think best. I'll do exactly as you like, for Matka shouldn't be made to suffer because of these idiots. So you will decide whether or no you need introduce me to them, etc. – feel quite free and Pik will behave superbly, even to praising to the skies their pasty colour!

Remember I leave London at 8.10 on the morning of the 22nd and should be at Fel. at 11.01. The train will probably be half an hour late, so don't get worried.

Pikus.

P.S.–I think that as I am coming next week I will bring the Grammar book instead of sending it this morning for 3d.

For the last week I've looked every day in the *Morning Post,** but there is nothing – At Whitsun there are many demands for London, but as I've told you already you must apply in person.

I kiss you passionately, my sweet Mamusienka, on your lovely mouth and on your impish eyes – I fold you to me in gentle affection and hope that you will be quiet and calm during your illness.

* For a situation for Miss Brzeska.

Saturday, 17th. Evening
Poor beloved pet,
I was sure last Thursday that you were ill. You see I caught cold on Wednesday evening through lying out on a bank in the country. I was ill all through the night, and the next day was a kind of martyrdom, as I bled again and got enervated, so that it's probably all my fault that Mamus is ill. I'm better to-day, but in the night was much worse. God, what a horror all this is, but let us hope that some day it will all go away, my dear one; we will be strong and healthy and able to work. I also am happy and pleased to come back to be nursed in those dear maternal arms and to be able to cheer up my dear companion a little. I have lots of news – I will tell you 'of how' one day I ran into ——[43] and his Jewess in the middle of the street, 'of how' he came to see me the next day, and I reproached him for all his rottenness to us and said that I would never go near his Jewesses. 'They have never liked you,' he said with *naïveté.* His editor is a fellow who knows 'Simpson',[44] the artist who did those two fine advertisements for 'Oxo', as well as the man with a black hat and red feather. Simpson has seen the —— Magazine[45] and admired Pik's drawing, and wants to know Pik and see more drawings. So I gave ——[46] some posters and some draw-ings to hand to the editor fellow. Let's profit all we can – he is rotten and I'll be generous with my rottenness to him – I want to give Mamus a nice companion for the winter. The old beast suggested starting again the *leçons françaises* but I absolutely refused him. He has no dignity, for if he loves his Jewesses he ought not to speak to me again after all I said to him about them. He doesn't seem to notice it. He hopes to have drawings for his magazine – the blood-sucker – you wait, old fool – I shall know Simpson and that's all.

Pik.

Richmond Park
18th June 1911
I am very anxious about Mamus although she says she is better and not worrying. The same worries I had on Thursday came again a little while ago (about 11 o'clock), I very much fear the same will have happened to poor little 'tulienka'; I hope I am wrong, and anyhow I'm keeping very quiet, not exciting myself, thinking of nothing but of the happiness we'll

have next Thursday. I have been lying out in the full sunshine for the last hour, and now I am going to change my place, for laziness is bad. In some ways I look ill, for my eyes and my cheeks are sunk, but on the other hand I have a much better colour than before. I am getting quite sunburnt, and Mamus will be pleased. Since she asked me not to, I have not been to the Museum and have done hardly any drawing – each evening I've gone into the country, except the other day when this *choroba czarta*[47] prevented me.

I shall only have 5 or 6 shillings after paying for my ticket – if you want me to come, little Mamuiska must get some pennies – if you think we are spending too much I won't come – think it over seriously, and I will do just as you please.

Pik.

20th June 1911

You see, I've told everyone that I'm going to Paris; I really can't borrow anything from anyone here, for they would say, 'How's this? He's going to Paris, and he hasn't a halfpenny – he has to borrow'; and then they won't think so well of me. It's stupid, but they are idiots, and I must act like them while I am with them; poor little Mamus knows that well enough. Send me a form with a note to the Post Office where you are known – but just as you like. I will come on Thursday at eleven. I am enjoying it in advance, but am holding myself in so as not to make myself tired.

Last night I had a great mouse-hunt. I caught one – the dirty little beasts made a disgusting noise all night, and did *pipi* in my saucepan on the sly. I guessed that they were probably hiding in my old rags hung in the cupboard, so I shook them and two filthy she-devils fell out. I only caught one, and as a punishment drowned her – I upset myself dreadfully in running after her. I went to bed at 8.30 and had a long sleep. This morning I'm a bit better, but I have a dreadful headache, stomach all upset, and still frightfully tired. The air of Felixstowe and the company of dear adorable Mamusienka will soon put me right.

I kiss you a thousand times and hope you are well. I'm sorry to be bothering you about these stupid money matters – I *do* lead you a dance.

Pik.

5 | Living together

A quick series of postcards altered all these arrangements. Pik suddenly thought it would be better to go to a place nearer London than Felixstowe, and told Zosik that he would make inquiries. On Wednesday, 21st June, she heard from him that Southend was a good place, that she was to find rooms, and expect him the next morning. She took her ticket, but heard in the train that Southend was a much-frequented and noisy town. Nothing in the world would induce her to go to such a place, and at the next station she darted out of the train and implored the station-master to tell her of a spot which was both small and quiet. He suggested Burnham-on-Crouch, saying that it was a quiet little yachting centre, very beautiful without being expensive.

In her carriage was a young girl who came from Burnham, and she told Miss Brzeska that it was several miles from the sea, but all the same there was a salt-water river, where she would be able to bathe. It was unbearably hot, and when Miss Brzeska got out at Burnham, she was so overcome by the heat and so flustered by her journey, that she forgot her luggage in the train, and went away with only her handbag and food-basket. Stunned and stupefied, her face so red that she looked as though she were drunk, she wandered about the streets searching for a room. In some houses the people did not like the look of her, elsewhere there were numberless children and dirt, and again in others the prices did not suit her. At the end of one little street she saw some green bushes, and instinctively went towards them. There, in the shade, she took off her shoes and stockings, which burnt her feet, and refreshed herself with fruit out of her basket. About six in the evening, when it was slightly cooler, she again took up her search. This time she found rooms in the house of two old maids, and next day Pik joined her. They bought their own provisions, which their landladies were to cook for them, and which these women stole most flagrantly. When Sophie tried to convey to them, by little exclamations of surprise, that she saw what was happening, they put on the table a large silver mug whose inscription proclaimed that it had been won by their brother for his honesty!

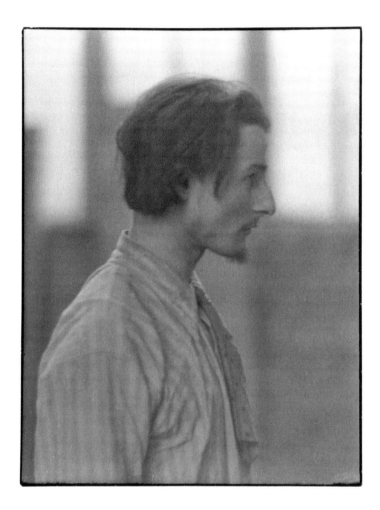

While they were at Burnham, Pik did his best to persuade Sophie not to try for another post, but to come and live with him in London. He told her he wanted her all the time, and that he had no one to speak to after he left his 'damnable box of an office'. It was surely sufficient, he said, that one of them should groan under the yoke; and if he had to submit to this 'business', which he loathed, he would at least like to have the satisfaction of feeling that he was enabling her to be free. Sophie had only about eighty pounds left, and she felt that this must on no account be touched except in the case of some real emergency; but Pik explained that to furnish a room they would need so little, scarcely more than a bed.

'What do you mean, a bed? Are we not two?' cried Zosik.

'Yes, but I will sleep in a hammock.'

Zosik protested that this was insanity, that no one could sleep in a hammock.

'What, no one? Aristocrats, perhaps, or middle-class folk wouldn't, but I'm an artist, and artists must lead a Bohemian life and not make themselves weak by comforts. I tell you, I shall sleep in a hammock, or if need be on the floor, so you need not count a bed for me.'

Zosik said that she would need a bed, anyhow, and also tables, chairs, and a cupboard. It was now Pik's turn to protest:

'What, tables and cupboards! Why not heavy armchairs and carpets right away? If that's your idea of an artist's life, I pity you; a table and two chairs, perhaps, but even that is not necessary.

'Oh, of course not. We can eat off the floor.'

'Well, why not? We can buy a few sugar-boxes, which will do splendidly.'

'But with winter coming on we shall need blankets, we cannot sleep in newspapers.'

'Pshaw,' said Pik, 'there are four months still before the winter comes; by that time I shall be earning more money as a draughtsman, and we shall be able to indulge in these luxuries.'

In the end, Sophie was persuaded, but first she made him promise not to put her in a rage – she was weak and nervy, and did not want to ruin her health after having more or less established it at Felixstowe.

'I promise you, on the faith of an artist, to be a good Pikus to his Mamus,' said Pik, and the matter was settled.

The sunshine and the enjoyment of their first freedom together in England were too exciting to allow of arguments, and they had four lovely days together, bathing and running in the fields. They overdid it, of course, and their health was no better in the end. Zosik threw herself about and jumped in the water as if she were mad, and Pik ran round far too much in the heat. The river water was dirty and unhealthy, and once Pik fell into a ditch of green, stagnant mud, which gave him rheumatism.

Before Pik left, it was decided that Zosik should stay on at Burnham until the end of August, and that he should find suitable rooms for them in London. A week or so later, he wrote to say that he had found two

splendid rooms, far cheaper than they had anticipated. They were seven shillings a week, and, what was more, his boss had raised his pay from six pounds to seven pounds a month, so that in future they would be rich, and able to live together in comfort. He asked her to come at once, and said he would meet her at the station.

Sophie started, full of misgivings. How would it be? Would they get on any better than in their first Kensington rooms? As usual on important occasions, she became nervous and superstitious. She told herself that if he met her at the station it would augur their happiness; if he didn't she would know that she had taken a wrong step. At the station there was no Pik to be seen. She waited and waited, and then decided to look for him; and so, with all her luggage, trundled round the noisy station. After half an hour she was in despair and went to the waiting-room, where she stayed patiently for some time. In the end she got annoyed: she began talking aloud to herself, and the other women in the waiting-room looked at her as though they thought she was possessed. Pik finally found her, having himself searched for her during the last hour.

Pik's enthusiasm and gay excitement were, however, in no way daunted, and Zosik had to go round then and there to see the new palace. There was no gas, a smoking lamp lit the stairs. The rooms smelt and were dreadfully damp. Sad at heart, Zosik returned to sleep in Pik's room, while he went out to buy himself a deck-chair and slept at the new premises. Next day he went along to see Sophie, enchanted with his night's rest; the chair was lovely, he had bought it in the King's Road for five shillings, and you could see by the marks on it that it had already made long voyages; it had even been to India.

In the afternoon they went out to buy a few necessaries. Henri always knew best about everything, or so it seemed, for he was of a very decided nature. Sophie was trying to get a clean second-hand bed or a cheap new one.

'Why on earth do you want to spend a pound on a bed?' cried Pik. 'It's crass folly, middle-class luxury. In one of these streets I saw a notice advertising a bed and everything complete for five shillings.'

Sophie suggested that at that price it would be 'walking'.

'Anyhow, we can go and see,' said Pik.

The man in the shop said it was hardly a bed for a lady to sleep on – it had no springs, and the mattress was worn.

'You can, at any rate, show it us,' said Pik.

In an old, dilapidated room where the boards squeaked and sagged they found a huge *bahut de famille*.[1] An enormous bed, *délabré, égratigné*,[2] which a hundred years ago had been new. The brown sack which called itself a mattress contained a few handfuls of rags which flaunted themselves at their ease in this tattered cover, giving the most distressing qualms as to its cleanliness. The idea of sleeping on such a *grabat*[3] gave Sophie a shudder throughout her body, but Pik had energy for two and said:

'We can take it, it isn't dirty, and, anyhow, one wouldn't sleep on it without spreading a cloth.'

'How can we tell who has slept on this bed?' said Zosik, and the shopman hastily replied that he could guarantee that nobody nasty had been in it – his wife had taken gentlemen *en pension*, and now they wished to let unfurnished rooms, so the bed was for sale.

'There, you see, Zosik,' broke in Henri, 'take it. We're so poor. We need other things as well – we shall never find elsewhere anything so cheap as this.' And as he saw Sophie hesitate, he said with an air of assurance: 'Well, I think we'll take it.'

Seeing the business settled, Sophie wished to get the thing a little cheaper, but Pik, with a lordly air and a cutting look, told her to be quiet with her saving of pennies, for it was cheap enough already; so that it was with some difficulty that she managed to have this ruined structure delivered without further charge.

They installed themselves that day – a small table for Miss Brzeska's work, two chairs, the deck-chair, a tub, and the famous bed made their complete outfit.

They soon found that their hoped-for little Paradise was a regular hell; there was a garage immediately outside Pik's room, and a chicken-run outside Sophie's. Sophie was particularly upset by all kinds of noises, and this situation soon drove her to a frenzy, greatly aggravated by the discovery of bugs in their rooms. On top of this, after three days Pik could stand his deck-chair no longer, and confessed that he could not do with another night of such torture. He was ill and tired, and as it looked as if they would soon be leaving, Zosik was against buying another bed, which would have

to be moved, so Pik had to share hers. It was a strange loading – these two in this ancient sarcophagus of a bed, bug-ridden and held together by bits of string. Across the threadbare mattress by the wall Miss Brzeska had put her old travelling-rugs, sewn together and padded with what she could find, while Pik lay on the bare mattress at the foot on a lower level. Nights of torture; for with every movement each disturbed the other. The days were no relief, for there was a continuous noise, and horror of the dirt made the place seem worse than a thousand hells.

In a couple of weeks they moved to a house in Paulton Square, but conditions were not much better. They were dreadfully underfed, Zosik cooking all the food on Monday – meat and potatoes and herrings – to be eaten cold for the rest of the week, augmented by milk and bread in small supplies. It is little wonder that she found life a constant irritation, and one quarrel culminated in Pik's throwing a herring at her. He was horrified by his action, and there was a most tender reconciliation. Throughout all this time Pik never complained, but was full of exuberance and excitement over the future. He was often touchingly attentive to Sophie, and with the money which she gave him for his fare he would bring her flowers and other small surprises.

Each month Pik would hand over to Zosik his seven pounds earned in the City, and as they endeavoured to spend each month a pound on things for daily life, cooking utensils, etc., they were often at the end of the month left with absolutely nothing, save the untouchable savings which Miss Brzeska held in reserve.

Their enchantment knew no bounds when they made their first friend. It was now October 1911, and they had been in London for over nine months, but had found no one to speak to. One day, outside the Victoria and Albert Museum, they saw a man who looked like an Indian, and Henri felt attracted by him. A few days later they found themselves together in the vestibule of the National Gallery, and all looked at each other, but were too shy to speak. A week later they were walking to the British Museum, and there was their friend ahead of them. Pik again hung back, but Zosik went to him and said that her brother was so anxious to know him. He was delighted, and they arranged for him to come to tea on the day after next. He was an Italian from Verona, called Arrigo Levasti,[4] and he came very often to see them, for he seemed as lonely as they were. Then Pik, feeling

it was wrong to hold anything from a friend, told him that he and Zosik were not brother and sister, and Zosik added that so far there had been nothing but a platonic love between them. Pik immediately said, 'That's not true,' which throws an interesting light on Henri's character; for later on, when they were to relate their history to Katherine Mansfield and Middleton Murry, he again made the same statement, adding that he and Zosik had often slept together. It shows that although he and Zosik lived together as brother and sister, he was ashamed for anyone to think it who knew they were not. After this their Italian friend's visits became rare, and by Christmas had ceased altogether, so that they were again left without anyone to talk to.

At Christmas Wulfsberg gave Pik five pounds as a Christmas-box, and Pik's first action was to buy Zosik a small porcelain oil-stove on which for several months she had set her heart. At the same time Pik's pay was raised by two pounds a month. In consequence of these sudden riches he and Zosik arranged to spend the following Saturday in buying Pik a trousseau, as he had had nothing since he came to London. They got a suit for twenty-six shillings, and Pik, ever so pleased to be so smart, thanked Zosik for getting him the suit. She found it very charming in him to thank her for buying him something with his own money.

He was always full of enthusiasm for the future, but Zosik's mind was of a matter-of-fact order and could not easily take in Pik's quick flights. For instance, he had a habit of lying: he said that lies were interesting and quite indispensable to an artist; she believed in what might be called a boring truth. This led to many disputes. Also Henri was very definite; everything with him was positive or negative, and the less he knew about a thing the more emphatic he became. Naturally his ideas would often change, and Zosik, with her added twenty years, did not always make allowances for this. Whatever you asked him he was always ready with an answer, and made it with such assurance that it was impossible to contradict it. Next day he might be just as emphatic in an entirely opposite direction.

Out of his 'Christmas-box' Pik sent ten shillings to his youngest sister Renée, and his letter to her shows the simple quality of his nature and his enthusiasm for art.

45 Paulton's Square, Chelsea
28th December 1911
My dear little Renée,

You will be tired of waiting for news of me, but I was hoping to receive Henriette's letter which Papa said was coming, before I replied. I send you a little present for your birthday, and this is how you will get the money. Go to the post-office the day after you get this letter – tell them your name: Renée Gaudier, and when they ask you who is sending the money you will say: 'Henri Gaudier, 45 Paulton's Square, Chelsea, Londres, S.W.' Don't make a mistake and they will give you 12 frs. 25 to 12 frs. 50, for it is ten shillings and not 10 frs. I am sending. Perhaps you had better ask Papa or Henriette to go with you. When you have got it you should give a little to Henriette so that she can bring you from Orleans a block of white paper (folio), there is some very good at the corner of the Rue Jeanne D'Arc and the Place de la Cathédrale at 40 or 50 centimes the block – a bottle of Chinese ink (marked J. M. Paillard) at 60 centimes – a pennyworth of good nibs (Gillott) and a nice new penholder. On top of that give her 1 fr. 50 so that she can buy you one of the series *Chefs d'oeuvre illustrés* or *Maîtres de la peinture*. She will get you 'Puvis de Chavannes', and if they haven't that, 'Giotto', and if they have no 'Giotto' then 'Botticelli', or 'Fra' Filippo Lippi' or 'Uccello', 'Ghirlandajo' or 'Cimabue', and if they have none of these, any Italian she can find with the exception of 'Raphael', 'Veronese', 'Carracci', 'Romano', 'Titian' or 'Tiepolo', and of all the French, English, German, and Spanish. But surely she will be able to get 'Puvis de Chavannes' or 'Giotto' or 'Cimabue' at Loddé's in the Jeanne D'Arc. Also she must bring you a box of 5 elementary Bourgeois water-colours for 40 centimes from the Galeries Orléannais and a good brush, not too fine, for 30 centimes, also at the Galeries where they sell double ones, and a big mug.

So			
	A Book	1.50	
	Paper	50	anyhow about
	Pens	30	3 frs. 50
	Colours	40	
	Brush	30	
	Mugs	40	

		3.40	

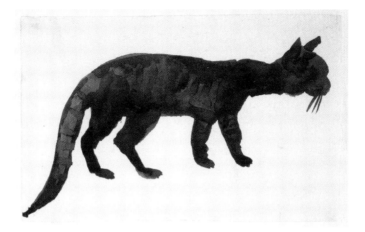

With the rest you can buy 2 francs' worth of good chocolate to celebrate New Year's Day, or jujubes – just as you like, and save the rest carefully in your money-box, and if you haven't got one, in any little box.

As I've already advised you, don't draw anything except from nature. Draw branches now that there are no leaves, birds, the cat, particularly since he's so fat and beautiful according to Henriette. But for every drawing take an entire new sheet of folio paper. The little page which you sent me

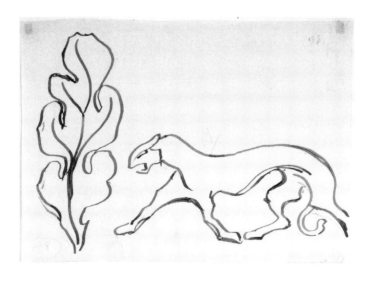

was very pretty, but too minutely drawn. Thus, with big strokes, boldly. Don't be frightened, make mistakes, as many as you like, but all the time draw very, very strongly.

Do things like these –

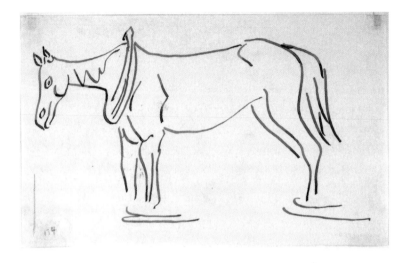

anything you like, in Chinese ink without using a pencil, and get used to colouring them afterwards just as you think, but if you put a lot of *yellow* remember that you should have *violet* near by, if *red,* then have *green,* if *blue,* then *orange.*

Yellow with red and blue
Blue „ red and yellow
Red „ blue and yellow

so that one colour always looks well with a mixture of the two others. In the box which Henriette will bring you, you should keep only the carmine, the Prussian blue and the gamboge – throw away the black and the sky blue.* …

* The remainder of this letter is lost.

Pik had an absolute passion for creating and, not content himself with doing new things each day, he spurred Zosik on to finish books and articles. He hoped to see them published and known by the world from one day to the next, but Sophie found their rooms far too noisy to be able to concentrate on her work. Pik for some months had been doing nothing but posters, and he was certain that he would sell these for large sums of money.

In the meantime they knew no one, and suffered greatly from the cold and from hunger. Although he was now earning nine pounds a month, they found it very little for the two of them to live on. They had clothes to buy, a bed for Pik, and extra bedding, and in addition to this, Pik was trying to pay Sophie back all the money she had spent during their first months together. They thought they ought to make every effort to re-establish her small reserve fund.

Their landlady used constantly to poke her head into their room: she was obviously insulted by their having no furniture, but as they paid their rent regularly and kept their rooms clean, she could say nothing. She was nearly eighty years old, this landlady, and constantly the worse for drink. Often Pik and Zosik, after hearing a terrific crash in the basement, would go down, to find her lying unconscious on the floor, and with great difficulty they would undress her and put her to bed. She never thanked them for these attentions, but seemed rather to bear them an increased grudge, keeping out of their way afterwards.

6 | Friends

It was not until January of 1912 that Gaudier first met an Englishman publicly interested in art. He had seen an article by Haldane Macfall in the *English Review*,[1] and was very much struck by certain statements, although he thought it weakly written and long-winded. Mr. Macfall had said, among other things, that he would fight anyone whose ideas were contrary to his, whether he were a bishop, a butcher or a burglar. Gaudier wrote to Mr. Macfall, telling him that he was a French artist, all alone in London, and earning his living in the City, and that he would be immensely pleased to make Mr. Macfall's acquaintance.

One day he came back from work full of excitement, and little by little, with much playfulness, he told the whole incident to Zosik. 'He certainly won't reply; such fortune could not possibly come to us,' said Sophie.

'That's just where you make a mistake,' said Pik, pulling a card from his pocket. 'The old fellow has already replied, and I'm to go and see him next Saturday; what's more, he will help me to sell my posters; we will take a nice house with a studio, and then I shall start to do some sculpture. Not a bad prospect, eh?'

They waited for Saturday in the utmost excitement. Pik put on his new twenty-six shilling suit, and Zosik bought him a special tie for one and sixpence. They felt that the doors of Paradise were to be opened to them at last, and they built fantastic castles in the air of how they would get a footing in many interesting houses, and both be universally recognized as great artists.

At 2 a.m. Henri returned from his first visit in the 'World'. Zosik was waiting anxiously for his news, but he said that he would tell her in the morning: he was too tired, and also it would only excite her and keep her from sleep. In the morning Zosik was early awake, and eager for his story as soon as he had opened his eyes.

'Well, disappointment is the lot of little sparrows like us. The author whom we thought so big, genial, and famous has none of these qualities, and lacks refinement and culture. To begin with, I was frightened of him – he has an atrocious mouth, a cow-like head ... and a moustache brushed up *à la Guillaume d'Allemagne*.[2] He seemed extremely alive, talked a great

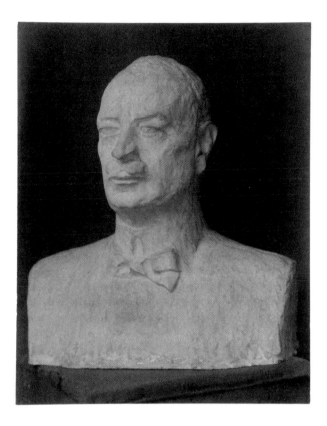

deal, gesticulated, and was very much taken up with himself. All the same, he's not a bad chap, and I'm very glad to have met him. His wife, too, who smoked like a factory chimney, seemed a pleasant, intelligent woman.'

Gaudier's accounts of people were nearly always brutal, and his anarchistic temperament made him speak particularly harshly of Mr. Macfall, who was a retired Army officer.

One result of this visit to the Macfalls was that Gaudier was to go there with Miss Brzeska on the following Wednesday, and take with him some of his drawings; and more immediately, two men whom he had met there, Hardinge and Alfree,[3] were to call on them that very evening at nine.

Zosik leapt from her bed. 'What! You tell me this right at the end instead of at once, so that I could jump for joy! Oh, what a devilish little tease you are; you wait till I pull your stork-like nose!' and Pik huddled under his blanket to escape her impetuosity.

They were very happy all that day, and Sophie used all her ingenuity in making their rooms look as nice as possible. The idea that people might pity them for their poverty, or think them dirty because poor, humiliated and tormented her. But Pik said that these were only stupid, sentimental ideas, that artists did not pay attention to such things, and that her being unable to work when things were in a mess was the one thing which made him feel that she was not a real artist; for himself, he could work under any conditions, and soon he would be famous. Henri felt that he owed nothing whatever to Providence, that it was sheer will-power and perseverance which had won him his scholarship, and that only submissive people were imposed upon. 'I have always been in revolt,' he said; 'even when I was a child, I would fight my parents until they had to give in.'

Hardinge and Alfree were to come about nine, but at ten forty-five no one had arrived, and Zosik decided to go to bed. At eleven, when all the room was disarranged, there was a ring at the door. Hurriedly they covered up the bed, slipped various objects out of sight, and scrambled into their clothes. Pik ran downstairs to open the door for their visitors, while Zosik tried to collect her wits. She was very anxious not to appear a fool before Hardinge, who was a writer.

They were both full of enthusiasm over Pik's drawings and posters; he had never shown them to anyone in England before, and though at the worst of times he was certain of fortune, he now felt that he had indeed arrived. After a quarter of an hour they left, and Zosik and Pik were no longer alone in the world. Next day a postcard came from Macfall telling Henri to take his posters to ——, adding that he would pay well. They would make at least fifty pounds – how rich they would be! They would go to Canterbury and see the Cathedral.

That day Pik went to work singing. He came back very dejected: they did not want any of his things. His Negress, being naked, was therefore indecent, the Bagpiper was too crude, and the Mermaid had not got a pretty enough face. This was their first disappointment, but it was soon forgotten, since each day there was a regular rain of postcards from Macfall, suggesting an orgy of prospective fortune.

His encouragement, sincere as it was, did not seem to lead to anything material, though it tided Henri and Sophie over a very difficult time by keeping their hope at white-heat, and so numbing the pain of their daily

life. Mr. Macfall tried very hard to get help for Gaudier. He introduced him to many people, and it was entirely due to him that Gaudier began to be known. He was not in a position to do anything big, and certainly he never realised that quite small help would have made all the difference in their lives. This was, I think, the case with most of the people who met them.

Henri would never ask for anything, or suggest that he was in any way poor. If he showed his drawings and they were liked, he would offer them as a gift. He was so generous and enthusiastic that the idea of there being any immediate necessity for help simply did not occur to anyone. Miss Brzeska had saved several remnants of furs and silks from the past, and always tried to make an impression of financial ease. She pretended she had a bank account, talked of cheques which had got mislaid, and of money orders which were on the way from France or Austria; while Pik's untidiness, on the other hand, would pass for a manifestation of the artistic temperament.

Miss Brzeska, who, during the last year and a half had been of so much use to Henri, now began to stand in his way. Her disposition was too difficult to allow of her being generally accepted, and many people who would have liked to befriend Henri refrained for fear of Sophie. Henri, on his side, was always so loyal to her that he preferred to keep people at a distance rather than have her feelings hurt.

Sophie's visit to the Macfalls was not a success. The fatigue of getting there, the heat of the rooms, and the unwonted meeting with a number of people, went to her head, and she became over-hilarious. In the course of the evening she dirtied her hands on some charcoal, and Mrs. Macfall took her upstairs to wash. She was there persuaded to have a glass of whisky to steady her, but instead of doing so it made her ten times more excitable. When they returned, Mr. Macfall was telling one of the guests, Miss Bagnold,[4] that a drawing she had made was full of genius (he had set his guests to do caricatures of each other), and Sophie, unable to control her irritation any longer, said in a loud voice: 'Not at all, her drawings are stiff and photographic, their only merit is that they strike a likeness. Miss Bagnold is a writer, not an artist.' Her manner was strident in this drawing-room, and soon everyone was on their feet to leave; and Mrs. Macfall was telling her that she would miss her last 'bus, and Mr. Macfall was holding her coat for her.

Miss Bagnold describes one of these dispersals:

'One night we came from Macfalls', Dolly and Lovat[5] and I, and some others whose names and faces are gone, and we were again on a tube railway station. Though we still expected it, the last train had gone. It was winter, and a wind like a wolf galloped down the tube tunnel. We stood in its passage, Gaudier talking. He did not drop a subject when he had added a little to it. He did not throw a word in here and there, and make a crisp sentence sum up a bale of thought. What had been talked of a quarter of an hour before at Macfalls' was still being followed up. Gaudier, his long front hair hanging in a string down the side of his white brow, was throwing his future and his past and his passion into the discussion. We lazier English stood and shivered, and tried to back out of the wind. Gaudier felt our bodies moving, grouped, away from him, and I remember as he talked, and his eyes and pale face shone, he put out his thin arms and surrounded us and held us fast in the wind so that our edging movements should not distract him.

'Lovat was the first to have the wit to be excited about him. But they soon quarrelled. His young vanity could not stomach Gaudier's blows.

'I did not really like him. But that is no judgement on either of us. Gaudier never seemed to like anyone. He rushed at people. He held them in his mind. He poured his thought over them, he burnt his black eyes into them, but when in response they had said ten words, they were jabbed and wounded, and blood flowed.'

To us who know in what poverty they had to live – having to count each penny and make full use of every scrap they had – Sophie's account of Mrs. Macfall's visit to them a few weeks later is full of humour. She came with her husband and Mr. Hare[6] one evening about half-past ten. While Pik showed his drawings to the men, Zosik answered her questions.

'Don't you suffer from the cold like this, without a carpet?'

'Well, you see, we are just leaving' (there was no question of a move at this time), 'and as my brother is occupied all day at his office, we have taken the chance of the week-end to roll up the mats and covers.'

'Oh, so you have mats and covers as well?'

'Yes, we have mats for the floor and covers for the beds,' said Zosik with absolute assurance, although she knew that Hardinge must have reported quite otherwise.

Then looking at their awful bed, terribly bent and untidy, Mrs. Macfall asked:

'Is this your brother's bed or yours?'

'It is his. This is his room. Mine is across the passage.'

'Oh, really! Have you got a good landlady? Does she do your meals for you?'

'Yes, sometimes, but when we are tired of home cooking we go to a restaurant, or we buy cooked foods, ham or cold chicken.' (Cold meats and potatoes cooked once a week!)

'Have you got a good charwoman to come in and do the rooms?'

'She is not over-good. I always have to supervise her, and even do the work after her; but what can you expect, they're all alike.'

This was too much for Pik, who had been listening to all this with one ear while talking to the two men, and with an impertinent laugh he said:

'Why are you telling all these fibs? You haven't got any charwoman.'

Poor Zosik was quite confused, but almost at once replied with force: 'Don't you meddle with my affairs: you are out all day, you know nothing of who does the work.'

Pik subsided and the conversation continued:

'Why don't you take one of these self-contained flats, like ours, for instance? They don't cost much, only about seventy pounds a year.'

'Yes, certainly that's very little, but then, you see, your husband doesn't need a studio, whereas my brother must have one, and that would make our rent a hundred pounds or more!'

'I suppose that *would* be too much?'

'Yes, just at the moment, for Pik isn't earning much, and I daren't plunge more deeply into my own capital; I've already had to go pretty far, since for a long time after we arrived Pik could get no work at all,' etc.

Mr. Macfall and Mr. Hare were very encouraging to Henri, and the party broke up with warm hopes that they would all meet on the following Wednesday. Mr. Hare tells me that Mr. Macfall, in writing to him about Gaudier, spoke of him as a young genius, but said that Miss Brzeska was a far bigger person, and wrote amazingly good stories; a remark which, when she heard it, gave Sophie a great deal of pleasure.

Mr. Macfall interested Lovat Fraser in Henri Gaudier, and Fraser called to see Henri, and ordered a large mask from him, for which he paid five

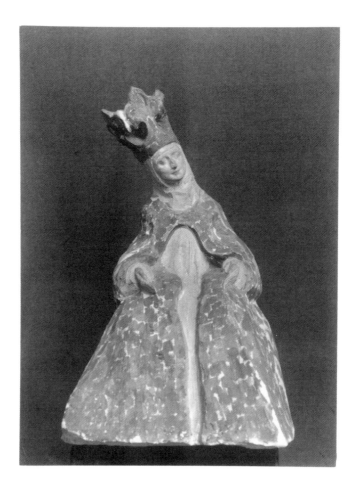

pounds. Henri went back with him to his studio, and was enchanted with his work, but Sophie did not like Fraser at all. She thought him affected and moon-faced. He told Pik that he should give up everything and be a sculptor, and Pik explained that he really was a sculptor, but had been doing posters as a pastime.

One evening, just as they had packed up their few belongings and were going to leave for other lodgings,[7] there was a ring at the bell. It was Mrs. Hare, who brought with her particulars of a real live commission. There was a proposal to make a small statue of Madame Maria Carmi, who was then taking the part of the Madonna in 'The Miracle' at Olympia.[8] Mr. Hare had spoken to Lord Northcliffe[9] and a few others, and Lord Northcliffe

had already said he would give fifty pounds. It was hoped that they would raise a subscription of two hundred pounds, and they would like Gaudier-Brzeska to do the statue.

With some difficulty they managed to accomplish their removal, and to get to Mr. Hare's house in Kensington in time to be taken to the show. At first Henri could not get into the right mood, and spent his time drawing horses, but towards the middle of the performance he took fire and did many excellent drawings of Madame Carmi. Mrs. Hare has a very beautiful one, which reveals in an amazing way his sculptor's instinct. He did a statuette, and two plaster casts were made, one of which Gaudier coloured.

Lord Northcliffe did not like them, gave Mr. Hare five pounds for the artist, and the idea was dropped. Mr. Hare bought one, and the other was sold at the Leicester Galleries in Gaudier's posthumous Exhibition.[10]

Gaudier now began on busts of Mr. Macfall and Major Smythies,[11] a friend of the Macfalls. He had said that he didn't require his sitters to sit, and indeed liked them to walk about; but Zosik noticed that it was a great relief to him when Macfall said he would prefer to sit down. The beginning of this bust did not go well, and Henri was about to destroy it when, much to his disgust, Macfall leapt up to save it, and carried it away.[12]

The work on Major Smythies was more successful. The Major watched the building up of his head with great interest, but objected to everything, as is, perhaps, not surprising: his nose was too flat, his forehead too high, and so on. At first Gaudier took no notice, but after a bit changed his tactics. 'I believe you're right. See, I will alter it.' And taking up some clay, he proceeded to make the alteration. After Major Smythies had gone, Zosik protested against his being so weak-minded as to be deflected in his own vision by an outsider.

'Poor Zosik,' said Pik, 'to be so blind. I only took up a little clay and put it on the bust so as to satisfy him, and then, when he wasn't looking, took it off again, and he never noticed.'

Gaudier was to do these busts for ten shillings each, and he hoped that Major Smythies would have his cast in bronze, which he did at a cost of twelve pounds.*

* This bronze was presented by Major Smythies in 1922, through the National Art Collections Fund, to the Manchester City Art Gallery.

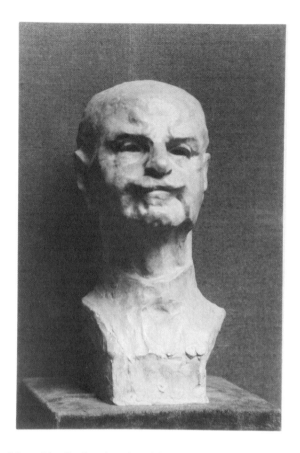

When Sophie told Pik that he should not dispose of his work so cheaply, he said: 'I'm a sculptor. I need clay to work with. For ten shillings I can get two hundred pounds of clay. I'm too poor to buy this otherwise, so it's better to take the money and create a work of art than to be puffed up with dignity and achieve nothing.'

These two busts caused some little talk in London, and Pik hoped, through the help of Macfall, to do several of Oxford undergraduates; but this seems to have come to nothing, though it kept him in a ferment of excitement.

Sophie made several attempts to interest someone in her writings: she lent a specimen to Mrs. Hare. A few days later Mrs. Hare suggested to her that she should take a house, and have a few paying guests, so as to live more comfortably. Zosik took this suggestion that she should become a

landlady as a direct reflection on the quality of her work, and was bitterly hurt. She was convinced that she was a great writer, and her whole energy went in trying to crystallize her ideas; but her surroundings and the lack of food were too much for her, and she achieved nothing; nor was she fortunate enough to meet anyone, save Pik, and for a brief moment Mr. Macfall, who would encourage her in her work, for her insistent nature drove people away from her.

In spite of this lack of sympathy from outside, her life with Henri was founded on the idea that they were both artists — she a writer and he a sculptor — and much of their time was spent in helping each other. Henri once said to her: 'Without my Mamus, I should have had nothing to show anyone; for as soon as I have done anything it disgusts me, and if you had not saved my works, I should have destroyed them all.'

One of these works was a 'Woman and Child', which Mrs. Hare bought for three pounds.[13] She had asked Henri how much he wanted, and he, in his usual way, had said: 'Oh, do take it as a present if it pleases you.' Its casting had cost him twenty-five shillings, but nothing would have induced him to mention this; and when Mrs. Hare offered him three pounds, he felt rich indeed.

Henri found the Hares' friendship a great comfort and had it not been for Sophie there is no doubt that they would have better understood the difficulties of his life, and contrived some way to alleviate them. But Sophie had to be reckoned with, and Henri's friends found this too difficult a task.

It was at the Macfalls', as we have seen, that Pik met Miss Enid Bagnold, and he thought her extremely beautiful. She came to sit for him,[14] and he expected that she would come every day; but her own activities diverted her attention, and week after week went by, filled with excuses and postponements. She herself tells the story of her finally sitting for him.

'It's a horrid story. I went to his room in Chelsea — a little, bare room at the top of a house — it was winter, and the daylight would not last long. While I sat still, idle and uncomfortable on a wooden chair, Gaudier's thin body faced me, standing in his overall behind the lump of clay, at which he worked with feverish haste. We talked a little, and then fell silent; from time to time, but not very often, his black eyes shot over my face and neck, while his hands flew round the clay. After a time his nose began to bleed, but he made no attempt to stop it; he appeared insensible to it, and the

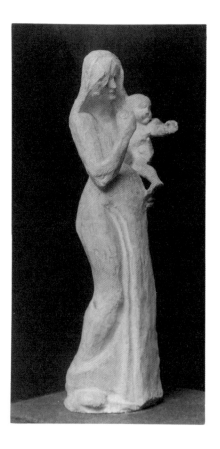

blood fell on to his overall. At last, unable to stand it any longer, I said: "Your nose is bleeding." He replied: "I know, you'll find something to stop it in that bag on the wall"; and all the time he went on working, while the light got less and less. The bag was full of clothes belonging to Gaudier and Miss Brzeska, most of them dirty, most of them torn. I chose something, long-legged drawers, I think, and tied them round his nose and mouth and behind his neck. "Lower!" he said impatiently, wrenching at it, unable to see properly. I went to my seat, but after a time the cloth became soaked through with blood. The light had gone, and in the street outside there was a terrific noise. It was a dog-fight, one large dog pinning another by the throat, and Gaudier left his work to come and watch it. He watched it to the finish with dark, interested eyes, his head against the window, and the street-lamp shining on his bloody bandages.'

Gaudier had found the previous uncertainty of Miss Bagnold's sittings a great trial to him, since he could not start a new work while he was expecting her from day to day; he therefore decided to give it up, and asked Zosik to sit for him instead. The history of this sitting throws an interesting light on their personal lives.

Gaudier's attempts to do Zosik had always resulted in such solemn effigies that this time she decided she would do her utmost to encourage a gay one. Although she was very tired with her work, and her nerves were on edge with the perpetual noise outside their rooms, she spent the sitting singing old songs from Rumania, Poland, France, and Russia. They were both for the moment in a frenzy of delight, and forgot that any cloud had ever dimmed the edge of their horizon. All their first happiness came back, care-free. The sitting lasted a long time, and in the end Zosik was terribly tired; but the portrait was a miracle, and they kissed each other for joy. Then, next day, came a little dispute. Zosik had given Gaudier two shillings for his fare, and he had promised to return one and ninepence. In the evening he came back with nothing — he had spent the money on sending photographs to people in Germany. Sophie was annoyed at his having broken his promise, and bitter words followed. Sophie went out for a walk. It was late when she returned, and Pik called to her from his bed with a gentle voice, but she would not go to him. He got up and came to her: 'Don't be angry with me, Sisik — I was very annoyed when you went out, but I'm sorry now, and I broke —' Sophie's mind flew to a vase they had bought, of which she was very fond, and she would listen no more. She flung invective upon invective at him, and in the end they separated for the night. After a sleepless night, she went into Pik's room, and he welcomed her with his usual happy 'good morning'. She repulsed him, but he pursued her until her rage burst forth once more, and entirely destroyed her self-control. After many bitter remarks from Zosik, Pik said:

'Well, since you hate me, I'll finish my work,' and taking the wet cloth from the bust of Zosik, he gave the forehead a half-hearted hit.

It was only then that she realized it was not the vase he had broken, but that he had taken his vengeance on the bust. It had, as a matter of fact, only a few dents in it, which were no doubt reparable, but Zosik was overwhelmed by the idea that, unable to beat her in his rage, he should have vented his anger on the clay head; she remembered the hours she had sat,

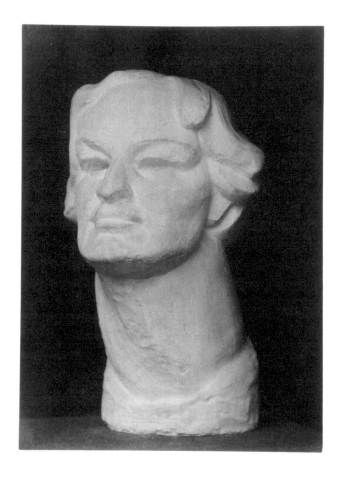

the trouble she had taken, and with one wild leap she fell upon it with her fists, beating it as if she were threshing corn.

'See,' she shrieked, 'I'll help you in your work!' and blow after blow fell upon the bust, until it was again nothing but a lump of clay.

Pik watched her with a little smile — timid and naïve: then he ran after her, but she fled exhausted to her room, and locked the door. Later on, when she was quiet again, she came out, and Pik said in his calm way:

'I'm not angry that you spoilt the bust — it didn't really satisfy me. I'll do another, a better one. Sisik will sit again.'

The next excitement and disappointment for Henri arose through a simple misunderstanding. Mr. Macfall introduced him to Mr. Benington,[15]

a photographer in the West End. Mr. Benington had seen Gaudier's head of Macfall and had expressed his enthusiasm. Mr. Macfall had passed this on to Henri, and hinted that Mr. Benington would have his head modelled for thirty pounds, and most likely have his wife done too. Gaudier was almost beyond excitement, but as Mr. Benington had never had any thought of sitting for his portrait, and did not know that Henri had any such expectation, many weeks passed without any conclusion being reached. In the end, he took several photographs of Gaudier and of his work,* but still did not know that more had been looked for.

Henri also met two Canadians, who suggested that he should go with them to Canada, where a sculptor was badly needed, and where they would all make their fortunes. With so many distractions, Henri began to be casual about his office – he arrived late and left early, and talked of nothing but escaping from so paralysing a position.

He was still interested in his small sister's art training, and sent her some of Mr. Benington's photographs, as the following letter shows:

15 Redburn Street, Chelsea
19th June 1912
Dear little Renée,
I am so glad that you have passed your exam – you see now how easy it is, and you probably had great fun that day at Checy's with your little friends.

Your drawings were good, and you should do them all the time, concentrating each time more. I send you a small money-order with this so that you can buy yourself colours, etc.

I thought you would like to have photographs of the statues which I have done lately. I give them to you because you are so good and so pretty. I am up to my eyes in work, but I shall try to come one of these Sundays. Keep well, water your little garden if it doesn't rain, and my love to you.
Henri Gaudier.

Do you eat lots of raspberries, you greedy one, and do you pick the roses? Give Maman a good kiss for me, and Papa and Henriette.

* Mr. Benington made a much larger series of photographs in 1918, at the time of Gaudier's posthumous Exhibition.

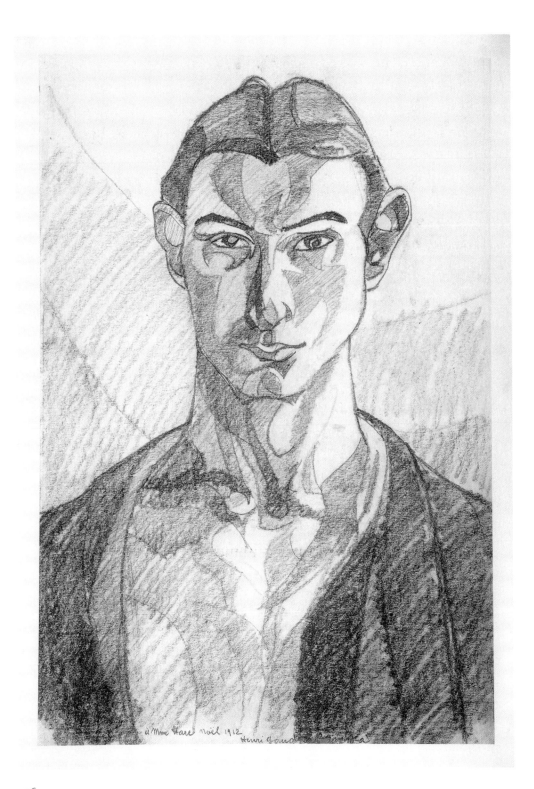

à Mme Hare Noël 1912
Henri Gaudier Brzeska

7 | More friends

It was at this time that Henri became intimate with Middleton Murry and Katherine Mansfield, the editors of *Rhythm*,[1] who had asked Mr. Macfall to introduce Gaudier to them, as they wanted his drawings for their paper. Pik went to see them, and came back enchanted. He had never met anyone so charming or so sympathetic. They were both young, he said, very young: Middleton Murry was strong in body, with refined features and a magnificent head like a Greek god, an Apollo or Mars; while Katherine Mansfield was not at all silly or vindictive; she hated women, particularly English women, finding them heartrendingly conventional. She was a curiously beautiful person, Slav in appearance, and very strong-minded.

Pik had never seen anyone like her before, and he did a drawing for Zosik, who was all impatience to know what she was like; and from the drawing Zosik thought that she must be like Catherine of Russia. 'I am sure that we shall become enormous friends,' said Pik, 'they are very fond of me and told me so, and Katherine Mansfield gave me an Indian knife as a token of her friendship.'

It is not surprising that they should have been drawn to Henri Gaudier. He was at this time full of a youthful attraction, like a young eagle flying in space. He was delicate of build, soft and feline but of a sinuous strength, with large, piercing eyes like a leopard's.

They had promised to call next day. Zosik was all excitement to see these demi-gods, and awaited their arrival in a ferment of nerves. It was raining in torrents, and Pik went out to buy a few plates and glasses; for so important an occasion they did not think their two tin plates and broken mugs sufficient. The visit was a great success; they praised Gaudier's drawings and talked nicely with Sophie. They went away in high spirits, arranging for the Brzeskas to come to them the next day.

When they had gone, Pik and Zosik were full of their praises, Pik saying that he was ready to have his head cut off for them. He wanted to sit down at once and write them a letter.

'What now, almost before they are out of the house?' cried Zosik.

'Yes, they are such darlings, Sisik dear, that we must tell them about us – but I won't write, I'll tell them to-morrow when I see them.'

Zosik asked him to wait for a week or so, but Pik felt that that would be dishonest, since they loved them; and then – flip – before she knew it, it was done.

In exchange, Katherine Mansfield told her own experience, which ended with these words:

'And then we got into this bed and we laughed and we laughed and we laughed without stopping, and since that time we have always slept together. But perhaps I am scandalizing you by talking of such things.'

'Not at all,' said Pik. 'We have also already slept together.'

They spent several hours in happy conversation, and Pik in an access of affection pressed Middleton Murry in his arms and fondled his head with his hands. Katherine Mansfield joined them in this demonstration of love, while Sophie sat at some distance in her chair. During this first visit Sophie talked far too much, and also Pik persuaded her to sing, which made her overexcited. After that it was Katherine Mansfield's turn; she had a sore throat, and went to sing in an adjoining room. When Middleton Murry said how good her voice was, Zosik replied with disconcerting frankness: 'Do leave the poor child alone. You can hear she has a bad throat and can do nothing.' Pik refused to leave until long after midnight, and they had to walk home in drenching rain.

Pik wanted to model their heads, but Katherine Mansfield said that they were going away in a couple of days to Sussex. They asked him if he would come to stay with them, but he said that he could not promise, as the week-ends were the only free times he had, and he could not spare them for pleasure alone, if it were to the detriment of his work. Few things could have been pleasanter for him than a visit to people he loved, living in a nice country house, and his refusal shows in a marked degree how seriously he took his work. He suggested, however, that they should take 'this poor girl Zosik' for a few weeks, which produced, after a prolonged blankness, an 'Oh yes, yes, do come'. Pik thought them perfect, and told Sophie that to be suspicious of them was as futile as objecting to spots in the sun.

Middleton Murry and Katherine Mansfield were often in town, and Gaudier began a head of Murry.[2] They talked of going to live together on a Pacific island, and Pik laughingly told Zosik that she must, of course, come in order to teach them to cook. Pik got it hot from Zosik for putting her at so venal a valuation. While they were bickering Katherine looked puzzled, and Sophie said: 'You are surprised to see us so quarrelsome.'

'No, you fascinate me, I can't make you out, you interest me tremendously.'

Encouraged by this remark, Sophie felt that while Pik was working on Middleton Murry she could confide in Katherine Mansfield; she felt that at last in her she had found a friend to whom she could open the pent-up torrent of her heart. She launched into a most intimate recital of their ascetic life, the daily routine, the poverty, the nervous irritations, their platonic love and her fears for Henri's health, his headaches, and his useless expeditions to King's Cross. Katherine listened to her with a strained expression, and then Sophie, in order to get closer touch and give herself assurance, took her hand and pressed it warmly in hers. Katherine Mansfield gave a slight shudder but remained silent, and Sophie, in order to break down this wall of ice, opened the deepest abysses of her mortified soul; she made her own heart bleed in living over a second time all these past torments, and, as she lived them again, they seemed to become part of herself, and to be conquered. Suddenly Katherine Mansfield, with a more marked shudder than the first, withdrew her hand; Miss Brzeska received a moral shock, slowed down in her outpouring and then stopped altogether.

Katherine Mansfield was looking at Middleton Murry with queer eyes, questioning, enigmatic; then he got up with: 'Tiger, darling, we must go.' Before they left, she said to Sophie: 'A Polish writer is coming next Wednesday, you must come then and finish your Polish tale.'

Pik was as enthusiastic as ever. 'They *are* darlings – I've not made his head half magnificent enough.'

But Zosik protested that they disliked her, to which Pik replied that it was impossible that such dear people should not like his Sisik – he would, however, speak to them about it when they met on Wednesday.

Zosik was very excited by the idea of meeting a Pole, who might, incidentally, help her with her work; but she dreamt that when they got to Murry's house they found the door barred by a huge cat. When she told this dream to Pik he laughed at her fears. Just as they were leaving, a telegram arrived, saying that Katherine was feeling unwell and would they please not come, and that a letter would follow. Day after day passed and no letter arrived. Pik was in the utmost distress; he wandered about their rooms and in the passage like a lost soul, and finally wrote to ask for a reason. Then came an express letter to Pik from Middleton Murry to say that he had been forced to telegraph at the last minute, for Katherine had come in late and very

tired, and had not been able to bear the idea of sitting for an evening with Miss Brzeska; would Pik forgive them and come alone that very evening. The letter ended by saying: 'You are a most exceptional boy, and I am sure that one day you will be great; every moment I spend with you is for me an immense pleasure. Wire if you can come.'

Gaudier felt very much annoyed and quite disillusioned, but he decided to go and settle the matter by a personal explanation. 'I still love Middleton Murry,' he said, 'since all this fuss is only an intrigue worked up by Katherine Mansfield, whom I have never really liked; and although nothing would have induced me to write such a letter to him, it only means that he is weak-minded and not that he is a fool.'

Zosik told him that it was his own fault, since, had he supported her in public instead of abusing her, they would never have dared to write in such a way.

Next morning he told Zosik that although they had been very nice to him he had been bored to death, and had been very distant all the time. He thought that they must, after all, be stupid people; for, incredible though it sounded, they had never noticed the statue of Charles I in Trafalgar Square, and they were people who considered themselves to be artists.

He said that Katherine Mansfield had suspected him of being homosexual, and had begun by asking him if he had not a passionate nature; in order to lead her on he had said 'No'; on which she had plunged deeper, suggesting that he sometimes had peculiar longings like the great French sculptor, or like the English writer who was driven out of England. 'Perhaps,' said Pik, while laughing in his sleeve. He thought that she was too cunning to drive him away from Middleton, since she saw how useful he could be to them. He felt sorry for Murry, who seemed to be entirely in the hands of Katherine Mansfield, who made love to him all the time, until he was squeezed dry.

They were both coming the next day, Middleton Murry to sit for his portrait and Katherine Mansfield to make it up with Zosik. Sophie said that she would go and rest, and would only come in for a few minutes at the end of the sitting.

At about four Pik called to her, but she took no notice; he then put his head in at the door with: 'Come on, it's all right, she isn't here.' Poor Murry looked like a ghost, and Zosik at once felt tenderly towards him and made

him some mint tea. He told her that he was terribly upset by Katherine's nervous behaviour. Miss Brzeska described the rest of the episode thus:

'"You won't be angry with me, will you, because I love you – I love you really," and taking my hand, he kissed it.

'Pik was much touched by this, and came over and enfolded us both in his arms, and there we stayed a little while with my head on Middleton's shoulder. I longed to give him a maternal kiss, but feared to disgust him. Then with a little hug we all separated, and with rich handshakes, we swore eternal friendship.'

On the first of September *Rhythm* was published. Gaudier expected to get a few copies, as it was the first time his drawings had been reproduced in this paper, and he wished to send them to a few friends in France. He was very much upset because his name was wrongly spelt 'Gaudier-Bizeska'; he thought that Katherine Mansfield had done this on purpose, so that Zosik's name should not appear. By the tenth two copies arrived. Murry had been out of town some little while, and the friendship had suffered so severe a shock that Henri, who was going away for a week's holiday to a place near Murry's country house,[3] swore he would not see them.

A week later he returned, full of life and energy, and there was no end to all that he and Sisik had to say to each other. He had been to stay a night at Murry's place – they had met each other on the cliffs. Before dinner he had overheard the following conversation relating to Sophie:

M.M.: 'I think she should come here now, there is plenty of room. Just let us speak to Gaudier about it.'

K.M.: 'Oh, no. I don't want to see her here – she's too violent – I won't have her.'

M.M.: 'But, Tiger, look here, she's not like that – I don't see why...'

K.M. (violently): 'Leave me alone, I don't like her and I don't want to see her – she'll make me ill again.'

This was a relief to both Henri and Sophie, for they now knew where they were, and Sophie found much solace in the fact that Middleton Murry had spoken nicely of her at a moment when there was no reason to do so except that of genuine good feeling.

The worries of the last few months had been, all the same, too much for Sophie, and she decided that she must go away to the country, recuperate her strength and get seriously settled to her work. After a good deal of

letter-writing to and fro she decided, on the enthusiastic advice of Pik, to go to an old house in Frowlesworth.[4] Her experiences there and her meeting with a woman she called *Niemczura*,[5] are most interestingly described in some of her writings, and were the topic of an amusing set of drawings in one of Gaudier's letters.*

Gaudier's last letter to Middleton Murry is a characteristic one, and it is quoted almost at length, since it throws rather a special light on his nature. It is a pity that a letter which Henri wrote earlier cannot also be quoted, and which Middleton Murry said was so charming and so interesting that he would keep it until Henri was famous. When asked, he replied: 'I am sorry that I have not the letter which Gaudier wrote me in 1912. Probably I destroyed it at the time of our quarrel, as young fools do.'

November 1912
My dear Murry,†

I was last night with M—— and was most surprised to hear you were in town. You apparently did not think fit to let me know, just as in the same filthy way you never informed me of the *Rhythm* show, against your promise, nor sent it to me either last month or this. Your acquaintance has been for me one long suffering – not only for me but also for the object of my love, which is twice worse. I met you at a dangerous turning, the brains burned by the recent summer, thirsty for good friendship, only with one drawback: poverty. Being then freshly strong, promising all kinds of things and favours, you behaved stupidly, thinking I was lashed to you, and that I would not mind any dirt. I was confirmed into my thought of the wickedness of Katherine Mansfield by a conversation I overheard when at Runcton. It was about my poor Zosik. You pleaded, and this to your honour, that you could receive her in your house, but K. M., with a fiendish jealousy, upheld to the end that Zosik was too *violent*. You will remember the whole story, which I need not trace more. I was wounded, and if I came once more it was only to take my Zosik's MSS., which with the same prejudice have been absolutely misjudged. I kept my mouth shut all this

* Page 131.
† This letter is a rough draft of a letter which was probably never sent, since Gaudier thought it best to obtain the return of some books before sending it. It was written in English. Middleton Murry does not remember if he received it, but has still one of the books.

time because I knew you were in devilish difficulties all the while. Now you have got over it and there is no reason why I should not say what I think and feel.

I loved you innerly and still sympathize with you as a poor boy chased by the Furies, but I must reproach you your lack of courage, discrimination and honour. Katherine Mansfield I never wish to see any more. I must ask you to kindly send back to me three books that my Sisik lent you, 'Bubu de Montparnasse', 'Poil de Carotte', 'Cantilènes du Malheur', against receipt of which I shall let you have 'The Cherry Orchard'.[6] I cannot send you your book and wait for you to send mine on – you have no word whatever and I cannot trust you in the least.

You must not think for one minute that I want *Rhythm* – it is vice-versa. My drawings have been among the best that have appeared in your paper, and more in the ideal of it than the putrid trash you exhibit this month of Yeats and Peploe. I will not barter the purity of my love, nor my conscience, for a halfpenny worth of *réclame*. You had promised me money for what had appeared, and you might have thought me anxious only for this money's sake – you are not in a position now to give me this money, and you might think I retire for this simple reason. It would be bad for you, but I suspect it greatly, so you will please me to retain Heal's £2 – for the advertisement in this month's towards the paper expenses. I shall never more contribute, and wish to cease all relations whatsoever, until being freed from the thraldom of your present love you reflect upon your actions and find yourself a much better and more reliable man.

Before putting the seal upon our short but unhappy acquaintance I wish to point out to you, as a friendly counsel, that the less K. M. writes for you the better it will be, either under Petrovsky's name[7] or her own – for it is not sincere but pure affectation: not art. Also that you discriminate more in matters poetical and pictorial and never insert any such rabble as Simpson's drawings or any such that do not represent concentrically Fergusson's idea – the only man with a real will in your agglomeration.

I wish you to read this letter twice over as I cannot express myself well in writing. My Zosik has been a month already in a most lovely Worcestershire cottage, on a hill, where she works, is free, and has not the sorrow to see herself insulted as she was in the grossest way, by whom you know.

H. G. B.

8 | A group of letters

Part I

During the last three months of 1912, while Henri was for the second time alone in London, his letters to Sophie again vividly convey his thoughts and his actions. During this period he received letters from France, summoning him to return for military duty, but against this he had steadfastly set his mind, and would listen neither to argument nor to exhortation.

For the week-end of November 10th, he managed to go to see Sophie at Dodford,[1] where she had gone after leaving Frowlesworth. She was in nice rooms at a farm-house, and Henri had heaps of gossip to tell her, among other things that Macfall had spoken of her as beautiful. This delighted her, and Pik was charmed that she could still be pleased with anything so frivolous. Miss Brzeska said that 'he was affectionate, animated, and vigorous, and his eyes blazed like torches.' They forgot how quickly the time had passed, and it was one a.m. before Pik went on tiptoe to his own room. The next day they went for a long walk in the country. In the garden of their house there were some old jars and a fifteenth-century Christ, which they decided to buy if they could get them very cheaply. Zosik had already bought four Indian curtains costing thirty shillings, and these were going to adorn a charming flat in London.

This week-end visit had rather a special value for them; their love for each other found peace in which to flower, and had Henri not feared to lose her continued companionship, he might have awakened in her a return of that physical love which he himself had always felt for her, but to which he had, so far, never confessed. As it was, he went away full of fondness for her, which became a little dulled through being perpetually unsatisfied.

15 Redburn Street, Chelsea
Friday, 11th October 1912
Dear Old Thing,
I miss you terribly – this place seems so big without my Zosik, and I'm very far from working well. I have every good intention, but I sleep much too

much and can't break myself of this. Yesterday evening I made a fairly good composition for Tomsy* and I will paint it on Sunday. I don't feel fit for much – to begin with I'm put out by this damned military service, my running away from which seems to irritate them most terribly. Secondly, your portrait doesn't progress very well, poor darling, anyhow I'm about dished with it, and then that ass ——,[2] the fellow I met at the British Museum, is supposed to come here to-morrow, and that takes away the last grain of hope that I had. But on Sunday I feel that I am going to work well, and I hope that next week will not be so sterile as this one. May it be the same for you too, my great big girl, and may the good sun protect you. It is a shame that all I do turns out so badly, particularly when it is for you, dear Zosik. I went to the Luggage-in-Advance office and they assured me that you should have your luggage to-day. If not, send a line to the station-masters at Ullesthorpe and Lutterworth to ask them what the hell they are up to.

Zosiulo, don't be angry with me ... in shaking the kettle to make the water come out I've broken the handle, and yesterday the lamp-glass burst in my face without any apparent cause, and I spent half an hour looking for the little bits of glass – my cauliflower was full of them – for I was having dinner. I take baths, like Sisik, only with less hot water, for it's more refreshing. I'm sorry that everything is so dirty in your Boarding House, and I'm afraid you will blame me for having got you into it, but you will remember, Sisik, that I told you not to go unless you wanted to. If you can't find anything else it would perhaps be better for you to go to Worcestershire, or even somewhere in Belgium, if you prefer that. I feel that it would be nice in the Ardennes – it's like the Black Forest, but we will go into all that later, and in the meantime I wish it was Christmas so that I might be with my Sisik, and that I was ten years older in order to be richer, and that my Sik had a lovely country house of her own. Don't you worry about 'Poorhouses,' my Zosisik, your Pipik won't let you go to one. If I am still poor when I am old I would kill us both rather than go into such charnel houses.

They are dirty devils who wish to frighten my Sisik. Stay where you are as long as you can – rest yourself – take a bit of breathing-space, or clear out quickly if it seems to you a better idea and you can get something advantageous. Good-night, old darling, I send you thousands and

* Mr. Hare.

thousands of kisses and now I'm going to bed, as to-morrow they wash the place.

Good-night dear Zosikmaly — the fog is so thick that you can't see the lights of Radnor Street, and it comes in through the cracks of the windows, and if you stop them up it comes down the chimney.

I have been a soldier since three o'clock this afternoon and consequently beyond benefit of civil law — may the good sun burst all the officers of this filthy regiment! Good-night.

Saturday morning
P.S.–Your card must have come while I was in bed — I got it this morning at 6.30, and I'm anxious about the luggage. Poor dear, you absolutely must get away if everything is so disgusting that you can't sleep. Your rascal of a Piknis sleeps far too well in your bed — I'm tired out, and this is perhaps the reason. Next week will slip away more easily — there won't be so many distractions, and perhaps I shall manage to get in some work. Zosiulenko, who is this Niemczura? A cook or some kind of servant, *albo? dama?*[3]

P.P.S.–I add this little page so that there shall be three. I dreamt about Wulfs last night and about my Zosik. He wanted to have novels and stories by Zosik for his daughter … and then stupidities, for we found ourselves, he and I, in a great room full of enormous machines, etc. Dear Mamus, I do not feel alone because I have a good Zosik, and I kiss her tenderly and warmly. Be good, dear love, and don't stay any longer in that foul hole where you were stuck by the moon. Good-bye, Zosiulik.

Pikusurinia.

15 Redburn Street, Chelsea
Sunday, 13th October 1912
Zosisikoiv Smarkoisowi,
I've been reading your letter over again, and you do seem to have got into a beastly hole, my poor dear, to be so embittered. Poor, poor darling — the old woman with cancer, the workhouse, the Vicar, the Niemczura, etc., and bad food and a rotten bed — it's really disgusting. My dear, I understand so well how you get annoyed with me, and I'm sorry I took all you said so seriously, and particularly that I scolded you about it. I am also furious that I

haven't enough money to send you a box of food – but I'll do that as soon as possible. That ass Fraser is doing such rotten things, affected and stupid and crude in colour. It is true that the colours are brilliant, but they have no relation to each other.

It only costs 10s. to 12s. 6d to go to Belgium by boat from London. If we have a few days at Christmas or the New Year we could perhaps go there together.

Your Pipik who loves you intensely, who loves you more each day,

Pikuś obesrany

if you wish him for a friend.

Monday, 14th October 1912
Zosik,

The Lousadas[4] don't come back for a fortnight – I telephoned. I got 10s. for overtime last Saturday and I send it to you, for I expect you need it, poor dear, since you left with only £2. Send me a p.c. to say how much you will need before the end of the month, and I will borrow it off the rent. ...

Mother now writes to say that she thinks I have acted wisely (in refusing to do military service), and that her first letter was wrong, which cheers me up very considerably.

I've done an illustration for Tommy and finished your *glowa szkaradna*,[5] which I'm pleased with. I saw the bronze group at Parlanti's[6] on Saturday, and I agree it's a scandal that such a beautiful little group should be flung away for a profit of £7 – still it is better than nothing. I hope that you are getting more sleep and that you are feeling quieter. Poor darling, may the good sun bless you.

Your Pipik.

H. Gaudier-Brzeska.

P.S.–Naturally, no *Rhythm* yet. Oh, the rotters!! I am writing from the studio. The boss is at Cardiff from this afternoon until Wednesday. I'm going to work hard. I will write a long letter at the end of the week, for this is only a line to go with the ten little shillings. Don't worry, Zosik, we are very near each other. I get your letters the day you write them. I work hard in order not to get depressed. I had potatoes and rice, which gave me wind in the belly, but I have had some peppermint and feel better.

16th October 1912

Sweet Heart,

There is a hurdy-gurdy playing blithely outside, the Scot and the Scotswoman are dancing, and Pik has made a crackling fire to cook an *ogonek*.[7]

For the last two years Pik has never vacillated nor oscillated about militarism. Naturally when I receive such a letter as the one I sent you, I can't help inveighing against all the prejudices with which the rich stuff the poor in order to keep them in slavery. I've written a strong but very dignified reply. I have said that I do not recognize any patriotic duty; that if they did not wish to wrangle with me they should not have meddled with my affairs, and that if my sisters, particularly the elder, because the young one seems to have said nothing, make such a fuss, let them go to the Devil. The final touch to the whole thing was getting this letter from G——,[8] which I enclose:

St. Jean de Braye
le 13 Octobre 1912
Conseil Général du Loiret.
Mon cher Gaudier,
Je viens de voir votre père qui m'a mis au courant de ce qui vous concerne. Je n'ai pas besoin de vous dire quel coup votre décision lui a porté. Vous l'avez rendu profondément malheureux, si malheureux que je dois vous l'écrire. Je vous ai, d'ailleurs, témoigné toujours assez d'intérêt pour avoir le droit encore de vous donner un conseil.

Je sais les raisons que vous avez données à votre père. Laissez-moi vous dire qu'elles ne sont pas sérieuses. Dans tous les cas, ce n'est pas à vous de vous en faire juge. Mon plus jeune frère vient de finir son service militaire. Les deux années qu'il a passées au régiment ne lui paraissaient pas moins dures qu'à vous; il avait aux jambes des varices qui l'ont fait beaucoup souffrir pendant et après les marches. Il n'en a pas moins fait allégrement ses deux années, sans se plaindre, heureux d'accomplir son devoir. Il faut vous dire que le service militaire est un devoir, et qu'on est toujours heureux de faire son devoir.

Puis, dans quelle situation vous mettez-vous? Vous vous fermez les portes de la France; vous ne pourrez plus revenir à St. Jean de Braye; s'il survenait

dans votre famille qui a été si bonne pour vous et où tout le monde vous adore, vous le savez bien, — s'il survenait, dis-je, quelque malheur dans votre famille, vous ne pourriez même pas accourir au chevet d'un malade qui pourrait mourir sans que vous auriez la consolation de l'avoir vu. Mon pauvre enfant, avez-vous bien réfléchi que, par là, vous vous mettez hors de la patrie et hors de la famille?

Vous travaillez, vous avez du talent; je crois que vous réussirez. Vous êtes-vous dit que votre situation nuira à votre succès d'avenir? Je ne sais si vous avez suivi, il y a à peu près deux ans, les histoires d'un auteur drama-tique de grand talent, Henry Bernstein, qui avait fait précisément ce que vous avez fait, et qui a eu l'humiliation, dans son succès, d'être contraint de faire amende honorable publique. J'aurais voulu avoir conservé la lettre qu'il écrivit alors ; vous l'auriez lue, et vous auriez compris quel poids vous vous attachez pour la vie!

Vous savez tout ce que votre père a fait pour vous; vous savez combien il vous aime. Votre décision l'a peiné à un point que je ne saurais dire; elle l'a beaucoup vieilli; je vous assure que je n'exagère pas. Je vous en prie, revenez sur votre décision tandis qu'il est temps encore.

Il est tard, il n'est pas trop tard. Vous serez évidemment puni, mais j'interviendrai de mon mieux pour que les choses n'aillent pas trop loin. Ce sera quelques mauvais jours à passer, mais vous vous éviterez tous de regrets pour l'avenir, et vous enlèverez à ceux qui vous aiment un souci si douloureux.

Croyez bien que c'est un ami qui vous parle, et qui vous parle parce qu'il a de l'affection pour vous. Je crois vous en donner en ce moment la preuve la meilleure.

Venez vite, mon cher enfant, réparer la faute que vous avez commise; je souhaite vous avoir persuadé. C'est le meilleur vœu que puissent former mon amitié pour votre père et ma sympathie pour vous.

G.

Personne ne sait rien encore dans le pays, que moi, qui ne dirai rien.'9

I have answered in a cold, strong, dignified manner:

'le 16 Octobre 1912
Monsieur (pas cher et autre),
Votre lettre fait preuve de très grde. sentimentalité. Vous êtes un barbare si vous vous glorifiez de votre frère qui souffrait tant de ses varices. Votre sympathie pour moi s'est montrée à mon retour d'Allemagne. Vous m'avez proposé une place de 50 frs. en disant c'est un peu de vache enragée à manger. Je ne vous reconnais aucun droit de me donner des conseils – je n'ai commis aucune faute envers qui que ce soit. J'ai reçu du gouvt. français 3000 frs. avec lesquels je me suis formé, vous et autres politiciens ont ... Je considère ces 3000 frs. comme venant du peuple, et je les rends au peuple par l'art.

Je serai naturalisé anglais dans 2 ans et si je ne puis pas un jour travailler à Paris, n'ayez crainte que je fasse comme Bernstein – j'irai droit en Allemagne, et vous aurez alors le piteux spectacle d'un artiste français érigeant un monument commémorant une défaite française pour se venger de la bassesse et étroitesse d'esprit de ses contemporains.'[10] Etc.

About eight large pages of abuse of this sort in short pointed sentences. Christ! What a brute! None of this is for one's father or for friendship or anything of that kind, but purely for himself, because he is the Maire of S. Jean de Braye, and he must see to it that there are no 'bad examples' in his district. Oh, I let him have it at the end, where I said, *C'est malheureux, déplorable, que la jeunesse française ne se révolte pas en masse contre cette infâme conscription.*[11]

Will that make the Zosik pet happy? Naturally I have not written to Middleton. I will buy a copy of *Rhythm* in order to have a record of my drawings, but I won't ask for anything nor lower myself. If he pays me, as he said he would, so much the better – if not, fft! Anyhow, I'm not going to humble myself any further, and if he pays me and writes to me I shall tell him quite clearly what I think,* as I have just done to G——.

I'll have £7 or £8 from the group. You know that the casting of Tommy's two plasters[12] is not yet paid for, and that will be £2 or £2 10s., and the bronze brings £10. Wretched Zosieki! Believing that I wanted to hide £2 from her in order to buy chocolate. You look out for yourself if I ever catch you!

* Letter printed at the end of Chapter 7 (page 112)

And now, my dear, it is really impossible that we should continue to live apart – stay for a month where you are to set yourself up, and then come back. I'm doing everything now – it is all quite clean, I don't waste time and I'm working hard. I shall be able to do just the same when you come back, and we shall get along beautifully. Zosik only needs a rest and change of air. I really can't live for three months without my Sisik. I miss her so that I cry most of the night (without knowing it at the time, since I sleep well – but in the morning my pillow is wet and my eyes all swollen). We must come to some arrangement, once and for all.

I've done a little jungle cat that I like, and I'm going to do another at once.

À bientôt, my unhappy and beloved darling. Najukochanek, you will come back to your Pisukonik at least after Christmas for two or three months, won't you? That is if you can work well, for I don't want to allow myself to be led away by sentimentality to sacrifice your work. You are the

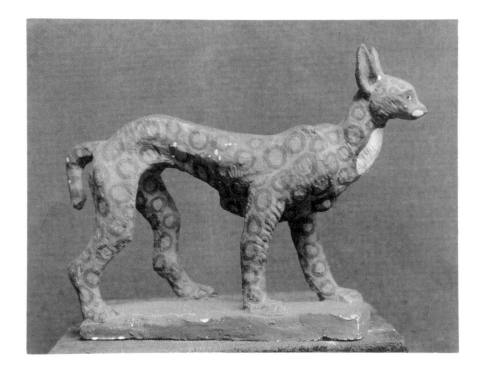

more intelligent, and it is you who must decide. I don't want to have any responsibility in the matter.

Pikus Gaudier-Brzeska.

Chelsea
24th October 1912
Najukochanisku Zosisik.
Your letter made me very unhappy. From one end to the other you do all you can to find fault with me, and you don't enter at all deeply into what you say; and what is more you cite instances that are historically false; the case of Rodin for one. I am more bothered by the thoughts of your ridiculous 'moral aim' than by your attacks against me. I have certainly got many faults – indeed, like everyone else, I have got every fault in a greater or lesser degree. Yes, I know I'm a spendthrift, but conceited, to the degree of having a wicked letter piled up against me in order to prove it? Never. Since you are so good a partisan of the old mystic philosophies which search into cause and effect, why don't you weigh a little what you are saying? You accuse me of being conceited, and then in the next line you say that I am perpetually changing my ideas and my opinions, even about art.

Surely this very fact proves that I am not at all conceited. Life, according to Bergson and the later philosophers, is simply intuition of the passing moment, and time, which flows continually, eternally, makes itself known by change. The conceited man is one who stops at a certain phase of his work or of his thought, and cries out loud, like you, 'When I say something, I believe it – I'm sure of myself,' etc. I'm not a bit like that. I look at things a great deal and I draw a great deal. I notice how everything differs, mingles with and knocks up against everything else, I am never sure that what I think is true, still less that what I have thought or said is true; and I can't bring myself to sacrifice new ideas, quite different from those I had yesterday, just because the old ones happened to have the honour of passing through my head and I advocated them ferociously.

You can talk till you are blue in the face,* art has no moral aim, and when it has been great has never had one, in any of its phases. It is simply

* 'chante autant que tu voudras.'

an interpretation of life; and life has no moral aim either – though one can draw a certain amount of morality from it to help the intellect in its battle with the elements. Ethics are a very secondary thing, but the consciousness of change is of the utmost importance, for without this, work cannot renew itself, art is gloomy and sad, and is no longer art.

When you have fully realized once for all that I am a poor Pikus for whom the only country in which he can work for the next few years is ENGLAND, perhaps you will at last understand. You don't, I think, realize that I have to be in a filthy office all day long, and that every minute I am devoured by the most torturing desire to be cutting stone, painting walls, and casting statues? You always seem to forget this, and that isn't at all nice of you. I only know stupid people, but through these I may be able to get out of the hell of shipbroking, etc., and naturally I won't risk my chances of this for the sake of the 'senseless honours' of pride. I hold Machiavelli's opinion that when you wish to attain an end you must use every possible means, and when you consider everything with a clear understanding, the misery I endure in business is far greater than the little troubles of the soul and mind which I experience in my dealings with these fellows whom I have to see.

You have a very good example of this – I too – this example being your-self. You have ruined the best part of your life because of this pride which you place above the work which you could and should accomplish. This leads you inevitably to that narrowest kind of egoism which puts the self on a pedestal, labelled 'Don't touch', and makes hay with the primordial conception of the individual as part of a society, having relations with the other individuals who compose it.

All you say against me makes me mad, because none of it is my fault – but yours – caused by the falseness of your principles about life itself. My love for you is entirely intuitive, whereas yours for me is a reasoned thing, and therein lies the first obstacle, causing all our differences of opinion. As you are so set on being alone, please stay alone and I, on my side, will manage as best I can. You insist that I am not sufficiently interested in your work – that I don't ask you questions – that I haven't read anything of yours since people here said it wasn't worth anything. That is a hideous lie. What can I ask you? During the two years that we have been together your work has only been in a state of preparation, and but for slight alterations,

is always practically the same — except that it gets more drawn out and amplified. You never set yourself a limit, and of its final form you seldom speak. Since I know the story from A to Z, what is the use of asking you questions about it? I have, as a matter of fact, read all the little notes you have put in the margin, and that is more than you can say for yourself about my drawings, which you never dream of looking at unless you want me to give you one, and then you go and hide it. The whole fuss is, of course, only a trifle, but you seem entirely unconscious of the fact that I work very hard to earn our living, and don't want to stop my artistic activity. You exaggerate every little fault; you never try to understand why I do this or that, but you expect me to fall in with all your quite arbitrary actions, which are the result of conceit and egoism, and utterly lacking in importance. It is this particularly that upsets me, and if it goes on too long it will wear down my love for you. I can't see why you don't adapt yourself a little more to circumstances. You reproach me again with not having written to you — this is utter madness, for I wrote you three letters at the end of last week. Then you say I never tell you about what I read. What time have I to read? You know quite well I have scarcely the time to work. All the same I am sending you some newspapers this morning, not because of your scolding, please note, but because I had already thought of sending them to you. You ask too late for provisions — I haven't enough money, and you will have to wait a bit. It is just as well, perhaps, not to send anything to Frowlesworth — but rather to Bromsgrove — however, please yourself.

I have seen a lot of fellows who know Murry, and they all say that he was quite a different person a year ago — gay, strong, alert. ... In spite of all Sisik may say, I'm sorry for Murry, and I don't at all hate him. As for *Rhythm*, no one knows exactly what has happened. ...

Macfall has produced a hideous article — 'The Splendid Wayfaring', which you will find in the *Art Chronicle*. He asked me for drawings to adorn it, and I gave him about sixty. The stupid editors made a fuss because my monkey had only three legs. Macfall had to go to them three or four times in order to convince them, but I believe all the same he himself wished I would put in a fourth.

The Lousadas come back next Sunday evening, and I shall probably have some ready money the week after. ...

25th October 1912

My dear, why do you say so many horrid things about your Pipik, who doesn't deserve them – it is not really nice of you – still, poor little one, you are hungry and alone, tortured by this Niemczura and this clergyman, so that it is silly of me to take it so much to heart.

I'm always very sincere with you, Zosik mia, only, as I always point out to you, I don't attach any importance whatever to what I have said or done, but only to the present. You know very well, beloved, that I love you with all my heart, so don't be sad, and clear your mind of all these horrid black ideas which keep coming to you incessantly. When you are a bit rested you will be quite happy again and come back to your Pipik – you wait and see. I shall be so happy when Christmas comes and I can talk with my Zosisik. I am working a great deal and hope that you are doing the same in Ambrosia.*

Your Pipik, who loves you dearly and who is always near you.

Pikusik.

Chelsea
Monday, 28th October 1912
Mon bon Dziecko Ukochany,[13]
I will go to Euston to-morrow evening and try to find out what I can about the hours of the country trains. I enclose a letter from the old woman at Bromsgrove which came at the same time as yours. Naturally my Sisik likes feather beds – get a big bedstead, *będsiemy spać mitsammen*[14] at Christmas!!!!!

It is absolutely true, without any doubt whatever, that you talk through your hat – you place Bergson with Nietzsche, Schopenhauer, etc. Bergson expressly demonstrates that the world is positive, real; and that it is pernicious and useless to rack your brains to find out if the world was created by a God or not. He emphasizes intuition as more valuable than reason – for reason is scientific and leads to the absurd. ... To make this clearer for you, I send you a little book which you really ought to read.

I regret much that I have said and done. You see, Zosik, I have only just opened my eyes on the world, and I'm dazzled. My feelings do not agree

* A reference to Ambrosia Cottage, where Miss Brzeska was staying.

with my reason – my words fail to convey just what I am longing to say. My touch with all things is very slight, and the primitiveness of my nature always gets the upper hand. As a punishment, I have sworn to translate the whole of the 'Divine Comedy' for Sisik, for I see that Dante suffered just as I do from this curiously ambiguous situation.*

As to my ideas about art, I'm perpetually modifying them, and I am very glad I do. If I stuck to some fixed idea, I should grow mannered, and so spoil the whole of my development. As far as I can see at this moment, I believe that art is the interpretation of emotions, and consequently of the idea. For this emotion I recognize as necessary only the discipline of technique, and at this moment I think the idea comes better the more the technique is simple and limited; on the other hand, I fully recognize that the more you limit your technique, the greater danger you run of falling into mannerism, which is the negation of all the emotion which we experience in front of nature.

Again, in this emotion I see three divisions; linear emotion, produced by the rhythm of outlines and of strokes, sculptural emotion, rendered by the balance of masses, such as they are revealed by light and shade, and lastly, pictorial emotion, produced by various coloured pigments. These

* Gaudier translated only the first five Cantos of the 'Inferno', a work which Miss Brzeska spoke of as *œuvre très mièvre – ennuyeuse jusqu'à l'indigestion d'Esprit et du tête*.[15] He had a Tuscan edition with a 'hideous English translation', which helped him where the passages were obscure.

three technical emotions seem to be very closely united in a vast intellectual emotion, which I do not know, but which, in the corresponding realm of spirit, I feel, in the form of pleasure, suffering, sorrow, joy, etc., and that's where the mystery lies. I used to think that to reproduce each form exactly was enough; then I thought it was only the light that mattered, and that if each variety of light was rendered perfectly, that which it lit would be thus rendered also. You will see for yourself that it is best for me to free myself gradually from all these prejudices – that I should deny, so to say, all that I have thought instead of becoming ridiculously engulfed – an example of pigheadedness. To tell the truth, I am sure of nothing, since it is only now that I am beginning truly to feel life.

According to the little book which I am reading about Dante, 'the devil lived on very good terms with very few people, because of his terrible tendency to invective and reproach, and his extraordinary gift for irony and irresistible sarcasm' – just like my own funny little Sisik.

To be quite honest, Sisik, I love you passionately, from the depth of all my being, and I feel instinctively bound to you; what may often make me seem nasty to you is a kind of disagreeable horror that you don't love me nearly so much as I love you, and that you are always on the point of leaving me – however, the more I know you, the more I realize that you do love me very deeply.

Cheer up, Sik, dear. I'm feeling well and looking after myself – for example, last Sunday, the landlady cooked me a good joint and potatoes. I have provided myself with lots of vegetables and fruit. Yesterday morning I got up at six o'clock – had a bath, went to the park for an hour, and got back to the house at eight o'clock. I worked hard until seven in the evening, went out for an hour, and to bed at eight. Next morning I was up at six again. I did a fairly big canvas in oils yesterday without any hesitation – I did it in one go, and am pleased with its colour and composition. It is a Whitechapel Jew, selling his wares.* In the afternoon, I half-finished the plaster group: two women running.[16] Now that it is finished it seems to me like an allegory – the Spirit of Liberty drawing women towards a nobler life. Since you left I have done innumerable drawings – about 600 to 1000,

* This canvas was reversed later, and the bas-relief of 'Wrestlers' worked on the new surface, so that the painting of the Jew is now at the back of the 'Wrestlers'. [17]

your portrait,[18] which I have begun three times, and which has taken me ages (it is finished now, and I am delighted with the beauty which comes out of it, and the absolutely refined charm of the face), a little statue of a monkey, one of a lynx, one of a puma,[19] the group, the picture mentioned above, and several illustrations of the Tomego Zajaia.*

I know a bookseller, Rider,[21] a pleasant fellow. It is he who has put me in touch with [Frank] Harris.[22] He has suggested that I should show in his shop little statues and pictures for sale — I'll take him my Jew and the plaster groups of Russian dancers. Zosik was right: Parlanti has given me back the plaster group — *mea maxima culpa!* Lousada has come back. I spoke to him on the telephone this evening; he is going to send me a card telling me what evening he can see me, and I will take him the bronze that Parlanti is bringing to-morrow. The Hares always ask for news of you directly they see me, and I think it would be nice if you wrote a little letter to Tommy. I don't think very much will come of Tommy's mythological stunt, and that's all to the good, since I about burst myself over each blasted design. I'm much better working at my own personal ideas. ...

Wulfsberg has promised to make a contract with me before the 1st of November. There is a rumour in the office that he is going to take me with him to Christiania (he said something about it to the Norwegian, but it is very doubtful). If he does propose it, however, I really ought to refuse, for in Christiania we would have to work from 8 a.m. to 9 p.m., and on Sundays until 2 or 3 in the afternoon. The town is a frightful nest of *can-cans*,[23] where everyone knows his neighbour, and where it would be impossible for me to do any kind of work. I ran off to see Tommy to ask him to keep an eye open for a job for me. I'll also have a look round myself, and I'll ask Lousada and also Rider, who, with Frank Harris, is running the new review, *Hearth and Home*.[24] It pays well, and there might be an opening there. All these are safety measures, for I don't think for a moment that Wulfs means to take me to Norway — it would cost him far too much.

You are quite right in thinking that the Past continues in the Present, and forms the Future. This is one of Bergson's big premises, and his theory of change is based on that. On the other hand, you have no right to judge me so severely. I am very young, and you are grown up, *nel mezzo del*

* Drawings for Mr. Hare.[20]

cammin di nostra vita,[25] as Dante said of the man between thirty-five and forty years; quite formed, while I am only in the making. What is more, when you first knew me, I was ill — then when I found work, I fell into another abnormality, the one in which I now am — driven nearly mad by too much work, and wishing all the time — no matter how — to get out of business. ...*

 My little darling, a thousand kisses on your sweet body. Keep cool! I only added feather-bed, large bedstead, on your card, because I understood that you would have two rooms — see? I enfold you in a profound embrace, and send much love from your insufferable but loving

Pikus.

Chelsea
31st October 1912
Ukochano Brzesko Brzescych,
By all that's marvellous I send you four fat sovereigns, all in gold in this sweet letter from your beloved??? pipik.† I will send you your little package to Dodford — it will probably be there on Monday — I will do it up this evening, and send it off to-morrow morning. I will put in it:

deux pains à 2 lbs. Allinson
beaucoup *des* citrons (il n'y a pas encore des oranges)
beaucoup *des* bananes
2 douzaines *des* punaises bien vivantes!
une boîte des allumettes vestas en cire[27]

but I can't send you any acid to clean your washbowl — it's too dangerous. To begin with, it might get broken on the journey and burn everything in the box, and besides, some always remains in the basin, particularly if it is not very good, *et ça te ferait tomber les kouaki de la pisia et te donnerait la colique.*[28] I send you some soda instead — it is the best. And what will my old donkey say if it finds chocolate from an A.B.C.‡ and good apples?? Eh?? You old miser!!

* The letter here contains three pages and a map about the Balkan War.[26]
† See Note at the end of this letter.
‡ Aërated Bread Company Restaurant.[29]

Don't miss your train on Saturday and don't tire yourself out by worrying. If you take the ten o'clock train, which I suggest, you will do very well, because you will have a little rest at Leicester and again at Birmingham – enough, but not too much.

You will find with this the third Canto of 'Hell'. I am tremendously interested in this 'Divine Comedy' and also in Dante's personality. He had something akin to Shakespeare in that he didn't rack his brains to find new things, but borrowed all the old Troubadour songs, and particularly those of Pons de Capdiul and Guiraut de Borneil, adding to them his own ideas. It was the same thing for the 'Hell'. Much is taken from Virgil's 'Aeneid', but whatever is used brings out Dante's idea.

I send in the box of fruits a little Life of him similar to the one about Bergson. …

Pik.

Note to the previous Letter

The four sovereigns which Henri gave to her played a very prominent part in one of the many trials of Miss Brzeska's life.

In 1918, she had come up to town to make some arrangement about Henri's posthumous Exhibition at the Leicester Galleries. She went to stay with the Pissarros[30] in Hammersmith, and was to go on to dinner with Mrs. Bevan in Hampstead.

A little before luncheon some discussion arose, and Mrs. Pissarro laughed. Miss Brzeska, quite mistakenly, thought that she was laughing at her, and left the room without a word. It seems that she went upstairs, fetched her handbag, and, not waiting to put on a hat, rushed into the street with the intention of going at once to Mrs. Bevan. Her poor mind was in so sudden and complete a state of confusion that she could not think of her direction, and some time in the afternoon found herself in Hyde Park. She walked all over the Park, and on into Kensington Gardens, talking aloud to herself all the while. She walked about all through the night searching for the way to Mrs. Bevan's, and by morning, tired and exhausted, but talking and swearing more loudly than ever, she dropped into an A.B.C. near Paddington Station to have some coffee before catching the early train to her home at Wotton-under-Edge. While she was in the A.B.C. the police came, and took her to the Paddington Infirmary.

Mrs. Bevan was informed, and went to see her, and the Doctor in charge thought her well enough to go home – Mrs. Bevan arranged to take her to the station and see her into the train. Before leaving, Miss Brzeska asked for her things, which had been taken away from her the day before, and these were returned, with the exception of her money, among which were these four golden sovereigns given to her by Henri in 1912, and since then most jealously guarded by her. Although several people wrote to the police, pointing out that these sovereigns were more in the nature of a keepsake than money, and that notes in their stead were no use, they were not able to obtain their return. From ten in the morning until nearly one Miss Brzeska endeavoured by argument and invective to get her sovereigns back, but in the end had to take the train to Gloucestershire, feeling again at the edge of her sanity.

City
31st October 1912
My dear child,
I hope that you are no longer feeling so poorly, and that you aren't tired. I have sent you this morning four sovereigns well done up in an envelope, and registered; you will probably get them at the same time as this.

Savoff, the Bulgarian, has fought the Turks 50 kilometres from Constantinople. The battle has gone on for the last four days, and is not yet finished. The principal armies are engaged. Apart from that, Turkey is in the hands of the Slavs, who say quite openly that they will divide it among themselves, and Austria accepts. This is all very good news, because after this war, there can be no further excuse for another.[31]

<div align="right">Pipik.</div>

15 Red. Street
Sunday, 3rd November 1912
Beloved,
For many months I have been a martyr to my need for music, and I have just satisfied this desire. I have heard with the utmost ecstasy Beethoven's 5th Symphony. There were very few people in the Albert Hall, which is immense, and I sat alone in a corner with my eyes shut, and didn't open them until the last note. I can't describe the Symphony to you, but the whole has a suave amplitude, and gives the impression of a very beautiful

young woman's torso, firm but soft, seen at first by rarefied lights, and then with strong light and shade something like this, but with sounds instead of tones.

Beethoven has my complete admiration. I like his music more than any other.

To tell the truth, I haven't worked very well this week — my eyes have hurt me — I have drawn intermittently, and have done a little sculpture. I stuck at the little group which I told you about, and finished it this morning once for all, after having changed it for the better by broadening the planes.

On Friday evening I washed out the big room, and as I had made a fire, I profited by it to have a good bath, which set me up. Yesterday I wasted a good hour in *zweifelscheissen*[32] in the French quarter, looking for ginger-bread for my Sisik, and didn't in the end find any. I didn't want to waste money on the 'bus, so another hour and a half was lost in getting home. I did up the parcel for Sisik, sent it off, and by then it was dark. I went out to buy paper, and in the shop heard of a studio where for 5s. I can go and draw from the nude from 8 till 10, Tuesdays and Fridays, for five weeks. That works out at 3d. per hour, which is ripping. When I began to wonder what I was going to do, there was only time left to go to the Museum. I rushed off filled with shame at the thought of half a day lost, and plunged with vigour into 'Art', a book on Rodin. I read it all through. I read it all between 5 and 10 o'clock, passionately and with understanding, and found heaps of things in it that interested me.*

All our sympathies are with Rodin, are they not, my Zosik? Things used

* Gaudier here gives Miss Brzeska a five-page précis of 'Art'.[33]

to be much worse in the Middle Ages. The other day I read of Van Eyck, who was sent to Portugal to paint the portrait of a Princess, betrothed to the son of his patron, the Duke of Burgundy.[34] Van Eyck had already painted the Retables at Bruges, and was in the maturity of his talent. The story tells of the journey, the festivities, the lords, the tournaments, and at the end, *et certain maistre Jean Van Eyck, petit valet de Monseigneur de Bourgoygne, qui, dit-on, sait peindre sur bois à la couleur à olle qu'il a inventée et auquel dame l'Enfante fit insigne honneur et trop grande grâce de lui laisser peindre son portrait.*[35] On the journey he slept with the servants, and attended to the horses.

Speaking of horses, I went this morning to Hyde Park to the famous Rotten Row.[36] My God! A rottener lot of broken-winded old hacks you never saw anywhere! To get over my disgust with these horses, I made a pilgrimage to Kensington Gardens to Watts' statue,[37] which looks splendid under the airy lights between the big walks.

Yesterday evening I delighted my heart with the 'St. Jean Baptiste', this afternoon with Beethoven. I also had a superb pomegranate, pink, large and beautiful like a lovely *pisia*[38] of dear Sisik, which I kiss distractedly, so much does she delight me. I have my doubts all the same! I am now going to the Library, will eat when I come back, then go for a walk, and so to bye-byes.

Pipik.

P.S.–I kiss my dear Zosik, all over her dear body, and I recommend her to the care of the beneficent sun. I couldn't put the bananas in, it would have made it too heavy: 5–15 lbs., 2s.; 15–20 lbs., 4s., and it was almost exactly 14 lbs. Next time I will put in other good things: the old man promised me that you would get them on Monday.

Ten thousand kisses full of love, close caresses, kisses, kisses – Zosienkoju. The Bulgarians are at Constantinople – good-night, darling.

Pik.

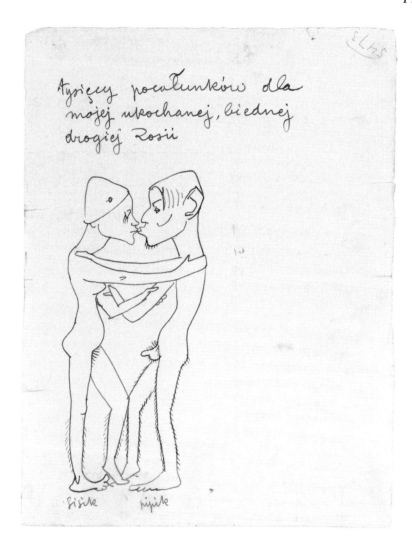

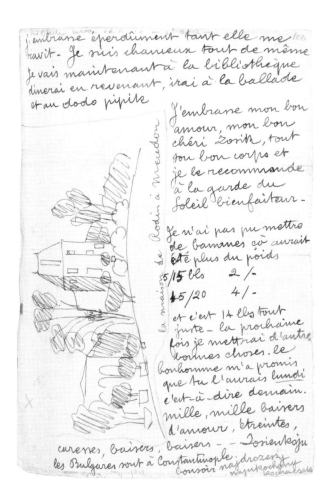

15 Redburn Street, Chelsea
5th November 1912

Dear Old Thing,

Our little differences are most excusable – not only are we of different sexes, but also of different nationalities. We are not the same age, nor have we had the same experience, nor do our talents follow the same course. In spite of all this, one thing remains. My Zosik loves me so much, and she is right in saying that if I have perfect confidence in her, and love her, it is because of her intelligence. I know I'm a queer devil. I try to excuse myself, and Sisik only tries to make me see where I am wrong in order that I may correct it once for all. When I am in a good mood, and have thought things over properly, I see that on the whole she is right. So let's finish all these harangues, and we will always love each other, just we two, because this is the only happiness on which we can count.

You mustn't get worried about bad dreams. In these last three years, while we have been in a weak and nervy condition, we have had dreadful nightmares each night, but they have never come to anything, for, say what you will, our situation is getting better. Last night, for instance, I dreamt that, with my Sisik, I saw lions on a plain. We had a hut, and it was raining; all that we noticed was that we were able to go inside the hut, and we were delighted to think that we should have fur coats made of lion skins – we started off with our guns well loaded and – not a lion to be seen! It's only the reaction of the imagination and of nerves too highly strung. Don't worry about the boss, that will be all right. He has dismissed the little English fellow, saying that ——[39] and I are quite able to do the work without him. He goes to Norway on the 25th, and won't be back until April 15th, so that he will probably arrange everything before he goes away. To-day he is in Paris running after a wood contract for next year.

If you are happy where you are, don't put yourself out, but work well, care-free; whatever happens, I will be prudent, and won't indulge in any stupidity, such as: taking a studio, giving up commerce, etc., in fact, any-thing which might worry you, and prevent you from writing well; for if there is one thing which I consider a labour of love for my Sisik, it is to enable the poor darling to work. I am so pleased that this time you have struck a good place,* and I commend you to the great beautiful SUN, that he may help you.

My dear, it is much too much *de luxe* to take your baths in front of a glowing fire, it is not at all good for you, brings on all sorts of dreadful ill-nesses – you should have cold water – really cold. I take a cold bath every morning, at first I used to add a little hot, but that was sheer cowardice, and it didn't go on long.

I have taken the Nijinsky to Bob Rider,† and have promised him 4s. in the £, so long as he sells it as best he can – also the head of Smythies, in order to try to get some commissions for portraits – when my 'Jew'[40] is ready, I will take it too. This evening I am going to the life class, and I shall enjoy it. I shall see *panis toutes nues*,[41] blast it all, and good ones too.

Leave the sweet little flowers to grow where they are – when the poor things arrive they are all mutilated, squashed, lifeless – they cry and make

* Miss Brzeska had gone to Dodford.
† Gaudier wrote of Mr. Dan Rider as Bob Rider.

me sad. Send me only your good kisses; kiss the little flowers for me, but do not destroy them, *ou gare à ton sale cucu quand je viendrai*.[42]

I am going to start to do coloured drawings for tiles, and paint friezes for wall-paper;[43] it amuses me much more than doing illustrations, and perhaps I can make something of it, for with the people I am in with at present, there is nothing to be got except by being exploited, and for the little statues I have to have ready money. All good things to you, beloved. I embrace you most passionately, and will write more to-morrow.

Thursday
Madrożka Milośé, I didn't go to draw at that class the other evening, because I got a letter from Lousada asking me to take him the bronze. I send you only £5, for I must keep a little for plaster for a portrait which Bob Rider has got me, a commission not yet definitely decided. The fellow is a friend of Rider's, and likes the portrait of Smythies, but he can't pay £10 for the plaster, because he is poor, so Bob is going to arrange with him for £5. Marsh* has written to me again, asking me to dinner at the Moulin d'Or[45] next Wednesday. Shall I square that by giving him 2 or 3 drawings, or not? What do you think?

I think I shall be able to sell some of the drawings for decorative tiles. Keep well, my Mamusienka, dear love. Be happy. Are you working well? Have you received the little parcel?

Pik.

* Mr. Edward Marsh. In replying to one of Mr. Marsh's letters Gaudier says: 'Your enve-lope bearing the Admiralty seal gave me a sort of fright – I had a vague idea I was going to be arrested for some reason or other – the look of governmental authority is always more or less frightening to people not accustomed to it.'[44]

Part II

12th November 1912
My dear love,
Now that I have got over all the fatigues of the journey,* two real impressions remain with me. In the first place, that sweet sensation of perfect and profound love which unites us one to the other, and next, the pleasantness of Sisik's curtains, and the grace of all the sculptures which decorate the garden. Dear, you are in a charming place, and the air is making you much stronger. All the lovely country, not grand, but very intimate, very human, and rather Celtic, with a gaiety of its own, has made a great impression on me, and even more on the Zosik, because she has had longer with it. ...

The terra-cotta mask[46] which I took away has no charm in a room, and I'm sorry I brought it – it's a good work, but to come into all its beauty, it needs the open air – the side of a hill. The four walls of a dirty room spoil the poor thing. I have hidden it so that I shan't be annoyed.

Yesterday I finished the two tiles which I had in hand – they are the best in colour I have done so far. I have seven. I'll go on doing them until the end of the year, and then try to sell them in January. This evening I started the nude – but there, again, I don't feel too happy, for now that I have communed with the body of my dear *dziecko*,[47] I don't find these models very beautiful, or even desirable to see. Anyhow, one must work, and put little Eros under the lash, when he tries too hard to tyrannize. I now feel just the same towards my good Zosik as I did during those first days at Combleux, when even to speak to someone seemed to me a sin against our love. ...

I read that the place left empty by the 'Gioconda' has been filled by the portrait of Baldassare Castiglione,[48] the perfect gentleman of the Renaissance, the author of a book very celebrated at that time, 'The Courtier'. ...†

I feel compelled to tell all this to my good child because it pleases me so much. I adore all those rich stories of the Italian Renaissance. They savour in a peculiar manner of the lovely Latin civilization, which reveals the ancient customs of Rome, and are deeply impregnated with one's own

* Gaudier had been to see Miss Brzeska for the week-end.
† Gaudier here gives a short Life of Castiglione.[49]

pagan Christianity – of which Christ and the Virgin are the supreme gods, and in which each saint has his own special and well-defined province.

My old dear wished to see her Pikus until the last moment, so she stretched her poor head and only looked at the front of the train. Although I cried out 'Zosik!' and made the most vigorous signals of distress, she would never look round to my end, and so, my poor darling, I saw you longer than you saw me.

I had £5 4s. 2d. from the boss for my expenses, so with the money I gave you, I have gained 30s. on the trip* – not counting the celestial joy of spending two such good days with my sweet lover. It was therefore one of the most splendid windfalls of our life. My dear heart of Zosienka, I kiss you with such passion, I lavish upon your lovely body all the deepest expressions of my love, and my soul is inseparably held in yours. ...

* Gaudier included this week-end in some business he had to do for his firm.

14th November 1912

My precious love,

I called on Marsh last night, and there saw the most magnificent examples of Girtin's work – it impressed me immensely, and Constable and Turner and Cotman – in fact, all the best 18th to 19th century English landscape. I am still enchanted with it all. ...

I went with Marsh to see Gibson[50] – he isn't at all the sort of chap I thought he was, but much more sympathetic. All the poets have joined together to hire a big house near the British Museum, where they live and work, and have underneath it a shop where they sell poetry by the pound – and talk to the intellectuals. Some of them have huge, vast rooms, while those like Gibson have only a tiny hole. He is boxed in a room, over the door of which is written, 'In case of fire, access to the roof through this room'. I have asked him to come and see me some day, so that I can see what sort of a fellow he is. Marsh thinks he is very talented.

This morning I had a letter from Frank Harris. He says that he will come on Sunday, and I have laid in two cwts. of clay. He continues, 'I would be very glad indeed for you to model my bust, if it is worth doing, but I go to New York to lecture at the end of the week, and I don't know whether you could do it this Saturday or Sunday. I would put a room at your disposal here, or I would come to you, whichever you prefer, please let me know. I have known Rodin for 25 years; I bought a dozen bronzes from him quite 25 years ago, and have admired him this side of idolatry ever since. It is twenty years since he asked me if he could model me, and I did not think I had done anything that deserved such an honour, so I refused.' It seems to me that to seek out a sentence like that last one, a man must be pretty conceited and pleased with himself. By special arrangement, there is a portrait of him by Fergusson in the last *Rhythm*. I admire this enormously – Marsh says that he would never have recognized Harris – Murry swears that it is the spit of him. In any case, for Fergusson to have knocked off so good a picture, the old chap must be a jolly good model, and we will put him through the mill with pleasure,* particularly as I am now dying to do a portrait.

I have been reading the doings of the Prince de Condé in the *Revue des Deux Mondes*,[51] and I was very much interested. What corruption under Louis XV! [etc.] ...

* Et nous le stigmatiserons avec plaisir.

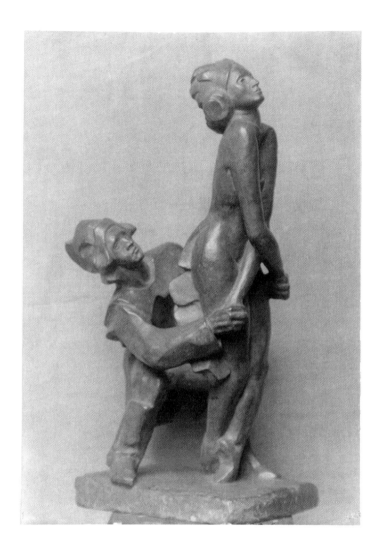

The Lousadas want to change the colour of the group to light green. It has now a marvellous patine of old bronze. I have written to Parlanti to make it green like the leaves of a cabbage. We will laugh, for they are so close that they will never buy anything big from me,* so I may permit myself the pleasure of letting them go to the devil.

* The £20 which the Lousadas paid for this group ('L'Oiseau de Feu') was, all the same, the highest price paid for any of Gaudier's works during his lifetime.

It is Maud Lousada who writes in the name of the Holy Duality, of which she is the Divine Spirit.

I went to the life class. It is kept by four stupid old women. The model – a lovely young boy – wore a tiny little cloth, and the quick sketch wasn't a quick sketch at all. The model takes his own pose – which is, of course, a good thing – and keeps it for ten or fifteen minutes. I should have liked to have a model who didn't pose at all, but did everything he wanted to, walked, ran, danced, sat, etc. To-morrow we shall probably have a woman.

My dear love, you are surely not working so assiduously that you couldn't find time to send me even a postcard, and me away from you and all, and so very anxious to have a word. You know very well the agony of being lonely, and you want me to write to you in the middle of the week. I have far less leisure than you have, and it makes me sad to see that you forget me. So make honourable amends next week by sending me a little postcard. I have not had time yet to translate 'Hell' for you. Monday, 2 tiles; Tuesday, class; Wednesday, Marsh; Thursday, cleaning the rooms; to-morrow, class; Saturday, Zoo and the Museum; Sunday, Frank Harris; and the rest of the time sleep and the office, from which I am now writing to you, in a moment of leisure. I love you so much, little Zosik dear, and I kiss you passionately from the head to the foot of your lovely body, and pray the warm sun for your happiness and the success of your work. I love you tenderly, and wait feverishly for the first chance of seeing you again, of possessing you fully and fondly.

Friday
I cleaned all yesterday, and then had a hot bath in front of a good fire, and slept without my clothes, in order to make believe that I was with my Sisik.

Don't talk to Tommy about the vases; he might want to have a share in the transaction, and we want it for ourselves – don't speak to anyone. As for the agate, I forgot to tell you that it is only volcano lava. I examined it very carefully and it is entirely without value. The stone Christ is certainly 15th century or earlier; I believe that without going wrong you could put it at the 12th or 13th century. English sculpture has always been behind the French of the Middle Ages by a couple of centuries. In French Art, this style of Christ would be of the 9th century, considering the crown and the form

of the cross and the work around the eyes and cheeks, but the moustache and beard are of a 12th or 13th century French style, so you might say that the whole piece, which is English, existed at the end of the 15th century and the beginning of it might go back as early as the 12th century. You must not dream of paying more than 15s. or 20s. for it – that is why I telegraphed.

Of the pottery vases, only consider the one with the smiling figures – the one standing alone in the garden, not either of those at the foot of the little stairs, and don't pay more than 10s. to 15s. After these purchases let's buy nothing more – for this reason – if we carry on like a couple of profane collectors we won't be able to enjoy the little money we have – there is nothing more horrid than lots of repulsive fragments which have no relation to each other all huddled in one dwelling. One ends by hiding them, and then they are no use. My Zosik is too much infected with the desire for property. The curtains and pots are quite enough, and it is not really worth your while to go charging all over the country for the remains of antiquity. We want neither to tie up our capital in antiquities nor to set up as antiquaries. We have need of all our activities to carry on our own affairs, and to publish your book. Remember, dear Zosik, that for that you will need a very great deal – so better buy nothing at all if you are not already committed, and leave the pots where they are. The memory of them and the desire they provoked are better than the possession. I don't believe that it is at all desirable to have them, and as for considering it an investment, they are not worth the trouble we should have – we should never sell them unless we had to, and then no one would buy them. I hope so very much that you have not yet committed yourself to anything.

I implore my Zosik to work hard and regularly, at least five hours a day. You must remember that each month you lose a week by your illness, and we are such poor devils that we must keep ourselves very much in hand and not waste our time, but produce.

My Zosik disappointed me – I had looked for a long letter, but there was nothing. You don't seem to have cared to hear about Castiglione – it makes me feel that it is no use bothering to tell you about things. You complained at the beginning that I never talked to you about things – but how can I if you pass it all over in silence?

It distresses me to see how you waste the good sunlight. You don't get through all your affairs until 11 a.m. and then you go for a walk until 12

— lunch 1 o'clock, and you don't get up from your rest until half-past two — and there's the day spoilt, you haven't time to write to me, and you ought to — whereas I, with many more preoccupations, visits and work, am expected to talk to you about all that is going on, keep you up to date, etc., and you give me no encouragement, for you don't seem to notice it at all.

Zosik love, please be a little sweeter and a little more noticing, I'm not at all annoyed — I know you are a dawdler, and I wish you weren't. If you want to make me happy at Christmas you ought to be through a good quarter of 'Matka'.* [52]

I kiss you a thousand times, dear beloved, and wait with great impatience for your news — send me a postcard on Wednesday — I shall get it on Thursday. Dear love and affection.

Pik.

P.S.—The wills I made are wrong. I will do them again, and they need 6d. stamps.

* One part of Miss Brzeska's 'Trilogy'.

16th November 1912
Dearest and Best,
I went to the Zoo.[53] The beasts had a curious effect on me, which I haven't hitherto experienced; I have always admired them, but now I hate them — the dreadful savagery of these wild animals who hurl themselves on their food is too horribly like the ways of humans. What moved me most was a group of four chimpanzees. They were like primitive men, they walked helping themselves with their hands, and looked like old men, their backs all bent. They discussed things in little groups, shared their food without dispute but with much wisdom — the strongest giving bread and carrots for the oranges and bananas belonging to the others. It's most depressing thus to see our own origin — depressing, not because we sprang from this, but that we may so easily slip back to it. Our knowledge is great, but how empty! How ephemeral! So small a thing, and we lose all. We no longer know chemistry as did the men of the Italian Renaissance, and it will be a long while before we re-discover their secrets. Art comes instinctively to us, but it is so uncertain. I have in front of me photographs of all Rodin's best works; the more I admire them the further I feel myself removed from all art, it seems so easy, so limited! We are part of the world creation, and we ourselves create nothing. Our knowledge allows us to make use of all the forces already in existence — our art to interpret emotions already felt; a big war, an epidemic, and we collapse into ignorance and darkness, fit sons of chimpanzees. Our one consolation is Love, confidence, the embracing of spirit and of body. When we are united we think neither of outer darkness nor of animal brutality. Our human superiority vibrates through our passions, and we love the world — but how insignificant we really are, and how subject to universal law! Mere midgets in the wide universe, but masters of our particular planet. Oh, Zosik, Zosik, how strange it all is; in my memory, I compare the slender springing grace of a lovely man with this hairy mass of monkey flesh, the mastery of an energetic head, full of individual character, with the stupid masks of chimpanzees who can scarcely raise the beginnings of a smile. These comparisons are so terrible, so formidable in the mind; for if the blind masses of humanity, which always persecute their pioneer spirits, had the desire, or rather the power, then would our tall and erect stature be bent, and we should be covered with hideous fur; the grass would grow over our finest works, and we should return to bestiality.

These wicked people who are so ignorant, we hate them – don't we, dear love? These brutes who have eyes for nothing save their animal passions, who think only of eating, who fight each other, and wallow in dirt – foul, disgusting fellows who only crush people of our kind, whose instinct is for beauty, for ideas and for reflection. Sweet dear, I am so blessed in being able to love you, and blessed be the day when the great sun guided me to you; without your love I should have been flung into an outer darkness, where bones rot, and where man is subject to the same law as beasts – final destruction, the humiliation of extinction. Dear, dear love, I press you to me with all my force, and only your help enables me to work. I thank you, dear Sun, lovely Star, for having created women and men that we may be united, mingle our personalities, melt together our hearts and, by the union of our passionate bodies, better liberate our souls, making of us a single creature – the absolute human which you have endowed with so many gifts.

Good-night, dear heart, sweet Sister, Mother. Think that we are together in the same bed, and by our perfect union, making prayer to God.

Sunday, 17th November
I woke up full of life, and was quickly at work. I painted. Yesterday afternoon I went to the Zoo and drew a little, not so much as I would have liked, because of the dark day and the distraction of my thoughts – all the same, I have a few drawings, and I painted two buffaloes,[54] one white and one black, each against the other, and I am happy.

I am sorry that I did not take Smythies sooner to Bob's. I should have been ready to sculpt Harris. He promised to come to-day, but a telegram has called him to America; he says he will come in January. On Friday evening I met at Bob's a young actor called Wheeler.[55] The same sort of type as Murry. He works like Pik by day, and acts in the evenings and on Sundays. ...

I went to the class again on Friday, they had a man again, but old, brutal, with a great belly. I worked well, and I asked the old woman when we were going to have a woman to draw. She promises one for this week. I am anxious to see if the old bitch will make her wear a rag as she did the boy – just as if she were in her *siuski czerwone*[56] – for all I know, they'll hang another over her breasts. The people in the class are so stupid, they only do two or three drawings in two or three hours, and think me mad because

I work without stopping – especially while the model is resting, because that is much more interesting than the poses. I do from 150 to 200 drawings each time, and that intrigues them no end.

Zosik love, I really must stop writing to you for to-day, for my little fire is already almost out and I must cook my supper on it, as they haven't yet put in the gas.

I have hung my beloved's mask above my bed, and the shadow it makes on the wall is so utterly like my Sisik's that I am constantly startled, thinking it is she. Kisses, sweet dear, I hold you to me in love and tenderness.

Tuesday

Sweetheart, the Lousadsiny invited me to supper last night, and they are coming here one of these days. I have only got £1 10s. left for the month, and, poor love, I cannot send you the stove, etc., but if I sell something, as I hope to do, then I will. Pet, I want so much to write to you this morning, but I have heaps to do and really must stop. I kiss you incessantly, I'm filled with longing and am always thinking of my Sisik and want so much to make love with her. *Je suis lourd à cause de cela et je vais essayer encore une 'tite putain quand j'aurai des siousious* («Five shillings, lay your money down, sir! Lay your money down!»), *à la santé de ma mamus, car ça m'empêche de bien travailler.*

Zosisik, ne sera pas zalouse, n'est-ce pas bon petit amour, c'est seulement pour vider ces vilains workis.[57]

Friday, 22nd

Dear love, you can't imagine what a state of mental depression I have been in lately. I am a bit better this morning. I have no real reason for detesting Tommy and Chuquie.[58] They've always been very kind to me; it is just my own stupid ideas. I went to see them last night, and I like them better than ever. Fraser asked very anxiously after my Zosik, if she were well, etc.

Dearest, I can't make any headway, these cheap lodgings depress me, and I'm going to clear out in the first week of December. I will take a nice little studio, not on the ground floor, because ground floors will always have the same disturbing effect, and will be so much money lost.

Boss won't make a contract, either with Watkins or with me, and that's all to the good; but what isn't good is that he is only going to give us a

£1 rise — we are going to try our best to leave him while he is in Norway. Zosik mustn't worry herself about anything. I shall always find work of some sort or other, and she has only to breathe the good air, and not force herself to work until the New Year. It is better to have an end in view, don't you think? Poor darling, don't write such long letters, it only makes you over-tired. I am a graceless creature who always will clamour for more honey, though the poor bee gives her very guts to provide it. Sometimes I am too hasty with my Mamus, and sometimes I accuse her of wickedness just to stimulate her to reply. How strange these sensations of love are — I almost become jealous of myself! ...

Poor darling, I haven't even a little sovereign to send you. I should have to borrow, and you wouldn't like that. Next Saturday is November 30th, and I shall then be able to send a little. I went to see Rider at his house in Hammersmith, and he spoke of Harris, but this for next week. Ten thousand kisses.

Pik.

Sunday, 24th November

My dear Love,

I am going to have a rest to-day, and I profit by it to write a long letter to you. Darling, when I say I am jealous of myself, it does not at all mean that I doubt your affection, it only means that I love you so much that I don't wish to see or speak to anyone. Zosiumo, you are such an intelligent Zosik that you should have understood that when I wrote to you as I did last week, I wasn't in a normal condition. The truth is that since my return I have been utterly upset — one day I was full of the most exuberant joy, and the next in the worst of depressions.

I came back overstrung by sex feelings which have lasted almost until now, and it is because of that that I am taking to-day quietly. I won't work at all. I shall buy slippers and an umbrella and stock my larder from the *Home and Colonial** [59] and soon be all right again, so don't worry about me. ...

Wheeler came yesterday to help me take the Bagnold head to Fraser's studio.[60] We hired a little hand-cart, and we laughed enough to piddle our pants. Wheeler has an engineer brother, who is going to try to get me some

* Henri had a horror of umbrellas, and all this is only a figure of speech for coddling himself.

regular and paying work in Birmingham, little ornaments, heads of lions, etc. He's buying a tiny statue for himself for £2.[61] Fraser's studio is a magnificent place, a huge room with two walls entirely taken up by windows, a gallery at one end, and two rooms above – all lit by electricity.

He has got a lot of pictures, but all scenes of carnival, a life superficial and automatic, with no kind of depth or idea. In order to flatter me, he has had a beautiful book bound, and stuck in the drawings which I gave him in the hopes of further passes to the Zoo. On the cover he has put in huge letters of gold, 'Studies by Henri Gaudier-Brzeska, 1912'. The tiles and the masks which I did at his house last March are framed in white passepartout, and look very well. Now don't you go accusing me of inconsistency, and of flattering Fraser. There is nothing of that. For the last six weeks I've made no attempt to see him, and then last Thursday I met him at Bob's, and he asked me to come with the Hares on Saturday and bring the head of Bagnold – she wants to have it cast, and is ashamed to ask me, because she has left it so long. I was full of curiosity to see Fraser's place, and also glad to get rid of these big heads of Bagnold and Murry.*

You remember my speaking of ——,[62] he is a queer devil. I told him I should like to see a couple in the act of love, and so he is going to arrange a meeting, but the difficulty is to find a woman. He suggested that I might draw his children – the little two-year-old girl is very beautiful, he says, lovely limbs – I must profit by this. I have worked well these last two evenings at the class. Tuesday a girl, without a rag, and Friday a beautiful youth with a wrestler's loin-cloth of black silk bordered with a lovely Indian stuff. If they all wore that sort of thing it would be all right, but a tiny covering is ridiculous.

On Friday I found waiting for me a reply-paid telegram from Marsh, inviting me to dinner. As I had the class and was terribly keen to work, I sent a letter yesterday morning returning the reply for 6d., inventing the little lie that I only came back at 10 p.m., and his telegram asked me for 8. One must follow the advice of Sisik and make oneself 'hoped for'.

This afternoon I am going to see some Americans, Gaylord Wilshire[63] at Hampstead, a syndicalist – very keen on the bust of Haldane Macfall. A well-known collector, Judge Evans,[64] is also very taken with the bust, he is going to come to see me in a fortnight's time, when I am settled in my

* Gaudier afterwards destroyed the head of Murry by throwing stones at it.

studio. On Wednesday, I went to look up Dan Rider, and he took me to the Café Royal,[65] and there I drew while he slept, because he had a ghastly headache; after that he took me to his house in Hammersmith, where we had a magnificent evening. He is very natural and open, and we soon became good friends, when we found that we were both passionate naturalists. Like Pik, he has studied and adored ferns, the reproduction of plants, seastars, the collection and life of shell-fish, flowers, insects. He talked a great deal about Harris, whom he admires tremendously. According to him, he is a most honest man of the Castiglione type. He knows all the big bugs, is an intimate friend of the Princess of Monaco, of Lord Howard de Walden,[66] of whom you will have received Rodin's portrait before you got this letter, and Bob really thinks that he will try to push me, because he liked enormously my Nijinsky and Smythies. It was Bob who introduced Fraser to Harris, and though Harris hates Fraser's affected ways, he has introduced him in many places, and has done a great deal for his reputation. Bob thinks me much better than Fraser, *un dieu sur une pelle à pain,*[67] which naturally pleases the old Pikus, who loves to be admired, but who, at the same time, sees its exaggerated stupidity, and is amused by it.

Zosiuno, you need have nothing to fear — whatever happens we shall be much better off than we were two years ago, when we knew no one but Slocombe. Poor darling, I am sorry to have bothered you by speaking to you of your work. Don't harass yourself, dear. Stay quietly in the little

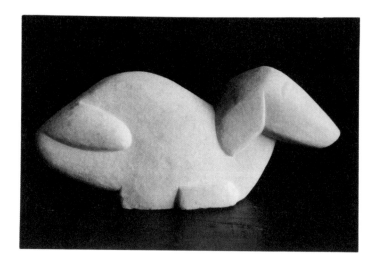

spot where you are, and I will fight in London, as far as in me lies, for our common good. We ought to be successful, because we are one with the dear sun, and that great god of ours has not ceased to shine since I began writing to you. I kiss you so lovingly.

More to follow.

Pik.

Monday

After I wrote to you yesterday I went to see Epstein. While I was ringing at the front door his missus stuck her head out of the window to see who I was. Epstein came to the door and asked me to come upstairs. There is an enormous difference between old Epstein's place and that of Fraser & Co. – Little Epstein, dirty and dusty and covered with plaster, sitting on the sill of his window, cutting at marble. In the room, two bunks mean and miserable (like Pikus' chair), one bigger than the other – a little table, very small, and nothing else. No picture nor image, nothing on the large white walls, only the torso of a woman, half-broken, in a corner. He spoke to me about his Oscar Wilde in Paris.[68] When he arrived he found that the sexual organs had been covered over with plaster – later the Prefect of the Seine covered the whole monument over with straw, as being altogether indecent. Epstein took off the straw, then the plaster, and restored to his Wilde his *couilles de taureau*,[69] which hung down at least half a yard, and through the petition of some artists he was able to get the better of the Civil authorities. Later on he showed me a little bronze, very beautiful, quite the nicest work of his I have seen – alive and sincere – a seated woman with her arms above her head. … We smoked together, talked of castings and marbles as usual, and I left.

I had no sooner got back to my room than I hared off to Hampstead – it is a beautiful suburb, built like Rome on seven or eight hills. I walked for two hours on the Heath in the fresh air, and discovered magnificent views of hills, like those of Malvern, but much more numerous, closer together and covered with trees. I went to the Americans' and was pleasantly surprised. I expected to see only business men from Wall Street, clean-shaven, hideously square shoulders, puffy skin and nasal accents. He is a little fellow about fifty years old, with a beard, a shy appearance, delicate, and not annoying, to look at. She, a large woman and more interesting. American skin, but hard, red, with few lines – you know, *peau de buffle*, hair dressed

à l'Allemande in bandeaux,[70] with a turned-up nose. In their room were assembled about thirty people, French and English. An elderly author, very interesting and sympathetic, with white hair and beard, Whiteing his name is and 'No.5 John Street' his work.[71] I must try to read it: his ideas on Art are sound and he spoke very clearly, I had a long talk with him and I like him. The party was freer than any I've been to before, it was possible to get into little groups and speak for a long time independently.

A Russian actress, ——,[72] a woman with a monocle and pretty stupid, asked me in French to explain to her futurism and cubism. When for a joke I made her believe that it had something to do with homosexuality, she asked me to go and see her on Thursday evening after dinner. She is at home on Wednesday afternoons, and as the boss is going to Cardiff this Wednesday, I rang up to say I was coming in the afternoon, which suits me better. She had asked me to come alone with Mrs. Wilshire, and it would have been no fun for me to have a *tête-à-tête* with the two of them; by going in the afternoon I have always a chance of meeting other people.

There was at the Wilshires' an old French woman characteristic of all that dirty middle-class race, dropsical, double-chinned, skin speckled with these little coalish black spots that you only see in the Latins – toads' paws on dirty tripe, and she lording it about – I wished her to the moon and the devil. I will write to you after Wednesday about the Russian, she speaks very good French, German and English, and is an actress. ...

I have been telling the tallest stories. The Americans call me Brzeska, and several of the French when they heard that I was *polonais* said to me that I spoke French and English like a Russian, and several others who had thought I was Italian saw very clearly from my type and my walk that I was Slav. What fools! What asses! It amuses me once in a while, and I shall go once more before I have my studio.

Pik.

Thursday, 28th November 1912
My dear good love,
Yesterday I went to the Russian, she is rather stupid, and I won't go again. In the afternoon I went to see Wheeler's brother, who is director of ——[73] and a pleasant fellow; he has travelled a great deal and is particularly fond of the Poles. Making use of Sisik's description, I talked to him of Cracow

and Zakopane, which he knew, and he was very keen on the Tatra:[74] so all this affair served to adorn the conversation and prepare the ground. He gets big contracts of copper, wire, carriages, motors, etc., for firms in Birmingham, and he has a great deal of influence with these people. He is going to give me an introduction to one for motor mascots: they have already complained that they have to get them from France, because there was no one here who could make them. He has recommended me to another for electric radiator ornaments. On top of this he is very much interested in sport, and has commissioned me to make two little statues in plaster – one of a wrestler and the other of a bather – which he will have cast in bronze by one of his firms.[75] In his office he has the very wrestler that I liked so much – a wonderful boy, strong, taut and finely square. I am going to see wrestling in the evenings two or three times, which will give me good sketches; I am also going to see some boxing matches and diving, and I'm terribly excited about it.

I will do him two little statues, the height of your little dancer, for £4 and 30s. extra for the plaster; I shall make £4 nett. Not much, I know, but the devil of it is that I must hit it off with him in order to get more work. He has promised also to give me some introductions for advertisements. He seems very honest, and I don't think he is promising all this in order to get a couple of works cheap. Anyhow, I'm prepared to expect the worst and count no chickens, save those of seeing beautiful athletes in action. The old hag at my evening class promised a magnificent model for to-morrow – a beautiful Frenchwoman. The fellow who was there on Tuesday was a poor little Italian workman, and it is from him that I have made my best studies. The old woman and the other idiots in the class think I am mad. As I have already told you, I work all through the evening without a stop in order to get my full six-pennyworth. They try to talk to me during the rests, but I don't reply. Only when I have finished, if they speak to me I reply, and if they don't, I just clear off, saying 'good-evening'. For fun I speak to the Italian models in Spanish, this gives me prestige and makes me seem queerer to the class – but I do it really from a desire to speak nicely to these poor devils, who seem frightened in the midst of such unimaginable brutes. It is impossible for you to picture these asses.

This drawing is very far from the mark and will give you only the dimmest idea of this band of coconuts. There is among them a young blood

who has always something to show or say in order to draw attention to his stupid person. One day it was a Russian ikon, which he neither understood nor admired, and another day it was a German amber and meerschaum pipe; but what took the cake was on Tuesday. It was raining cats and dogs, and the fool came in a hideous pair of suède boots, quite new. He fidgeted about so with these boots that the old hag complimented him on his footwear – he took them off and showed them to everyone – not to me though, for I have sent him packing a couple of times already, and he doesn't dare come near me. He kept saying, 'It was when I was going to

maîtresse élève élève élève élève

Russia some years ago, I bought them in Sweden for shooting, you know they are very comfortable for shooting'. Pah! I can see the fool from here! *Un très sale coco*.[76] Anyhow, it didn't interrupt me, because I forgot it all as soon as I began working.

Yesterday, after I had been to the Russian's, I went to Macfall's, he lives quite close. He spoke again of his hideous painting, accusing Fergusson of having copied it; that Fergusson only did his still life under the influence of Macfall; that he (Macfall) introduced to the world Turner, Steinlen, Nicholson, Orpen, Fergusson, and Simpson; that he (Macfall) is very busy, but will find time to introduce me to the world; that he will write an article on me, the great Macfall, Gaudier-Brzeska no more than a toad. He told me to do something for the Royal Academy. At this I laughed in his face, and told him that he didn't begin to know the slightest thing, neither of

drawing nor of writing. ... In the end, I told him quite gently that I didn't look for help from anyone, and we parted the best of friends.*

Pik.

This afternoon I went to the British Museum. I looked particularly at all the primitive statues – negro, yellow, red, and the white races, Gothic and Greek, and I am glad to say I was at last convinced of a thing which had for a long time bothered me. I had never felt sure whether the very conventional form of the primitives, which gives only an enormous sensation of serene joy or exaggerated sorrow – always with a large movement, synthetized and directed towards one end – had not a comprehension more true, more one with nature: in other words, ampler and bigger, than modern sculpture from the Pisani through Donatello up to Rodin and the French of to-day. Having very carefully studied the two aspects, at the moment I think not. Up to what point I am absolutely justified I can't at all say. My first reason, and the one I consider most sound, is that primitive sculpture seen in large quantities bores me, whereas modern European sculpture seen in the same quantity interests me infinitely, without boring me, and if I go away from it, it is because the strain of looking at it and understanding it upsets me, tires me. I have to go away, but with regret and with the firm intention to come back soon. All that seems to mean that I am an individual – a Pik Gaudier Brzeska – and it is my individual feeling which counts the most. Why? I do not know nor do I wish to know. I accept it as a fact which does not need explanation.

Now, when I think it out I see that in modern sculpture the movement, without being so big, is nearer to the truth. Men do not move in one movement as with the primitives: the movement is composed, is an uninterrupted sequence of other movements themselves divisible, and different parts of the body may move in opposed directions and with diverse speeds. Movement is the translation of life, and if art depicts life, movement should come into art, since we are only aware of life because it moves. Our expressions belong to this same big movement, and they show the most interesting aspects of the individual; his character, his personality. What kept me in doubt was, I think, the very simplicity of the early primitives in rendering

* 'Amis comme cochons'.

movement, their conception of things in general being very simple, that of the modern being more complex. To-day it all seems to me the other way round – the movement of the primitive is a misconception of true movement, is a fabrication of his mind, an automatic creation which corresponds in no way with the natural movement of the living being. In one word, it is complicated because he does not take the trouble to probe deeply, but invents, creates for himself. The movement of the modern seems to me to be simple because, putting aside all his natural capacity as a human automaton, he uses his energy to see well, in order to render well what he has felt well in seeing well. ... To conclude, in order not to afflict my Zosik's ears too much, I am in entire sympathy with the modern European movement – to the exclusion always of those moderns who belong to the other class, those who invent things instead of translating them.

Pipik.

London
Saturday, 30th November 1912
Dear Sisik,

At last I send you the gingerbreads, poor dear. It seems a long time to have to wait for four wretched buns. Yesterday evening I met Enid Bagnold in the King's Road;* she asked me to do a plaster cast of her head, and I told her it would cost £3, so I shall make 35s. on her, which will do for casting a statue, which I will begin to-morrow – I have sent Parlanti to get the model from Fraser. She asked after you and wishes you etc. etc., anything you like. She asked me if I wasn't lonely. I replied rather evasively that I was working. That made her laugh in a rather cynical way and say, 'O well, I don't think you mind much'... *Sale garce abominable!*[77] I'm not quick at repartee, and while I was chewing over what to say, she started talking of something else. The girl at the Library also asked after you. I told her you were in the country and she said, 'Oh, that's nice', and that you wouldn't come back for several months, 'Oh, that's nice' – everlastingly 'Oh, that's nice'...

Tommy is still trying to do business with the 'Madonna' since Carmi is in London in a ghastly piece called 'Venetian Night'.[78] ...

Many kisses and my love in your heart, dear Zosik.

H. Pik Gaudier-Brzeska.

* Miss Bagnold was studying painting with Mr. Walter Sickert.

15 Redburn Street, Chelsea, S.W.
Tuesday, 3rd December 1912
Sisik dear,

I went back to Hampstead on Sunday, worked in the morning, and needed some fresh air by 5 o'clock. I talked all the evening to an American woman: she has a pleasant face, but there is always this twist of the lips in speaking – this nasal tone that drives you mad. She is receptive, admires artists, because they can probe to the depths of existence; admires good music and interested me very much with stories of the customs of Red Indians and their music. They weren't snobs, these American devils I saw – but there is plenty of that to make up for it in the English who go there. There is something queer about them all. There is no need to be sincere with any of them. The Wilshire woman is intelligent; he is very reserved, smiling, and rather shy – they both have a bit of a lost look. I can't make them out. Anyhow, one can always study people, as there are always new ones there, so I'm told, and you always can talk to one or two people without being disturbed during the whole evening.

Wednesday
You are a wretch. You write me two very abusive postcards, and you carry on like a fiend instead of keeping quiet. My poor darling is very upset I know, but I cannot help feeling that the excursion to Bromsgrove was terribly rash, and to be so afraid of getting the old illness again is unworthy of a courageous Sisik like mine. Anyhow, another time Sisik won't go on like this, but will behave like a sane person. As for the buns, etc., I couldn't get them on Saturday for two reasons: (1) I had to look for a studio and had a rendezvous at 2.30, and I knew you weren't dying of hunger; (2) I couldn't get the books, as all the shops shut at twelve and I only got out at one, and also I knew that you didn't need books any more than bread.

Friday
Beloved, I am very tired; I have done nothing but rush from one place to another, and on top of that have done a lot of work. Last night I went to see the wrestlers[79] – God! I have seldom seen anything so lovely – two athletic types, large shoulders, taut, big necks like bulls, small in the build with firm thighs and slender ankles, feet sensitive as hands, and not tall. They

fought with amazing vivacity and spirit, turning in the air, falling back on their heads, and in a flash were up again on the other side, utterly incomprehensible. They have reached such a state of perfection that one can take the other by a foot and, without exaggeration, can whirl him five times round and round himself, and then let go so that the other flies off like a ball and falls on his head — but he is up in a moment and back again more ferocious than ever to the fight — and Pik, who thought he would be smashed to bits!

I stayed and drew for two hours and am going to begin the statuettes on Sunday. The negotiations for the £50 studio have fallen through.[80] I must look for another. On Wednesday evening I went to see the Bagnold because of the plaster cast. She is staying with Dolly and another girl whom I don't know. There was a boy there called Lunn;[81] we spoke of Murry but I don't want to see him again: I don't dislike a person easily, but when at last I do, it's for good. We arranged with the Bagnold that she should take the plaster for £3 — with what is left over I will bake one or two little statues and buy a decent book for Christmas. The Bagnold still has the same peculiarity. In the middle of a conversation she rushed away to the Embankment without saying a word. Affected, of course — but in spite of that she is the most interesting of girls — she at least tries to understand and to get into touch with things.

I learn through the *Guerre Sociale* that Kropotkin, the great Anarchist, lives in London.[82] I have heard the Wilshires speak of him and must ask them for his address — I should be the happiest devil if I could do his portrait. I enclose an article about him, although you haven't been interested in politics for the last two weeks.

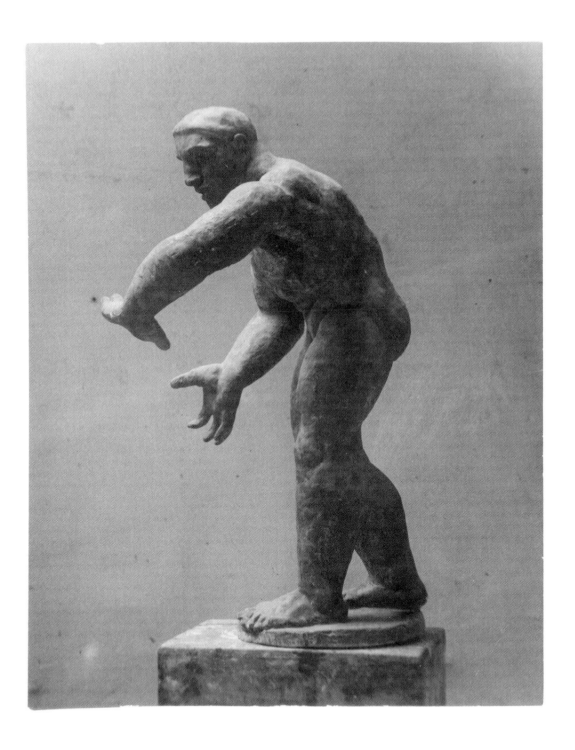

I'm half asleep, dear love, and I don't remember what I meant to say. It will come into next Sunday's letter, and you shall have a long one next week. I am in a state of creative effervescence. I'm looking after myself well, I sleep well (for the last 7 or 8 days I haven't got up until 8 o'clock). The boss doesn't come to work until 11 a.m., and to-morrow he leaves for Norway.

I kiss you with all my heart, press you and hug you, dear love. I pray the Sun for you, your health and your work. I'm very happy about the hysteria and all that you tell me. I kiss you a thousand times.

Your Pik.

P.S.—Tommy, when referring to you, speaks in a general way of nerve maladies, which shows clearly that you must seem very nervy, for I have never said that you were ill in any kind of way. Tommy and Chuquie have put quite a pace on to find me a studio. They still want me to take the £50 one, and they say that the other ones further out are no good at all — that one needs a big one in a good position. As they insist so and as they are morally responsible I have left them to it. Tommy, with his knowing air, has given me to understand that if I take the studio he wants me to take he will get me some orders for illustrations — if not he will do nothing. That is the 'hoped-for change' he speaks of in his letter to you. 'La Chuquie' is already bucked at the idea of helping me to move and of putting things in order, while Tommy will arrange terms, etc.

Oh, Sisik, do for goodness' sake calm yourself — I suppose not before our bread is assured from some other source.

Good-bye, 10,000 ... kisses.

Zosik, dear, I kiss you, I kiss you.

Pik Brzeska.

[Postcard] 10 a.m. 7th December 1912
Sappho, I understand that the important thing for you is intellectual intransigence, but for me the important thing is sculptural intransigence. Till you can understand this there will be no possibility of our discussing things with any accuracy and consequent possibility of agreeing. As usual, your pride detaches itself in its omnipotence, and you don't take the trouble to think of what you are writing. Your wailings on what I wrote to you are

ill-placed – those on the Bagnold erroneous, those on the studio, etc., un-reasonable. I will write all about it in a letter – Sisik sees the dark side of everything too much – herself included, and I repeat that if I were to carry on as she does, I should never do a statue in my life. Get into your head once for all that I'm a workman, and it is nothing to me to be *hoflieferant*[83] so long as I produce. Tender kisses.

<div align="right">*Pik.*</div>

[Postcard] 4 p.m. 7th December 1912
Sappho–Wulfs has left and I have just made a contract with him for a year at £10 per month. I can't leave him before the end of next year, nor can he send me away before then. It is better than two years – one is a little freer, although I am such a queer, bad Pik, who makes Zosik unhappy. But, Zosik, it is never intentional, and you are a little too pessimistic, for you often scold unreasonably when you get on your high horse. As to the studio, there were some concessions I didn't want to make, so I am looking for another, more modest, at £25 to £30, in Chiswick. I don't want to upset the Hares and so alienate them. Lousada telephoned to ask if I had any statues, and I said No. I had better wait a little. I will get him to come in January. Much love.

<div align="right">*Pikusik.*</div>

[Postcard] 9th December 1912
I have refused the studio because it is damp and I should have to pay £50 plus rates and taxes. I have another to look at, as big as Epstein's – gas and water all included at £36 a year, but no bedroom. I suppose I could make one inside. Next door there is a smaller studio which is, even so, at least twice as big as Fraser's used to be, at £26 a year, and probably I ought to take that and hire a room at 3s. a week, but I am awfully attracted by the big one, which has a furnace to do plaster moulds. I went to the Wilshires' again yesterday and met two charming people there, an actor and his wife – very sound ideas about art. They have been in England for 9 years and now that they have the chance they are clearing out, they detest it so much. They are Scotch, and they are going to America, where they say the people are just as stupid, but there is more freedom. I am writing you a long letter, kisses,

<div align="right">*Pik.*</div>

9 | Studio life

At Christmas Henri went to Dodford again, but he and Sophie did not re-capture the joy which they had found the time before. Sophie was feeling ill during these few days, and Pik caught a dreadful cold. It rained all the time, and they sat together in a room without talking. The landlady, it seems, hurried all the farm-hands to bed so that Pik and Zosik might be left undisturbed, and Zosik said she believed the landlady suspected they were not brother and sister, and if not, it was a typical example of English purity — ready even to encourage incest so long as it did not become obvious.

Pik stayed with her for four days, irritable and contrary all the time, and then, just before he left, told her that he was fonder of her than he had ever been before: he implored her to come and live with him in London. He said platonic love could not last for ever — that she had made excuses from month to month, from year to year, and with all this waiting his passion had died down — and then he hurried away to catch his train. Zosik was left very much disturbed, and Pik's letters only added to her worries. He complained much of feeling ill, he bled a great deal at the nose, didn't take regular meals, and suffered from the cold.

With the help of the Hares, he at last found a studio, and he wrote to Sophie:

The studio is a marvellous place, and I feel as if I had been lifted from Hell into Heaven, I am filled with inspiration, and burn with the holy and sacred fire of creation. What infinite peace after the hellish din of Redburn Street!

Ideas keep rushing to my head in torrents — my mind is filled with a thousand plans for different statues, I'm in the midst of three, and have just finished one of them, a wrestler, which I think is very good. I'm also doing sketches for a dozen others. God, it's good to have a studio! It's disgusting that so fine a hole should remain empty while I am at this filthy 'business'. Zosik could be quiet here, and would write better than while stowed away in the country. ...

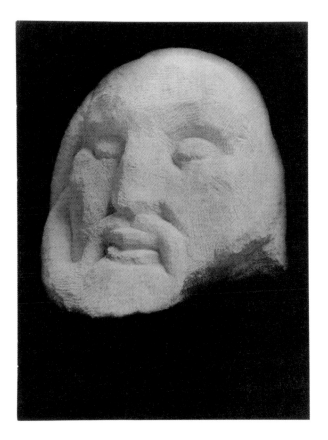

A little later he wrote to Dr. Uhlemayr:

454a Fulham Road, Studio 5
6th January 1913
On the advice of some friends and patrons, English *mécènes* without gener-
osity, I have taken this studio in the hope that it will bring me more work.
Anyhow, I can work better here than in ordinary rooms – though what
I really want to do is to sculpt a large statue in hard stone, and for that
I must first get a commission. All this year I have been reduced to doing
little statues in plaster and bronze, and portraits, which haven't in the least
satisfied my desires or my ability.

The struggle for life is hard here, worse than elsewhere, because all these
wretched people are without sensibility, without heart, attracted only by

what is eccentric and odiously pretty. To get anywhere one must either wait for ages or prostitute one's art. The only advantage is that art fetches a higher price here than elsewhere, but against that food and lodgings are very dear. I would willingly go elsewhere, but where? I can't go back to France, for last October I deserted their Army, slaughterers of the Arabs, and if I return it is I whom they will slaughter. In Belgium there is nothing doing. Germany swarms with artists, and I'm not sure that the stupid law would leave me alone. It's better to persevere here, for in another three years I shall be a British subject and definitely free; after that we will see, perhaps I could go to Munich, Berlin or Vienna, it's my greatest desire, and when I have reached my full vigour, at 40 or so, I shall set up in France. Philosophically, if I forget my surroundings, I enjoy life and I feel that I am gaining an enormous experience, and in matters of art a very delicate sensibility. Life normally is so lovely, although filled with grave doubts; an artist always suffers, mostly because of the enslaved people who surround him, bleating like a lot of sheep. I still work uncongenially during the daytime at tapestries and calicoes, silks and carpets, but there it is – we must have bread, and in good times to come these will only be happy memories. ...

One day at a friend's he met a girl with a demon-like expression, who, when he was alone with her in the studio, looked at him with wicked eyes, and complained that the old days of Bacchanalian debauch were over. Pik was again suffering from pains in his head, and in telling Sophie of this incident, he said that he had asked the girl to bring some of her friends to his studio, where they would indulge in some of the 'exercise' she seemed to want – it would do him good, 'and the old Sisik, who has so often recommended this to her Pik, will surely not mind'.

To Sophie's surprise, although she had formerly persuaded herself to the contrary, she found that now she did mind – she was terrified of Pik's getting into the hands of some girl who would tarnish his innocent nature. She gave greater consideration to all that Pik had said to her, and for the first time she began to feel, mingled with her fondness for him, the magnetism of a physical affection. Pik said that his studio would make a charming home, that it had a small kitchen, and everything of the utmost convenience. Sophie decided to join him, and in February 1913 arrived in London.

The first blow which met Miss Brzeska on her arrival was Pik's telling

her they could only sleep in the studio for a day or two, since the solicitors had said it was only to be used as a studio and not as a domicile. They would have to find a room somewhere for Zosik, and Pik could sleep in the studio on a camp bed which he would turn into a chair by day. Pik had promised, before she came, to clean the place, so as to receive her regally; but there had been other things to do, and when she arrived the studio was in the utmost dilapidation. There was a pool of water on the floor.

'Oh,' said Pik, 'that's nothing, the roof fell in two days ago and the rain came in, but they have repaired it now – don't let us worry about such things, let's have supper. I'll run and get a bottle of wine – eh! Sisik, darling, and then we will have a little love and then to bed.'

Sophie describes the situation: 'I had to wash all the plates and forks before we could start supper, everything was covered with indescribable filth – the Underground trains which passed just outside the window made a row enough to split my head in two, the draughts on all sides were as if we were on a lighthouse in the open sea, soot from the stove suffocated my nose and throat, and the general untidiness threw me into a nervous exhaustion.'

All night long in this strange room the light from a street lamp shone through its high window, and an old torn blind flapped and gesticulated in the gusts of wind which entered through a broken pane.

For the next fortnight Sophie lay ill with influenza. When she was better, she looked for a room and found what, at night, seemed to be a dream of quietness. She took it, only to find next day that she was surrounded with noises and, what was more, the landlord proved to be a milkman who, at 4 a.m. each day, was up and rattling his pails just outside her room.

She tried again to get a post as a governess, but she was always turned down, which is no wonder, since the demands were for a 'strong, young, cheerful, domesticated woman'.

Miss Brzeska had gold fillings in her teeth, and when she went to see friends or people she wished to impress with her importance, she would smile in order to show the gold; but when speaking to prospective landladies, she took great care to keep her mouth closed as much as possible, so that they should not suspect a millionairess, and raise their prices.[1]

Henri Gaudier was very happy during these months, never daunted in his enthusiasm, always expecting a regular flood of orders which would be sure to burst upon them from one day to another. He calculated only

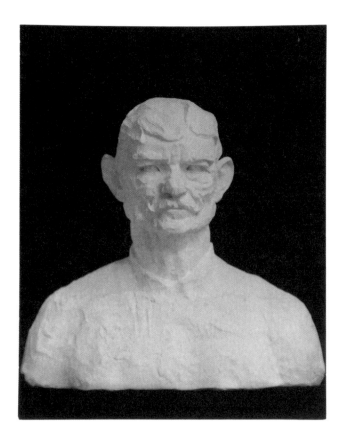

in hundreds. They would take a magnificent flat and have a house in the country, spend the summer in Switzerland and the winter in Florence, London, etc.

These air-blown castles were perhaps due to the influence of Frank Harris, who had returned from America and was seeing a good deal of Gaudier. He must have found Gaudier's aliveness a great help, as also his sure judgement on quality. Gaudier, on his side, gained impetus from the financially larger life of Frank Harris. Harris came several times to sit,[2] and at one of the sittings Zosik met him. They seem to have got on rather well at this first meeting, and she and Pik were invited to dinner on the following Tuesday. Zosik had many misgivings – she hadn't unpacked her clothes, she had nothing suitable to wear, and for three nights she had hardly slept. Then Pik came home to get ready, and somehow before they

could stop it they found themselves angrily bickering. In the end, Pik said:

'Zosik, don't be angry — see, we've again said dreadful things to each other, things we don't at all mean.'

She protested that she was now too tired to go out, but he persuaded her. She dressed in some strange, high-necked, tight-waisted red blouse with silver trimmings, and Pik was shocked, asking why she had got herself up likc a landlady. There were then more words, which concluded by Pik's not minding what she wore, but Sophie said she wasn't going to sit opposite him and feel his critical eye upon her all the evening, to avoid which she dragged out of the bottom of her box a collar of old lace which had belonged to some Polish ancestress.

They arrived at the Harrises' punctual to the minute, but Frank Harris was busy, and they waited an hour. They occupied themselves by studying the things in the drawing-room. There was a statue of two lovers by Rodin which Mrs. Harris, according to Pik, was always hiding behind vases. Pik pulled it out into the middle of the mantelpiece, and Zosik said that if Mrs. Harris moved it back she would tell her what she thought about it. At last came what Zosik calls the 'Triumphal Entry', Mrs. Harris on her husband's arm. The opening of dinner is amusing as Miss Brzeska described it.

' "What do you drink at dinner?" asked Mrs. Harris, who spoke to me with the utmost sweetness, never separating herself from her smile all the evening.

"Well, really, I shouldn't drink at all, because of the state of my nerves."

"Just make an exception for this evening," threw in Pik, who was also smiling. The smile of a lovely and gracious lady is contagious, so we were all smiling as if some beatitude had fallen upon us from on high.'

They had champagne, it seems, and a very nice dinner, and everyone was in excellent form. Afterwards, they had great discussions about books, and Zosik said that she couldn't abide Balzac; that five times she had tried to read him but could never get to the end; that he was overdone and long-winded. Harris rose in his defence, and so the hours passed, until finally he suggested to his wife that it was time she went to bed. Pik on these occasions would never go, and it always ended by their being shown the door and, what is more, having to walk home, since the last 'bus had gone.

At the end of a long, revolutionary political letter to Dr. Uhlemayr, Gaudier refers to the people he is meeting:

12th March 1913

I've lately met people who have a little more influence than those I've known before, and I'm to be introduced into the best circles of English *mécènes* (you can imagine their mugs), the Lord —— (who protects Ibsen because he is dead and Rodin because he no longer needs it), Lord ——, Lord ——, etc., who wishes to buy things cheaply, keep them for a few years and probably sell at a large price – anyhow, I have no illusions – Illusion is a winged girl, but the English fog is so heavy that she can scarcely shake her feathers. I am in the midst of a portrait of a writer called Frank Harris, and he promises that in a few months everything will be going well with me. It's about time, for I am a little discouraged, I have suffered frightfully from all manner of miseries since I left Germany, doing all kinds of jobs, but if in the end I can give myself up entirely to my art I shall be the happiest man in London. ...

Then Frank Harris went away, and things seemed to stand still – Pik dropped out of London life, and no one came near the studio. About August he was much disappointed at hearing that Harris would only have his bust done in plaster, but revived with the idea that he was an Artist, and Harris just a middle-class nonentity who would be too greatly honoured if Gaudier-Brzeska were to worry over his stupidities.

At this period the Brzeskas' friendship with Brodzky[3] made an amusing interlude in their lives. Brodzky was a greater relief to them, for he did not mind their joking at his expense, yet he irritated as well as amused them. He gave them a sense of solidity, for he seemed a person so much less rooted than they were that they could offer him their protection; and they were able entirely to follow their own bent, since he was too indolent to interfere.

Gaudier started a portrait of Brodzky for the Albert Hall Exhibition,[4] and he suggested to Sisik that she should come to the studio to meet him. 'He is a Pole, born in Australia and brought up in America, not very clever, but a pleasant enough, amusing fellow,' Pik explained.

'I suppose, since he's a Jew, he's very materialistic,' said Zosik.

'Yes, frightfully, I tell you that the first time he came to see me, I was in the midst of arranging my drawings, and there were quantities spread all over the floor; he had hardly crossed the doorstep before he cried out,

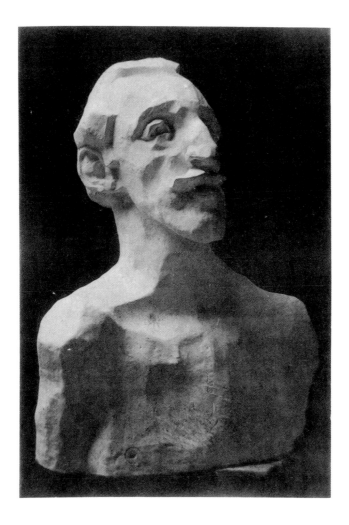

without even stopping to wish me good day: "Aou! What are you doing? Walking on your drawings? There are mines of gold in them. How wasteful you are!"'

Sophie found Brodzky lying at full length in the basket chair; he seemed half asleep, and could not bring himself to get up to welcome her. She was reminded of a big serpent warming itself in the sun. Pik, in his presence, seemed to be thrown into a vivid energy. He kept darting about, and every now and then would rush at Brodzky, leap on him, wrestle with him, or thump him about. Brodzky would defend himself as best he could, calling

him 'Savage' and 'Redskin'. It pleased Pik to be thought an elemental, and Brodzky and Zosik would call him 'Savage Messiah', a name deliciously apropos.

Once when Pik came back to the studio, Brodzky leapt up, seized his hat and hung it on a peg to save it from the spirit of destruction which consumed the master of the house. He might easily treat it as he had treated his own, new a month before and now a crumpled piece of felt. Pik always looked like a scavenger who had spent the night on the floor of a pub – he thought that a man could not be clean and at the same time an artist.

Ezra Pound says that Gaudier once burst out about Epstein: 'Work! Work? I know he does not work. His hands are clean!'[5]

It was arranged that Brodzky should paint a portrait of Sophie, for which Pik bought a canvas. It went on for weeks, and got worse at every sitting, until Pik was horrified, and called it a regular 'academy' piece.[6] Pik's friendship with Brodzky was often strained, and Brodzky's attitude towards this portrait was more than usually trying to him. Although they were very friendly, when they met there was always a slight antagonism on Gaudier's side. On one occasion, before a dinner party to which they had invited Cournos,[7] Pik said:

'I hope that this time you haven't asked Brodzky.'

Zosik had, and Pik swore that he would go to the Museum and stay there until eleven o'clock in the evening. Zosik had thought that Pik was fond of Brodzky, but Pik said:

'Because I fool about with him, it does not mean that I love him. He is stupid and materialistic, and has no talent at all.'

Pik stayed all the same, for his outbursts did not mean much, and Sophie prepared a nice meal of hors-d'oeuvres, meat, vegetables, fruit, and biscuits, with a good French wine to go with it. But all was spoilt, for Pik was insufferable: gobbled his food and behaved like a bear, chipped in whenever Zosik wanted to speak, and contradicted her from beginning to end; to have any say at all, she had to raise her voice to a scream, which frightened Cournos. Brodzky, according to Miss Brzeska, spoke little at dinner, since he was too much occupied with eating, though, from time to time, he encouraged Pik in his savage explosions. At eleven he left, and Cournos soon after, evidently with the fear that Pik and Zosik might come to blows in front of him.

Gaudier admired Brodzky's drawings, but used to tell him that he would never know anything about painting, and that he had really better give it up.

There was great excitement over Brodzky's expected millions from America,* and Zosik and Pik were delighted that he took the prospect of riches so calmly. They had a big 'beano' in Pik's studio to celebrate Brodzky's good fortune, and they became very merry: Sophie had not laughed so much for many a year.

Frank Harris now returned from America, and though Pik had not heard from him while he was away, he at once expected great things from his return. They did not see much of each other, but when they met, Frank Harris was full of promises, and said he would buy the marble dog for five pounds, or the high relief in red and yellow.[8] One of Harris's projects was that Henri should go with him to China. He was extremely friendly and full of ideas, on the strength of which Gaudier gave up his work in the City. This was, of course, a daring move, and for the first two months no one bought anything from him. Mrs. Hare tells me that in order to earn a little ready money, Henri obtained work as a porter at Covent Garden, getting up in the small hours and carrying baskets of fruit and flowers; he was not very strong, and found this work a great strain, but it brought in a little money, and gave him his day in which to work at his sculpture.

Zosik's nerves were giving her much trouble, and she told Pik never to accept any invitations for her, but always say that she had a cold.

'Shut up,' said Pik, 'I am a sculptor, not a bloody diplomatist,' and when Zosik called him an egotist, he said: 'I love myself better than anyone else – everyone loves himself best.'

One evening he called on the Harrises after dinner, and Mrs. Harris took him to the dining-room to give him a meal, but although he was hungry, he said he had already eaten. They all thought he was looking very ill, thin, like a ghost, and the Simpsons, who were there, tried to persuade him to go to the seaside. Harris said that as soon as he had his paper he would give him the job of caricaturist, and that he expected this would be in a fortnight; but so many fortnights had gone by, with the same project in view, that Pik had begun to lose heart.

* A newspaper report that Brodzky had inherited millions.

In September Gaudier had had his studio for nine months, but hadn't managed to earn the forty pounds which would pay the rent.

One day they had arranged to go to Richmond with Brodzky for a picnic, when Henri received a telegram from Mr. Harris: 'Good news for you – will be with you soon after three.' Zosik and Brodzky had to go alone to Richmond, leaving Pik to join them later, for so exciting a telegram must mean at least a fortune which it would never do to miss. When Pik came he whispered into Zosik's ear that it was the French Ambassador, which threw Zosik into a tremendous flutter of excitement. She thought that France had at last realized what a splendid artist they had in Gaudier; the Ambassador himself had come to congratulate Henri, and tell him that he would be able to go back to Paris without fear of military service.

After half an hour Pik said: 'It wasn't exactly the Ambassador, but his secretary. He says that he will get the Ambassador to sit for me.'

The secretary was Paul Morand;[9] he had been very enthusiastic over Pik's work, and thought that he might help Gaudier to place some of his drawings in France. He suggested that through his father, who was then Director of the Arts Décoratifs in Paris, he would show some of Henri's drawings to Rodin, or perhaps to Maillol. After this first visit he did not come back for so long that Pik and Zosik had given him up, until one day, on going into the studio, Zosik found a young man of about twenty-four, who looked a little like a Japanese, but whom, to her surprise, Pik introduced as Monsieur Morand. He was intending to bring the Ranee of Sarawak[10] to see Pik, and told Miss Brzeska that she was an English lady brought up in India, to which Zosik replied that she was then probably far more intelligent than people brought up in this country. M. Morand passed over this undiplomatic remark in silence, and Zosik, understanding her *faux pas,* bit her tongue for shame.

When M. Morand took the Ranee of Sarawak to Pik's studio, she admired his sculpture, thinking it simple and alive, though she did not buy any. She chose a dozen of his most recent drawings, and when she asked the price, Pik, according to formula, said that he would be delighted if she would accept them as a present. She took them away, and later on sent ten pounds to Gaudier through M. Morand. He tried also to sell for Gaudier

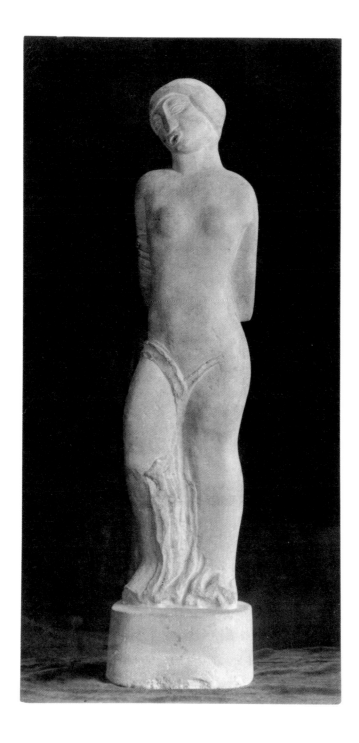

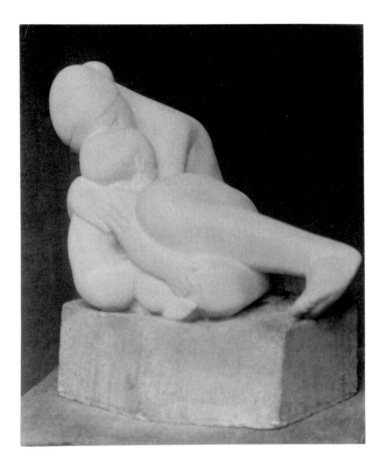

'La Chanteuse Triste', now in the Tate Gallery, London,* but wrote to say that the lady to whom he had hoped to sell it had jumped out of her skin with horror at the sight of such a manifestation of modern art.

Wolmark[11] also encouraged Gaudier a good deal at this time, and they did each other's portraits. Wolmark did two portraits of Henri, one a small one, now in America, representing him naked to the waist, with a statue and a big sculptor's knife; the other large, and conspicuous at the International Exhibition of 1913, where it was first shown as 'The Man with the Green Face'.[12]

* Presented by Mr. C. Frank Stoop.

Henri at this time was wearing a scarlet Russian tunic and a heavy black cloak and sombrero, and Wolmark shows him thus in the portrait.

One day he arrived at Wolmark's with his face terribly swollen, unable to speak or to eat. After some hours he began painfully to jerk out his story. As he had passed through Soho, a carter had flung some insult at him, and Gaudier had naturally answered back. The carter got down from his cart and went for Gaudier, thinking him only a puny youngster, but Henri, throwing back his cloak, gave him such a blow that he fell unconscious in the street. At this moment some man came out of a public-house behind, and hit Henri on the jaw, dislocating it. Henri had the presence of mind to force his jaw back into its place, and then ran away before he was surrounded by a crowd. 'But before I left, I dug my foot into the carter's chest as a parting gift, and I heard his bones scrunch.' Wolmark says that he will never forget Gaudier, scarcely able to speak, describing in a whisper this last ferocious thrust.

Wolmark introduced Gaudier to several people, and among others to Mr. Kohnstamm, who very much liked the Maternity statue, now in the collection of Mr. Eumorfopoulos.[13] His interest seemed to flag when Pik said he wanted forty pounds for the group. Gaudier's erratic pride often prevented his making a little money at a time when he badly needed it. At times he would give a statue away for a song, and at others he would ask what was then a quite exorbitant price.

Mr. Edward Marsh says that when he went to Henri's studio, he never saw any drawings, that at that time he did not even know that Gaudier did drawings, save for two or three slight ones which Gaudier had once sent him in a letter. All that was on view was a series of rather large pieces of sculpture, each costing about fifty pounds, quite a formidable sum in pre-war money.

10 | A holiday

Towards the end of September 1913, ill-health and the Ranee of Sarawak's unexpected ten pounds decided Pik and Zosik to take a holiday at Littlehampton,[1] and Pik was in a heaven of joy at the prospect, since he hadn't seen the sea for over a year. They made each other endless promises: Zosik not to get excited, and Pik not to force Zosik to run about, since it was better for her to keep quiet. They decided to take only one room, and to use the money saved for some excursion. Pik said he would sleep quietly on one side all night, and never jump about.

Their holiday started badly, for Zosik had indigestion and could eat nothing; she was tired out with packing and anticipation, while Pik, on the other hand, had got it into his head that they would be late for the train; so they rushed like madmen through the streets, to find themselves at the station with two hours to spare. Pik was like that. When he got an idea into his head, were it catching a train or cutting a piece of marble, he could think of nothing else, even though he might feel dead with fatigue. On their arrival at Littlehampton, Pik was so excited that he forgot all his promises and was for rushing Zosik down to the sea without either rest or refreshment.

It was a curious life that these two spent, strangely wrapped up in each other, and yet, because of the hardness of their lives, constantly angry with each other. Their arrival at Littlehampton was typical. They had been up since early morning, and it was mid-afternoon, they had had nothing to eat, and were naturally tired.

Zosik: 'Don't be so rough – you're just a hooligan, without any sense of decency.'

Pik: 'And as for you, you're nothing but a stupid old woman, full of imaginary illnesses – you think of nothing but your nerves and your stomach and the devil knows what.'

Zosik: 'Oh! You disgusting egoist – you know quite well that it is now three o'clock and that I've not been able to eat anything since yesterday, and you won't even take me somewhere to have a little hot milk.'

Pik: 'Hot milk! What crass stupidity! Let's get down on the beach and see the sea.'

Zosik: 'That's all very fine for you, since you're hungry, and have a bas-ketful of provisions that I can't touch.'

Then they went and had some milk, and ten minutes later were sitting side by side in the sunshine as happy with each other as two children who are the best of friends.

They left looking for a room until the sun had set, and they then had to drag from place to place, finding everything so expensive that in the end they were forced to accept a dingy room with a bed which was a regular implement of torture and fit to kill a saint. Pik had insisted on paying a week's rent in advance in case they lost their money; which meant that they could not leave, but had to endure the torture of their bed. According to Miss Brzeska, Pik bounded about as if he had St. Vitus's Dance, and each morning they both ached from head to foot with the pain of sleeping on the iron bars of the bed. Each evening as they went to bed it was: 'Three more nights of torture.' 'Only two more nights', etc.

It was hard work to keep Henri interested on this holiday, for almost at once he wished to rush back to town and start cutting stone again. At first he bought a fishing-rod, but after a fishless day and a half he found it a boring occupation. Then Zosik set him to doing embroidery in coloured cottons for a blouse she was making. This was an excellent idea, and Pik was enchanted; he sat at it from early morning until late at night and could scarcely be dragged away. Next day, he was up with the lark and already at his sewing. He kept comparing it with Zosik's: his was the more brilliant; had the better design; he would do lots and lots; it would be a delightful occupation for the evenings when he got back to London. For several days they sat together on the beach working at this blouse, then Pik became restless and life was again a turmoil.

One day they decided to go for the day to Arundel Park.[2] As usual, the excitement of the project upset Sophie, and she could not concentrate on getting ready; she dawdled about and fussed with one thing and another, while Pik waited, impatient to be gone. At last he could stand it no longer and started off alone. Zosik followed him, feeling hurt and angry that he had not waited for her. When she caught him up, Pik told her that she would never make an artist, since she was so much concerned with all her little affairs – so much on her high horse over absurd futilities; and for the hundredth time they found themselves saying the most dreadful things to

each other. Pik, in a moment of fury, flung down the provisions he was carrying, and apples and sandwiches were spread in the dust, while he strode on ahead. He looked back, to see Zosik on her knees, picking everything up, but he didn't stop, and she toiled after him with the bags of food. One of the bags broke, the apples fell into a ditch and Zosik had great difficulty in getting at them. Henri saw her in this predicament and rushed to help her.

'Zosik, darling, don't let us quarrel; we're only tired and hungry; let's be happy! We're a couple of queer fish – but it's quite natural – artists can't have the same nature as common bourgeois folk. We are capricious and proud and it makes things harder – don't you think so, Sisik?'

Very soon they were sitting in the park, transported by the beauty of it all; the lake and the hills with woods spread over their slopes. They took off their shoes and stockings so that the sun might warm them better, and they ate their lunch among a flock of peacocks, which took food out of their hands. Later they found a crystal stream and refreshed themselves with its bright cold water. It was one of the happiest days they had ever had, and in the evening, as they left the park, they watched the deer on the hillside.

One big stag was calling deeply and beating the branches of trees and the long grass with his antlers. Zosik was frightened, but Pik told her that it was the setting sun that gave him this longing. They followed him at a distance, and he looked magnificent with his great antlers sweeping the air and his rich colour outlined against the green of the hillside. He went over to a group of does who were feeding with some young stags nearby, and the young stags fled before so regal an approach, while the does allowed themselves to be driven, like sheep before a sheepdog, into a small, wooded enclosure, where the royal stag would make love to them through the night.

Many of Gaudier's best drawings and the two pieces of sculpture by which he is usually known are the result of this vision of deer, and it was with joy in his heart at so pleasant an experience that he returned to London next day, leaving Zosik to stay on for a week or two more.

His first letter came to her a few days later:

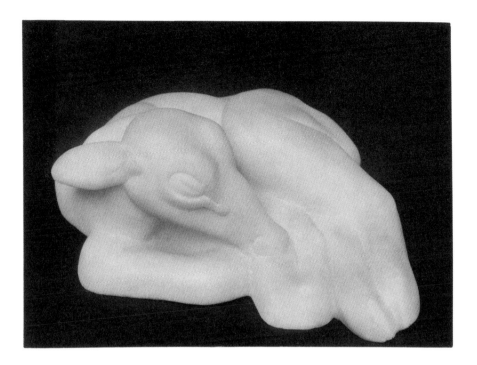

454a Fulham Road, No. 5
8th October 1913
Sweet little Sosisiko,
I don't know where to begin, there are so many things to tell you. First of all, the Jew from Cracow is at Wolmark's – he is really intelligent; he knows all the artists from Cracow, and has very good taste. He is fed up with the English. He thought he was going to find people full of energy, etc., etc. He has never done saying how stupid they are. I went to the Wagner concert[3] with them – the Cracovic and Wolmark. They played all the best parts of 'Lohengrin', 'Tannhäuser', 'Tristan' and 'Parsifal' and 'Götterdämmerung', and it's an insult to God, the stupidity of this rotten composition is unsurpassed – there is no kind of unity – no agreement, no depth. The melodies are dull, slow and sentimental, with inevitable claps of thunder. I convinced Wolmark that Wagner is neither great, nor even an artist. The other argues that Wagner is good, and as he speaks well, he may be forgiven. Afterwards they took me to a *café à putains*.[4] We cleared out at once and ran into

Epstein. He praised Strindberg's 'Cabaret'. Yesterday I had been with one Jew to see the other Jew, Epstein; he's doing most extraordinary statues, absolute copies of Polynesian work with Brancusi-like noses. We stayed there all the afternoon and then 'Crac' came round here and wanted to buy my little alabaster Venus for £3.[5] I let him have it because it will go to Cracow – otherwise he certainly wouldn't have got it so cheap. He then took me to Wolmark's, where we had dinner, and from there we went to the Café Royal because we had invited Epstein. On the way we met Brodzky. We sat with Epstein, his wife, a French engraver called Norbel, and Augustus John, who looked as if he would burst. While we were drinking someone called me and I looked round, to find Marsh, with Mark Gertler – I talked to him and he invited me to dinner next week. Although Sisik won't like it, I accepted. On Monday morning I arranged my garret in Bishop's Road, and yesterday I went with Fabrucci[6] to Putney, so it is only to-day that I have been able to see Harris and ——[7] about the money due to me. Tippets[8] has written for the rent, which I can't pay him, so that I *must* pick up something from somewhere. To-morrow is the International,[9] and the day after I have an interview with a big dealer – Duveen[10] – to make some garden ornaments. Wolmark has got me this and has one or two other ideas on foot, so these two days have been very much occupied and I've been able to do very little work.

Epstein told me that Brancusi is a Rumanian and not an Italian – to-morrow I'll send you more gossip.

Your devoted Pik.

454a Fulham Road, Studio 5
13th October 1913[11]

Thanks awfully for your sweetness – as usual your love becomes clouded over once there's a question of money. Well, if there's any reason for blowing me up for going to that Café it's because I lost hours of sleep, but never did I spend a penny. Wolmark saddled me with the Jew, asked me to look after him, and as he is intelligent I said I would, and he's sufficiently sensitive to see that I found it awkward, so he insisted on paying. As for ——,[12] I've asked him several times before yesterday – but what can I do, he is almost bankrupt. His place no longer exists, for the bailiffs have sold his books – not all, but some of them. I went in last night, as he was going to give me a statement, but as he only wished to part with £1 I said 'No', for I needed

at least £3, for which I would come again on Saturday. But what can I do? He hasn't got a farthing. Harris says he has owed him. …

As for Brodzky, he's been ill and has spent the little money he had; it's hardly my fault he can't pay me what he owes.

You are angry with me about the little statue, but in this I thought I should be giving you pleasure, since it would go to Poland. It's at this moment that I need money if I've ever needed it, and what will really put you in a fury is that I shan't even be paid for the statue until the end of the month. Rant and scream as much as you like – it makes no impression on me so long as your worry is to do with material things. If you want to stay at Littlehampton I don't want to beg you to come to me – no fear! Your little ways are far too gentle – particularly at this moment! Naturally I haven't paid Tippets, because I need first to 'get myself good food,' according to your instructions. I'm just fed up and don't care what happens – if I break my neck so much the better. Since you tell me to go to the devil, I return so charming a compliment with interest.

Gaudier-Brzeska.

Does it interest you to know that Wolmarca had a boy yesterday morning?

II | People and exhibitions

While Sophie was left alone at Littlehampton she became very much worried about Pik's inability to look after money, and the way he allowed several people to be his debtors, and did not call upon them for payment. She realized that her own savings were nearly at an end, and Pik had earned practically nothing for so long that it was small wonder she got into a panic over their finances. She had decided not to go back to London, but when she wrote to tell Pik of this, his calm way of taking it made her feel that she was, perhaps, losing her power over him, besides, it seemed to her stupid to be spending twelve shillings for a room in Littlehampton while Pik was paying for rooms and a studio in London. This, taken with the fact that Pik would spend less if she were there than if he were alone, made her decide at a moment's notice to come up to town. She had not time to warn Pik, and he had gone out. His rooms and his studio were locked, and she had no money left in her purse. She ran from one place to the other, hoping to meet him, and finally had to wait up in the landlady's kitchen until Henri's return at 2 a.m., a none too good beginning for their renewed life together.

When Zosik was pessimistic and complained of the hardness of life, Pik would say: 'I cannot complain, if I am earning nothing at the moment, that doesn't matter at all; it is sure to come. I despise people who complain. I have always had good luck because I know how to defend myself. I never have any debts, and am never despondent. Everyone is his own master, and the weak naturally perish because they haven't the strength to fight.'

Just before Miss Brzeska's return from Littlehampton, Gaudier had noticed a girl standing in front of his 'Wrestler'.[1] He spoke to her, and found her intelligent, not prudish nor hypocritical, and she agreed to sit for him. The story of this first sitting is striking. After she had sat for some time, and Henri had done a dozen drawings or so, he said suddenly: 'Now it is your turn', and quick as a flash, he had taken off all his clothes, seized a large piece of marble, struck an attitude, and told her to start drawing.

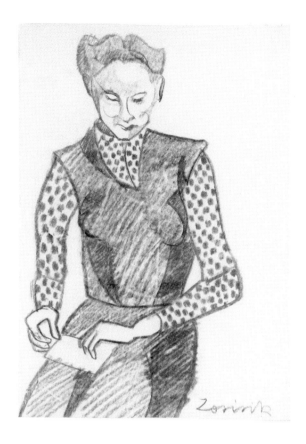

Pik was delighted to have a model, and they were soon great friends. One of the first things she told Pik was that she had no pretensions to being a pure woman, and that she had felt very much annoyed with some man who had lectured her on the beauty of virginity.

Sophie said that she was trying to seduce Pik, but this was not the case, for their friendship was a Platonic one. Pik answered Sophie's comments with: 'Well, of course, I intend to make love to her, since my Zosik is no use, and keeps me waiting so long.' Zosik gave him her blessing, and said that she must be allowed to be behind a screen, and when Pik asked her if this wouldn't make her jealous, she replied that since she was unable to satisfy his wishes, she would not be so mean as to hinder his pleasures with others. 'Good Sisik,' said Pik, 'you will always be the favourite, and she will be the concubine.'

Pik was always very anxious to please his new friend when she came to his studio, and kept asking Zosik for shillings to buy cakes for *ma —— qui est pauvre*.² Miss Brzeska acidly suggested that Miss —— would not be so poor if she did not smoke so much. After several weeks Pik brought her to see Sophie. Miss Brzeska was feeling particularly irritated by the noise around her, had stopped up her ears with cotton-wool, and was sitting right up against the wall, with her back to the room, so as not to see its bare misery, and was singing at the top of her voice. Pik had to call her two or three times before she turned round.

A little after this, —— went to Paris for a few weeks, and came back with sensational tales of how she had danced naked, greatly to the delight of the artists there; how Isadora Duncan had wanted to meet her, and how several theatres had offered to engage her. Also Modigliani had wanted to sleep with her, but she had refused because he drank and had no money. She was going back to Paris in a few days. Pik was charmed, he thought her dashing and brilliant, and admired her unconventionality.

Gaudier and Sophie had many discussions over Rodin, who had at one time been such a god in Pik's life. He considered that his head of Smythies was as good as any Rodin, and that those of Brodzky and Wolmark were probably better, and quite original.

'I am an artist,' he said, 'and nothing but art has any interest for me. So long as I do good sculpture, I don't care how I arrive at it.'

This last remark annoyed Sophie, who said that it did not accord with what he used to think, to which he replied that what he had said yesterday was no precedent for what he might say to-day – that he was only twenty-two, and that she must realize that he was developing. He brought her some of his drawings, men with Brancusi-like heads, but he denied that they were derived from Brancusi, and said that they were a direct evolution from his old work, and that his sculpture had by now become quite abstract. This made Zosik fear that he would sell nothing; but Pik's reply was that he wasn't a dealer, but an artist. To Major Smythies, who protested against Gaudier's abstract work, he wrote:

'We are of different opinion about naturalism, I treat it as a hollow accomplishment: the artificial is full of metaphysical meaning, which is all-important.'

Nina Hamnett, who was one of Gaudier's friends at this time, obtained

for him some sculpture lessons in Hampstead at two and sixpence an hour, and she also introduced him to Roger Fry. Fry had said that he would like to meet him, and that he could, perhaps, give him some work at the Omega Shop.[3]

'What is this Fry?' asked Miss Brzeska.

'A very advanced painter, who has started the Omega workshop for modern art in decoration, furniture, and other things: a fine man, who has put his capital into giving work to artists, into making their existence easier. He is entirely disinterested, and when I see him to-morrow, I shall show him my most advanced works, which, to tell the truth, are only old-fashioned, neo-impressionist work.'

Fry, it seems, was much pleased with the poster for 'Macbeth'[4] and with the alabaster 'Boy',[5] and said that he could sell this latter for twenty pounds. He ordered a special poster, and also a tray, for which Pik might expect a few pounds, though he did not know how much, for, as he put it to Sophie, 'one can't bargain with a splendid fellow like Fry'.

At the Alpine Club Exhibition,[6] organized by Fry, Gaudier exhibited five works;[7] his red stone 'Dancer'* he likened to Ezra Pound's poems, and when Zosik asked for an explanation of this, he said:

'Well, if you can't understand it, I can't explain it to you. I just feel it, and there's an end of it.'

He felt that his work was not simple enough, and his search for greater simplicity often resulted in an added complexity of form. He exhibited also the 'Torso',[9] now in the Victoria and Albert Museum: 'a marble statue', he wrote to Major Smythies, 'of a girl in the natural way, in order to show my accomplishment as a sculptor'.

He thought that Duncan Grant, with his big picture of Adam and Eve, shown at the Alpine Exhibition, was the Phoenix of English painting, and Miss Brzeska suggested that Fry's pictures were thoroughly academic and chocolate-coloured, 'a family trait, since he is a nephew or son of Chocolate Fry'.

Pik sold his 'Fawn', which gave him tremendous pleasure, and later Cournos told him that someone wished to buy two statues of his for fifteen

* National Gallery, Millbank.[8]

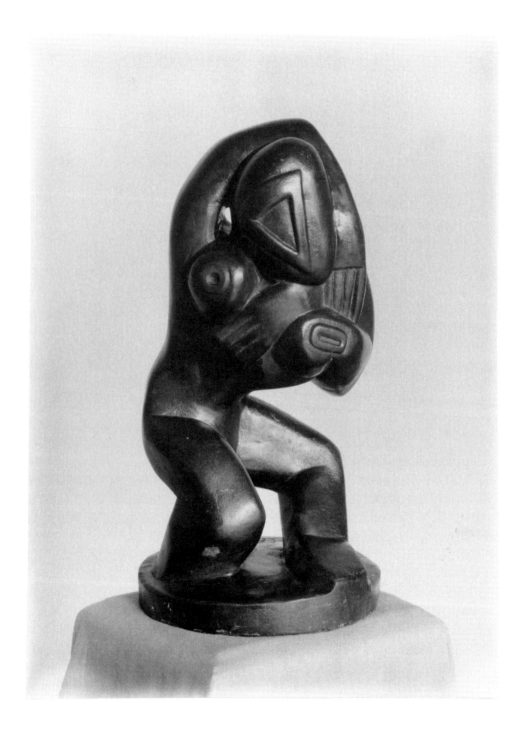

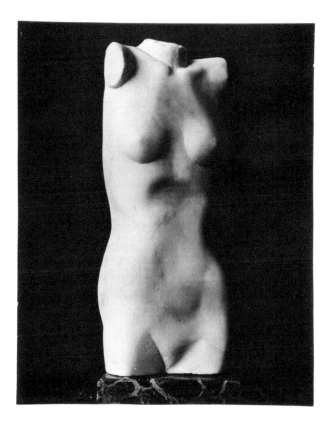

pounds. Pik agreed, but when he heard that this 'someone' was Ezra Pound, 'the abstract poet', his joy knew no bounds.

There was some talk of Mr. Kohnstamm buying 'La Chanteuse Triste', but this must have fallen through, for he purchased an alabaster relief[10] instead. Mr. Sydney Schiff[11] went to visit Gaudier at his studio in Putney, and bought the 'Dancer', which he presented later through Miss Brzeska to the Victoria and Albert Museum.[12]

Mr. Schiff had two bronzes made of this statue, and Gaudier wrote to him:

'I am naturally glad that Mme. Schiff likes the statuette. It is a sincere expression of a certain disposition of my mind, but you must know that it is by no means the simplest nor the last. The consistency in me lies in the design, and the quality of surface – whereas the treatment of the planes tends to overshadow it.'

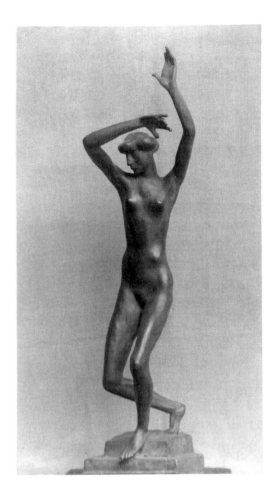

Mr. Stanley Casson, in his book, 'Some Modern Sculptors', writes:

'In this [Gaudier's] interpretation of movement he really achieves a new style in modern sculpture. 'The Dancer' is a figure in which movement is detected rather than seen, and detected at a moment when it is neither static nor in motion: when it is potential, and yet not stopped. No sculptor, to my knowledge, has ever depicted a figure thus *descending* out of one movement into another. Rodin's definition of movement as "transition" is here carried out more clearly than he could ever have wished, and more effectively than he could ever have achieved. There is no representation of motion here, only its full and direct expression.'[13]

Gaudier had a profound belief in himself; he would often say: 'It was an honour for So-and-so to be in my company.' He said also: 'You will never make me believe that a man who is strong and healthy-minded cannot accomplish his ends. I have always done everything that I wanted to do. So long as I have tools and stone to cut, nothing can worry me, nothing can make me miserable. I have never felt happier than at this moment; you must take happiness where you can find it, it's no good waiting until it comes and offers itself to you.'

This was near the beginning of 1914, and apart from his studio expenses, Pik was only supplying twenty-six shillings a week for their rooms, their food, their clothes; and Zosik had to use her own savings, which by now had dwindled again to about sixty pounds.

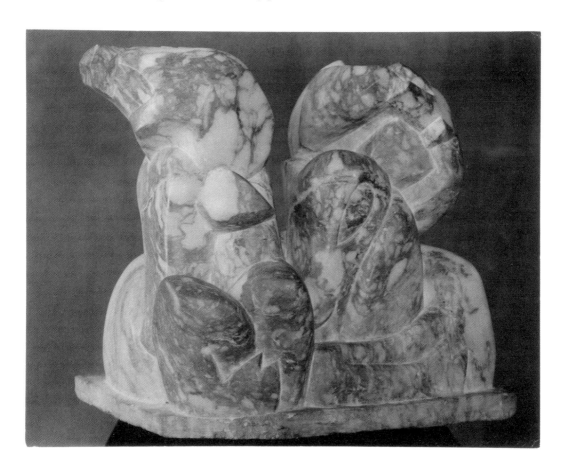

Their rooms were very cold: they had only a tiny oil-stove, and Pik suffered from this discomfort. Zosik was able to do less and less of her literary work: she was entirely occupied with mending and cooking and cleaning and being ill, until she came to wonder if she was only destined to be mentioned in the annals of great twentieth-century men as someone who had had an influence on one of their lives.

Gaudier was now great friends with Ezra Pound,[14] and this friendship lasted until Gaudier's death. It was the strongest attachment that he made in England. Mr. Pound describes their first meeting in his book on Gaudier. Henri was enchanted that Pound should have bought two of his works, and in addition to these he was to make him a marble box for five pounds.[15] He was also at work on a large bust of Ezra Pound[16] which he hoped would one day find a place in the Metropolitan Museum, New York.

Miss Brzeska described an evening she and Henri spent with Ezra Pound. As usual, she was very nervous and excited before starting, while Pik added to her worries by pressing her to hurry, and by objecting to all she put on. He did not want her to wear goloshes, and hated her to take an umbrella. *Quoi! Tu penses à emporter ce sale meuble? Affreuse vieille bonne femme – pourquoi ne pas emporter les fourchettes ou ta commode?*[17]

He refused to carry her umbrella, saying that he was not a lackey. When the wind blew hard, he took the umbrella from her and closed it angrily, so that she arrived at Pound's tired, wet, and bedraggled.

Pik had these swift ferocities: it was due to their difference of age, their poverty, and their sexual estrangement. Afterwards he would be so sorry, and she too would make resolutions to be much more patient; and then, as she said, 'my nerves got the better of me, and all resolutions went to the winds'.

At the Café Royal, Zosik's excitement led her into talking very loudly, and it is small wonder that Mr. Pound wished to escape from her company. He had been extremely attentive to her all the evening, and on the way home Pik actually offered to carry her umbrella, having seen Pound do so, but this time Sophie kept it to herself.

Gaudier hoped now that Pound would buy the 'Stags',[18] which were to be exhibited at the London Group,[19] and a friend of Pound's ordered two marble charms at ten pounds each.[20] Again Pik felt that life would be full of ease, and he arranged for Zosik to go away for a splendid holiday in

France. She badly needed this holiday, for she was very run down and, among other things, had a sudden feeling that she was mad, which was a great shock to her. But she had to wait until they received the money and, as usual, the idea proved but a castle in the air.

At the London Group Exhibition, held at the Goupil Gallery, Gaudier was exhibiting, among other things, the 'Stags', the 'Dancer', and the 'Maternity Group',[21] which last Konody at the time called 'affectation in stone'.[22] Pik was very much excited about going to this Exhibition, and Miss Brzeska says that when they asked him at the door who he was, his voice trembled as he replied: 'I am Gaudier-Brzeska, who is exhibiting here'.

The London Group closed in March 1914, and Gaudier had sold nothing. There is a detailed account of his financial position at this moment.[23] From October until the end of March, he had earned forty-seven pounds nine-teen shillings, and out of that he had spent twenty-four pounds twelve shillings for materials, tools, studio, and exhibitions, leaving less than four pounds a month for their life together, washing, clothes, food, and rooms. Again Henri found Sophie useful to him, for her slender savings made life possible. The months of May and June were very peaceful, and they often went together to Richmond Park, where they enjoyed the flowers. One day Pik was so much entranced with the beauty of nature, that he said that he would probably return to a naturalistic style in his work.

Henri went home much more often in the evenings, talked and read to Zosik, and did not get angry because the washing was hung out to dry in the room. He praised Zosik's careful economy, which enabled them to con-tinue as independent beings.

12 | The war

When summer came, their hard-won domestic peace was over, for with the heat their rooms became infested by bugs. It was too much, and Zosik broke down entirely, for though each morning they exterminated every bug, by the evening new ones had come. They took other rooms,[1] and Miss Brzeska went again to Littlehampton, where she found a charming land-lady, a Spaniard, who was a great comfort to her.

Pik, who now found himself entirely without money, went round to his various friends to ask them to pay their debts, but for one reason or another he could get none of them to pay. He wrote to Sophie: 'Send me ten shillings, ——[2] promised to pay me to-day, but has disappointed me. I have asked him so often. He seems always to have enough for his girls, and for the Café Royal, but as far as I am concerned, I can die of hunger. Since you left, I have only had three pounds, and most of that I have had to spend on things for my work, so for the last four days my cat and I have lived on milk and eggs given me on credit, and it isn't enough; my stomach is already dreadfully upset, and I haven't a halfpenny.'

Zosik sent him some money, and at the same time his friends seem to have paid their debts. Paul Morand came again to see him and suggested that Gaudier should call on the Ranee, whom he had brought before. But Gaudier, however hard up, could never ask people to buy things from him, nor would he visit people in the hope that they would buy.

Then Zosik came back to London with a plan. They had a friend, a French girl,[3] whose sister was coming to London. She suggested that they should take larger rooms in a quieter place, buying the necessary furniture with her last pounds, and take in these two girls as boarders. The three of them would do the house-work in turn, thereby giving each of them a fortnight's freedom for work. Pik was enthusiastic, rooms were found, the money was spent and all nicely arranged, when, a week later, war was de-clared, and the girls rushed back to France, leaving Miss Brzeska with her rooms and her surplus furniture. This is a typical example of the ill luck which had beset her all through her life, and it is small wonder that she believed that the Furies were against her.

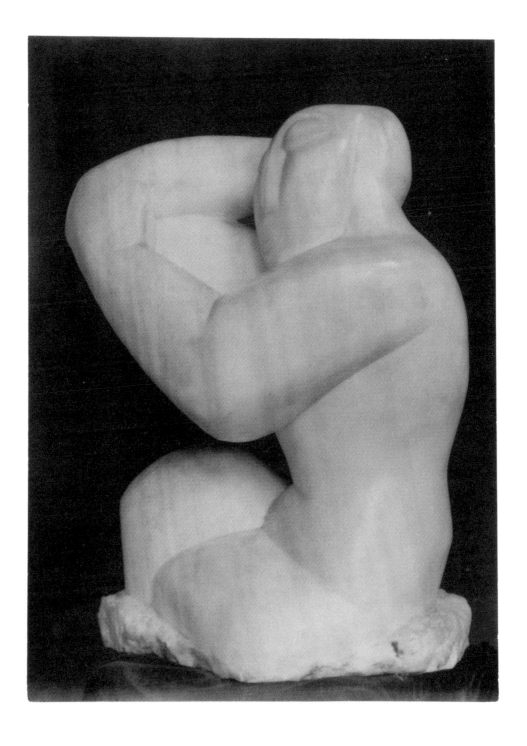

The outbreak of war was a great shock to them both, and Pik at once wanted to go to the Consul for his passport. For a little while Zosik dissuaded him, saying that the war would soon be over, that it was a full moon,* which would surely bring bad luck, that he owed nothing to France, and so on. They had both, at different periods, long before, dreamt that Pik would be killed in a war, and this added greatly to their fears; but after a couple of weeks Pik could stand it no longer, and said: 'One has to die some time; if it is in bed or in the war, what does it matter?' So he got his passport and left for France.

Zosik was in despair – she felt for the first time that she had always been very hard on Pik, that her recriminations had been small-minded, and that every time it had been Pik who had taken the first steps to make up any quarrel. She longed beyond endurance to have him back that she might be really charming to him.

Next day, when she was going to sit in the Park, whom should she meet but Pik. She thought it was a spirit and ran away, but he called after her: 'Zosik, Zosik, I have come back'. He then told her what had happened.

'When I arrived in France I was told that I was a deserter and that I should get twelve years' imprisonment. They didn't want my kind at the Front. So they whisked me off to a prison, and told me that I should be shot by the sentry outside if I attempted to escape. There was a tiny window in my cell, with a bar across the middle, and as I had one of my chisels with me, I managed after many hours to get the bar loose. I looked out, and saw no sentry; so being small, I succeeded in squeezing out, scaled a wall and ran across many fields. I ran for several hours until I got back to Calais, where I lay concealed until it was dark. I then slipped into the harbour, having persuaded the man at the gate that I had come with baggage that morning. I even made him believe that he remembered my lighting his cigarette for him. I told him that I had been in the town for a bit and that I must get back to England by the night boat – and here I am.'

It all seemed fantastic and miraculous, and they were so happy to be together again that for some time there were no disagreements. Pik thought that he would not try again to go to the Front, and Zosik remembered how

* Miss Brzeska had a half-moon in her family crest, and felt that it was this which had brought her ill luck throughout her life.

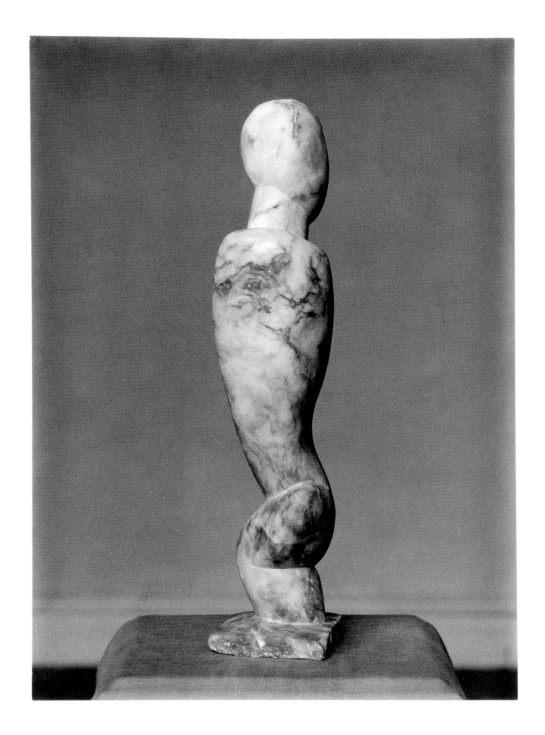

desolate she had felt without him. Pik tried to persuade her to be his lover in a fuller sense, but she said that she was ill and tired, that she would give him her intellectual and spiritual love, and that he must be satisfied with that.

After a while, some dispute arose – Pik found her clothes old-fashioned, her shoes worn out; she was particularly ill at the moment, and forgot her resolutions to be patient. Pik went to live in his studio,* while she stayed in her room.

Early one morning in September, he came and knocked at her door; he had come to say good-bye, for he was off to the Front again, having obtained a new and more satisfactory passport. Sophie thought it a trick to get into her room, and would not open it to him; after half an hour he went away. She then rushed to her window and called him back as he was half-way down the street. They had a very happy last two days; she did not try again to shake his determination to go, and though all his friends said that it was stupid to go a second time, he said: 'I'm going, I absolutely must; there's no more to be said about it, and nothing else to do'.

Unfortunately, none of his letters to Miss Brzeska from the Front have been preserved; but Mr. Pound, in his book, quotes several written to friends, which throw a very interesting light on his reactions to the war. Four letters, hitherto unpublished, one to Mr. Edward Marsh and three to his home, take him to the end of 1914.

[Copy of letter to Mr. E. Marsh.]
1st October 1914
My dear Eddie,†
Here I am face to the foe. I have been at the Front for the last fortnight and have seen both latent and active fighting. By latent I mean staying days in trenches under heavy artillery fire, keeping ready for any eventuality [such] as a raid or an unforeseen forward movement from the enemy – by active, a nice little night attack that we made last Saturday night upon an entrenched position. We crept through a wood as dark as pitch, fixed bayonets and pushed some 500 yards amid fields until we came to a wood.

* During this period Gaudier was great friends with T. E. Hulme, who also was killed in the war.[4]

† The original of this letter is in English.

There we opened fire and in a bound we were along the bank of the road where the Prussians stood. We shot at each other some quarter of an hour at a distance of 12–15 yards and the work was deadly. I brought down two great giants who stood against a burning heap of straw – my corporal accounted for four more, and so on all along the line. They had as much luck, unhappily, for out of 12 of my squad that went we found ourselves five after the engagement, and on the whole company the toll was heavy. ...

Confident in ultimate success, I remain,

Yours ever,

Henri Gaudier.
Au front: par Le Hâvre (French army at the front)

4th October 1914

Dear Parents,

I've been in the trenches for 15 days, and in spite of a most bloody night attack and four days' exposure to a regular hail of shells I've managed to reach the age of 23 to-day.

I am now resting with my battalion in a little fortress of which the only rottenness is having to sleep in the cellars. This sleeping out all over the place and in any weather has given us all diarrhoea, and the drugs which they give us aren't much use. Apart from this everything is all right – naturally life is very monotonous and animal, one hasn't the energy nor the desire to think, and one is too disturbed to concentrate anyhow. I kiss you all tenderly and hope to see you soon.

Henri.

9th November 1914

Dear Father,

Thank you for your card – I have already told you that I am in front of the town sacred to the Kings,[5] that should explain and I cannot say more. The Cathedral burnt in front of my eyes, now you will understand. I had a good laugh last night. My Lieutenant sent me to repair some barbed wire between our trenches and the enemy's. I went through the mist with two chaps. I was lying on my back under the obstacle when pop, out came the moon, then the Boches saw me and well! *pan pan pan*! Then they broke the entanglement over my head, which fell on me and trapped me. I took

my butcher's knife and hacked at it a dozen times. My companions had got back to the trench and said I was dead, so the Lieutenant, in order to avenge me, ordered a volley of fire, the Boches did the same and the artillery joined in, with me bang in the middle. I got back to my trench, crawling on my stomach, with my roll of barbed wire and my rifle. The Lieutenant was dumbfounded and I shall never forget his face. When things had quieted down I went out again, did my job and got back at 5 a.m.

Henri Gaudier Soldat
Iᵉ Section 7ᵉ Cie 129ᵉ de Ligne
3ᵉ corps au front par Le Hâvre.

12th November 1914
Dear Father,
Thank you for your letter of the 6th. The day before yesterday I wrote you a card telling you of my adventure in a barbed wire entanglement. At the time I hadn't noticed it, but I find that I have two wounds, one tear on the right leg made by the wire, and a bullet wound in the right heel. I put some iodine in it when I was in the trench, and yesterday I had it bathed, but it doesn't prevent me from walking as well as before.

Everything was all right in your parcel, nothing was pillaged. You must not send me any more clothes – every week I get some from London and I'm expecting another parcel at this moment. The only thing I want is tobacco at 50 centimes.

I'm not at all bored in the trenches. I am doing some little pieces of sculpture. A few days ago I did a small Maternity statue out of the butt-end of a German rifle, it's magnificent walnut wood and I managed to cut it quite successfully with an ordinary knife. The Captain had asked me to do it to give as a present to someone.* I can't tell you the names of the officers, etc. – anyhow, there's no need, you will know later on, and they are most sporting fellows.

Love to you all and thank you for your good wishes.

Henri.

* Monsieur Ménager (Gaudier's Captain) tells me that Gaudier did three or four bits of sculpture in the trenches, either from the butts of rifles or in soft stone, using only his penknife. These works were preserved for a little while and then thrown away to make room for clothing.

By the New Year Gaudier had been made a corporal, and a few weeks later, a sergeant. A letter which he wrote to Mr. Schiff shows that his energy was as much alive as ever.

26th February 1915
I learnt of Currie's death[6] while in the trenches near Rheims some time in November, I believe, and of course I was not surprised; he had tried once when I was at his place. He was a great painter, and a magnificent fellow; in ordinary times, I should naturally have been more afflicted, but as you may imagine, death is here a daily happening, and one is expecting it every minute. ...

These last twelve days I have succeeded in making the enemy angry – we were only 50 yards off, and I got a bugle to blow false alarms, then I insulted them, and went out of the trench with a French newspaper. A German came out to meet me, and gave me the *Hannover Zeitung* and *Kieler Nachrichten* in exchange; it was very amusing, but I profited by the excursion to discover an outpost, on which I directed our artillery. At 3 p.m. four big shells fell on it, and the twenty chaps in it went up to heaven. I also brought one down with my rifle the next day. ...

In April Mr. Schiff sent him some money, and he replied: 'I can only thank you for the note, and consider it as an advance on account of work you want me to do for you.'

This is, I believe, the only instance of his having accepted any money by way of a gift, and even here, in the emotional climax of war, there is no question of not repaying its full value. He sent ten shillings to Zosik, and told her that life at the Front was curing him of many faults. His last letter to Mrs. Bevan arranges for news of his death, should it occur, to be given to Sophie. 'As I may fall, I should be grateful if you would ask for news of me from Capitaine Ménager, Commandant, 7ᵉ Compagnie, 129ᵉ Infant., 3ᵉ Corps, to convey it to my sister, but only if I have been at least six weeks without sending any news.'

Monsieur Ménager writes of Gaudier in a letter dated 9th March 1929:

Nous admirions tous Gaudier, non seulement pour sa bravoure, qui était légendaire, mais aussi et surtout pour sa vive intelligence et la haute idée qu'il avait de ses devoirs. ... A ma compagnie il était aimé de tous, et je le tenais en particulière estime car à cette époque de guerre de tranchées j'étais certain que – grâce à l'exemple qu'il donnerait à ses camarades – là où était Gaudier les Boches ne passeraient pas.[7]

In the meantime, Miss Brzeska went away to teach at a girls' school. The food was miserable, and the noise, to her, appalling, so that after a few months she had to leave. She found a small attic in the neighbourhood for very little money, and six times a week she went to teach French to the children of Lady G. at a house five miles away. For this she received six shillings a week; it was a two hours' walk each way, and she had to leave at eight o'clock in the morning and walk all through the mud of the country lanes. Lady G., she said, was very kind to her, and spoke to her sympathetically on her arrival.

Miss Brzeska was back in London when she heard of Henri's death in June 1915.* He had written to her saying that he longed to come back, and that when he did, he wanted her to be his wife. In the meantime, she had

* Henri Gaudier was killed at about one o'clock in the afternoon of June 5th, 1915, during the attack on Neuville St. Vaast.

been feeling terribly desolate, and had sent him a letter, which crossed his, blaming him for her life in England, and demanding that he should come back and take her away. After hearing from him she spent some time thinking of his proposition, and finally replied most sympathetically, but did not post it at once, adding here and there new thoughts and new hopes for their future happiness together.

Before she was ready to post this letter, she received the information that Henri had been killed. She felt that her first complaining letter had perhaps driven him into danger, and the torture resulting from this thought is a constantly recurring theme in the closely-written diary which she kept for the next seven years.

Many people will remember Miss Brzeska in the streets of London, a strange, gaunt woman with short hair, no hat, and shoes cut into the form of sandals. She felt that the world was against her, and never for an instant did she forget the tragic loss of her 'little son'. He became for her the whole of her life, but a life consumed by remorse, in that she had not been to him a companion more complete, more lively, and more sympathetic.

Henri Gaudier, on the other hand, had regretted nothing, always using his energy to the full and feeling sure of ultimate success.

Notes

These notes provide essential information about lesser known individuals, places and publications, and clarify references which may result obscure to today's reader. Names omitted by Ede have been revealed where possible, but a small number of individuals remain unidentified.

Most foreign language passages have been translated, with the exception of those in which unverifiable transcription errors or Gaudier's habit of mixing languages and inventing words make the translation impossible.

A reference to Evelyn Silber's catalogue raisonné (*Gaudier-Brzeska. Life and Art*, Thames & Hudson, London, 1996) is provided for the identified sculptures. In addition to Silber's expertise, the notes draw substantially from Paul O'Keeffe's biography *Gaudier-Brzeska: An Absolute Case of Genius* (Penguin, London, 2004).

SEBASTIANO BARASSI, EVELYN SILBER and JON WOOD

1 THE MEETING

1 The Bibliothèque Sainte-Geneviève was founded as a monastery library in the 6th century. It moved to its present premises in the Place du Panthéon in 1851. Specialising in humanities and social sciences, in Gaudier's days it was frequented mostly by students and educationalists.

2 The street where Sophie lived, a short walk from the Bibliothèque Sainte-Geneviève.

2 MISS BRZESKA

1 The account of Sophie Brzeska's life before her meeting with Gaudier is based solely on her writings and it has not been possible until now to verify it against alternative sources.

3 HENRI GAUDIER

1 In the area of Saint-Germain-des-Prés. Gaudier stayed at a lodging-house run by the Robert family.

2 Dr. Benedikt Uhlemayr (1871–1942) taught at a gymnasium in Nuremberg from 1907 to 1933. He had two sons, Gunther and Walter, but nothing is known about his wife. He was a supporter of education for girls and a fervent opponent of the Third Reich. It seems likely that he had links with one or both of Gaudier's schools, the École Primaire

Supérieure in Orléans and the Merchant Venturers' Technical College in Bristol. Gaudier stayed at his house at 9 Schlüsselfelderstrasse for three months, from late April 1909.

3 Slang for 'teenage girl' (literally 'baked fish' in German) and 'Boulevard Saint-Michel' (in the Latin Quarter).

4 James Abbott McNeill Whistler (1834–1903), *Arrangement in Grey and Black: The Artist's Mother*, 1871, now in the Musée d'Orsay, Paris.

5 Paul O'Keeffe (*Gaudier-Brzeska: An Absolute Case of Genius*, Penguin/Allen Lane, London, 2004, p. 41) has identified this as Armand Colin Libraries and Éditeurs, in rue Mézières. Ezra Pound's *Gaudier-Brzeska: A Memoir* was published in London in 1916 by John Lane, and reprinted in an expanded version in 1960 by Marvell Press, Hessle.

6 Gaudier's or Ede's misspelling of 'St. Sebaldus'. The Sebalder Wald is on the outskirts of Nuremberg.

7 Auguste Rodin (1840–1917) made several versions of *The Thinker*, the earliest dating from 1881–82.

8 All of Gaudier's paintings from this period are lost.

9 French for 'he tried to beat me, but I kicked him so hard that he could not do it.'

10 Only a small number of Gaudier's childhood drawings survive, in the Musée des Beaux Arts, Orléans.

11 In 1903–7 Gaudier was enrolled on the course *Section Commercial* at the École Primaire Supérieure in Orléans.

12 In Bristol Gaudier studied at the Merchant Venturers' Technical College for a year, from September 1907. His host and guardian was George Smith. Henri stayed at Smith's house at 24 Cotham Grove, becoming a good friend of his daughter Kitty. He continued to correspond with her until just before his death.

13 The *Bristol Sketchbook* (Kettle's Yard, Cambridge) covers the period from Gaudier's arrival in Britain in 1908 to his visit to Munich in July 1909. It also includes drawings made in Cardiff in October 1908, while en route to Germany and during his first days in Nuremberg in April 1909. In the past a number of sheets were removed; for example, the front page with the heraldic design (signed and dated 25 March 1908) is now tipped into p. 32 of H.S. Ede's manuscript *A Life of Gaudier-Brzeska* (the Henry Moore Institute Archive, Leeds).

14 Watercolour drawings now in the Musée des Beaux Arts, Orléans. *The Rubáiyát of Omar Khayyám* was a collection of poems attributed to the Persian polymath Omar Khayyám (1048–1131), first translated into English in the 19th century by Edward FitzGerald.

15 In the *Bristol Sketchbook* (Kettle's Yard, Cambridge).

16 See, for example, *Fighting Spirit: The Bittern* and *Grace and Speed: The Golden Eagle's Wing* (Kettle's Yard, Cambridge).

17 Henriette was born in 1893, Renée in 1899.

18 Richard Burdon Haldane, Viscount Haldane (1856–1928), was a Liberal politician. As the Secretary of State for War he implemented the Haldane Reforms (1906–12), which were designed to prepare the British army for a major war in continental Europe.

19 Two of these drawings are in H.S. Ede's manuscript *A Life of Gaudier-Brzeska* (the Henry Moore Institute Archive, Leeds).

20 In Nuremberg Gaudier completed two sketchbooks, one now at Kettle's Yard, Cambridge, the other at the Musée national d'art moderne, Paris.

21 German for 'Doctor, Mr. Gaudier, it's Count Zeppelin with his airship!'

22 Paul O'Keeffe (*Gaudier-Brzeska. An Absolute Case of Genius*, Penguin/Allen Lane, London, 2004, p. 307) suggests that this might be Ede's or Gaudier's misspelling of Kraftshof, a village near Nuremberg with a fortified church drawn by the sculptor in a sketchbook now at the Musée national d'art moderne, Paris.

23 Gaudier was in Munich for most of July and August 1909. Drawings made in the city appear in the *Bristol* and *Nuremberg* sketchbooks at Kettle's Yard, Cambridge, and in a sketchbook at the Musée national d'art moderne, Paris.

24 Founded in 1886, C.P. Goerz was a Berlin-based camera and lens manufacturer. By 1910 it was the world's leader in military optics, with branches in Berlin, London, New York and Paris (at 22 rue de l'Entrepôt). Its products included cameras, binoculars, meteorological and aeronautical instruments and scientific telescopes.

25 Paul O'Keeffe (*Gaudier-Brzeska. An Absolute Case of Genius*, Penguin/Allen Lane, London, 2004, p. 75) has identified this as Royan, at the mouth of the Gironde, north of Bordeaux.

26 This letter is almost certainly misdated. The reference to *Mi-Carême*, the French half-Lent festivity, suggests it was written in early March, most likely on the 4th.

27 *Simplicissimus* was a German satirical magazine founded in 1896 by Albert Langen and published until 1967. It combined outspoken political writings with avant-garde illustrations and graphics. *La Guerre sociale* (1906–15, founded by Gustave Hervé) and *Les Hommes du jour* (1908–23, founded by Victor 'Flax' Méric) were French anarchist and anti-militarist journals.

28 In the neighbouring village of Combleux. The cottage was owned by Monsieur Clément and his wife.

29 Monsieur Coutant.

30 German for 'decorative arts'.

31 The weekly magazine *Le Rire* was the most successful of the Parisian *journaux humoristiques*. It was founded in October 1894 by Felix Juven and published until the 1950s. *Le Charivari* was a daily newspaper, published from 1832 to 1937. Both publications featured caricatures and political cartoons. Gaudier used the pseudonym 'Gérald' for his submissions, which were not published.

4 THE FIRST MONTHS IN LONDON

1 Wulfsberg & Co. were ship-brokers and timber merchants. The firm's London offices were at St. Mary's Chambers, 14–20 St. Mary Axe, in the City. Gaudier worked there for two and a half years.

2 In the Cast Courts of the Victoria & Albert Museum.

3 Elisa Félix (1821–1858), best known by her performing name Rachel, was a leading actress in the *Comédie Française* and mistress to several famous French figures, including Louis Napoleon (the future Napoleon III) and the Prince de Joinville, son of King Louis Philippe.

4 ' "Where? When? How much?" to which the actress replied, "Tonight, at your house, for nothing".'

5 A firm of paper, envelope and card makers.

6 'Mr Jars, male goose in French.'

7 French for 'little French prankster'.

8 In 1911 prints by Francisco José de Goya y Lucientes (1746–1828) were on display in rooms 70–73 of the Victoria & Albert Museum. *Los Caprichos* (Fantasies) date from 1797–99, *Los Desastres de la Guerra* (Disasters of War) from 1810–20 and *La Tauromáquia* (Bullfight) from 1815–16.

9 Spanish for 'Where is Mummy going?'

10 The omitted text is reproduced in Appendix 3.

11 German for 'indecisive'.

12 Ralph Waldo Emerson (1803–1882) was a Transcendentalist American philosopher and writer. The title mentioned by Gaudier ('The Sun Rules the World') does not correspond to any of Emerson's publications in English, suggesting that it might be a German anthology.

13 Henri's and Sophie's first lodgings in London were in Edith Road, Hammersmith. Sterndale Road is about a quarter-mile to the north, off the Shepherd's Bush Road.

14 French child-speak for 'milk'.

15 Henri corrects Sophie's French grammar: 'your enormous mistakes, horrible little scribbler. "Lui laissant la charge *de* gosses" – *des* gosses, a vague indefinite number (there could be ten, twenty or thirty kids). On the other hand, "*de* 3 gosses" – of a few kids, of several kids. "Je suis forcée d'avoir *des* mioches": you get it right there – why not in the first case? You scatterbrain. Nature is not *magnanime* but *magnifique*: *magnanime* only applies to people. "Loin *de* méchants h...," *des* – as for kids. Abaye – abbaye.'

16 *Nike* (Victory) *of Samothrace* (3rd century BC, Louvre, Paris); Michelangelo's *Dying Slave* or *Rebellious Slave* (both 1513–16, Louvre; modern plaster casts at the Victoria & Albert Museum, London); and Auguste Rodin's *Saint John the Baptist* (1879–80, one version at the Victoria & Albert Museum).

17 James Keir Hardie (1856–1915) was the first Independent Labour Party Member of Parliament. The demonstration mentioned by Gaudier was in aid of the South Wales Miners' Relief Fund.

18 Gaudier refers to the troubled childhood and later private life of the French actress Sarah Bernhardt (1844–1923).

19 The *Trilogy* was Sophie's most ambitious literary project. It remained unfinished.

20 French for 'you shouldn't judge people by their appearance'.

21 Italian for 'the comedy is over'.

22 German for 'slavish imitation'.

23 The *Aphrodite of Milos*, more commonly known as *Venus of Milo*, dates from around 130 BC. It has been on display in the Louvre since the 1820s.

24 French for 'fair and gentle damsel who will be his noble wife'.

25 'Forest, Cordy and Sloc[ombe]', unidentified acquaintances of Henri and Sophie in their early days in London.

26 French for 'sink let him sink, "and we don't care, dee dum dee dum" etc.'

27 Probably 28 May.

28 The sculpture's original title is *Celle qui fut la belle heaulmière* (She was once the helmet-maker's beautiful wife) (1885–87, Musée Rodin, Paris).

29 *Three Fates*, from the East pediment of the Parthenon, 447–438 BC, by Phidias and assistants (Elgin Marbles, British Museum, London).

30 *River God* (possibly Ilissos), from the West pediment of the Parthenon, 438–432 BC, by Phidias and assistants (Elgin Marbles, British Museum, London).

31 Praxiteles's *Aphrodite of Knidos* (also known as *Venus of Cnidos* or *Venus Pudica*, because of her right hand covering the pubis) was one of the most copied statues in the ancient world. The 4th century original is lost.

32 Plaster casts of *David* (1501–4; the original is in Florence) and the *Slaves* (1513–16; Louvre, Paris) are in the Victoria & Albert Museum, London. *Night, Dawn, Evening* and *Day* are the reclining allegorical figures sculpted by Michelangelo for the Sagrestia Nuova in the church of San Lorenzo in Florence (1520–34).

33 French for 'old woman'.

34 Séverin Faust (1872–1945), known by the pseudonym Camille Mauclair, was a French poet and art critic. His *Auguste Rodin, The Man, His Ideas, His Works* was published in London in 1905.

35 German for 'exchange', 'discussion'.

36 Polish for 'argument'.

37 *The Studio* was an illustrated monthly magazine of fine and applied arts, published in London from 1893 to 1964.

38 'Who knows if at some particular time she would not have taken a big fellow … and who knows if at some particular time she did not worry hugely about that.'

39 German for 'convinced'.

40 Polish for 'Polish tricks of Zosienka Brzeska'.

41 King George V and Queen Mary were crowned at Westminster Abbey on 22 June 1911.

42 French for 'down there'.

43 Slocombe.

44 Joseph W. Simpson (1879–1939) was an illustrator and caricaturist. He published *The Book of Book Plates* in 1903.

45 'W K' magazine, unidentified.

46 Slocombe.

47 Polish for 'devilish illness'.

5 LIVING TOGETHER

1 French for 'family chest'.

2 French for 'dilapidated, scratched'.

3 French for 'flea-bag'.

4 Arrigo Levasti (1886–1973) was an Italian schoolteacher and author who spent his youth travelling aimlessly across Europe.

6 FRIENDS

1 Haldane Macfall (1860–1928) was an author, art critic and amateur painter. He published numerous books, including a *History of Painting* in eight volumes. *The English Review* was founded by Ford Madox Ford in 1908 and became a forum for the most important writers of the time. It was published, with some interruptions, until 1937.

2 Gaudier refers here to Wilhelm II (Friedrich Wilhelm Viktor Albert von Hohenzollern, 1859–1941), the Emperor of Germany and King of Prussia who ruled between 1888 and 1918.

3 Henry C.M. Hardinge was an author and playwright, Geoffrey S. Alfree (1889–1918) a watercolourist and landscape painter.

4 Enid Algerine Bagnold (1889–1981) was a novelist and playwright. When she met Henri and Sophie she was, like them, only an aspiring artist. From 1908 she attended Walter Sickert's art courses, developing a talent for etching. Her first literary work, *Diary Without Dates*, a polemical chronicle of her experiences as a nurse during the war, was published in 1917.

5 Dolly Tylden was Enid Bagnold's flatmate. Claud Lovat Fraser (1890–1921) was a painter, designer and author. Born to a prominent family, he abandoned his law studies to pursue a career in the arts, studying for a short period under Walter Sickert. In 1912 he illustrated, with Gaudier and others, one of Macfall's essays on art, *The Splendid Wayfaring*, published in the November issue of the journal *Art Chronicle*.

6 Thomas Leman Hare (1872–1935) was an art critic and author of numerous books, notably on Renaissance painting. He was associated with several art journals; in 1912, for instance, he published in *The Connoisseur* articles on the painter J.D. Fergusson and on Léon Bakst's designs for the Ballets Russes. In the 1920s and early 1930s Hare was editor of the art magazine *Apollo*. At the time of meeting Gaudier he lived with his wife Thérèse at 35 Pembroke Road, Earl's Court.

7 At 15 Redburn Street, Chelsea.

8 *The Miracle* (1911) was an extravagant and very popular play written by Carl Vollmöller and directed by Max Reinhardt. It included vast crowd scenes, processions, real horses and an entire moving hill. It was shown at the Great Hall, Olympia, from 23 December 1911. The actress playing the Madonna was the Italian Maria Carmi (real name Norina Matchabelli, 1880–1957). Gaudier saw her last performance in the role, on Saturday 10 February 1912.

9 Alfred Charles William Harmsworth, Viscount Northcliffe (1865–1922), was a powerful and influential publishing tycoon.

10 *A Memorial Exhibition of the Work of Henri Gaudier-Brzeska*, comprising 46 sculptures, a tray and vase and numerous drawings and pastels, was held at the Leicester Galleries, Leicester Square, in May–June 1918. Ezra Pound wrote the preface to the illustrated catalogue, which contained an advertisement for his memoir. As early as May 1916 the Galleries' proprietors had suggested a memorial show to Sophie, through the painter Robert Bevan (1865–1925), but she had decided to postpone it until after the war. Bevan and his Polish wife, Stanislawa de Karlowska (1876–1952), had met Henri and Sophie in the autumn of 1913. The painted plaster cast of Maria Carmi as *The Madonna of 'The Miracle'* is at Kettle's Yard, Cambridge; the other is presumed lost (Silber cat. 9).

11 R.H. Raymond Smythies (b. 1860) was a retired army officer and collector of Tibetan dresses and Far Eastern artefacts. Sophie, who disliked him, nicknamed him 'Colonel Squeeze'.

12 The bust is presumed destroyed (Silber cat. 11).

13 Location unknown (Silber cat. 16).

14 *Enid Bagnold*, collection of Viscountess Astor (Silber cat. 17).

15 Walter Benington (1872–1936) was a Pictorialist photographer. He made portraits of many of London's leading artistic, literary, political and scientific figures.

7 MORE FRIENDS

1 John Middleton Murry (1889–1957) was a prolific writer and art critic. He published over sixty books and numerous essays and reviews on literature, social issues, politics and religion. In 1918 he married Katherine Mansfield (real name Kathleen Mansfield Beauchamp, 1888–1923), a New Zealander author. Murry founded the quarterly magazine *Rhythm* in the summer of 1911, with fellow Oxford student Michael Sadler. The title was inspired by the theories of the French philosopher Henri Bergson, and the visual style strongly influenced by the Scottish Colourist J.D. Fergusson. The content was often experimental and provocative. Mansfield became assistant editor in 1912, but the magazine only survived until March 1913, closing for lack of funding.

2 Destroyed (Silber cat. 21).

3 In Runcton, near Chichester, West Sussex.

4 A small village near Birmingham.

5 Polish pejorative for 'German woman'.

6 *Bubu de Montparnasse* (1901) by Charles Louis Philippe; *Poil de Carotte* (1894) by Jules Renard; *Cantilènes du Malheur* (1902) by Jehan Rictus; and *The Cherry Orchard* (1904) by Anton Chekhov.

7 Boris Petrovsky was Katherine Mansfield's pen name.

8 A GROUP OF LETTERS

1 Sophie stayed with a Mrs. Hollyoak at Ambrosia Cottage Farm, in Dodford, near Bromsgrove, Worcestershire.

2 Clouser.

3 Polish for 'neither? a lady?'

4 Julian George Lousada was a distinguished solicitor and art collector. His son Anthony (1907–1994), himself a lawyer, collector and patron of the arts, remembered being taken aged seven to Gaudier's studio in Putney. There the sculptor showed him some small clay sketches, each covered by a brown paper bag which was removed with a flourish.

5 Polish for 'ugly head'.

6 Alexander Parlanti ran the Albion Works art foundry in Parsons Green Lane, Fulham. Gaudier refers here to the sculpture, commissioned by Julian Lousada, showing Adolph Bolm and Tamara Karsavina in the Ballets Russes' production of Igor Stravinsky's *The Firebird* (the original plaster and Parlanti's cast are lost; ten later bronze casts exist; Silber cat. 18).

7 Polish for 'little tail'.

8 Monsieur Gallouëder, Mayor of St. Jean de Braye.

9 'My dear Gaudier,
 I have just seen your father who told me the news about you. I don't need to tell

you how much your decision shocked him. You have made him deeply unhappy, so unhappy that I have to write to you. I have on the other hand always been sufficiently interested in you to feel that I have the right to give you a piece of advice.

I know the reasons which you gave your father. Let me tell you that they are not serious. In any case, it is not up to you to be the judge. My youngest brother has just finished his military service. The two years he spent in the army did not seem less hard than yours. He had varicose veins on his legs which were very painful during and after the marches. Nonetheless he did his two years cheerfully, without complaining, happy to do his duty. I have to tell you that military service is a duty, and that one is always happy to do one's duty.

And then, what kind of situation are you putting yourself into? You are closing the doors to France; you will never be allowed to return to St. Jean de Braye; should anything happen to your family – a family who has been very good to you and where everyone adores you, as you know well – should any misfortune, as I say, happen to your family, you could not even rush to the bedside of a sick relation who might die without you having had the consolation of seeing them again. My poor child, have you thought it through, that by this you are cutting yourself off from your country and family?

You are working, you are talented, I believe you will be successful. Have you thought that your situation will damage your future success? I don't know whether you followed, about two years ago, the story of a very talented playwright called Henry Bernstein, who had done exactly what you have done, and who had the humiliation, in his successful career, to be forced to make amends publicly. I wish I had kept the letter which he wrote then; you could read it and you would have understood what a burden you are putting on yourself for life!

You know how much your father did for you; you know how much he loves you. Your decision has hurt him so much I cannot describe it; it has made him age a lot, believe me, I am not exaggerating. I beg you to reconsider your decision while there is still time.

It is late, but not too late. Of course you will be punished, but I will do my best to intervene so that things do not go too far. It will be a few hard days to go through, but you will save everyone regrets in the future, and you will take away such a painful worry from those who love you.

Believe me, it is a friend talking to you, talking to you because he cares for you. I think I am giving the best proof of it to you at this moment.

Come back quickly, dear child, to undo the harm you have done; I hope I have persuaded you. It is the best wish that may come from my friendship for your father and my care for you.

G.

Nobody knows anything around here, apart from me, and I won't say a word.'

10 'Sir (not dear or anything else),

Your letter shows too much sentimentality. You are a barbarian if you take pride in your brother suffering so much from his varicose veins. You showed how much you care for me when I came back from Germany. You offered me a place for 50 frs. and said it was a taste of hard times. I do not accept that you have any right to give me advice. I have not committed any offence against anybody. I received 3,000 frs. from

the French government towards my education, you and other politicians have ... I consider those 3,000 frs. as coming from the people and I am giving them back to the people through art.

 I will be naturalised English in two years, and if I cannot work in Paris one day, do not worry that I will do what Bernstein did – I shall go straight to Germany, and you will then have the pitiful spectacle of a French artist erecting a monument commemorating a French defeat to avenge for the baseness and narrow-mindedness of his contemporaries'.

11 'It is unfortunate and regrettable that the French youth do not revolt en masse against this immoral conscription.'

12 *Maternity* (location unknown; Silber cat. 16) and *The Madonna of 'The Miracle'* (Kettle's Yard, Cambridge, Silber cat. 9).

13 Mixed French and Polish for 'my good beloved child'.

14 Mixed Polish and German for 'they will sleep together'.

15 French for 'very mawkish work – boring to the point of indigestion for mind and spirit.'

16 Destroyed.

17 Boston Museum of Fine Arts (Silber cat. 66)

18 *Portrait of Sophie Brzeska* (Tate, London).

19 All presumed lost or destroyed.

20 'Zając' is Polish for 'hare'.

21 Daniel James 'Bob' Rider ran a bookshop at 36 St. Martin's Court, off the Charing Cross Road. He occasionally displayed and sold small sculptures and pictures in the shop, which became a renowned meeting place for artists and intellectuals.

22 James Thomas 'Frank' Harris (1856–1931) was an Irish author, editor and publisher. During the years he spent in London (1882–1914) he edited numerous publications, including the *Evening News*, the *Fortnightly Review* and the *Saturday Review*.

23 French for 'gossips'.

24 *Hearth and Home* was a women's magazine founded in 1911 and edited by Frank Harris until 1912. Enid Bagnold (who was briefly Harris' lover) was on the staff for a short time.

25 The first line of Dante's *Inferno*, 'Midway upon the journey of our life'.

26 The omitted text is reproduced in Appendix 3.

27 French for 'two 2 lbs. loaves of Allinson bread / many lemons (it is too early for oranges) / lots of bananas / two dozen lively bed-bugs!! / one box of wax matches'.

28 Mixed French and Polish for 'and it would make you drop the *kouaki* of the *pisia* [vagina] and give you a colic'.

29 Founded in 1862, the Aërated Bread Company mass-produced additive-free breads. From 1864 it ran a very popular chain of teashops.

30 The French painter Lucien Pissarro (1863–1944), son of Camille, moved to London in 1890, marrying Ester Bensusan two years later. He was one of the founders of the Camden Town Group (1911–14) and was, with Gaudier, Alfred Wolmark and Robert Bevan, on the Artists' Committee of the London Salon in 1914.

31 Gaudier refers here to the First Balkan War, fought over Macedonia by Montenegro, Serbia, Bulgaria and Greece against the Ottoman Empire. General Mikhail Savoff was the Bulgarian Minister of War and Head of the Army.

32 German for 'questionable shit'.

33 The omitted text is reproduced in Appendix 3.

34 Jan Van Eyck travelled to Portugal in 1428 to paint a portrait of the Infanta Isabel, the daughter of King John I. The portrait was apparently commissioned to persuade Philip the Good to marry the Infanta, which he did two years later.

35 French for 'and a certain master, Jan van Eyck, a little valet of Monseigneur de Bourgoygne [Burgundy] who, they say, paints on wood with oil colours he invented and to whom the Infanta did the distinct honour to let him paint her portrait.'

36 Rotten Row is the track running along the south end of Hyde Park. Created as an avenue where fashionable Londoners could go for walks and socialise, it later became a horse-riding track.

37 George Frederic Watts (1817–1904), *Physical Energy*, 1904, sited in Kensington Gardens since 1907.

38 Colloquial Polish for 'vagina'.

39 Watkins.

40 *Head of an Idiot/Head of a Jew* (according to Horace Brodzky a self-portrait), Tate, London (Silber cat. 30).

41 Mixed French and Polish for 'completely naked ladies'.

42 French for 'or watch your naughty little bum when I come.'

43 Some of these designs are in the *Journal* started on 5 April 1911 (collection Omar Pound).

44 Edward Howard Marsh (1872–1953) combined a career as a civil servant, notably as long serving Private Secretary to Winston Churchill (who was at this time at the Admiralty), with strong literary and artistic interests. A close friend of Rupert Brooke, he became his literary executor, editing his collected poems in 1918. Between 1912 and 1922 he edited five anthologies of Georgian poetry. Marsh was a supporter of contemporary art, befriending and buying the work of several artists, including Mark Gertler and Paul Nash.

45 A fashionable restaurant in Church Street (today Romilly Street), Soho.

46 *Portrait Mask of Sophie*, presumed destroyed (Silber cat. 7).

47 Polish for 'child'.

48 Leonardo Da Vinci's *Mona Lisa* (c.1503–6) was stolen from the Salon Carré of the Louvre on 21 August 1911. The thief was an Italian employee of the museum, Vincenzo Peruggia (1881–1947), who wanted the painting returned to Italy. *Mona Lisa* was re-covered in November 1913 in Florence, and returned to the Louvre the following year. The *Portrait of Baldassare Castiglione* (c.1514–15), which temporarily replaced it, is the famous painting by Raphael.

49 The omitted text is reproduced in Appendix 3.

50 Wilfrid Wilson Gibson (1878–1962) was a poet and a friend of Edward Marsh. He worked as assistant editor at Middleton Murry's magazine *Rhythm*. From November 1912 he lived in a room above the Poetry Bookshop run by the poet and critic Harold Edward Monro (1879–1932) at 35 Devonshire Street, Bloomsbury.

51 Renowned French monthly literary and cultural affairs magazine, founded in 1829.

52 Polish for 'mother'.

53 The Zoological Society of London, in Regent's Park.

54 *Brahmin Bulls*, Kettle's Yard, Cambridge.

55 Ewart Wheeler was an aspiring actor, and the brother of Charles Wheeler, the engineer and Director of Supplies for the General Post Office who commissioned work from Gaudier later that month – see letters of 24 and 28 November.

56 Presumably meaning 'having her period' (Ede's transcription from the Polish is inaccurate, and the original is now illegible).

57 Mixed French, Polish and English: 'I feel burdened with all that and I will try another little whore when I have a few bobs («Five shillings, lay your money down, sir! Lay your money down!»), to the good health of my Mamus, and because it stops me from working well. Zosisik, you won't be jealous, will you, dear little love? It is only to empty those naughty bags [colloquial Polish for «testicles»].'

58 The Hares.

59 Founded in 1883 by Julius Drewe and John Musker, by the turn of the century the Home & Colonial Stores were one of Britain's biggest retail store chains.

60 At 45 Roland Gardens, off the Old Brompton Road, South Kensington.

61 Probably the plaster *Workman Fallen from a Scaffold*, presumed lost (Silber cat. 29).

62 Ewart Wheeler.

63 Having started a career as a land developer, Henry Gaylord Wilshire (1861–1927) became an outspoken socialist politician. In 1907 he published a collection of his editorials entitled *Socialism Inevitable*.

64 Judge Evans was an important art collector, and a friend of Lovat Fraser.

65 Opened in 1865 on Regent Street, throughout the 20th century the Café Royal was one of London's most fashionable venues.

66 Thomas Evelyn Scott-Ellis, 8th Baron Howard de Walden (1880–1946) was a landowner, author (under the name T.E. Ellis) and patron of the arts. He commissioned a bust portrait from Auguste Rodin in 1905 (Tate, London).

67 French for 'a god on a baker's shovel', presumably meaning 'he puts me on a pedestal'.

68 The American sculptor Jacob Epstein (1880–1959) exhibited the completed *Tomb of Oscar Wilde* in his Cheyne Walk studio in June 1912, prior to its removal for installation in the Père Lachaise cemetery in Paris. The tomb was reproduced in the journal *The New Age* in June 1912 and generally well reviewed by the press, despite its unconventional archaising design inspired by Assyrian sculpture in the British Museum.

69 French for 'bull balls'.

70 French for 'buff skin' and hair dressed 'German-style'.

71 Richard Whiteing (1840–1928) was an author and journalist. His novel *No.5 John Street*, about the life of the destitute in London, was published in 1899.

72 'Beatrice von Holthoir', actress, playwright and later translator from the Russian.

73 Director of Supplies for the General Post Office.

74 The Tatra is the mountain range on the border between Poland and Slovakia.

75 *Wrestler* (original destroyed, except for the head, now at Kettle's Yard, Cambridge; five posthumous casts of the whole figure exist; Silber cat. 32). The bather was probably never made.

76 French for 'a very dirty oddball'.

77 French for 'horrible dirty bitch!'

78 *Venetian Night* was a play by Max Reinhardt and Carl Vollmöller set in 1860 Venice.

It was at the Palace Theatre, Shaftesbury Avenue, for three weeks. In 1914 it was made into a movie starring Maria Carmi.

79 Charles Wheeler gave Gaudier tickets to the London Wrestling Club, off Fleet Street, in the City.

80 The Hares found a studio on the Fulham Road for Gaudier, but he thought it too damp and expensive.

81 'Lunn' was either one of the life models in the drawing classes attended by Gaudier or one of the boys who went with Ewart Wheeler to the London Wrestling Club.

82 Pyotr Alekseievich Kropotkin (1842–1921) was a distinguished geographer, best known as one of the founders of anarchist communism. He lived in exile for most of his life, spending prolonged periods in England (1876–77, 1886–99, 1909–17).

83 German for 'purveyor', 'seller'.

9 STUDIO LIFE

1 Eventually they found two rooms at 86 Bishop's Road, Hammersmith.

2 *Bust of Frank Harris*, presumed destroyed (Silber cat. 45).

3 Horace Brodzky (1885–1969) was an Australian painter and printmaker of Polish origins. He moved to London in 1908, and from 1914 he was involved in the New English Art Club and the London Group. Gaudier made several portraits of him, including a plaster bust (Silber cat. 47). In 1933 Brodzky published the biography *Henri Gaudier-Brzeska 1891–1915* (Faber & Faber, London), and in 1946 he edited a book of the sculptor's drawings (*Gaudier-Brzeska Drawings*, Faber & Faber).

4 *Portrait of Horace Brodzky*, Fogg Art Museum, Cambridge MA (Silber cat. 47).

5 Ezra Pound, *Gaudier-Brzeska: A Memoir*, John Lane, London, 1916 (Marvell Press, Hessle, 1960, p. 80).

6 According to Horace Brodzky (*Henri Gaudier-Brzeska 1891–1915*, Faber & Faber, London, 1933, p. 70), Sophie destroyed the painting.

7 John Cournos (real name Johann Gregorievich Korshoon, 1881–1966) was a Russian-American author. He arrived in London from the United States in June 1912, and later associated himself with the Imagist poets around T.E. Hulme and Ezra Pound. He is best known for his novels and critical writings, and for his translations from the Russian. His first publications date from the late 1910s.

8 *Dog (Dachshund)* (private collection; Silber cat. 96) and the painted relief *Dog* (Art Institute of Chicago; Silber cat. 48).

9 Paul Morand (1889–1975) was a diplomat, novelist and poet. His first publications (novels and short stories) date from the early 1920s.

10 Lady Margaret Brooke (1849–1936), the Ranee of Sarawak (Borneo), was Queen Consort of the second White Rajah of Sarawak, Charles Anthoni Johnson Brooke (1829–1917).

11 Alfred Wolmark (1877–1961) was a painter and stage and glass designer who pioneered Post-Impressionism in Britain. Born in Warsaw, he emigrated to London as a child. Much of his early work featured scenes of Jewish life in the East End of London, the area in which he grew up. Gaudier modelled a bust portrait of Wolmark in March 1913 (Walker Art Gallery, National Museums Liverpool; Silber cat. 46).

12 *The Sculptor/Portrait of Henri Gaudier-Brzeska* (1912, private collection) and *Portrait d'Henri Gaudier-Brzeska* (1913, Musée des Beaux Arts, Orléans).

13 Alfred and Rudolf Kohnstamm were leather merchants based in Beckenham, Kent. They were assiduous supporters of modern art and early patrons of Alfred Wolmark and Jacob Epstein. Alfred Kohnstamm saw *Maternity* (Musée national d'art moderne, Paris; Silber cat. 64) in Gaudier's studio, but decided that it was too expensive at £40. The sculpture was later bought from the Omega Workshops for £20 by George Aristides Eumorfopoulos (1863–1939), a banker and collector of Oriental art and Modernist sculpture.

10 A HOLIDAY

1 On the West Sussex coast.
2 Four miles inland from Littlehampton, Arundel Park is a vast expanse of open downland on the edge of the South Downs.
3 A performance by the Queen's Hall Orchestra directed by Sir Henry Wood, at the Queen's Hall, Langham Place, Westminster.
4 French for 'café with prostitutes'.
5 *Female Figure (Venus)*, Manchester Art Gallery (Silber cat. 50).
6 Aristide Fabbrucci (here miss-spelt by Gaudier) was an Italian sculptor and stonemason. He occupied one of the five studios at 454a Fulham Road, where he met Gaudier. From late October 1913 they shared a studio under the Putney railway bridge (Arch 25, Winthorpe Road). Their amicable relationship is reflected in Fabbrucci's lending Gaudier ladders, modelling stands and a turntable, as well as making stone offcuts available to him. He also rescued Gaudier when, according to Ezra Pound's account, he got his hand trapped under a large piece of stone.
7 Bob Rider.
8 Gaudier's landlord at the Fulham Road studios.
9 The private view of the *International Society of Sculptors, Painters and Gravers' Autumn Exhibition* at the Grosvenor Gallery, Bond Street. Gaudier exhibited one sculpture, *Crouching Male Figure* (location unknown; Silber cat. 33).
10 Joseph Joel Duveen, Baron Duveen (1869–1939) was among the most influential art dealers of all time. Having accumulated enormous wealth dealing in Old Masters, he made important donations of artwork to many British galleries, and funded large extensions to the British Museum and the Tate Gallery (both named after him).
11 Ede misdates this letter, which was written on 10 October.
12 Bob Rider.

11 PEOPLE AND EXHIBITIONS

1 Gaudier refers here to the *Sixth Salon of the Allied Artists Association*, at the Royal Albert Hall, where he showed *Wrestler* (Silber cat. 32) and five other pieces. The 'girl' was the Bloomsbury artist and writer Nina Hamnett (1890–1956), whose work was also in the exhibition. For confirmation see Hamnett's book *Laughing Torso* (Kessinger, London, 1932; Virago, London, 1984, pp. 38–43).
2 French for 'my [Nina], who is poor'.
3 The artist and writer Roger Fry (1866–1934) opened the Omega Workshops in the

summer of 1913. Based at 33 Fitzroy Square, Bloomsbury, Omega combined showrooms with studios, providing artists with both an affordable place to work and a commercial outlet for their creations. Having struggled financially for six years, it closed in 1919.

4 Kettle's Yard, Cambridge.

5 Dartington Hall, Totnes (Silber cat. 56).

6 The *Second Grafton Group Exhibition* opened on 2 January 1914 at the Alpine Club Gallery on Mill Street, off Conduit Street, Piccadilly. Founded the previous year, the Grafton Group was an exhibiting society whose members were at this time Roger Fry, Duncan Grant and Clive Bell. Other artists, including Gaudier, were invited to exhibit alongside them.

7 *Red Stone Dancer* (Tate, London; Silber cat. 69), *Boy* (Dartington Hall, Totnes; Silber cat. 56), *Crouching Fawn* (Ivor Brake; Silber cat. 62), *Cat* (Collection Brunneburg; Silber cat. 70) and *Water Carrier* (private collection, on long-term loan to the Emerson Gallery, Hamilton College, Clinton NY; Silber cat. 74).

8 Now Tate, London.

9 Ede refers here to *Torso I* (Tate, London; Silber cat. 61), which was not shown at the Alpine Club but was in an exhibition of the London Group at the Goupil Gallery, in March 1914.

10 *Amour*, Tate, London (Silber cat. 35).

11 The novelist Sydney Alfred Schiff (1868–1944) was a well-known London socialite and a friend of some of the most important artists working in England and France in the 1910s and 20s.

12 Now at Tate, London (Silber cat. 58).

13 Stanley Casson, *Some Modern Sculptors*, Oxford University Press, London, 1928, p. 98.

14 The American poet Ezra Pound (1885–1972) was one of the most prominent figures of Modernist literature. When he met Gaudier he was involved in the Imagist movement and had already developed a strong interest in the visual arts. In 1914 he was, with Gaudier and Wyndham Lewis, one of the founders of Vorticism, coining the movement's name. His 1916 homage (*Gaudier-Brzeska: A Memoir*, John Lane, London, 1916) describes in detail his friendship with the sculptor and the artistic developments around them.

15 The box (private collection; Silber cat. 72) was commissioned by Ezra Pound for presentation to the poet and diplomat Wilfrid Scawen Blunt (1840–1922). Gaudier carved it in less than two weeks, and when it was presented to Blunt at a dinner on 18 January 1914, it contained scrolls of dedicatory verses by Pound, W.B. Yeats, Thomas Sturge Moore, John Masefield, Victor Plarr, Frederic Manning, Richard Aldington and F.S. Flint.

16 The *Head of Ezra Pound* (also known as *Hieratic Head of Ezra Pound*, Raymond Nasher Collection, Dallas TX; Silber cat. 79) was commissioned by the poet in January 1914. It was first shown in May 1914 in the exhibition *Twentieth Century Art* at the Whitechapel Art Gallery, London.

17 French for 'What! Are you thinking of taking this dirty piece of furniture? Ugly old woman – why not take the forks, or your chest?'

18 Art Institute of Chicago (Silber cat. 77).

19 The London Group was founded in 1913 by radical young artists (including Epstein,

Gaudier and Wyndham Lewis) to create an exhibiting forum for several avant-garde groups. Its first official exhibition was held in March 1914 at the Goupil Gallery, 5 Regent Street.

20 Pound's friend and the two charms have not been identified.

21 Gaudier exhibited five works: *Stags* (Art Institute of Chicago; Silber cat. 77), *Redstone Dancer* (Tate, London; Silber cat. 69), *Boy with a Coney* (Collection Brunnenburg; Silber cat. 76), *Caritas (Maternity)* (Musée des Beaux Arts, Orléans; Silber cat. 75) and *Torso I* (Tate, London; Silber cat. 61).

22 Paul George Konody (1872–1933), art critic, writing in *The Observer*, 8 March 1914.

23 In Sophie's *Matka*, Cambridge University Library, folio 152b.

12 THE WAR

1 At 185 Munster Road, Fulham.

2 Frank Harris.

3 Marie Borne, a French teacher, met Sophie and Henri in Littlehampton in September 1913. Nothing is known of her sister. Gaudier made a head portrait of her (*Mlle. Borne*, location of the original plaster unknown; at least seven bronze casts exist, one at Kettle's Yard, Cambridge; Silber cat. 106).

4 Thomas Ernest Hulme (1883–1917) was an English poet and philosopher. He met Ezra Pound in 1908 at The Poets' Club, which he had co-founded with the aim of instigating a revolution in English poetry. He later became interested in philosophy and the visual arts, translating into English texts by Henri Bergson, Georges Sorel and Wilhelm Worringer, and supporting artists such as Jacob Epstein and David Bomberg. He met Gaudier in 1914, contributing with him, Pound and Wyndham Lewis to the birth of Vorticism and the publication of the journal BLAST.

5 Rheims.

6 John S. Currie (c.1884–1914) was a portrait painter and a member of the New English Art Club. On 9 October 1914 he shot his mistress Dorothy O'Henry and himself at their home in Hampstead. She died at the scene, he a day later at the Chelsea Infirmary.

7 'We all admired Gaudier, not only for his courage, which was legendary, but also and above all for his quick intelligence and the high opinion he had of his duties. ... In my Company he was loved by all, and I held him in high esteem because in those days of trench warfare I was sure that, thanks to the example he set to his comrades, wherever Gaudier was the *Boches* [Germans] would not get through.'

List of illustrations and concordance

The illustrations in this new edition of the *Savage Messiah* are those H.S. Ede originally included in the 1929 manuscript version of his book, with the exception of the 'Page from Anatomical Notebook'. These original photographs and drawings have all been especially re-photographed in the Henry Moore Institute, where the manuscript is housed, and reprinted here, in ways that show their archival context. Several are shown for the first time, including a number of previously unknown drawings and sketches that appear on the verso of other drawings. In those few instances where a drawing is a copy, the location of the original is provided where known. The ordering is based on that chosen by Ede for both the 1929 manuscript and the 1930 Heinemann edition of his book.

Each of the captions in the list of illustrations below begins with the title originally used by Ede in 1930. Where a work was not listed, we have provided either a new descriptive title or Gaudier's own. At the end of each entry and in brackets, we have provided the reader with more up to date titles of works, where appropriate. Finally, we have provided a concordance listing the page number where the illustration appears in the 1929 manuscript (MS) and the 1930 Heinemann edition (H).

p. 98 'The Madonna': MS: 148; H: XV (*The Madonna of 'The Miracle'*, 1912).

p. 100 'Major Smythies': MS: 150; H: XVI (*Major Smythies*, 1912).

p. 102 'Woman and Child': MS: 153; H: XVII (*Maternity* or *La mendiante*, 1912).

p. 104 'Enid Bagnold': MS: 155; H: XVIII (*Enid Bagnold*, 1912).

p. 106 'Henri': MS: 160; H: XIX (*Self-Portrait/Henri Gaudier-Brzeska, à Mme Hare, Noël 1912*, 1912). Original drawing in National Portrait Gallery, London.

p. 121 'Jungle Cat': MS: 185; H: XXI (*Cheetah* or *Jungle Cat*, 1912).

p. 126 'Drawing for the Dante Translation': MS: 192; H: XXIV.

p. 131 'Sisik and Niemczura': MS: 199; H: XXII. Drawing in letter from Henri Gaudier to Sophie Brzeska, 31 October 1912.

p. 132 'Sisik in Her Tub': MS: 199; H: XXIII (verso of p. 131). Drawing in letter from Henri Gaudier to Sophie Brzeska, 31 October 1912.

p. 134 'Torsos': MS: 202; H: 125. Original drawing in letter from Henri Gaudier to Sophie Brzeska, 3 November 1912, The Albert Sloman Library, University of Essex.

p. 135 Drawing: MS: 204; H: not incl.

p. 136 'Sisik: pipik': MS: 205; H: XXV (verso of p. 137).

p. 137 'La Maison de Rodin à Meudon': MS: 205; H: 43 (verso of p. 136).

p. 139 'Zosisik a beaucoup des sous': MS: 209; H: 129.

p. 141 'Seated Fawn': MS: 210; H: XXVI (*Crouching Fawn*, 1913).

p. 143 *Firebird*, 1912: MS: 215; H: not incl.

p. 146 'Zosik': MS: 219; H: 135.

p. 152 'Marble Dog': MS: 177; H: XXVIII (*Dog*, 1914).

p. 156 'The Life Class': MS: 236; H: 146. Original drawing in letter from Henri Gaudier to Sophie Brzeska, 28 November 1912, The Albert Sloman Library, University of Essex.

p. 160 'Wrestlers': MS: 243; H: 150. Original drawing in letter from Henri Gaudier to Sophie Brzeska, 3 December 1912, The Albert Sloman Library, University of Essex.

p. 161 'The Wrestler': MS: 242; H: XXIX (*Wrestler*, 1912).

p. 165 'Head of a Man': MS: 248; H: XXX (*Head of Christ*, 1913).

p. 168 'Mr. Frank Harris': MS: 255; H: XXXI (*Bust of Frank Harris*, 1913).

p. 171 'Brodzky': MS: 259 (photograph missing); H: XXXII (*Portrait of Horace Brodzky*, 1913).

p. 175 'La Chanteuse Triste': MS: 266; H: XXXIII (*Singer*, 1913).

Colour plates

'Tiger's Head', 1907

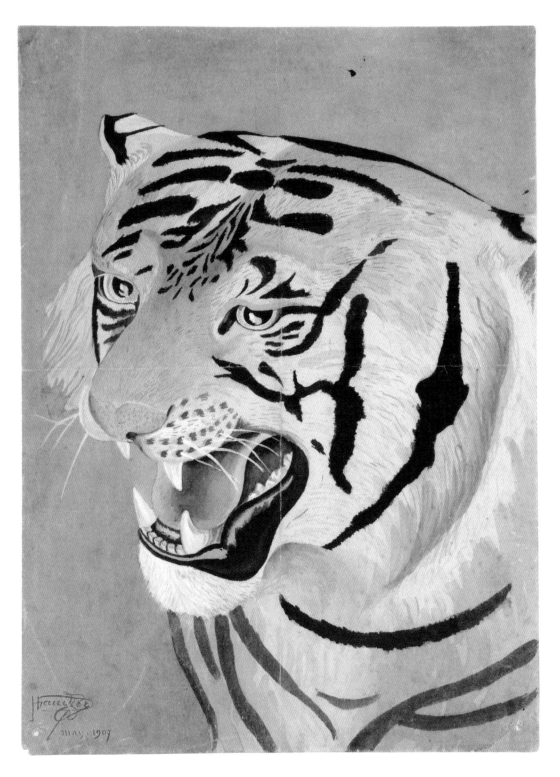

TOP *Llandaff Cathedral, c.1908*

ABOVE **The Severn, Monmouthshire from Aust**, 5 August 1908

Shrine in St James's Gardens. Bristol, 4 August 1908

Ye Olde Dutch House – Bristol.

'Drawing from Bristol Sketch Book', 25 August 1908

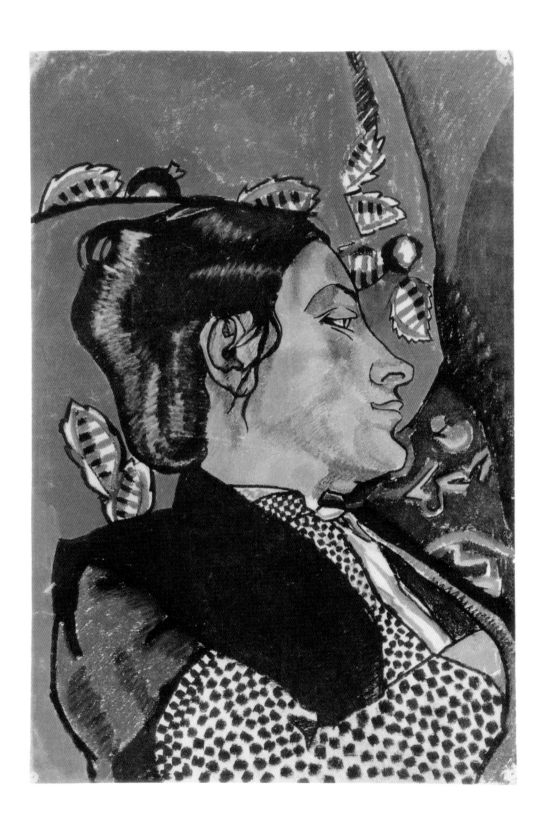

'Zosik' (*Sophie Brzeska*), 1913

'Pink Roundel' (*Design for a Medallion*), *c.*1914

'Green Cock', c.1914

'Blue Roundel' (*Design for a Medallion*), *c*.1914

Design for a Medallion, *c.* 1914

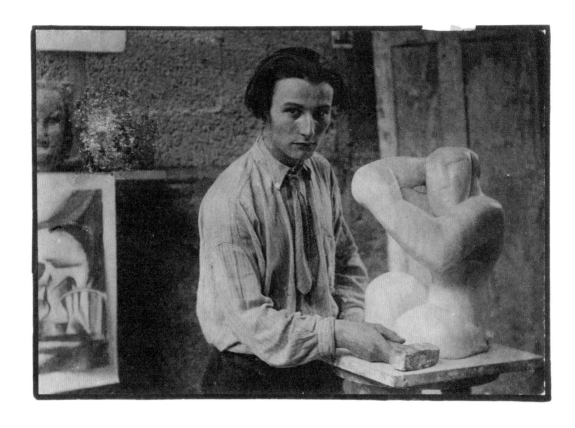

'Portrait of Gaudier, with statue', by Edward Cahen, 1914

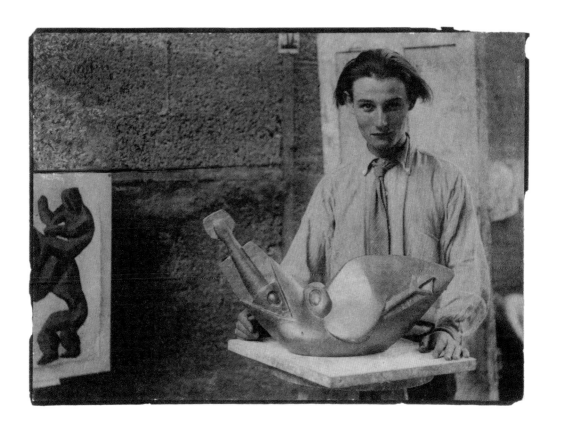

'Portrait of Gaudier, with statue', by Edward Cahen, 1914

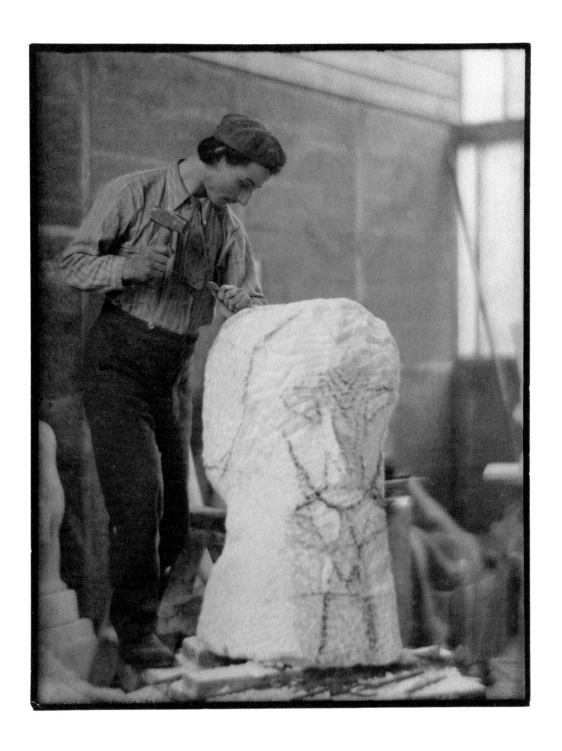

'Gaudier working on the Ezra Pound statue', by Walter Benington, 1914

Each edition of *Savage Messiah* published over the last eighty years shows a different approach to cover design and in turn to the image and concept of the book itself. On the cover of *A Life of Gaudier-Brzeska* (1930) we find an embossed rendition of the sculptor's own signature. This serves to highlight the fact that the book contains Gaudier-Brzeska's own words, whilst also suggesting that the publication has his authorial involvement and carries his quasi-autobiographical stamp of approval. This strategy was used again for the cover of the first edition of *Savage Messiah*, published a year later. Retrospectively, it can be read as echoing Ezra Pound's *Gaudier-Brzeska: A Memoir* (1916), which used an impressed image of Gaudier-Brzeska's own *Green Stone Charm* (1914) for the cover. It also anticipates the cover of Horace Brodzky's *Henri Gaudier-Brzeska* (1933) for which the artist's own 'HG-B' monogram was employed.

In the editions that follow text is generally replaced by image, as publishers opted for Gaudier-Brzeska's self-portraits. This again evokes the autobiographical, as well as providing readers with an image of Gaudier-Brzeska in his own hand. The pastel *Self-Portrait* (1913) provides a devilish image of the artist that coincides with Ken Russell's 1972 film. The 1979 Gordon Fraser edition uses a small drawn self-portrait of 1912. This drawing was also used by S.W. Hayter in 1967 for a medallion which was commissioned by the French Mint to commemorate the fiftieth anniversary of Gaudier-Brzeska's death. The image of the sculptor lighting a cigarette, which featured on the cover of the 1987 Gordon Fraser reprint, was taken from the small collection of limited edition prints accompanying the 1930 *A Life of Gaudier-Brzeska*.

A Life of Gaudier-Brzeska,
London: Heinemann, 1930

Savage Messiah,
London: Heinemann, 1931

Savage Messiah,
New York: Knopf, 1931

Savage Messiah,
New York: Literary Guild, 1931

Savage Messiah,
New York: Knopf, 1941

Savage Messiah,
London: Gordon Fraser, 1971

Savage Messiah,
London: Outerbridge & Lazard,
1971

Savage Messiah,
London: Sphere Books Ltd
(Abacus edition), 1972

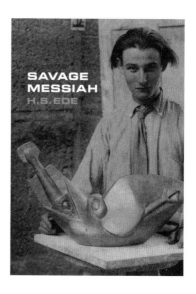

Savage Messiah,
London: Gordon Fraser, 1987
(reprint of 1971)

Savage Messiah,
Cambridge: Kettle's Yard; Leeds:
the Henry Moore Institute, 2011

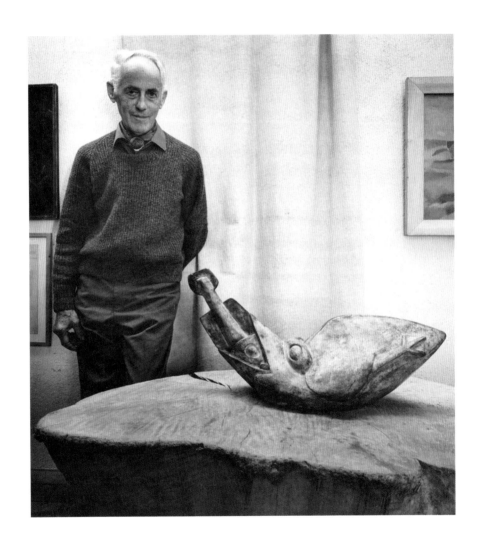

H.S. Ede with Gaudier's *Bird Swallowing a Fish*, Kettle's Yard, *c.*1970

'Something about an artist, and poverty and love and London': the story of the *Savage Messiah*

SEBASTIANO BARASSI and JON WOOD

Born in 1895 in Penarth, near Cardiff, Harold Stanley 'Jim' Ede always wanted to be an artist. In the 1910s and early 1920s he studied painting in Newlyn, Edinburgh and at the Slade School of Fine Arts in London. Forced to give up his creative aspirations by the need to earn a living, in April 1922 he joined the staff of the National Gallery, Millbank (then known only unofficially as 'Tate Gallery'), where he worked until 1936. Hired as an Assistant with responsibilities ranging from administrative tasks to commissioning postcards and cataloguing the collections, in time he became the most determined champion of modern international art on the National Gallery's staff. He facilitated the acquisition of works by Vincent Van Gogh and Pablo Picasso and advocated, albeit without much success, the inclusion in the collection of artists such as Constantin Brancusi, Georges Braque and Henri Rousseau. His interest in modern art motivated him to take on, alongside the Tate job, the role of Secretary of the Contemporary Art Society.

While holding such official positions, Ede liked to think of himself above all as a friend of artists. It was primarily through his friendships that he developed the ideas on art and gathered the collection which would later form the foundation of Kettle's Yard. In the inter-war years he frequently hosted at his home at 1 Elm Row, Hampstead, artists such as Ben and Winifred Nicholson, David Jones, Christopher Wood, Barbara Hepworth and Henry Moore, and he was in regular contact with others in Paris, most notably Constantin Brancusi and Joan Miró.

Ede relished the idea of collecting works by artist-friends, in particular those who shared his taste for everyday and natural objects such as shells, pebbles and bones. It was this very interest that drove his instantaneous appreciation of the combination of natural and mechanical forms, in rough stone fragments and geometric design, that he found in the work of the French-born sculptor Henri Gaudier, known then, as often today, as Henri Gaudier-Brzeska. Gaudier had been killed on the French front in June 1915. On his death, all his possessions, including the contents of his London

studio, had been inherited by his partner, the Polish-born Sophie Brzeska, thanks to a private arrangement sanctioned by a document signed by Henri on his departure to the front. In the following years Sophie, who was an aspiring author, did what she could to promote Gaudier's work. However, the shock of his premature death caused a rapid deterioration of her health and in 1922 she was interned in a mental hospital in Gloucester, where she died intestate in March 1925, aged 53. Given its size and in the absence of known heirs, the State became the beneficiary of Brzeska's estate. In addition to her personal belongings, it included sculptures, paintings, drawings, notebooks and sketchbooks by Gaudier, as well as most of her own papers. In April 1926, with all searches for a next of kin having failed, Gaudier's works and Brzeska's papers were offered to the National Gallery; soon after they arrived at Millbank and were first seen by Ede.

He described the circumstances of this encounter in *A Way of Life*, his 1984 book about the genesis of Kettle's Yard:

In that same year [1926] I first heard of Gaudier-Brzeska. A great quantity of his work was dumped in my office in the Tate: it happened to be the Board room and the only place with a large table. It was ten years after Gaudier's death and all this work had been sent to many art experts for their opinion, and London dealers had been asked to buy. It had become the property of the Treasury, and the enlightened Solicitor General thought that the Nation should acquire it, but no, not even as a gift. In the end, I got a friend to buy 'Chanteuse Triste' for the Tate, I subsequently gave three to the Contemporary Art Society, and three more to the Tate. It took some doing to persuade them to accept even this, and the rest, for a song, I bought. Since then it has seemed my task to get Gaudier established in the rightful position he would have achieved had he lived into the present time.[1]

Ede's account overlooks, perhaps understandably, some of the more problematic circumstances surrounding the acquisition of the estate, and exaggerates his role in the distribution of works to the Tate and the Contemporary Art Society.[2] In fact, after an abortive attempt by the Treasury to sell the

1 H.S. Ede, *A Way of Life: Kettle's Yard*, Kettle's Yard, Cambridge, 1984, p. 16.
2 A detailed account can be found in Roger Cole, *Gaudier-Brzeska: Artist and Myth*, Sansom & Co., Bristol, 1995, pp. 187 ff.

entire collection through commercial channels, the Tate agreed, somewhat reluctantly, to take 3 sculptures and 17 drawings on permanent loan. The Contemporary Art Society, of which Ede was Secretary, selected 3 sculptures and 18 drawings for distribution to public museums and galleries.

What remained were 19 sculptures, 13 oil or pastel paintings, 1,595 drawings, a few sketchbooks and notebooks, several letters from Henri to Sophie, her diaries from 1915 to 1922 and her creative writings. All this was purchased by Ede for £60, which was a modest sum given the size of the estate, but which represented a substantial portion of his annual income of around £260.[3] To avoid accusations of misconduct – the acquisition of the estate by a civil servant would have been seen as improper – the purchase was made by a friend of Ede's, the American artist Edward McKnight Kauffer, who then sold everything on to him.

As he began to read the correspondence and diaries, Ede became fascinated, one might say obsessively so, with the story of Henri Gaudier and Sophie Brzeska. He soon began to draft plans to turn it into a book. The first step was to acquire from the Treasury the copyright for the papers and artworks. This he did in 1929, again with the help of McKnight Kauffer. The publication was part of Ede's plan to promote Gaudier's oeuvre, which, following the initial boost given it by the efforts of Sophie and Gaudier's friends, notably Ezra Pound,[4] was at risk of fading into obscurity. For Ede such a danger was highlighted by the Tate's handling of the estate's acquisition, which deeply disappointed him. He felt that by treating Gaudier's work with indifference the Tate had neglected its duties, especially since the 1917 Curzon Report had recommended that its remit should be broadened to include the modern and contemporary work of foreign artists. In fact, it appears that the Tate's frosty reception to Gaudier's work was due mostly to the troubled negotiations held in 1918 by the National Gallery's director, Charles Aitken, with Sophie Brzeska, following her offer (which was later withdrawn) to hand over some of Gaudier's works to the Gallery

3 Based on the Retail Price Index, £60 of 1927 is equivalent to £2,700 of 2011; using the Average Earnings Index it is equivalent to £11,500.

4 Pound published the first book on the sculptor, *Gaudier-Brzeska: A Memoir*, in 1916. Two years later he wrote a text for the catalogue of the *Memorial Exhibition* organised by Robert Bevan and Stanislawa de Karlowska at the Leicester Galleries in London.

for safe-keeping.[5] Ede's feelings were no doubt coloured by his growing unease with some of the Tate's policies, and by his belief that he had a far better understanding of recent art than most of his superiors.

His confidence in the value of Gaudier's work, coupled with a sense of ambition and responsibility for it, meant that for the rest of his life Ede relentlessly championed the sculptor's oeuvre. He did this by giving works to museums and galleries,[6] by enthusiastically supporting exhibitions, films and publications, and finally by creating, with Kettle's Yard, a space to display and celebrate sympathetically the artist's work.

The publication of the biography now widely known as *Savage Messiah* represented by far the most important of Ede's contributions to the promotion of Henri Gaudier-Brzeska as a major modern sculptor. His first idea had been to write a book about Sophie. However, Gaudier's central role in her life and Ede's admiration for his work shifted the focus towards both of them, with the sculptor eventually becoming the main protagonist. Ede evidently found Brzeska's character overwhelming and thus, from a personal point of view, a difficult subject on which to focus his narrative. As he explained, 'the intensity of [Sophie's] emotions, and the setting upon her of the madness, which in 1922 enveloped her, have overpowered me. For ten years I have approached nearer and nearer to her personality; hoping to grow sufficiently accustomed to her strange life to be able to enter into it without becoming absorbed; but always I have recoiled.'[7]

In 1928 Ede began to translate and organise the materials he had acquired, endeavouring to give them narrative shape. Soon he began to correspond with those friends and relatives of the couple he was able to locate,

5 Frances Spalding, *The Tate: A History*, Tate Publishing, London, 1998, p. 56.
6 Ede gave one sculpture, some 50 drawings and Gaudier's tools to the Musée des Beaux Arts, Orléans, in 1956; one original sculpture, 12 posthumous casts, 40 drawings, one print and one sketchbook to the Musée national d'art moderne, Paris, in 1964, towards the creation of the *Salle Gaudier-Brzeska*; 6 drawings, 34 letters and Sophie's diaries and creative writings to the University of Essex in 1964; 12 casts from original sculptures and 6 drawings to the Tate Gallery between 1966 and 1974. Other beneficiaries of Ede's gifts in the 1960s were the National Gallery of Scotland, City Art Museum St. Louis, Albright-Knox Art Gallery Buffalo, Museum of Fine Arts Boston, Kunsthalle Bielefeld, the universities of Manchester, Warwick and Sheffield, and Cardiff City Council.
7 H.S. Ede, *An Odd Woman*, manuscript, 1930s, Kettle's Yard Archive, Cambridge (published in Appendix 1).

and to collect the information necessary to fill in the gaps about their lives. There were many of these, since the correspondence and diaries in his possession only covered the last few years of Gaudier's and Brzeska's lives. Interestingly, Ede decided to concentrate on the couple's troubled life as struggling artists, with primary focus on their relationship and their fight to have their artistic achievements recognised. This choice may have been determined by the existent publication on the sculptor, Ezra Pound's 1916 *Memoir*, which was the only substantial piece of writing on Gaudier available at that time. Pound had written from the point of view of a friend as well as an art critical champion, using many of the sculptor's own writings, including articles, reviews, manifestos and correspondence with friends, though excluding Sophie. As a counterpoint to this, Ede decided to concentrate on the couple's lifestyle and relationship. This point was mentioned by a number of the reviewers of the book in the early 1930s. Frances Warfield, for example, reviewing the Knopf edition in *Forum* in 1931, wrote:

The book, an invaluable addition to Ezra Pound's memoir, which appeared in 1916, has been published appropriately in companion size to Pound's; the two are interdependent. The older book is Pound speaking – of the delightful, erudite young madman whose promise of genius he recognized and encouraged before it was too late. The new one is Gaudier only – Gaudier and Miss Brzeska, the dry, possessed Polish woman with whom he maintained a jarring platonic relationship through five years of adoration and exasperation and whom he probably would have married.[8]

Ede was determined to make the publication a success and sought the advice of some influential friends, including T. E. Lawrence 'of Arabia' and the novelist Arnold Bennett. Both offered Ede encouragement and guidance on literary style and publishing matters. Lawrence also acted as a reader,[9] and his comments were largely enthusiastic. In one letter to Ede, he spoke of the book as 'a remarkable work. So loose and yet so full of form. It exactly fits its subject [...] You get across to those who read it a most

8 Frances Warfield, 'New Bohemians', in *Forum*, May 1931.
9 Ede began corresponding with Lawrence after reading *Seven Pillars of Wisdom*. Lawrence found Ede's comments on the book useful, and a friendship ensued. In 1928 Ede read the manuscript of Lawrence's memoir *The Mint* (which remained

living portrait of these people.'[10] Later he suggested that the book should be entitled ' "a boy and a woman" yes: with subtitle "Study in the relations of H. G-B and Mlle B." or something about an artist, and poverty and love and London.'[11] Bennett negotiated with publishers on Ede's behalf, eventually securing contracts in Britain and the United States.

Ede initially contacted David Garnett at Nonesuch Press as a possible publisher. Garnett offered useful advice on the contents of the book, and his correspondence with Ede suggests that an agreement for the publication was reached.[12] However, this arrangement collapsed as Ede, in the meantime, had approached two other publishers: John & Edward Bumpus and William Heinemann. In the end the book was published in November 1930 by Heinemann, with the title *A Life of Henri Gaudier-Brzeska*. It was produced as a limited, numbered edition of 350 leather-bound copies, and sold at fifteen guineas. In addition, the first ten copies, priced at fifty guineas, were signed by Ede and each contained one original drawing by Gaudier. Sales of this edition were extremely disappointing. According to Heinemann, only 23 copies were sold in the first year (of which 18 to Ede himself), and the publisher made a loss of £1,250.[13]

Meanwhile, Ede also secured a contract with Alfred A. Knopf for the publication of the book in the United States. Worried about Gaudier being almost unknown in the States, Knopf pressed Ede for a catchier title. Bennett suggested 'Savage Messiah', a reference, taken from chapter 9, to one of the nicknames given to Henri by Sophie and Horace Brodzky. Knopf and Ede both liked it, and 'Savage Messiah' became the final title of the book. It was published in the United States in February 1931, and in March 1931 the Literary Guild of New York made it its Book of the Month. This involved the distribution of 55,000 copies to members, which contributed to making the book an unexpected success, with total sales in

unpublished), writing extensive, page-by-page notes on it. Soon after their first meeting in February 1929, Ede gave Lawrence the typescript of Gaudier's biography for his comments. Over the next four months Lawrence read the book twice and sent Ede his comments in numerous letters (Kettle's Yard Archive).
10 T.E. Lawrence to H.S. Ede, 3 June 1929, Kettle's Yard Archive.
11 T.E. Lawrence to H.S. Ede, 2 January 1930, Kettle's Yard Archive.
12 Kettle's Yard Archive.
13 C.S. Evans (Heinemann) to H.S. Ede, 26 November 1931, Kettle's Yard Archive.

America thought to have reached 80,000 copies.[14] The popularity of the book explains why in 1935 it became the subject of a play, also called *Savage Messiah*, which was written and performed in Philadelphia, without Ede's knowledge (he first found out about it in the 1970s).[15]

Encouraged by the American sales, in April 1931 Heinemann published in Britain a cheaper, 'popular' edition of the book, complete with the new title. This had already been planned alongside the deluxe version and proved a moderate success, with the first print-run of 2,000 copies selling out within a month.

Compared with the deluxe volume this was a much more modest and affordable publication.[16] Ede clearly thought the two quite different. He believed the deluxe edition better reflected the quality of Gaudier's work, whereas the smaller, popular version better conveyed the romantic love story, as he commented in his introduction to the latter:

In publishing this cheap edition of what is the real book, namely, 'A Life of Gaudier-Brzeska', I had forgotten that its setting would be entirely different so necessitating some alterations to the text. The original book was designed to go to some 300 people all of whom, presumably, would know Mr. Ezra Pound's 'Life of Gaudier-Brzeska'. I had therefore felt it unnecessary to speak of Gaudier's work, hoping rather that the eighty or more magnificently produced illustrations, placed in careful conjunction with the text, would speak for themselves, and so I devoted myself only to the human aspect of Gaudier's life which to my mind has so much of the piercing quality of his sculpture. In 'Savage Messiah' his work is scarcely reproduced at all and so the thing becomes one-sided, leaving unknown, to those who do not look for it themselves, the great essential of his life – his artistic achievement.[17]

The main editorial difference between *A Life of Gaudier-Brzeska* and *Savage Messiah* was the number and quality of illustrations. There were

14 The figure is mentioned by an unidentified writer from the Black Sun Press, Paris, in a letter to Ede dated 11 June 1931 (Kettle's Yard Archive). Alfred A. Knopf reprinted the book in 1941 and in 1969, the latter in the *Vintage* series.

15 Marc Berlin (London Management) to H.S. Ede, 18 May 1972, Kettle's Yard Archive.

16 The first Heinemann edition was a substantial volume (35 × 28 cm) with 67 collotype reproductions of drawings and 24 illustrations in the text.

17 The full text is in Appendix 1.

also a few minor textual changes, mostly corrections of the spelling of foreign words. However, as Ede pointed out, the different weight of the illustrations in the two editions had a major impact on the overall feel of the text, with the emphasis shifting from art book to biographical novel. Such a shift is also evident in the changing tone of the reviews of the two editions. For example, E. M. Forster opened his piece on *A Life of Gaudier-Brzeska* in *The Spectator* by suggesting that 'This is not a book which the artist himself would ever have bought. Printed on hand-made paper, with sixty-seven collotype plates and numerous illustrations in the text, it would not have appealed to a young man who often had nothing to eat ... He now appears embalmed in dainty and dignified pages.'[18] On the other hand, the majority of reviews of *Savage Messiah* seized on the vivid account of poverty that the book provided and the emotional turmoil that charged Henri and Sophie's relationship. The *Sphere London* critic wrote: 'If you dislike reading about unbalanced, untidy people, avoid this book. Here is sordidness, a sordidness of packing-case furniture, bed-bugs, drunken landladies and empty stomachs.'[19] Many dealt with the authorial position and approach that Ede adopted. T. W. Earp, writing in *The New Statesman*, attacked the 'hybrid form of biographical fiction or of fictionary biography' that *Savage Messiah* represented for him, arguing that Gaudier had become the newest victim of this current trend.[20] He ended his review by attacking the book's more risqué passages, accusing Ede of what he called 'castitaphobia', which he playfully defined as 'a form of dangerous reaction from the old Victorian prudery.'[21] Clemence Dane, writing in *The Book Society News*, attacked Ede's novelistic style: 'A biographer should never put possible thoughts in the mouth of a subject, or describe probable ideas, actions and reactions, however much he may be convinced that the people concerned did so feel, think and behave'.[22] Two reviewers who both knew Gaudier personally, Richard Aldington and Rebecca West, wrote positively about the book and the strategy Ede took. Aldington stated: 'For several

18 E.M. Forster, 'An Artist's Life', in *The Spectator*, 25 April 1931, p. 669.
19 *Sphere London*, 2 May 1931.
20 T.W. Earp, 'Through the Keyhole', in *The New Statesman*, 2 May 1931.
21 *Ibid.*
22 Clemence Dane, *The Book Society News*, 1931, p. 6.

reasons I am glad that Mr. Ede has written this successful book about Henri Gaudier and Miss Brzeska. It will cover gaps for those who knew Gaudier as an acquaintance, and even for those who knew him well; while, for the greater number who never saw him, the book provides an excellent sketch of a tragical life-history, one of the innumerable personal tragedies of the War.'[23] Rebecca West wrote in *The Daily Telegraph*:

The young woman who wants her family to let her go to the Slade had better not take 'Savage Messiah'. But it is to be highly recommended to all others for its amazing vivid representation of how the human mind really works as from the way that on the basis of rational probabilities we suppose it to work. It is, in particular, one of the most interesting books about an artist ever written, because Mr. H.S. Ede has been able to avail himself of uniquely informative material.[24]

It is difficult to assess whether in all *Savage Messiah* was a commercial success. It received positive reviews in important daily papers and literary magazines on both sides of the Atlantic, appearing on the bestsellers' list of at least three newspapers.[25] Several publishers showed an interest in producing foreign language editions and approached Ede, though none of these enquiries resulted in publication.[26] Ede considered sales altogether disappointing,[27] and his view was shared by the New York offices of Alfred Knopf.[28]

In 1936 Ede left the Tate Gallery. He spent the following twenty years living with his wife Helen between Morocco, the United States and France,

23 Richard Aldington, 'A Tragical Life-History: The Idealism and Artistic Sincerity of Henri Gaudier', in *Referee London*, 17 May 1931.

24 Rebecca West, 'The Pursuit of Misery', in *The Daily Telegraph*, 1 May 1931.

25 See *The Daily Herald* (London) of 5 May 1931, *The Observer* (London) of 10 May 1931 and the *Daily News* (Colombo, Ceylon) of 30 May 1931.

26 In 1931 Curtis Brown Ltd. enquired about Swedish rights; Jespersen og Pio Forlag about Danish-Norwegian rights; E.P. Tal & Co. of Vienna and C.H. Beck'sche of Munich about German rights; Éditions Bernard Grasset and William Aspenwall Bradley about French rights.

27 In response to a lost letter from Ede, on 10 June 1931 Lawrence wrote: 'I'm most sorry that it has not sold hugely. It deserved to: it is a really good book. The British Public is a queer chancy thing. I had, in my heart of hearts, expected a boom in it, to about 25,000 or so.' (Kettle's Yard Archive).

28 See correspondence in the Kettle's Yard Archive.

funded by book income and lecturing. On his return to Britain in 1956, he started work on what he considered the 'mission' of his final years, the setting up of Kettle's Yard. This was his carefully designed Cambridge house, opened to all visitors interested in his collection of artworks, furniture and natural objects which, of course, included many of Gaudier's sculptures and drawings.

Around 1963, concerned with the need to raise funds for the running and the extension of Kettle's Yard, Ede started to make enquiries about the possibility of republishing *Savage Messiah* in Britain and in France.[29] The new British edition was a long-winded affair. The Gordon Fraser Gallery first expressed an interest in the book in late 1968, but negotiations with Heinemann (which still owned the copyright) and production problems delayed the publication until September 1971.[30] This edition consisted of 5,000 paperback copies, with an additional print run of hardbound copies for libraries.

Ede was also involved in two film projects on Gaudier: two documentaries directed by Arthur Cantrill for Firebird Films in 1968;[31] and the 1972 feature-length movie by Ken Russell based on *Savage Messiah*. Films also led to more books and in November 1972 Sphere Books was licensed by Gordon Fraser and Ede to publish an edition of 10,000 paperback copies to coincide with the release of Ken Russell's film, and to cater for the popular market. A still from Russell's film was used for the cover. That year a new American edition was also published, by Outerbridge and Lazard, whereas new negotiations for the French translation of the book again failed.[32] The resurgent interest in Gaudier in the 1970s was confirmed by other projects in which Ede was briefly involved: a radio play on Gaudier and Brzeska for

29 Kettle's Yard Archive.

30 This edition was reprinted by Gordon Fraser in 1979 and 1987.

31 The documentaries are entitled *Henri Gaudier-Brzeska* and *Henri Gaudier Brzeska Drawings*. The latter (16′ 28″) is silent, starts in black and white and ends in colour. It consists of a simple sequence of works on paper (drawings, sketchbooks and prints). The biographical film (28′ 33″) is narrated by Richard Bebb, with Daniel Monceau reading passages from Gaudier's letters and writings. The musical soundtrack was composed by David Lumsdaine and performed by the Pierrot Ensemble. Alternating black and white with colour sequences, the film combines images of sculptures, drawings, letters and Walter Benington's photographs of Gaudier.

32 Interest in a French translation expressed by Librairie Marcel Didier, Paris, is

BBC Radio 4 [33] and the erection in 1976 of a commemorative blue plaque at 454 Fulham Road, the site of one of Gaudier's studios.

Interest in Gaudier and his work was stimulated by the films, and Russell's in particular. These films all have close links to *Savage Messiah*, Ede and his promotion of Gaudier's work. Corinne and Arthur Cantrill, husband and wife, were Australian film producers who had been introduced to Gaudier's work by the Australian sculptor Robert Klippel. They were put in contact with Ede through Alan Bowness, and wrote to him at Kettle's Yard in early 1967 about their idea to do a documentary on the life and work of the sculptor. Writing to Ede that summer, Corinne Cantrill mentions *Savage Messiah*, though clearly referring to the earlier deluxe *A Life of Henri Gaudier-Brzeska* of 1930: 'We recently bought a copy of the *Savage Messiah* – one of the large, limited edition copies. A dreadful extravagance, it cost us £18. But it is a beautifully printed book and we love it. However, if a paperback had been available, we probably would not have bought it.' [34]

During their research for the films, they were in contact not only with Ede, but also with curators at the Tate and with Ethel Kibblewhite's granddaughter. They had also written (and heard back from) Ezra Pound.[35] Filming started in summer 1967, including a visit to Kettle's Yard, and finished in the early spring the following year. The biographical film was shown at the National Film Theatre in London on 4 April 1968, a screening that Ede attended, watching the thirty-minute documentary for the first time. It is difficult to say precisely what Ede made of the film, which innovatively employed electric turntables for the display of his sculpture (in a manner that recalls Brancusi), although it seems that he found the musical soundtrack too intrusive and distracting. Ede nevertheless bought a 16mm print of the two films in May 1968 for £100, for future use at Kettle's Yard.

mentioned in a letter from Madeline Jayne to H.S. Ede dated 7 December 1971 (Kettle's Yard Archive).

33 Written and produced by Maurice Leitch, *Savage Messiah* was broadcast on 27 April 1974, one of three episodes in the series *Real Life Love Stories*.

34 Corinne Cantrill to H.S. Ede, 18 July 1967, Kettle's Yard Archive.

35 Corinne Cantrill to H.S. Ede, 10 October 1967, Kettle's Yard Archive: 'we hope to go to Rapallo when it is convenient for him.'

Ede's experience of the Cantrill films, including the interest they attracted by bodies such as the Arts Council, the British Council/UNESCO and the BBC, no doubt gave him valuable insight into the ways in which the moving image could be used not only to promote Gaudier and his work, but also to secure additional funding for Kettle's Yard. He had seen the Firebird films as also serving this function, as Corinne Cantrill's letter to Ede regarding commercial rights reveals:

About lending your prints: it would be unwise to lend or use the prints in a commercial way at all. What type of commercial use did you have in mind, in any case? The commercial rights of the films rest with us, and when prints are sold, it is on a non-commercial and educational basis only. Did you have in mind to show the films to raise funds for Kettle's Yard or the University? If it were a charitable screening, obviously charitable, and the films were shown in one of the colleges or through one of the Film Societies, that should be straightforward. But please don't make the prints available to cinemas as a supporting film or anything like that, say in return for a donation. That could lead to difficulties. And it could get us into serious trouble for breach of agreements with our narrators.[36]

Not surprisingly, the commercial and promotional opportunities that the film industry offered informed the contact and relationship with the filmmaker Ken Russell. It was Ede who approached Russell, not the other way around. Russell at the time was the *enfant terrible* of the British film industry, widely known for *The Boy Friend*, starring Twiggy, and for the scandalous *The Devils*. Ede wrote to him in late 1967, during the time that Arthur Cantrill was working on the Firebird Films picture. Russell wrote back to Ede from his house in Ladbroke Square in London, following his approach, in January 1968, saying:

Thanks a lot for your letter and the enclosed review which I received from the BBC this morning. I seem to remember reading a life of Brzeska many years ago – I do not think it was your work, however – and suddenly it all became very vivid once more. I certainly think that it is a subject for a film

36 Corinne Cantrill to H.S. Ede, 30 May 1968, Kettle's Yard Archive.

and very much in the particular area in which I am interested. I gratefully accept your offer of the loan of a copy of your book. If you could send it to the above (private) address, I will read it at once and give you my immediate reaction.[37]

Having received *Savage Messiah*, Russell wrote again to Ede: 'Thank you for the book which I found very exciting. It would certainly make a very good subject for a television film and I would be very interested in discussing the matter further with you.'[38]

Although Ede tried (unsuccessfully) to invite Russell to the screening of the Firebird film on 4 April 1968, it is clear from the correspondence that both men saw the book as the main source for the film. It would not only share the same title, but it would also feature the works and rooms of Kettle's Yard itself. Filming eventually started in early 1972. Russell filmed at Kettle's Yard in April that year and Ede was paid £100 for the expenses occurred during those few days' filming. The close relationship between the film and the book was clearly envisaged by Ede as a means of promoting both the publication, which was often on sale at screenings, and Kettle's Yard, which it was anticipated would benefit from a percentage of the film's royalties. Copyright and royalties were complex between book and film rights, and Ede, Kettle's Yard, Heinemann, London Management and Ken Russell Films were all listed beneficiaries.

The film was released in September 1972. Russell wrote to Ede in person, reassuring him about potential reviews, the cast (regarding Scott Antony, who played Gaudier) and the credits:

It is a pity you can't see the film in London – the sound, picture and presentation will be so much better than in Cambridge. Thanks for your couple of letters. At the moment I'm feeling quite recovered but alas quite broke so won't be able to buy either of the Gaudiers – though I'd have liked the Duck very much. I shouldn't worry too much about the reviews of the film – I'm not particularly loved by the critics – in fact most of them hate my guts and would rather damn the film than praise it no matter what it was

37 Ken Russell to H.S. Ede, 25 January 1968, Kettle's Yard Archive.
38 Ken Russell to H.S. Ede, 'Monday' (no date), Kettle's Yard Archive.

like. Whatever you may feel about the appearance of the actor playing Gaudier he certainly <u>doesn't</u> look either prosperous or self-conscious in the film – that is one thing I can positively assure you of. Tomorrow I am off to America to promote the film. There is going to be a special showing at the Museum of Modern Art where I think they will have on show all the Gaudiers in their possession. And I will mention your <u>book</u> to all and sundry – press, T.V., radio and all. It <u>does</u> say based on the book by H.S. Ede on the screen credits, by the way, just in case you think we are not aware of your great contribution.[39]

Russell was clearly at pains to ensure that Ede did not feel sidelined or without credit for his role in the film. What the 77 year-old Ede himself made of the film is difficult to say. It seems, from his correspondence with friends, that he was a little disappointed by it, perhaps misjudging the kind of film that Russell would make. It also seems that Ede wanted the film to be amended. In a letter to Ede, Edward Patman from MGM EMI writes: 'I am afraid I have to tell you that there is no possibility of the film being altered or added to as you suggest.'[40]

It is also clear that the film was not quite the immediate commercial success that MGM had anticipated either. Patman writes:

As to the life of the film SAVAGE MESSIAH, I can tell you that it will eventually play in countries throughout the world, though at the present time it is not the success we had hoped it would be. It could be that the film is ahead of its time and that later audiences may appreciate it more. At the moment it is finding the going very difficult and we are very disappointed about this.[41]

The film was shown at the Venice Film Festival and also in Cambridge. It was released in the United States in autumn 1972 and Outerbridge and Lazard took the opportunity to advertise their new edition of the book. In the publicity in *The New York Times* in January 1973, Ede's *Savage Messiah* was advertised, with a photograph of Scott Antony as Gaudier, with reference to the Russell's film. *Newsweek* were quoted as saying that Russell's film 'succeeds

39 Ken Russell to H.S. Ede, no date, Kettle's Yard Archive.
40 Edward A. Patman to H.S. Ede, 27 December 1972, Kettle's Yard Archive.
41 *Ibid.*

in communicating the white-hot energies of the creative act.' And regarding Ede's book, Dorothy Parker was quoted as saying: 'Please, will you put down whatever that thing is that you're doing and read *Savage Messiah* … It is a great book. And you don't get "great" out of me for red apples.'[42]

In retrospect, looking back now almost forty years on, Russell's film provided Ede's 'great book', to quote Dorothy Parker, with an extraordinary, new lease of life and with access to a younger and more international audience than had hitherto been possible or imagined. Russell's and Cantrill's films also coincided, in the late 1960s and early 1970s, with a new international fascination with rebellious young artist. This was the period of conceptualism and of student uprisings, as well as celluloid teenage anti-heroes. *Savage Messiah*, on the page and on screen, captured the spirit of this cultural moment. From the 1970s Henri Gaudier-Brzeska would be called to mind as the Scott Antony – the Brixton Boy, Warren Beatty look-a-like and 1970s heart throb – as well as through those moody black and white photographs taken by Walter Benington, showing a goatee-bearded Gaudier in his studio.[43] Both images of the artist, one of 1914 and the other of 1972, are given voice and life, across time, through Ede's narrative. But if *Savage Messiah* gave Gaudier speech, then it also served to consolidate the idea, so central to Ede's first 1930 publication, that the life of Henri Gaudier-Brzeska and the work of Henri Gaudier-Brzeska were inseparable and always to be viewed in dialogue with one another, each informing and contextualising the other. This combination of art and life, central to the philosophy of Kettle's Yard and his collection, is arguably one of the central legacies of Ede's *Savage Messiah* and key to any assessment of this book's impact on our understanding of the art Gaudier left behind. Though a fiction – and a very well researched one at that – Ede's book reminds us that art is *of* artists, as well as *by* them, and that the personal and public circumstances of a work of art's making are central to its charge and meaning. Having read Ede's *Savage Messiah*, readers today will not only still go away with a good story in the heads, but will also acquire a way of imaginatively and sympathetically approaching the work that Gaudier made, seeing it both in the half-light of its time and in the light and layers of its subsequent, authorial appreciation.

42 *The New York Times*, Tuesday 16 January 1973.

43 *Daily Mail*, Thursday 10 February 1972, p. 15.

A feat of composition:
H.S. Ede's sources for *Savage Messiah*

EVELYN SILBER

An extraordinary opportunity fell into Jim Ede's lap when crates and trunks of Henri Gaudier-Brzeska's work arrived in the Boardroom of the National Gallery on Millbank in late June 1926.[1] Over and above the sculptures and huge cache of drawings, pastels and sketches there were personal papers. They included not only the letters Gaudier had written to Sophie Brzeska during their periods of separation from 1911 to 1914, but all her literary manuscripts. These comprised nearly 1,000 handwritten pages – drafts towards her planned autobiographical novel, headed 'Détails pour Matka', the journal postdating Gaudier's death headed 'A la très chère mémoire', together with short stories and other accounts of her life and relationship with Gaudier and its grievous aftermath. Most were written in French, a few pieces in English and Polish. Their vivid conversational style and emotional rawness gave the impression of eavesdropping on their lives and innermost thoughts. The quality of the material, disjointed and in parts harrowing, but rich in intimate reflection, detailed replays of trysts, visits and domestic incidents, persuaded Ede that he had the basis for a biography to complement Ezra Pound's 1916 *Gaudier-Brzeska: A Memoir*.

His correspondence with the Treasury Solicitor reveals that on 14 October 1927, within two months of his first proposing to purchase the remaining estate, Ede was negotiating for Sophie Brzeska's papers to be included with Gaudier's works as part of the estate which Edward

1 The papers may have followed in 1927, since in January 1929 Ede wrote to the Treasury, stating he had been sent Miss Brzeska's papers in 1927, and in the letter of 14 October 1927 in which he first states his intention of writing a life, also refers to 'Miss Gaudier Brzeska's papers which you had left with me.' (National Archives, London, TS17/1299 290510; published in Roger Cole, *Gaudier-Brzeska. Artist and Myth*, Sansom & Company, Bristol, 1995, pp. 212–14).

McKnight Kauffer was now purchasing on Ede's behalf: 'I am hoping later on to write a life of G.B. and these papers would be of great value to me in dating the various movements of his life...'[2] By September 1928 he already had a manuscript draft and by early 1929 it appears the Nonesuch Press was prepared to publish it.[3] By January 1929 Ede was pursuing the whereabouts of Gaudier's tools and missing correspondence; a journal written by Gaudier in Paris, Sophie Brzeska's letters to Gaudier and his wartime letters to her were the obvious lacunae; these were not found, though Gaudier's July 1914 *List of Works* did turn up. In March 1929 Ede got McKnight Kauffer to purchase the copyright for 5 guineas, thus safe-guarding himself as far as possible against subsequent claimants from the Gaudier family who might challenge the legitimacy of his ownership or use of the material.[4]

Ede's own *Preface*, reproduced both in the limited edition *Life* and in *Savage Messiah*, suggests that he is transmitting a transparent, unmediated account from which his own personality and views have been effaced:

I have personally met very few of the people mentioned in this book, and any remarks about them in no way denote my own feeling, but entirely those of Henri Gaudier and Sophie Brzeska.

My authority for what I have written has mostly been a Diary kept by Miss Brzeska, whose statements I have checked both with letters from Henri Gaudier and by conversations with people who knew them both.

2 Ede to the Treasury Solicitor, 14 October 1927, National Archives, London, TS17/1299 290510.

3 See Roger Cole, *Gaudier-Brzeska. Artist and Myth*, Sansom & Company, Bristol, 1995, p. 228.

4 The Brzeska estate papers are in the National Archives, London, TS17/1299 290510. A letter (8 February 1929) from Dr. Brown, the Treasury Solicitor, to Edward McKnight Kauffer points to the possible legal flaw: '... it is not known whether the copyright in Gaudier's writing was transferred to the deceased although the physical property in the documents no doubt passed to her. I am, however, prepared to sell and transfer to you such rights as the Crown may have in the copyrights in these writings for the sum of £5.5.0.' (reproduced in Roger Cole, *Gaudier-Brzeska. Artist and Myth*, Sansom & Company, Bristol, 1995, pp. 216–17). Already in July 1930, Germain Gaudier was enquiring what had happened to his son's work; see *ibid.*, p. 232.

In reality the book was an artfully edited interweaving of selected sources chosen to enhance its focus on the creative but emotionally fraught relationship between the protagonists, with Henri Gaudier-Brzeska and Sophie Brzeska as a latter-day Rodolfo and Mimi living *la vie de bohème* in Paris and London.[5] In the process other relationships are omitted or relegated to walk-on parts and Sophie Brzeska's views and literary accomplishment are paradoxically both promoted and subverted.

Pound's 1916 *Memoir* was Ede's starting point since it was the text through which Gaudier's life, achievements and reputation as an avant-garde artist who died young had hitherto been projected. Ede takes the quality of Gaudier-Brzeska's work to be self-evident from the photographs reproduced or assumes that his readers will have gleaned this knowledge from Pound. As he later stated:

The original book was designed to go to some 300 people all of whom, presumably, would know Mr. Ezra Pound's 'Life of Gaudier-Brzeska'. I had therefore felt it unnecessary to speak of Gaudier's work, hoping rather that the eighty or more magnificently produced illustrations, placed in careful conjunction with the text, would speak for themselves, and so I devoted myself only to the human aspect of Gaudier's life which to my mind has so much of the piercing quality of his sculpture.[6]

Pound had been outspoken in his characterisation of Gaudier as a sculptor, annexing him for the Vorticist cause and picking out for praise chiefly those works made during the period of their close friendship in 1913–14. He considered the 'squarish and bluntish' works, such as *Boy with Coney*, and abstract pieces, such as *Birds Erect*, to be more important for Gaudier's ultimate direction as an artist than the more traditional works – *Singer* and *Seated Woman [Grief]* – preferred by Alfred Wolmark, Horace Brodzky and Roger Fry.[7]

5 Originally published in the form of stories in a journal, Henry Murger (1822–1861) re-worked *Scènes de la vie de Bohème* as a play in 1849 and as a novel in 1851. It was the source for Giacomo Puccini's opera *La Bohème* (1896).

6 From the additional introduction to the 1931 British edition (see Appendix 1).

7 Ezra Pound, *Gaudier-Brzeska: A Memoir*, John Lane, London, 1916 (Marvell Press, Hessle, 1960, p. 78).

One may infer that Ede was not in entire agreement with Pound's views but he never refers to them overtly, perhaps to gloss over the now dated controversy over the defunct Vorticist group. While depicting their relationship as 'the strongest attachment [Gaudier] made in England' he focuses on Pound's role as patron and supporter. He hints at sympathy with the more conservative view by quoting Stanley Casson's praise for the fluid bronze *Dancer* (in his 1928 book, *Some Modern Sculptors*) and P.G. Konody's criticism of *Caritas* as 'an affectation in stone.'[8] In his introduction to the 1931 edition (Appendix 1), Ede also describes *Dancer* and *Singer* as 'two of the finest pieces of work done in this country.' Most likely he saw the virtues of both since the pieces accepted by the Tate and the Contemporary Art Society, largely through the beneficence of his friend, Frank Stoop, cover the spectrum of Gaudier's carving – *Singer, Woman* (relief) and *Love Scene* (relief), as well as *Red Stone Dancer* and *Imp*.[9]

Ede, thus, courteously bypassed Pound's politically charged arguments while using the information he had gathered and the media attention his book had attracted as a springboard for his own biographical project. Pound's *Memoir* had reproduced all Gaudier's published writings and provided an unsystematic list of works. The excerpts included from Gaudier's correspondence to Pound himself, his mother-in-law Olivia Shakespear and Edward Wadsworth, provided first-hand testimony of a year's close friendship between the two men. It had been an impressive first step in creating 'a vivid picture of a remarkable artist' (*The Times*) and in attracting support for Pound's assessment of his talent; 'There is no doubt that Gaudier Brzeska was a genius' (*New Statesman*).[10]

Despite being a deeply felt partisan tribute Pound's book contained only cursory biographical details about Gaudier's upbringing and circumstances in London. Gaudier is framed as an artist and personality almost exclusively

8 *Savage Messiah*, pp. 189 and 193.
9 It is unclear how much influence Ede may have had on discussions among the Tate Gallery Trustees or with Frank Stoop. Disingenuously Ede claimed to have presented six works to the Tate Gallery and the Contemporary Art Society himself; see H.S. Ede, *A Way of Life. Kettle's Yard*, Kettle's Yard, Cambridge, 1984, p. 16.
10 These quotes appeared in the advertisement for *Savage Messiah* in the catalogue *Henri Gaudier-Brzeska. An Exhibition of Drawings and Statues*, John & Edward Bumpus, London, April–May 1931.

by his interactions with other (male) artists and writers – Horace Brodzky, Alfred Wolmark, Wyndham Lewis, Jacob Epstein and, centrally, Pound himself. There are passing allusions to Gaudier's poverty and one vague reference to his having worked in an office. His companion, Sophie Brzeska, is mentioned only five times as a background figure and source of information. These references maintain the thin fiction of her as his sister, though the attentive reader may remark that she is referred to as Miss Brzeska not Miss Gaudier-Brzeska, that the references to his parentage and upbringing in Orléans do not include her, and that Gaudier's addition of Brzeska to his name is located in 1911.[11]

The *Memorial Exhibition* held at the Leicester Galleries in Leicester Square, London, in May–June 1918, provided a wealth of potential sources, since nearly all the lenders had known both Gaudier and Brzeska – Haldane Macfall, Major Smythies, Enid Bagnold, Ewart Wheeler, the Hares and Lousadas, Sydney Schiff, Horace Brodzky, Alfred Wolmark, Raymond Drey, Mr. and Mrs. Robert Bevan, Roger Fry, Ezra Pound and Mrs. Ethel Kibblewhite. Most of these and many other artist colleagues, notably Jacob Epstein and Wyndham Lewis, were available for Ede to consult, and could in turn lead him to other contacts.

Finally, there were the Gaudier family and people who had got to know the student Gaudier during his scholarship residencies in Bristol, Cardiff and Nuremberg during 1908–09 – Kitty Smith, the daughter of his host family in Bristol, Mr. Ching, Cardiff coal merchant and Gaudier's employer in 1909, and his Nuremberg host, Dr. Benedikt Uhlemayr. As the schedule of manuscript sources given in Appendix 2 indicates, there was other material inaccessible or unknown to Ede but most of the major sources and

11 'Piecing together Gaudier's early biography from Miss Brzeska's data' and 'Miss Brzeska had forgotten...' (Ezra Pound, *Gaudier-Brzeska. A Memoir*, cit., p. 41); 'his sister tells me...' and '... even his sister then thought the group [*The Embracers*] unsaleable, and told me later she believed I had only taken it out of charity...' (*ibid.*, p. 45); 'He also parodied himself and his sister in wax, which parodies she threw either at him or at the stove.' (p. 49); 'At this time [1911] he calls himself definitely H. Gaudier-Brzeska.' (p. 42). The significance of the artist's self fashioning as Gaudier-Brzeska and his identification with Eastern European culture through Sophie Brzeska is discussed in Jon Wood, '"Cela s'appelle tout simplement Jaersh-ka": the Eastern European imaginary of Henri Gaudier-Brzeska', in Sebastiano Barassi (ed.), *WE the Moderns: Gaudier-Brzeska and the birth of modern sculpture*, Kettle's Yard, Cambridge, 2007, pp. 65–74.

first hand recollections were at his disposal.[12] Roger Cole has traced those whom Ede approached for material and there are passing references to accounts or letters provided by Mr. Ching, Frank Harris, Enid Bagnold, Sydney Schiff, Edward Marsh, the Bevans and Alfred Wolmark.[13] Where Pound's account of Gaudier's early life is largely mythical, Ede sheds much light on the Gaudier family background and the scholarship period not covered by the estate sources. Arguably the most significant contributions were the revelation of Dr. Uhlemayr's crucial importance as a mentor and confidant and Gaudier's tender relationship with his little sister, Renée.

All these witnesses and sources are secondary to the central relationship. Demonstrating an impressive flair for plot and marketing for a man whose previous authorial experience was a slender volume on *Florentine Drawings of the Quattrocento* (Ernest Benn, London, 1926), Ede focused on the unconventional love story of Henri Gaudier and Sophie Brzeska between 1910 and 1915, relying very heavily on the Brzeska estate material he had acquired. It is hard to avoid the impression that he had set out to write a bestseller so studiously did he omit discussion of Gaudier's work, including Brzeska's references to it. In an appendix, published only in the deluxe *Life* but not included in *Savage Messiah*, he did publish with additions Gaudier's *List of Works*. He excluded all assessment of Gaudier as an artist or of his place in the contemporary art world. It is as if the aura of explosive creative energy and frustration that surrounded the pair provided sufficient context for their *vie de bohème*. It is not surprising that the plot of *Savage Messiah* has proved fertile ground for adaptation into other art forms.[14]

12 Of Gaudier's immediate circle, Claud Lovat Fraser, T.E. Hulme and Spencer Gore had already died.

13 Roger Cole (*Gaudier-Brzeska. Artist and Myth*, Sansom & Company, Bristol, 1995, pp. 221–27) writes, based on source material some of which now appears to be lost, that Ede corresponded with Germain Gaudier, Dr. Uhlemayr, Enid Bagnold, Horace Brodzky, Wyndham Lewis and Kitty Smith. Bagnold's account of sitting for Gaudier is used intact and the manuscript references to her were vetted by her and her husband, Sir Roderick Jones. Ede touches lightly on information from Frank Harris (pp. 168–69), Alfred Wolmark and Edward Marsh (p. 177), Sydney Schiff (pp. 189 and 202) and Mrs. Bevan (p. 202).

14 The effectiveness of the device and plot is reflected in the extensive borrowings and dramatizations of the story produced in other art forms. Ken Russell's 1972 MGM EMI film *Savage Messiah*, with Dorothy Tutin giving a convincing performance as Sophie,

Pound and later Horace Brodzky claimed special authenticity and authority for their accounts of Gaudier by virtue of first-hand knowledge and common artistic concerns.[15] Ede makes up for not personally knowing Gaudier by co-opting the authority of its principals, dramatizing his account through his relentlessly intense focus on their relationship which is centre stage throughout. Gaudier's relationships with Brodzky, Wolmark, Epstein, Pound and the rest are described through the lens of Brzeska's observations and accounts of their discussions, gossip and arguments. They are effectively presented as 'other', viewed as outsiders unpredictably useful or useless, friendly or threatening, talented or stupid in the claustrophobic theatre of their own impassioned struggle for love, survival and artistic fulfilment.

Other relationships about which Ede had plentiful data are omitted or downplayed in the interests of the central relationship. This is particularly evident in his handling of Gaudier's female friendships. Kitty Smith, with whom Gaudier had enjoyed an affectionate rapport during his stay

is the best known version, but there are many others: the protagonists of Gordon Daviot's 1934 play, *The Laughing Woman*; Victor Stamp, the artist protagonist of Wyndham Lewis's 1937 novel, *Revenge for Love*, modelled in part on Gaudier. In 1941 the painter Arshile Gorky borrowed Gaudier's letters to help him woo his future wife (see N.D. Vaccaro, 'Gorky's debt to Gaudier-Brzeska', *Art Journal*, 23, 1963, pp. 33–34). An off-Broadway musical, *Mamushka*, with lyrics by Allan Rieser and music by Amy Engelstein, was performed at the Waverly Place Theatre, New York, in February 1994. A dance performance called *Sisik*, devised and performed in Britain by Louise Tonkin, also dates from the early 1990s.

15 Pound's *Memoir*, chapter V, describes their friendship and converging artistic interests, calling Gaudier '...the best company in the world, and some of my best days, the happiest and most interesting, were spent in his uncomfortable mud-floored studio when he was doing my bust.' Horace Brodzky disagreed with both Pound's and Ede's accounts of Gaudier. He drafted his own memoir in 1919 to contest Pound's interpretation (manuscript at the Henry Ransom Humanities Research Centre, University of Austin, TX), set it aside and revised it in the wake of Ede's book, publishing it as *Henri Gaudier-Brzeska 1891–1915*, Faber & Faber, London, 1933. Brodzky similarly asserts (p. 12) close friendship and common purpose. 'We were very close and had few secrets from each other. We were always frank and had no need to be hypocritical. I owe him much. It was he who taught me how to draw...' Both discuss some of Gaudier's sculpture and his working methods. For the construction of Gaudier-Brzeska's persona, see S. Shalgosky, R. Brookes and J. Beckett, 'Henri Gaudier: art history and the Savage Messiah', in Jeremy Lewison (editor), *Henri Gaudier-Brzeska, sculptor (1891–1915)*, Kettle's Yard, Cambridge, 1983, p. 25.

in Bristol in 1908, who was clearly very fond of him, and with whom he corresponded, is never mentioned. Ede met her and was shown letters and drawings she owned.[16]

The painter, Nina Hamnett, puts in an appearance merely as 'one of Gaudier's friends at this time', finding Gaudier a teaching job and introducing him to Roger Fry. However, the powerful episode in which Hamnett and Gaudier modelled naked for each other and the subsequent sexual banter about her, between Gaudier and Brzeska, is anonymised.[17]

The romantic potential of the young French teacher, Marie Borne, who spent several weeks with them in London during the summer of 1914, and for whom, according to Brzeska, Gaudier showed a marked partiality, is minimised. Ede's narrative suggests nothing beyond Mlle. Borne's friendship with both, following their meeting at Littlehampton the previous year. Sophie Brzeska's *Matka*, on the other hand, describes her jealous anxiety as Gaudier takes Mlle. Borne to the moving pictures, to a performance of Maurice Maeterlinck's *Monna Vanna* (which opened on the London stage in late June 1914, having previously been banned) and to a soirée at painter Renée Finch's home, which he tried unsuccessfully to dissuade Brzeska from attending.[18] It could be argued that in thus excising rivals for Gaudier's affection Ede is speaking for and emphasising the importance of Sophie Brzeska, but such a view is undercut by his insistence that Gaudier not Brzeska is the focus of his text.

Now that Ede's source texts have been critically revisited and omitted passages from letters re-incorporated (see Appendix 3), the reader can re-examine other aspects of Ede's choices as translator, editor and author

16 *Savage Messiah*, pp. 28–29. A possible rationale for this exclusion is that Gaudier appears to have had no contact with Kitty 1912–14 and kept her in ignorance of Sophie Brzeska's existence. Gaudier to Kitty Smith, 19.1.15 (Appendix 2).

17 Nina Hamnett was the model for one of the *Torsos* and for the bronze *Dancer* (1913). If Ede's motive was to protect Hamnett's reputation, Hamnett herself had no such concerns since she revealed the full story in her autobiography, *Laughing Torso*, Kessinger, London, 1932 (Virago, London, 1984, pp. 38–39).

18 *Savage Messiah*, p. 194; Sophie Brzeska, *Matka*, Cambridge University Library, Add. Ms. 8554, fols. 162d–164d. Gaudier also drew her and modelled her portrait; see Evelyn Silber, *Gaudier-Brzeska. Life and Art*, Thames & Hudson, London, 1996, cat. 106, p. 275.

within contemporary discourses of social decorum, bohemianism, creativity, nationality, gender and medical practice. Somewhat disingenuously Ede stated, in his *Preface*, that 'in translating Gaudier's letters I have occasionally left out passages that are mere repetitions, or of no general interest.'[19]

Some passages may have been removed to avoid offending those on the receiving end of some of Gaudier's and Brzeska's most outspoken remarks (such as the unflattering descriptions of patrons and hosts, hostile comments about John Middleton Murry and Katherine Mansfield, and Ewart Wheeler's interest in voyeurism). Elsewhere the rationale for omissions is less clear or more questionable, notably the downplaying of anti-semitic remarks. Similarly, some of the coarser invective and sexually explicit language is significantly toned down; there is evidence in Ede's correspondence with Edward Marsh, who was advising him on his translations from French, that the latter found some of the sentiments expressed too strong for publication but also some of Ede's suggested translations too anodyne.[20] Other omissions, such as Gaudier's comments on Goya prints, provide important insights into his personality and artistic sympathies; these are quite lengthy passages but, textual balance aside, their loss weakens the portrayal of the artist.

By far the most problematic area of Ede's use of sources and the one about which he appears to have been most uneasy in retrospect, was his handling of Sophie Brzeska's own writing. He denigrated its literary value while going on to make extensive use of it. When he was making his case to the Treasury Solicitor to have Brzeska's papers included with the estate residue being purchased by McKnight Kauffer, he disingenuously described her writings as being mostly useful 'in dating the various movements of his life':

19 *Savage Messiah*, p. 8.
20 'The fact that men want to have women is usually taken for granted in good society, like the fact they want to piss or shit – and there is nothing else in the letter. If you do publish it I should translate pissier, "possess" – not very good – but you can't put fuck or roger! I should translate putain "whore".' Edward Marsh to Ede, June 1929, Berg Collection (Papers of Sir Edward Marsh), New York Public Library. Ede replied (18.6.29), 'It is very hard to know *where* to draw the line if you are out to be detachedly realistic.'

There are some 900 pages of closely written French entitled 'A la très chère mémoire'. This is a diary of the years 1915–1922. Its interest is chiefly pathological as she was in a very highly strung state after Gaudier's death, and by 1919 was no longer what we call sane. I do not believe it has any literary value but it retains an interest as it refers often to incidents in the life of Gaudier-Brzeska.[21]

The opening of *Savage Messiah* is extremely dismissive since, despite her superficial charm, Brzeska is 'a woman who was bodily ill and mentally diseased, whose life had been a succession of continual emotional crises; of terrors, of intuitions of evil, forebodings of madness, outbursts of rage, meditations of suicide, and intimations of her own greatness.'[22]

However much this characterisation might have been modified by later passages revealing her intelligence, sharp humour, powers of observation, wide reading, practicality or feminist views, an overriding impression of neurotic instability has been established at the outset.

'Diary', the term also used by Ede in his *Preface*, has been the term used generically to describe both 'Détails pour Matka' and the post-1915 *Journal* by subsequent writers.[23] This is greatly to over-simplify them and gives a highly misleading impression of their literary content. Only the entries in the 1915–22 'A la très chère mémoire' are regularly dated. The earlier Orléans and Cambridge manuscripts though broadly chronological are rarely dated. The writing and ink colour also suggest some periods of sustained composition covering several events. While episodic, many entries appear to have been composed weeks or months after the events described; for instance,

21 Ede to the Treasury Solicitor, National Archives, London, TS17/1299 290510; published in Roger Cole, *Gaudier-Brzeska. Artist and Myth*, Sansom & Company, Bristol, 1995, pp. 212–14.

22 *Savage Messiah*, p. 11.

23 Roger Secrétain, *Un sculpteur 'maudit'. Gaudier-Brzeska 1891–1915*, Le temps, Paris, 1979, p. 16; Roger Cole, *Burning to Speak. The Life and Art of Henri Gaudier-Brzeska*, Phaidon, Oxford, 1979, p. 12; Jeremy Lewison (editor), *Henri Gaudier-Brzeska, sculptor 1891–1915*, Kettle's Yard, Cambridge, 1983, p. 31; S. Shalgosky, R. Brookes and J. Beckett, 'Henri Gaudier: art history and the Savage Messiah' in Jeremy Lewison (editor), cit., p. 25. See also Evelyn Silber, *Gaudier-Brzeska. Life and Art*, Thames & Hudson, London, 1996, p. 61, note 49.

an account of Ezra Pound offering to place her *Hero* story in a journal and subsequently being unable to do so, an event which she locates in December 1913, was written at Littlehampton in May 1914.[24]

Brzeska's frequent use of direct speech gives her texts an impressive immediacy, but one must question whether the dialogue represents reportage or a mixture of memory and literary license. To call them 'diaries' also does less than justice to what were intended as drafts for her planned autobiographical novel, *Matka*. The partially fictive character of Brzeska's 'diary' was perceived by W.B. Yeats on his first reading of *Savage Messiah*, 'a most moving book but one wonders how much is from Miss Brzeska['s] diary and if she was not after all a great novelist.'[25]

Ede's *Preface* states, 'Where it has been possible, I have used Miss Brzeska's own words, putting them between quotation marks; but usually the Diary is too diffuse, and too personal to Miss Brzeska, to allow of a direct translation.'[26] At an earlier stage in the preparation of his book, Ede had been encouraged by David Garnett of the Nonesuch Press who had access to Brzeska's original work to 'quote Miss B. more and tell less in your own words. My wife has also read it very carefully and her opinion coincides with mine...'[27] However, Ede's quotations are almost exclusively passages of direct speech and it is very rare for Brzeska's own authorial voice to be heard; her amusing account of social embarrassment with everyone smiling compulsively during a dinner with Frank Harris and his wife is a rare instance of Brzeska's humour and powers of observation surfacing.[28]

Yet many passages, notably their first meeting at the Bibliothèque Ste. Geneviève and rapidly evolving friendship, are a complex fusion of Ede's embellishments and close paraphrases from her text, in some cases from two

24 Sophie Brzeska, *Matka*, Cambridge University Library, Add. Ms. 8554, fol. 140b. For further details of Brzeska's fictionalized accounts, see Evelyn Silber, *Gaudier-Brzeska. Life and Art*, Thames & Hudson, London, 1996, pp. 62–64.

25 W.B. Yeats to Olivia Shakespear, 2 August 1931, published in Allan Wade (ed.), *The Letters of W. B. Yeats*, Hart-Davis, London, 1954, p. 782.

26 *Savage Messiah*, p. 8.

27 David Garnett quoted in Roger Cole, *Gaudier-Brzeska. Artist and Myth*, Sansom & Company, Bristol, 1995, p. 228.

28 *Savage Messiah*, pp. 168–69.

texts since there are several Brzeska versions of some parts of the narrative. Brzeska's unhappy upbringing, life before and meeting with Gaudier, are told in extended form in both the Orléans portion of 'Détails pour Matka' and, much more succinctly, in the version of *Matka* written in autumn 1915 and intended for, but never sent to, the French writer, Romain Rolland.[29]

Un jeune homme – tout jeune et beau comme un ange – (mais avisé des pêches) assis en face d'elle fait des croquis des assistants et de Pleurette [Sophie] – Il la regarde de ses magnifiques yeux dont étincelle l'intelligence. Il lui sourit d'un sourire engageant et questionneur.[30]

There was above all a young boy about twenty – Brr – very good looking – a lively eye – he threw me slightly timid looks – but persistent – He was an artist – everything showed it – even his work – his anatomical drawings – 'No, you must not amuse yourself with this little one – he is very attractive that's true but he's not for you – too young – dangerous for a woman in the autumn of her life – and then flirting with him only for the pleasure of the game – No that would be too mean – The young get fired easily – You must not cause suffering and show off yourself – He is too fine for you.' This was the conversation I had with myself – but the young lad was not at all discouraged – Evidently he felt sympathetic to me – he always tried to be next to me with his old books – this inconvenienced me because of the Russian – but I hadn't the heart to look at him unkindly ... Once I asked him to show me his book of drawings – He was very happy to – tried to chat to me – Since then he came every evening and sat down if there was an empty place beside me – One evening he waited at the exit for me – We walked together for a while 'Le cheri' evidently needed to chat to me – I began to take an interest in the young life of this idealist who only thought of Art and great works.[31]

29 Sophie Gaudier-Brzeska, *'Matka' and other writings*, Mercury Graphics, London, 2008, pp. 11–48.
30 *Matka*, Musée des Beaux Arts, Orléans, fol. 124c.
31 *Matka*, account addressed to Romain Rolland, translated by Gillian Raffles, in Sophie Gaudier-Brzeska, *'Matka' and other writings*, Mercury Graphics, pp. 32–33.

There are certainly diffuse, repetitious passages and scant punctuation but it is a moot point whether these were insuperable obstacles preventing Ede from directly quoting Brzeska more frequently, albeit in edited form, or whether he effectively appropriated Brzeska's literary work adding in interpolations of his own. His text is vivid, moving, well written, but a tone of naive sentiment smooths out Brzeska's jagged rhythms of passionate enthusiasm and bitter cynicism. One misses the sharp edge of Brzeska's physical descriptions and character sketches, such as her entertaining description of Major Smythies, or the chaotic immediacy of the episode between Horace Brodzky, Sophie Brzeska and Gaudier which gave rise to Ede's title, *Savage Messiah*.[32] Or her description of Epstein responding to her congratulations on his exhibits at the 1914 London Group exhibition opening: ' "Me, popular?" He smiled bashfully with his little mouth like a chicken's bum.' ['avec sa petite bouche de cul de poule']. They go on to discuss Epstein's two *Flenite Figures*; Wolmark admits that at first he did not like them but has got used to them, at which Brzeska mischievously reminds him that at Epstein's one man show at the Adelphi (December 1913) 'he had abused the group of Birds Epstein was showing; "But don't you remember we taught you to like Epstein's work?" Wolmark blushes while Epstein laughs, pursing up his shy little girlish mouth.' ['tortillant sa bouche de fifille timide'].[33]

Brzeska was an indispensable source but she is definitely regarded as a figure of secondary importance; the biography was Gaudier's not hers. In his introduction to the first edition of *Savage Messiah*, Ede offers an apologia for not realising how little this new audience might learn about Gaudier as an artist from the revised format of *Savage Messiah* with its fewer and less carefully placed images than the luxurious limited edition *Life*. To make up for this he quotes an excerpt from the appraisal of Gaudier's work in the 'Preface' of the J. & E. Bumpus exhibition catalogue of 1931.[34] He then goes on:

32 Original in Evelyn Silber, *Gaudier-Brzeska. Life and Art*, Thames & Hudson, London, 1996, pp. 58 and 86; *Savage Messiah*, pp. 170–72. This could easily have been quoted direct, so close is Ede's paraphrased account.

33 *Matka*, Cambridge University Library, Add. Ms. 8554, fol. 149d–150a.

34 *Henri Gaudier-Brzeska. An Exhibition of Drawings and Statues*, John & Edward Bumpus, London, April–May 1931.

One other thing seems to me to be ambiguous in 'Savage Messiah', and that is the position of Miss Brzeska. In the big book, from the title alone, it is clear that she is not the subject of the book and only comes into it because of her connection with its hero. In 'Savage Messiah' there is nothing to show that the book does not set out to be a record of both their lives, and the reader may rightly wonder not to find Miss Brzeska's letters and larger quotations from her Diary. Had these thrown any further essential light on Gaudier's character I should have quoted them. Though they are of supreme interest in the picture of Miss Brzeska's own life, and of necessity have an indirect interest in Gaudier's, since these two became so intimately connected, I do not feel they form part of this brief biography.[35]

This revealing introduction was not repeated in the second impression of the first English edition, published in 1932, nor in any subsequent edition. The terminology places Sophie Brzeska as peripheral to the 'hero' Gaudier, it implies that Sophie Brzeska's letters survived, which they did not. Finally, it provides a blanket escape clause for Ede's own editorial and authorial voice. Brzeska here suffers the fate she foresaw in one of her penetrating, self-lacerating moments of reflection early in their relationship: 'Am I merely fated to play a role in Pik's life, perhaps mentioned in the annals of great men of the 20th century as a woman who exercised a certain influence on the great sculptor? No, that would be too grotesque.'[36]

Finally, Ede struggled psychologically with the tenor and intensity of Brzeska's writing; in Appendix 1 is a short unpublished piece by Ede, known as *An Odd Woman*, in which he summarised Brzeska's increasingly isolated life and fragile mental state after Gaudier's death. Apparently dating from the later 1930s it perhaps reflects Ede's sense that she deserved a more fitting epitaph:

I had a great desire to write of Sophie Brzeska's life in England during the seven years which followed the death of Henri Gaudier, but the intensity of her emotions, and the setting upon her of the madness, which in 1922 enveloped her have overpowered me.

35 Additional introduction to the 1931 edition (Appendix 1).
36 Sophie Brzeska, *Matka*, Cambridge University Library, Add. Ms. 8554, fol. 137.

For ten years I have approached nearer and nearer to her personality; hoping to grow sufficiently accustomed to her strange life to be able to enter into it without becoming absorbed; but always I have recoiled.

Now that some of her work has been made available – mostly in translation but uncut and with the original idiosyncratic punctuation and phrasing intact – it is for the first time possible to hear Brzeska's own voice.[37]

An argument can be made that even as he told their story drawing so heavily on her work Ede traduced aspects of Brzeska's work by his use of it in *Savage Messiah*. Yet he had also, in his own way, honoured the hope expressed by Brzeska on the third anniversary of Gaudier's death, but which he never chose to reproduce or quote, as perhaps a more fitting prologue – 'It is inconceivable that our story won't live on, that it won't move those who only know base physical passion. Our story will become a legend.'[38]

37 Sophie Gaudier-Brzeska, *'Matka' and other writings*, Mercury Graphics, London, 2008.

38 Sophie Brzeska, *Journal*, 5 June 1918, The Albert Sloman Library, University of Essex, Special Collections; passage cited in full with the original French in Evelyn Silber, *Gaudier-Brzeska. Life and Art*, Thames & Hudson, London, 1996, p. 64, note 59.

Appendix 1

Unpublished texts

H.S. Ede's introductory note from the 1929 manuscript

My Editors are anxious that the various pet names for Miss Brzeska and Henri Gaudier should be explained – I herewith tabulate them :-

Sophie Suzanne Brzeska – Mamusin, Mamus, Madka,

> Zosienka, Zosia, Pikna Zosienka,
>
> Zosienkie Brzeskie, Maman Matuska,
>
> Mamusienka, Mamusi, Zosieki, Zosik,
>
> Zosienko, Mamiska, Maminska,
>
> Matka, Matus, Matulenka, Mamuska,
>
> Matusienka, Mamuiska, Sisik,
>
> Zosisik, Zosikmaly, Zosinlik,
>
> Zosiulenko, Zosurinio, Zosiulo,
>
> Zosisikow, Najukochanck, Sik,
>
> Madroska, Dziecko, Zosuino,
>
> Sappho, Sosisiko, Julienka.

Henri Alphonse Gaudier – Syn, Pik, Pipik, Pikus,

> Pikusik, Piknis, Pisukonik,
>
> Savage, Redskin, The Savage Messiah.

Additional introduction to the 1931 British edition[1]

I find that 'Savage Messiah' needs some word of comment on the artistic position of its hero Henri Gaudier. In publishing this cheap edition of what is the real book, namely, 'A Life of Gaudier-Brzeska', I had forgotten that its setting would be entirely different, so necessitating some alterations to the text.

The original book was designed to go to some 300 people all of whom, presumably, would know Mr. Ezra Pound's 'Life of Gaudier-Brzeska'. I had therefore felt it unnecessary to speak of Gaudier's work, hoping rather that the eighty or more magnificently produced illustrations, placed in careful conjunction with the text, would speak for themselves, and so I devoted myself only to the human aspect of Gaudier's life which to my mind has so much of the piercing quality of his sculpture. In 'Savage Messiah' his work is scarcely reproduced at all and so the thing becomes one-sided, leaving unknown, to those who do not look for it themselves, the great essential of his life – his artistic achievement.

To bridge this gap, I will quote five paragraphs from the catalogue to a recent exhibition of Gaudier's work.[2]

It is difficult to give him (Henri Gaudier) an exact position in the History of Art; he was little more than a boy when he was killed while fighting in the French Army, and to some extent he still had the crude outlook of a boy. His work is experimental, but impelled by an amazing force, a fierce and indomitable power to cut in stone. It is derivative of Egyptian Art, of Asiatic Art and of Negro Art, but in passing through Gaudier's mind it was subjected to an essentially contemporary outlook. Even in the short time in which he lived he arrived at so personal an expression that his work represents one of the most marked stages in the transition to twentieth century sculpture.

He is of the Brancusi, Modigliani, Picasso school, but even so, quite different, apart and individual. His output is the direct interpretation of his own mind, an interpretation whole-heartedly sculpturesque. He sculpts for the sake of sculpture and for nothing else; this sculptural energy grows from within the stone and stops

1 Ede wrote this text for a folding leaf to be attached to the first page of the 1931 British edition of *Savage Messiah*, published by Heinemann. In the copy at Kettle's Yard, the text is followed by a handwritten note by Ede which reads: 'At the end of this Edition will be found a resumé of Miss Brzeska's life after Gaudier died; it was written as a preliminary to a more detailed account which I had intended to publish under the title of An Odd Woman.' See footnote 3.

2 From the *Preface* to the catalogue *Henri Gaudier-Brzeska. An Exhibition of Drawings and Statues*, John & Edward Bumpus Ltd., 350 Oxford Street, 27 April – 23 May 1931. The *Preface* is unsigned and no author is cited on the cover. It follows quotes from Ezra Pound and Ford Madox Ford, suggesting that it may have been written by Ford, though it is also possible that the author was Ede himself.

at a surface form only because it has here reached its full expression. This single-ness of purpose, this rounding of idea, gives to each of his works an individual charm, which is of the essence of art, no side stream, but one of the main arteries in its historical development.

Had Gaudier lived he would surely by now have ranked amongst the leading sculptors of our day – but it is idle to speculate on what he might have been – it is sufficient that he has already achieved two of the finest pieces of work done in this country: 'The Dancer' at the Victoria & Albert Museum, and 'La Chanteuse Triste' at the Tate Gallery.

His drawings are like wind: no draughtsman in modern times has come near to his swift assurance and certainty of line unless it be Picasso. In drawing his technique was more mature than it was in sculpture. It is hard to imagine any-thing more skilful than some of his animal drawings; their calligraphic poise and the unhesitating way in which they are placed on the paper, making use of the whole space and keeping the proportions of the thing he is drawing, indicate a superb mastery of his medium.

His influence on Modern British Sculpture has been far reaching, for in the four short years during which Gaudier worked he resuscitated the traditions of the ancients with so contemporary a vitality that each artist who has come into touch with his work has seen with greater clarity the fundamental qualities of sculpture.

One other thing seems to me to be ambiguous in 'Savage Messiah', and that is the position of Miss Brzeska. In the big book, from the title alone, it is clear that she is not the subject of the book and only comes into it because of her connection with its hero.

In 'Savage Messiah' there is nothing to show that the book does not set out to be a record of both their lives, and the reader may rightly wonder not to find Miss Brzeska's letters and larger quotations from her Diary. Had these thrown any further essential light on Gaudier's character I should have quoted them. Though they are of supreme interest in the picture of Miss Brzeska's own life, and of necessity have an indirect interest in Gaudier's, since these two became so inti-mately connected, I do not feel they form part of this brief biography.

An Odd Woman [3]

I had a great desire to write of Sophie Brzeska's life in England during the seven years which followed the death of Henri Gaudier, but the intensity of her

3 *An Odd Woman* (also known by the title of *A Very Odd Woman*; manuscript at Kettle's Yard, Cambridge) was conceived as a foreword or postscript to *Savage Messiah*. Eventually Ede decided against its inclusion and it remained unpublished. The ref-erence at the beginning of the second paragraph ('For ten years I have approached nearer and nearer to her personality') suggests that Ede completed the text in the late

emotions, and the setting upon her of the madness, which in 1922 enveloped her have overpowered me.

For ten years I have approached nearer and nearer to her personality; hoping to grow sufficiently accustomed to her strange life to be able to enter into it without becoming absorbed; but always I have recoiled.

When Henri Gaudier died in 1915, Miss Brzeska felt that she had been perhaps instrumental in his death. He had written to ask her to be his wife, his lover, his physical as well as spiritual companion and she had not answered generously; she feared that war might have made him cruel; her situation in England was so hazardous; she had no friends and war was upon her and she longed to be in France amongst a people whose tongue she loved. It seemed to her that Gaudier, instead of asking for her love should bestir himself to obtain her release from the prison which England had become to her, a prison which she had accepted only on his account.

She wrote to tell him this; she seemed to ignore all the outpourings of his heart; after all it was springtime and they were perhaps meaningless. A few days after-wards she wrote him a letter full of affection and love, ready to be all he wanted, but it was too late, her letter was returned to her with another saying that Henri Gaudier had been killed in action. She could never afterwards forgive herself for her ungenerous suspicions; though the torture which she suffered made her feel that God was punishing her too much; that he was being unjust, since she had never before realised the fullness of her love for Gaudier. An unjust God was of course impossible; so God must go, and in this going her last refuge was torn from her. She craved death and prepared to kill herself, but always there was the haunting hope that perhaps, after all, Gaudier had not been killed; that one night she would hear him calling in the street, 'Zosik – Zosik', as he had called that first morning when he so surprisingly returned from the Front. She scarcely dared to leave her rooms, so present was this hope.

Her hectic life of maidenly sterility was beginning to tell upon her; she was 45 and as she walked in the road she seemed to interpret gross looks and gestures from men and boys on her account. She muttered insults under her breath and strode faster into the impenetrability of her own isolation.

One aim only seemed clear to her, she must achieve strength of body and calm of mind sufficient to finish the book which she and Henri had so often

1930s. However, a handwritten note in the Kettle's Yard copy of the 1931 additional in-troduction (see footnote 1) indicates that Ede began to work on an account of Sophie's life after Henri's death as early as 1931. This is confirmed by another handwritten note, at the end of this manuscript, which reads: 'Probably the last paragraph should be omitted – what preceded it had been meant as a foreword to a fuller book.'

discussed. It was a book about her own life, and would form a lasting monument to Gaudier's fame.

To wish to have Gaudier recognised as the genius he was became, from now on, her one idea, and absorbed her every thought. Though she was poor she refused to part with his better sculpture and drawings; she wished to keep them together, hoping as in the end they did, that the nation might acquire them. She was anxious to have an Exhibition of his work, but it was not until 1918 that this was arranged at the Leicester Galleries, and it is due to her indefatigable energy and drive that this Exhibition was so comprehensive. Mr. Pound had written a book about Gaudier, 'mostly about himself' Miss Brzeska thought, but it served as a note from which enquiry might spring. It was now impossible that Gaudier's name should be lost to history, and Miss Brzeska retired to the country.

For the last year she had been much beset by the fear of madness, and every month she was mercilessly the victim of illness. From her room she used to observe a farmer tilling his fields. He was fat and repulsive, yet in the derangement of her mind she conceived a passion for him: she craved that she might press herself to him, and she became held by the desire to feel the weight of his belly against hers, and with that pressure fling him from her. Always she felt an utter contempt for him, yet side by side with this she followed his every movement until she began to believe that he tilled the fields in front of her window, only to exhibit himself to her. Soon, in her distorted thought, he had pledged himself to her, and when it reached her that he had become engaged to some girl in the village, she felt she had been personally slighted. She used to buy butter and eggs from this farmer's mother and would make cutting remarks about him, remarks which no one understood or heeded. They felt her a queer woman, humoured her and got out of her path. Once by chance, she met the farmer, it was their first actual meeting, and in a voice, which was to her pregnant with meaning, but to him a mere commonplace, she congratulated him on his engagement. He twisted his hat in his hands, and shyly said he must get off to the fields. This meeting added fuel to her already raging fire; he must be anxious to lie with her, he would deceive his fiancée on the slightest encouragement, and so on, without end. Thus did her loneliness and her madness press in upon her, torturing her and goading her: for all the time she realised that it was an unreasoned need, and all the time she tried to drown it by her own work, by books and walks in the country. She loved the fields; nature and its unfolding, but ever with her was this haunting lust. Later on she fled before it and went into Gloucestershire, to Wotton-under-Edge.

Here she lived in one of a row of tiny houses. She had a little strip of garden which led onto a back lane. Miss Nina Hamnett once visited her here and Mr. Sydney Schiff wrote to her, sent her books, a lamp, port and sherry, but even so she sank into a completer loneliness, a sharper isolation. The war was just over, but still anyone the least bit queer was hounded as a German spy, and Miss

Brzeska was very queer; her short hair, her long curiously shaped dresses and blouses, and her bare legs and feet, were cause for endless remarks and gathering together of following children, often encouraged by their parents who would cry after her in the country lanes. Sometimes at the edge of her endurance Miss Brzeska would pick up a stone and throw it at them, would run at them hurling torrents of obscene language and shaking her fists; thus she would gain an hour's peace and would sit under a hedge, write a poem or read the latest fiend literature. Mr. Schiff had sent her two volumes of Proust and she was outraged by the style.

In her row of cottages she was tormented by the noise of her neighbours; she believed that all their noise was made only to irritate her. To a certain extent this was true, but also they had some excuse. Miss Brzeska kept strange hours; she worked at night, going to bed at three in the morning after cooking herself some supper. At these hours she would get silence, broken only by the snores of neighbours, except when she herself made some noise by which they awoke. Then they would bang on the walls and curse her through the boarding, and she, to drown their voices, would sing her poems at the top of her voice.

Sometimes in winter, to obtain release from persecution, she would leave her house carrying a suitcase and dressed as though to go on a journey. The neighbours would spy her from their windows. She would then sit out in a field all day, or shelter in a barn and towards tea time, when the light had gone she would slink home and creep into her house as though she would burgle it. Then there was blissful silence; for hours she sat and wrote and never a stirring to right or to left. Towards two o'clock in the morning she would steal downstairs to cook herself some supper, and as she moved she trod upon a walnut which she had dropped on the floor; scrunch, crash, such a noise in all the darkness. Her heart beat and she scarce dared breathe. Downstairs in her agitation the saucepan fell from her hand with a resounding rattle into the sink, and the water taps made a screech in the pipes. The neighbours awoke 'she's back' and after that no more peace. She wrote an 'ode to the poker' to commemorate her neighbour, who, she thought was always poking the fire, making an unearthly din for no purpose but to annoy her. When she wished to rest in the afternoon, 'Little Willie' next door was set to play on the stairs close to her bed. 'You make as much noise as you can my boy' she would hear him told. For three nights she sang loudly when Willie went to bed, keeping him from sleep, hoping thus to tire him for the day time.

And here, already as I write, I feel myself becoming obsessed by the persecuted side of Miss Brzeska's life; it is true it occupied more and more of her consciousness, but concurrently with it she was reconstructing her past life with Gaudier, keeping herself up to date with modern thought in writing, painting and music; revising her memory in the classics, in Shakespeare, in Goethe, in Racine and Corneille. This went on until 1922. In August of that year she was cleaning herself some salad, she had added a little soda to the water for special cleanliness; she

looked from time to time into her garden. Sitting out in the lane on a chair was a middle aged man asleep under his newspaper. Miss Brzeska took this opportunity to go and empty her slops into the drain by his chair.

With his anger her writing cease.

A few weeks after she was in the common ward of the Gloucestershire Asylum. Her landlady went to visit her and in a letter to Mr. Schiff says: 'I waited in the hall, when, there came our fine young woman, rushing down the stairs, so fast that her two keepers could not keep up with her. She had tied her shawl around her face so that I should not know who she was, and when she came up to me she started to scream.'

Miss Brzeska died of a bronchial chill in 1925. When I wrote to the officer in charge of the Asylum he replied: 'Miss Brzeska was a very bad case indeed – during the three years she was with us we were unable to elicit any reference to her past life'. To them she was nothing but a cursing violent woman, and yet all her pages of diary – all her inmost thoughts such as I have read, from her childhood until her capture in 1922, were available; perhaps not in Gloucestershire, but tied up in some department under the Court of Lunacy.

This short note must serve to indicate the direction of Miss Brzeska's life during the ten years following on Gaudier's death, and extracts from her diary could give in detail her thoughts and her behaviour from the age of 44 until her death at 53.

Letter to Dr. Uhlemayr [4]

15 Redburn St., Chelsea
18th June 1912
Dear Dr. Uhlemayr,
Yes, it is because of my friend Zofia Brzeska that I thought you annoyed. I had spoken about her in one of my last letters and since I got no answer I said to myself 'well well! he's thinking Gaudier has got away from his parents in order to fool around with some woman, not at all a nice thing to do, it really isn't worth while writing to him.' I now see that I thought this because I didn't get one of your letters, having left Sterndale Rd. exactly a year ago. I ought to tell you that I was even astonished myself by such an idea for I had never thought of you like that; so I'm ever so pleased to have been mistaken and to know that our friendship is better than ever.

4 This is Ede's translation of Gaudier's only known letter to Dr. Uhlemayr that was not included in *Savage Messiah* (the original is in a German private collection, the translation's manuscript at Kettle's Yard, Cambridge). As it was not edited for publication, the translation, from the French, is tentative in places.

Zofia Brzeska is more than a friend, this is certain: without her help in Paris, both material and moral, I would have conked out long ago, and this help was all the more precious since Brzeska was herself poor and ill. For the last two years we have pulled together and by our united efforts have successfully combated the difficulties of living. For the last eight months since our finances have got a little better through hard work we have been sharing a small place in Redburn Street. The effect we have on each other, from an artistic point of view, is wonderfully productive. If I have developed quickly it is thanks to an inspiration which comes from loving and which is very maturing, and to that almost jealous artist emulation driving one to do better because of it.

As for her, the same happens. She writes far better now than when I first knew her. We are certainly very happy – but oddly so – not sentimental – we don't spare ourselves much and we work endlessly. Nature has made men and women that they may complete themselves and so the more fitted to survive, and it is wise to obey; this is what we have done and will do. Brzeska is forty years old while I am only twenty, so we are both thirty, and it should not surprise you to see the advance I have made in the last three years. Most men squander their youth running after *cocottes* and trying to be clever. Far better to steel oneself and prepare one's armour and lance for the tournament than to go dancing, laughing and fooling around, only to arrive at the end of the day when the fight is over and the prizes given.

I can only be thankful that I met Z. Brzeska, and that I decided at once to join up with her. She is a very live wire and serious, has a real force and an excellent technique as a writer – very energetic, with an understanding of what is good and true but is a fanatic in regard to cleanliness (which causes many little quarrels and disputes because of my plaster etc.)

She is also capable of an appalling hatred against anyone who offends her. She doesn't in the least represent the type of *ewig weibliche* [traditional femininity] but of a new femininity, steel-like and strong as a man. Having more or less the same temperament and each being indulgent to the other's faults we come to love each other more and more, with a love based on friendship, considering sexual passion a secondary business – and not the more usual love springing simply from passion – without companionship and as such transient.

I remember very well your speaking about aid from the French Government, but this is in no way desirable. First it is impossible, for if I took anything from them I should have to serve in their army and this would be death. I could never subject my nature to the exigencies demanded of an officer and so they would send me to one of those disciplinary Companies in Morocco. My health being none too good I would only come back feet first, and only then if jackals and hyenas did not rave over my starved carcass. Actually help from wherever it may come brings with it dependence and idleness. If I am left to myself and if I am

worth keeping alive, in other words, if I have enough energy, *sangfroid* and talent I will always find a way of keeping out of the rut.

I have a fairly good job here in a firm of design for carpets and textiles etc. *Kunstgewerbe* [applied arts] and with that as a basis I have done my utmost to make contact with wealthy people. I've got to know a few, and have done portraits and small statues, which I am still doing, and one fine day I'll get clear of the textile firm and will be free to work at what I want. So regarding Canada I have had long discussions with the President of the Canadian Arts Club. It seems the country is beginning to sit up and there is quite a demand for portraits etc. and sculpture on building. I am keeping in touch with him and he is going to introduce me to a sculptor, the only one in Toronto, who even has to refuse work. The English who know me naturally urge me to stay in London and everyone puts himself out to find me the most advantageous work. I will certainly stay where I can find 'the more money'. I do think that my work days are over and now everything must combine to the success of all my efforts. I am not *un cher petit français indolent et élégant*. I have a will and this should conquer or else I perish with it. So as I said to Mme. Uhlemayr, I'll probably come next year if all goes, to *me promener* [for a tour] in Germany, and then how good it will be to see each other again.

On Thursday evenings I go to read the art journals at the South Kensington Museum. I'm lucky for since the English don't speak any other languages I have a whole table to myself and it is covered with all the best magazines in French, German, Italian and Spanish. Sometimes I look at a Dutch publication though it's very rare to find anything worth reading in it, it's called *Oude Holland*, 'Old Holland', and I don't excite myself over anything but modern art. The old masters interest me very much until the end of Giotto and Fra' Angelico – but I detest all the rest from Botticelli to what can really be called modern art, namely the Impressionists, for all this long period of art does no more than converge towards bad photography, and the ancient Dutch painters with the exception of Jan van Eyck are all in the same boat.

I wish I could see Paul Lehmann's work in colour. I think I must have seen reproductions of his work in black and white for I know his name. What I want to know is whether Klimt has much influence in Vienna and if Hodler is restraining himself a bit, for he seems to become more and more mannered. The Czechs are doing interesting work but I can't get hold of anything about them, neither about the Russians nor the Poles. There are, I think, great reserves of energy amongst the Slav people, a bit confused by bureaucratic corruption – and it will interest me enormously to see how all this develops. Spain also has gone ahead and with solidity and quite naturally Italy – buried as she is in her Renaissance – has only a few names of which Severini, the only worthwhile man among the Futurists, is the clearest star. His colour is of a solar splendour – limpid as the spectrum – and

he uses it with great feeling. He reminds me quite a lot of <u>Segantini</u> in the feeling and use of his colour in its true sense, but he is head and shoulders above him. Peploe and Fergusson have also a quite captivating sense of colour and form, but they both live and work in Paris. Fergusson even edits an art magazine called 'Rhythm' which is published in English and French in London and which often contains his drawings. The letterpress is in the hands of a chap called Murry and is mostly pretty stupid. In England itself there is no one but <u>Frank Brangwyn</u> and even so though considered sacrosanct by the critical divinities of France and Germany, he repeats himself too much to be given any serious consideration. I have a friend – <u>Fraser</u> who is also a good colourist, but he is only a beginner and I can't tell but his English hypocrisy gets itself mixed into his work and I find that not a little disturbing.

A Russian sculptor called Jacob Epstein also works here. He has just finished a tomb for Oscar Wilde to be put into the Père Lachaise Cemetery in Paris next July. I saw it last Sunday in his studio. Oscar Wilde flies slowly, his eyes closed, in space. The whole work is treated with strength, the expression and setting urgent in their invincible movement and refined feeling – a sculpture, in a word, which will live forever, though the total effect seems too small. The whole thing is big – you see what I mean [sketch of the monument] – and the sculpture seems too refined and small – it is cut direct in the stone – without modelling.

I have written to Fergusson and sent him some of my drawings for publication in 'Rhythm' – if they appear I will ask them to send you a copy.

Is Herr Graümann painting better things now? What he showed me in Dachau when I saw him weren't up to much – perhaps he has better work in Munich. He was with a chap called Kerzen or some such name – someone I did not like at all who seemed very presumptuous and scornful. I like Graümann a lot – he's a little Jew of intelligence and openness. Give him my best wishes when you see him – but naturally you needn't tell him that I called him 'a little Jew'.

Zofia Brzeska (whom I usually call 'my sister' or 'Matka' for simplification) joins me in sending you our best wishes.

Bièn à vous.
H Gaudier-Brzeska

Appendix 2

Manuscript sources for the study
of Henri Gaudier's life

EVELYN SILBER

The following list aims to cover all the surviving manuscript and letter sources dating from Henri Gaudier's lifetime. It is necessarily less than complete since some of his most important correspondence, such as that with Dr. Benedikt Uhlemayr from 1910–14, which was accessible to Ede in the original, has not been accessible subsequently, and has never been reproduced or transcribed in full. Other correspondence referred to by previous authors on Gaudier has become inaccessible, and there may still remain unknown letters in private collections.

The manuscript sources fall into two areas: writings by Sophie Brzeska concerning Gaudier and her relationship with him and the letters written by Gaudier. Regrettably, none of Gaudier's correspondence to Sophie Brzeska after his enlistment in August 1914 survives, and only a small fragment of one of her letters to him has survived. Given the care she lavished on keeping the rest of his correspondence, the circumstances under which she (or someone else) destroyed these letters remain mysterious. Autograph notes also survive in some of Gaudier's sketchbooks and in the notebooks.

Given Gaudier's youth, the survival of about 300 letters and postcards is impressive and suggests the esteem in which he was held by his friends and colleagues, and the enduring loss felt at his death. There is an extensive correspondence to and from many of these, including Sophie Brzeska, in the aftermath of his death, as collectors, notably John Quinn, negotiated to purchase work, and as the *Memorial Exhibition*, held at the Leicester Galleries in Leicester Square in May–June 1918, was in preparation. However, this material falls outside the scope of this edition.

Location key

C	Archive, Kettle's Yard, University of Cambridge
E	Special Collections, The Albert Sloman Library, University of Essex, Colchester
G. Raffles	Gillian Raffles
MCAG	Manchester City Art Gallery
NYPL	Berg Collection, Papers of Sir Edward Marsh, New York Public Library, NY
Orléans	Musée des beaux arts, Orléans
P	Musée national d'art moderne, Paris
Perth	Fergusson Gallery, Perth and Kinross Council
PC	Private Collection
Tate	Tate Archive, London, TGA 9115
V&A	National Art Library, Victoria & Albert Museum, London
WU	whereabouts unknown
Y	Beinecke Rare Book and Manuscript Library, Yale University, New Haven, CT, Pound Papers, Y Cal mss 53 (Ezra Pound Additional), Box 7

Publication key

Cole (1979)	Roger Cole, *Burning to Speak. The Life and Art of Henri Gaudier-Brzeska*, Phaidon, Oxford, 1979
Cole (1995)	Roger Cole, *Gaudier-Brzeska. Artist and Myth*, Sansom & Company, Bristol, 1995
Ede, *Life*	H.S. Ede, *A Life of Gaudier-Brzeska*, Heinemann, London, 1930 (limited edition of 350 copies); holograph in the Henry Moore Institute Archive, Leeds
Raffles	*'Matka' and other writings by Sophie Gaudier-Brzeska*, translated by Gillian Raffles, Mercury Graphics, London, 2008
Lemny	Henri Gaudier-Brzeska, *Notes sur Liabeuf and sur Tolstoï*, with introduction by Doïna Lemny, l'Echoppe, Paris, 2009
O'Keeffe	Paul O'Keeffe, *Gaudier-Brzeska. An Absolute Case of Genius*, Penguin/Allen Lane, London, 2004
Orléans	*Henri Gaudier-Brzeska*, Musée des beaux arts, Orléans, and Musée d'art moderne, Toulouse, Orléans 1993 (exhibition catalogue)
Paris	*Henri Gaudier-Brzeska dans les collections de Centre Pompidou*, Musée national d'art moderne, Centre Georges Pompidou, Paris, 2009 (exhibition catalogue)
Pound	Ezra Pound, *Gaudier-Brzeska: A Memoir*, John Lane, London, 1916 (edition cited: Marvell Press, Hessle, 1960)

Secrétain	Roger Secrétain, *Un sculpteur 'maudit'. Gaudier-Brzeska 1891–1915*, Le temps, Paris, 1979
Silber	Evelyn Silber, *Gaudier-Brzeska. Life and Art*, Thames & Hudson, London, 1996
SM	H.S. Ede, *Savage Messiah*, Kettle's Yard and the Henry Moore Institute, Cambridge and Leeds, 2011

Writings by Sophie Brzeska about Henri Gaudier

Matka
1910–11
Orléans, MO 93.2.1

Matka
1911–15
Cambridge University Library, Ad. Ms 8554
Headed, 'Détails pour Matka'.

Journal
1915–22
E (with other writings by Sophie Brzeska)
Headed, 'A la très chère mémoire'.

Sketchbooks and autograph writings by Henri Gaudier

Some sketchbooks contain autograph text by Gaudier. Most have many pages missing. Dispersed pages exist in a number of collections, notably in Orléans and Leeds (in Ede's manuscript *A Life of Gaudier-Brzeska*).

Black notebook
1902–09 and 1916–17
C, HGB 141a
French school ruled exercise book, ruled, 38 pages and 2 inserts, 25 pages torn out. Includes texts in French, Polish and English in Gaudier's and Brzeska's hands. The dates are inscribed on the first page, and the frontispiece is inscribed 'S.S. Gaudier-Brzeska'.
221 × 173 mm

School exercise book
April – July 1908
Last known location: Gekowski, London (1991)

Exercise book from the Merchant Venturers' Technical College, Bristol. Contains English exercises and doodles.

Sketchbook
1907
Orléans, MBA MO 150–163
Includes drawing after a Chinese print of a tiger, after Ingres and Correggio, a sketch of Gaudier's bedroom at St. Jean de Braye, and pen drawings apparently made in London.
220 × 350 mm

Bristol Sketchbook
July 1907 – April 1909
C, HGB 149
Contains British and German scenes.
141 × 231 mm

Pompidou Sketchbook
December 1908 – May 1909 (?)
P, 3376D
Includes Cardiff, natural history and classical scenes, and German scenes.
230 × 142 mm

Nuremberg Sketchbook
1909
C, HGB 150
Contains primarily watercolour landscapes of German scenes.
161 × 244 mm

Paris Sketchbook
1910
C, HGB 151
Contains watercolours, drawings and animal studies.
148 × 235 mm

Bibliothèque Ste. Geneviève Sketchbook
1910
Orléans, MO 138
Includes drawings of fellow readers and notes and drawings on anatomy, after sculpture, etc.
215 × 176 mm

'Le Chaos' Sketchbook – Paris
April 1910
Tate
Includes drawings made in the Bibliothèque Ste. Geneviève and transcriptions from Baudelaire.
268 × 212 mm

Six folios dealing with the execution of the anarchist Jean-Jacques Liabeuf
July 1910
Deposited at P (once part of the correspondence with Brzeska).

Two leaves headed 'La fuite de Tolstoï'
13 October 1910
Deposited at P (once part of the correspondence with Brzeska).

Journal
Begun 5 April 1911
Tate
Signed 'Henri Alphonse Gaudier', with 'Brzeska' added later, apparently in Gaudier's hand.
Includes designs for wallpapers for Sanderson & Sons, notes on ideas for caricatures and posters, design for 'temple of love' entitled *Matka* with notes of colours, materials and names of doors etc. (all dated 5 April 1911); studies after Michelangelo and notes on drawing sculpture after Goya prints; three pages on 'la question juive' based on an essay by Bernard Tuft; notes on the art of Egypt, Greece, the Middle Ages and Renaissance; landscape sketches, including Richmond Park.
256 × 202 mm (to perforations)

Scribbling book
*c.*1912
Orléans, MO 110
Contains medal designs, including Katherine Mansfield and John Middleton Murry.
210 × 140 mm

Translation of the first five cantos of Dante's Inferno
November 1912
E and deposited at P (once part of the correspondence with Brzeska).

Book of figure studies
1913 (?)
Tate
Contains mostly satirical pen sketches of people seen going about daily life.
260 × 218 mm (260 × 216mm to perforations)

Chenil blue book
1913–14
Tate
Includes numerous abstract, mechanistic and Vorticist-style designs, related to
Torpedo Fish and other ideas for 'toys'.

Vortex Gaudier-Brzeska
1914
Princeton University Library, NJ
Manuscript of the essay published in *Blast I*, July 1914, pp. 155–58.

Draft letter to 'Auceps' (Richard Aldington)
March 1914
Tate
Published in *The Egoist*, 16 March 1914, pp. 117–18.

Blue notebook
1914 and 1920–21
C, HGB 141b
Ruled notebook, 83 pages, at least 2 pages torn out. Includes Gaudier's 'List of
Works' (title, medium, size, price and owner where applicable), with annotations
by Ede from the late 1920s; also writings by Brzeska, in French, and accounts.
Inscribed 'Henri Gaudier-Brzeska, arch 25, Winthorpe Road, Putney, S.W. 9 July
1914'.
228 × 175 mm

Letters by Henri Gaudier

Date	To	Location of MS	Published	Comments
8.10.07	Kitty Smith	Tate		Flower sketch on postcard inscribed, 'La chose la plus chère est la famille, mais ensuite vient la patrie.'
5.10.08	Kitty Smith	Tate		Postmarked Bristol. 'A merry birthday' in stylised gothic lettering with roses on fictive parchment
5.10.08 Postcard	Kitty Smith	Tate	O'Keeffe, p. 21	Postmarked Cardiff. Pen view of windmill and cottage signed 'H Gaudier', ... 'after Rembrandt'. Card includes birthday wishes. Account of recent visit to Llandaff Cathedral
20.4.09	M. & Mme. Gaudier	WU formerly Mr Baillet-Gaudier	Ede, *Life*, p. 22; *SM*, p. 31; Secrétain, p. 30	Announces arrival in Nuremberg and recounts journey
15.5.09 Postcard	Kitty Smith	Tate		View of Henkersteg and Wasserturm, Nuremburg
18.5.09 Postcard	Kitty Smith	Tate	O'Keeffe, pp. 31–32 and 36	Shows 'Heilig Geist Spital, Nuremberg'. States he has only a month more to stay with the Uhlemayrs as Dr. Uhlemayr leaves for France on 15 July, where he will probably call on Gaudier's parents. Gaudier has arranged lodging in Munich with an old lady and her daughter, but cannot remember names or address
31.5.09	M. & Mme. Gaudier	WU formerly Mr Baillet-Gaudier	Ede, *Life* pp. 23–24; *SM*, pp. 33–35; Secrétain, p. 30	
9.7.09 Postcard	Kitty Smith	Tate	O'Keeffe, pp. 15 and 36	View of Nuremberg
30.7.09 Postcard	Kitty Smith	Orléans		Photo of Raphael's portrait of Bindo Aldoviti. Sent from Germany
31.8.09 [postmark] Postcard	Kitty Smith	Tate	O'Keeffe, p. 37	From Munich, view of 'Weg zum Höllenthal mit Waxenstein', refers to missing piece of correspondence where Gaudier said all he disliked about Munich. He now makes up for it by saying what he likes

Date	Recipient	Repository	Source reference	Description
8.9.09	Kitty and Sedgeley Smith	Tate	O'Keeffe, p. 4	From Munich. Advises them to send next letter to St Jean de Braye, plans to send fruit from home to Bristol as he did the previous year, if the season is good. Expects to go to Paris as draughtsman in office of Hachette or Armand Colin
[?].10.09	Dr. Uhlemayr	PC, Germany	Ede, *Life* pp. 15–16; *SM*, pp. 22; Cole (1979), pp. 12 and 19, note 14	Written from Paris. Working in bookshop
Undated [10.09]	Kitty Smith	Tate		From 14 rue Bernard Palissy, where he has been for two weeks. Apologises for one-month gap in correspondence. Can send no fruit because of wet cold summer. Loathes his work, which involves spending all day at a desk typewriting letters and some translations from English, German and Spanish, which is more interesting. Does not like Paris much, too big, suburbs and long way to real country
1.1.10	Dr. Uhlemayr	PC, Germany	Ede, *Life*, p. 16 (incomplete); *SM*, p. 22; Cole (1979), pp. 12 and 18, note 15	Praises Rodin
Undated [early March 1910]	Dr. Uhlemayr	PC, Germany	Ede, *Life* p. 27; *SM*, p. 37, Cole (1979) pp. 14 and 18, note 23 (stating major part unpublished); O'Keeffe, p. 307, note 8 (also calling attention to misdating)	Ede dates 4.10.10 and comments Henri had returned to work in an office in Paris on the basis of the reference in this letter. However, the Mi-Carême reference indicates 3rd Thursday in Lent, which would place the letter on 4 March, as Easter that year was 27 March. Ede's reference could therefore be to his earlier office job with Colin
5.3.10	Dr. Uhlemayr	PC, Germany	Ede, *Life*, pp. 16–17 (incomplete); *SM*, pp. 23–25; Cole (1979), pp. 12–13, note 18	Intention to learn to sculpt in wood
26.3.10	Kitty Smith	Tate	O'Keeffe, pp. 15 and 40–41	From Paris. Reassures her he is fine and not drowned, though the Seine floods affected basement of the house where he lives. States he left publishing house job 'about 12 days ago.'
2.4.10	Kitty Smith	Tate		Has new job with C.P. Goerz 'who make cameras and looking glasses.' Says he plans to revisit England the following year
Undated [envelope postmarked 3.5.10]	Kitty Smith	Tate		Tells of solitary evenings in library, reading, delight in riches of the past. Loneliness: 'I must find somebody whom to talk to, and as I know nobody that is worthy of my friendship here, I must bother old friends [books], that are the best.'

Date	Recipient	Location	Reference	Description
24.5.10	Dr. Uhlemayr	PC, Germany	Ede, *Life*, p. 18 (incomplete); *SM*, pp. 26; Cole (1979), pp. 13 and 18, note 22	Decision to give up colour for sculpture
18.6.10	Dr. Uhlemayr	PC, Germany	Ede, *Life*, pp. 13–15 (incomplete); *SM*, pp. 20–21	Account of relationship with Sophie Brzeska
22.6.10	M. & Mme. Gaudier	WU formerly Mr Baillet-Gaudier	Ede, *Life*, pp. 25–26; *SM*, pp. 35–36; Secrétain, p. 40	Responds to parents' anxiety. Announces he has left Goerz without notice and is now working at 5 shillings an hour as a draughtsman for textiles. Is determined to be a sculptor in wood and may go to Poland or Russia
11.7.10	Sophie Brzeska	E	Ede, *Life*, p. 26; *SM*, p. 36	In English. Reports recent visit from father
Undated [late June – end July 1910]	Sophie Brzeska	E	Ede, *Life*, p. 26 (excerpt); *SM*, p. 36	In English. Planning to resist pressure for commercial career on forthcoming short visit to parents
8.10 [envelope postmarked 22.8.10]	Kitty Smith	Tate	Cole (1979), pp. 13 and 18, note 19	Has left Goerz 2 months ago and now working as a draughtsman for 'stuff and carpet designs.' But aims higher to become an artist. Has carved a picture frame. Hopes to work for a few years, get studio, make sculptures
11.11.10	Dr. Uhlemayr	PC, Germany	Ede, *Life*, pp. 30–31 (incomplete); *SM*, pp. 40–41	Written from St Jean de Braye and referring to his recovery from illness. Cole, p. 18, note 25, refers to lengthy correspondence about family row over Sophie Brzeska
[?].1.11	Sophie Brzeska	Orléans, MO 92.6.1	Cit. Orléans, p. 175	Written on verso of photograph of Epstein's *Bust of Euphemia Lamb*. Picked up on visit to a gallery to see exhibitions of paintings by Augustus John and sculptures by Eric Gill. This was at the Chenil Gallery, Chelsea, where both Gill and John showed in early 1911. In January-February 1911 Epstein was also exhibiting several works, including one of *Euphemia* (60) at the National Portrait Society exhibition in the Grafton Galleries
25.2.11	M. & Mme. Gaudier	Original lost	Cole (1979), pp. 16 and 18, note 27	Cole states there is a copy in the files of Musée national d'art moderne, Paris, now WU
21.4.11 [postmark]	Kitty Smith	Tate		From c/o S Kensington PO. Apologies for not spending Easter with them. No mention of Sophie Brzeska, but says living like a monk focussed on art

Date	Correspondent	Source	References	Notes
Saturday 22.4.11	Sophie Brzeska	E	Ede, *Life*, pp. 34–35; *SM*, pp. 43–44; Paris, p. 197	In French, like all subsequent letters to Sophie Brzeska. Drawings after Michelangelo and Rodin, St John the Baptist in Ede, *Life* (manuscript), p. 89. Extensive references to Goya 'Los Caprichos' prints
Undated [but connected with 22.4.11]	Sophie Brzeska	Orléans, MO 1308	Cit. Orléans, p. 175	A number of drawings after Goya and Hokusai are on leaves from a small notebook (163 × 77 mm), now Orléans, MO1308–14. MO 1308 verso contains a comment to Sophie about the Hokusai drawing relating to her superstitions about the moon
23.4.11	Sophie Brzeska	E	Ede, *Life*, pp. 35–37; *SM*, pp. 45–48; Paris, p. 197	Pencil drawing of horse lying down reproduced in Paris, p. 198
25.4.11	Sophie Brzeska	E	Ede, *Life*, pp. 37–40; *SM*, pp. 48–50; Paris, p. 198; O'Keefe, p. 93	Visits Horsenden Hill, near Sudbury
13.5.11	Sophie Brzeska	E	Ede, *Life*, p. 40; *SM*, p. 51–54; part published in Cole (1979), p. 18, note 34; Paris, pp. 198–99	Keir Hardie and Neo-Impressionist sketches included, reproduced in *Life*, pp. 42 and 44. Reproduced in Paris, p. 199
14.5.11	Sophie Brzeska	E	Ede, *Life*, pp. 45–46; *SM*, pp. 54–55	Describes depression, upset and dependence upon Sophie
19–20.5.11	Sophie Brzeska	E	Ede, *Life*, pp. 46–54; *SM*, pp. 55–65; Cole (1979) p. 18, note 34; Paris, pp. 199–201	Cf. Ede, *Life* (manuscript) for St John the Baptist enclosure and Ede copy of sketch of woman spanking boy, after Goya. Incorporates Goya sketch, reproduced in Paris, p. 199. Includes small sketch of seated woman (Sophie?), reproduced in Paris, p. 201
Sunday [27?] 28.5.11	Sophie Brzeska	E	Ede, *Life*, pp. 56–59; *SM*, pp. 66–70; Paris, pp. 201–02	Reflects on classical and modern sculpture
3–5.6.11	Sophie Brzeska	E	Ede, *Life*, pp. 59–66; *SM*, pp. 70–76; Cole (1979), p. 18, note 39; Paris, pp. 202–04	Letter contains sketch of women conceived in boxed masses, reproduced in *Life*, p. 63 and Paris, p. 203. Visits Kew
12.6.11	Dr. Uhlemayr	PC, Germany	Cole (1979) p. 18, note 40	Cole states there is a summary copy in Musée national d'art moderne, Paris
14.6.11	Sophie Brzeska	E	Ede, *Life*, pp. 66–69; *SM*, pp. 76–78	Plans to visit Sophie at Felixstowe on 22.6
17.6.11	Sophie Brzeska	E	Ede, *Life*, pp. 69–70; *SM*, pp. 79–80	Illness

Date	Author	Repository	Source reference	Description
18.6.11	Sophie Brzeska	E	Ede, *Life*, p. 70; *SM*, pp. 79–80	
20.6.11	Sophie Brzeska	E	Ede, *Life*, pp. 70–71; *SM*, p. 80	
28.12.11	Renée Gaudier	Orléans, MO 118	Ede, *Life*, pp. 79–83; *SM*, pp. 88–90; Orléans, p. 174, fig. 184; Paris, illus. pp. 224–25	Includes demonstration drawings of oak leaf, panther and horse
5.1.12	Haldane Macfall	V&A	Cole (1995), pp. 26–27	From 45 Paulton Square
15.1.12	Haldane Macfall	V&A		Refers to meeting Mr. Hardinge and Mr. Alfree, to large poster designs and to need to wait until free of foreign influence and having produced enough work before exhibiting
27.1.12	Haldane Macfall	V&A		Refers to [first?] visit to Lovat Fraser's studio, to visit that day to British Museum to see ancient sculptures and sketch visitors, and to being thrown out of Whitechapel Library for sketching
[?].2.12 [5.2.12]	Haldane Macfall	V&A		From 12 Redburn St. Complains about the price of clay when wanted in small quantities. Working on portrait heads, including Sophie's. Has met Holbrook Jackson and been asked to do a pen portrait of G.K. Chesterton for *T.P. Weekly*
12.2.12	Haldane Macfall	V&A		From 15 Redburn St. Relates visit of Hares to commission Madonna statuette, his views on 'The Miracle' and work on clay sketch
26.2.12	Haldane Macfall	V&A	Cole (1995), p. 32	Relates struggles with the *Madonna* and completion of the mould. Visit to Major Smythies and comments on his collection. Illustrates Burmese seal of tiger biting the sun, which he admires
15.4.12	Haldane Macfall	V&A		Thanks Macfall (money for clay) and refers to work on his portrait. Refers to visit to a Cabaret
Undated [4.12]	Haldane Macfall	V&A		Reference to *Portrait of Major Smythies* and to near complete *Bust of Haldane Macfall*
24.4.12	Raymond Smythies	Manchester Art Gallery		From 15 Redburn St, Chelsea
1.5.12 Postcard	Haldane Macfall	V&A		Discussion about casting of the bust
6.5.12 Postcard	Haldane Macfall	V&A		Reference to visit by Hares who liked Macfall bust and bought 'statuette with child' – *Maternity (La mendiante)*

Date	Recipient	Archive	Reference	Description
7.5.12 Postcard	Haldane Macfall	V&A		Manoeuvres to get some allegedly free/cheap clay
10.5.12	Haldane Macfall	V&A		Macfall's bust at foundry. Sure he has not enough sculpture for a meaningful show, with only 2 or 3 portraits
12.6.12	John Duncan Fergusson	Perth (copy)		From 15 Redburn St, Chelsea. Encloses 8 recent drawings to be considered for *Rhythm*
18.6.12	Dr. Uhlemayr	PC, Germany	Cole (1995), pp. 21–22, illus. sketch of Tomb of Oscar Wilde; Cole (1995), pp. 37–41	Sketch of *Epstein's Tomb of Oscar Wilde*, reproduced in Cole (1995), p. 41. See pp. 277–80 for English translation by Ede
19.6.12	Renée Gaudier	WU formerly Mr Baillet-Gaudier	Ede, *Life*, p. 97; *SM*, p. 105; Cole (1979), p. 27, note 21	
1.7.12	Haldane Macfall	V&A		Working on statuettes 'half natural size'
20.9.12 Postcard	Sophie Brzeska	E		
25.9.12	Edward Marsh	NYPL	Cole (1995), p. 53	Alarmed by Admiralty crest. Accepts invitation to see Marsh collection
8.10.12 Postcard	Sophie Brzeska	E	Cole (1979), illus. p. 23	Photo of Westminster Abbey
11.10.12	Sophie Brzeska	E	Ede, *Life*, pp. 108–09; *SM*, pp. 114–116; Paris, pp. 204–05	
13.10.12	Sophie Brzeska	E	Ede, *Life*, p. 110; *SM*, p. 116–117	
14.10.12	Sophie Brzeska	E	Ede, *Life*, p. 110; *SM*, p. 117; Paris, p. 205	
16.10.12	Sophie Brzeska	E	Ede, *Life*, pp. 111–13; *SM*, pp. 157–65; Paris, pp. 205–06	Encloses copy of letter re: military call up, and his reply
17[?].10.12	Haldane Macfall	V&A		Gaudier has called when Macfall out. Busy on statuettes
19.10.12 Postcard	Sophie Brzeska	E	Paris, p. 206	Photo of Orléans, Musée de Peinture
24–25.10.12	Sophie Brzeska	E	Ede, *Life*, pp. 115–18; *SM*, pp. 122–25; Paris, pp. 206–07	

Date	Correspondent	Location	Published reference	Notes
Undated [late October 1912] Fragment	Sophie Brzeska to Gaudier	Orléans		Sent from Frowlesworth, Leicestershire, where Sophie was lodging
28.10.12	Sophie Brzeska	E	Ede, *Life*, pp. 118–22; *SM*, pp. 125–29; Paris, pp. 207–08	Announces he is translating Dante's *Inferno* (folios now in Paris; see Lemny, p.12). A Dante sketch with part of this letter now in Ede, *Life* (manuscript), p. 192
29.10.12 Postcard	Sophie Brzeska	E	Paris, p. 208	
31.10.12	Sophie Brzeska	The Henry Moore Institute Archive, Leeds	Ede, *Life*, pp. 122–23; *SM*, p. 208	4 pages including caricatures from letter tipped into Ede, *Life* (manuscript). p. 199. Four gold Sovereigns enclosed
Undated [November 1912]	J. Middleton Murry	WU	Ede, *Life*, pp. 105–106; *SM*, pp. 112–13	Possibly never sent. Final break with Murry and Mansfield
3.11.12	Sophie Brzeska	E	Ede, *Life*, pp. 124–25; *SM*, pp. 133–35; Paris, pp. 209–10	Includes Torso drawings, reproduced in Paris, p. 209. Drawing of Gaudier and Sophie Brzeska kissing, sketch of Rodin's house at Meudon, part of letter in Ede, *Life* (manuscript), p. 205
5–7.11.12	Sophie Brzeska	E	Ede, *Life*, pp. 127–29; *SM*, pp. 137–39; Paris, p. 210	Drawings of Sophie with money and taking a bath cut from this letter in Ede, *Life* (manuscript), p. 199
5.11.12	Edward Marsh	NYPL		Long time since they met. Asks to see Girtin watercolours
7.11.12	Edward Marsh	NYPL		Rendezvous arranged at 'Moulin d'Or'. Mentions his Nijinsky on show in Dan Rider's Shop
7.11.12	Haldane Macfall	V&A	Cole (1995). p. 61, facsimile reproduction	Lousada to try and get bronze exhibited at International and hopes also for Macfall's portrait. Hopes for Frank Harris's support – hears he likes 'the coloured Nijinsky now in Rider's shop'
8.11.12	Edward Marsh	NYPL		Apologises for date error in meeting. Misleadingly postmarked 8.11.20
12.11.12	Sophie Brzeska	E	Ede, *Life*, pp. 130–31; *SM*, pp. 140–41; Paris, pp. 210–11	
14.11.12	Sophie Brzeska	E	Ede, *Life*, pp. 131–33; *SM*, pp. 142–44; Paris, p. 211	

15.11.12	Sophie Brzeska	E	Ede, *Life*, pp. 133–36; *SM*, pp. 144–46; Paris, p. 212	
15.11.12 Postcard	Sophie Brzeska	E	Paris, p. 212	
16.11.12	Sophie Brzeska	E	Ede, *Life*, pp. 136–38; *SM*, pp. 147–48; Paris, p. 212	Encloses drawing of Gaudier and prostitute
17.11.12	Sophie Brzeska	E	Ede, *Life*, pp. 138–39; *SM*, pp. 148–49; Paris, p. 213	
22.11.12	Sophie Brzeska	E	Ede, *Life*, pp. 139–40; *SM*, pp. 149–50; Paris, p. 213	
Sunday 24.11.12	Sophie Brzeska	E	Ede, *Life*, pp. 140–42; *SM*, pp. 150–53; Paris, p. 214	Includes sketch of stage in Lovat Fraser's studio
Monday 25.11.12	Sophie Brzeska	E	Ede, *Life*, pp.142–44; *SM*, pp. 153–54; Paris, pp. 214–15	
28.11.12	Sophie Brzeska	E	Ede, *Life*, pp. 144–48; *SM*, pp. 154–57; Paris, pp. 215–17	Sketches of life drawing class reproduced in Ede, *Life*, p. 146, *SM*, p. 211; and Paris, p. 216
30.11.12	Sophie Brzeska	E	Ede, *Life*, pp. 148–49; *SM*, p. 158; Paris, p. 217	
Tuesday 3–6.12.12	Sophie Brzeska	E	Ede, *Life*, p. 149–52; *SM*, pp. 159–62; Paris, pp. 217–18 and illus.	
7.12.12 10.00am Postcard	Sophie Brzeska	E	Ede, *Life*, p. 152; *SM*, pp. 162–63; Paris, p. 218 and illus.	
7.12.12 4.00pm Postcard	Sophie Brzeska	E	Ede, *Life*, p. 152; *SM*, p. 163; Paris, pp. 218–19	
9.12.12 Postcard	Sophie Brzeska	E	Ede, *Life*, p. 153; *SM*, p. 163; Paris, p. 219 and illus. p. 226	
16.12.12	Lovat Fraser	Roger Cole		Requests more zoo tickets. Reference to *Ornamental Mask* going to casters
Undated [12.12]	Lovat Fraser	Roger Cole		Thanks for tickets. Discussion about a model who did not show up

Date	Recipient	Location	Reference	Description
31.12.12	Edward Marsh	NYPL		New Year greetings and new studio address
Undated [1.13]	Lovat Fraser	Roger Cole		
Undated [1.13?]	Sophie Brzeska	E	Ede, *Life*, p. 154; *SM*, p. 164	Refers to *Wrestler* and move to 454a Fulham Road
6.1.13	Dr. Uhlemayr	PC, Germany	Ede, *Life*, p. 155; *SM*, p. 165–66	
6.1.13 [letter wrongly dated 1912]	Horace Brodzky	Institut Néerlandais, Paris	Cole (1979), p. 34, note 2	From 454a Fulham Road, expressing willingness to meet Brodzky, inviting him to supper
7.1.13	Lovat Fraser	Roger Cole		From 454a Fulham Road. Encloses Parlanti invoice, dated 6.1.13, for £5 for waste moulding and casting in plaster one mask [*Ornamental Mask*]
9.1.13 Letter card	Edward Marsh	NYPL	Cole (1979), p. 34, note 3	Invite to visit new studio
13.1.13 Postcard	Edward Marsh	NYPL		Meeting arranged at 'Chanticleer', Frith St.
21.1.13 Postcard	Edward Marsh	NYPL		Introduces Horace Brodzky
7.3.13	Lovat Fraser	Roger Cole		Refers to carving reliefs and to casting in plaster of an animal, and working on Frank Harris's portrait. Announces imminent removal to new flat. Refers to Sophie as 'my sister'
12.3.13	Dr. Uhlemayr	PC, Germany	Ede, *Life*, p. 159–60; *SM*, pp. 170	Is working on portrait bust of *Frank Harris*
24.3.13	Lovat Fraser	Roger Cole		
24.4.13	Lovat Fraser	Roger Cole		Requests two Sunday zoo tickets. Female model never showed up but working from a man
28.4.13 Postcard	Lovat Fraser	Roger Cole		Requests another print of front view of *Frank Harris*
26.6.13	Edward Marsh	NYPL	Cole (1979), ref. p. 30	Sends tickets for Allied Artists exhibition
8.10.13	Sophie Brzeska	E	Ede, *Life*, p. 171–72; *SM*, pp. 181–82; Paris, p. 219	

Date	Recipient	Repository	Citation	Notes
10.10.13	Sophie Brzeska	E	Cole, p. 34, note 30 [same as 13.10?]; Paris, p. 219	
10.10.13	Wyndham Lewis	WU	Cole (1979), pp. 35 and 41, note 1	
10.10.13	Edward Marsh	NYPL		Agrees to meet Marsh and 'Spencer' at 'Chanticleer'
13.10.13	Sophie Brzeska	E	Ede, Life, p. 172–73; SM, pp. 182–83	
14.11.13 Letter card	Sydney Schiff	Orléans	Cole (1979), p. 34, note 40	
18.11.13 Letter card	Sydney Schiff	Orléans		
1.12.13 Letter card	Sydney Schiff	Orléans	Cole (1979), p. 34, note 40	
Undated [late Oct 1913– July 1914]	Edward Marsh	NYPL	E. Marsh, A Number of People, 1939, p. 362	Provides Marsh with address and directions to Arch 25 Studio, Winthorpe Road, Putney. Marsh records his only studio visit was 20 July 1914
5.3.14	Edward Marsh	NYPL		
25.3.14 Postcard	Edward Marsh	NYPL	Cole (1979), pp. 37 and 41, note 15	
Undated [4].14	Renée Gaudier	Orléans	Paris, illus. pp. 230–31	Awaits arrival of 2 blocks of stone (unfinished Lady Hamilton vases). Discusses possibility of war and intention to serve in French regiment as volunteer. T.E. Hulme's address given as emergency contact
23.7.14	Haldane Macfall	V&A		From Arch 25, Winthorpe Road, Putney. Has called and missed Macfall, and now wants Macfall to visit studio
5.8.14	Deed of gift to Sophie Brzeska	Roger Cole	Cole (1995), pp. 89–90 (part facsimile)	
Undated [9.14] Postcard	Ezra Pound	Y	Pound, p. 55	Written from Le Havre during training. Orders to be ready in 5 weeks

Date	Recipient	Archive	Citation	Notes
Undated [Sunday 9.14] Postcard	Mrs. E. Kibblewhite	PC	Sotheby's, 11.11.09, lot 144	Postcard with photo of Tourneville fortress at Le Havre, where they are drilling. Provides preliminary address for 'Henri Gaudier, soldat'
10.9.14	Alfred Wolmark	Leeds, the Henry Moore Institute Archive, in Ede, *Life* (holograph)	O'Keeffe, illus. pp. 262–63	Postcard with photo of Gaudier's company
14.9.14	Ezra Pound	Y		2 postcards from Le Havre
Undated [?.9.14] Postcard	Stanislawa de Karlowska (Mrs. Robert Bevan)	Tate	Cited in Cole (1995), p. 97	Postcard captioned: 'Bombardement de Reims par les Allemands, le 18 september 1914.' Reports survival and doing well in the trenches, with weather getting cold
Undated [?.9.14]	Stanislawa de Karlowska (Mrs. Robert Bevan)	Tate		Several near misses from shells. Getting used to weight of gear. Still optimist about short campaign
Undated [9.14] Postcard	Ezra Pound	Y	Pound, p. 55	From Le Havre: 'we are off to the front.' Image showing Gaudier's troop with him in back row
19.9.14	Mrs. T. Leman Hare	WU		
24.9.14	Ezra Pound	Y	Pound, p. 55	In French
28.9.14	Ezra Pound	Y	Pound, facsimile, p. 28	In French
30.9.14	Mrs. T. Leman Hare	WU		
1.10.14	Edward Marsh	NYPL	Ede, *Life*, p. 185; *SM*, pp. 198–99	At front for last 2 weeks. Report of action
4.10.14	M. & Mme. Gaudier	WU	Ede, *Life*, p. 186; *SM*, p. 199	
4.10.14	Stanislawa de Karlowska (Mrs. Robert Bevan)	Tate		Has spent 15 days in front line and fought once in 27 September. Reports he felled two Germans but lost twelve comrades
10.10.14 Postcard	Edward Marsh	NYPL		
11.10.14	Ezra Pound	Y	Pound, p. 56 (excerpt)	In English
15.10.14	Mrs. T. Leman Hare	V&A (transcript)		In French

Date	Recipient	Location	Reference	Notes
21.10.14	Stanislawa de Karlowska (Mrs. Robert Bevan)	Tate		Refers to sentry duty guarding railway line. 'I am in good health and have found the time to do some sculpture. It was yesterday, we were in a shepherd's fold about 300m. We had to guard a wall of the building. ... I used my pickaxe and my knife to fashion, out of a large stone in the wall, a little figure of a woman dancing.'
24.10.14	Ezra Pound	Yale Beinecke Library	Pound, p. 56	In English
3.11.14	Horace Brodzky	Institut Néerlandais, Paris	Brodzky, p. 163	In English
3.11.14	Stanislawa de Karlowska (Mrs. Robert Bevan)	Tate		Has heard of Currie's suicide. Yearns for news of town in his 'dreary and monotonous existence'.
7.11.14	Ezra Pound	Y	Pound, pp. 56–57	In English. Mentions he has written in previous week to Richard Aldington, Mrs. Shakespear and John Cournos
9.11.14	Ezra Pound	Y	Pound, pp. 57–58; O'Keeffe, p. 270	In English
9.11.14	M. Gaudier	WU formerly Mr Baillet-Gaudier	Ede, *Life*, p. 186; *SM*, p. 199; Cole (1995), pp. 97–98, Secrétain, p. 275	Written from near Rheims. Witnessed Cathedral on fire
12.11.14	M. Gaudier	WU formerly Mr Baillet-Gaudier	Ede, *Life*, p. 187; *SM*, p. 200; Cole (1995). p. 98; Secrétain, p. 275	Reports barbed wire wound to right leg and bullet wound to right heel. Has carved several small pieces of sculpture including a *Maternity* made from German rifle butt
12.11.14	Stanislawa de Karlowska (Mrs. Robert Bevan)	Tate	Cole (1979), pp. 42 and 44, note 5; Cole (1995), p. 99	Thanks for letter and parcels and reports he is loaded with clothing gifts pack weighs 35 kgs. Cut leg on barbed wire and had hurt heel with ricocheting stone. 'I have made a sculpture in the trenches of a maternity, from the butt of a German gun. The captain has it.'
18.11.14	Edward Wadsworth	Archive of Modern Conflict, London	Pound, pp. 72–73	Thanks Wadsworth for letter and woodcuts (Flushing Harbour, Rotterdam and ?Newcastle). Reports slight wound received 8 November. Refers to despatch previous day of his essay 'Vortex Gaudier-Brzeska', published in BLAST, July 1914
23.11.14	Mme. Gaudier	Orléans	Paris, illus. p. 231	Thanks for packet. Describes conditions and reports his wound has healed
25.11.14	Stanislawa de Karlowska (Mrs. Robert Bevan)	Tate		Thanks for vest, pants and chocolates. Comments on generosity of gifts received. In charge of an advanced post

Date/Type	Recipient	Location	Reference	Description
29.11.14 Postcard	Stanislawa de Karlowska (Mrs. Robert Bevan)	Tate		Thanks for cigarettes and appreciates warmth of underwear sent previously
29.11.14 [postmark 1.12] Postcard	Ezra Pound	Y	Pound, p. 58; O'Keeffe, illus. p. 273	With image of Rheims Cathedral after fire bombing of 18 September
Undated [1.12.14]	Ezra Pound	Y		Encloses Vortex essay
5.12.14	Stanislawa de Karlowska (Mrs. Robert Bevan)	Tate		Refers to sending postcard from Rheims. Advised her to write to Geneva Institute for Research into the Disappeared and Prisoners of War for her own missing relatives. Refers to own missing nephew who disappeared on 15 September and his hopes he is prisoner
16.12.14 Letter card	Edward Wadsworth	Archive of Modern Conflict, London	Summarised in Pound, p. 73; Cole (1979), pp. 43 and 44, note 10	Compliments Wadsworth on birth of child, referring to receipt of this news from Pound and Cournos. Thanks for two packets. Occupying trenches 30 miles north of previous position
18.12.14	Ezra Pound	Y	Pound, pp. 58–59; Cole (1979), p. 43	
23.12.14	Stanislawa de Karlowska (Mrs. Robert Bevan)	Tate		From Aisne Valley; describes pleasure in cigarettes sent by Bevans to Gaudier and two comrades. Sends sprig of mistletoe as thanks. Now in Craonne sector. Describes wet trenches, rain, attrition through sickness, frequent attacks and clouds of crows feeding on dead
27.12.14	John Cournos	WU	Cole (1995), p. 100	Looks forward to rest behind lines from 5 January, after liquid mud of trenches. Requests news of the Kensington colony, neo-Greeks and neo-Chinese and asks after The Egoist
Undated [late December 14 – early January 15]	Stanislawa de Karlowska (Mrs. Robert Bevan)	Tate		Refers to giving German a Christmas present and sending best wishes to 1915
1.1.15	Stanislawa de Karlowska (Mrs. Robert Bevan)	Tate		Description of winning battle with Saxon troops in opposing small woods and bringing back horse's saddle 'full of loot'

Date	Correspondent	Archive	Citation	Description
8.1.15	Edward Wadsworth	Archive of Modern Conflict, London	Cole (1995), ref. p. 101	Written from Aisne Valley at rest after 25 days in trenches. Thanks for a woodcut. Reports promotion to Corporal
8.1.15	Mrs. T. Leman Hare	Imperial War Museum, London		
Undated [9.1.15]	Mrs. Olivia Shakespear	WU	Pound, p.66; Secrétain, ref. p. 275; Cole (1979). p. 43; Cole (1995). p. 101	Cole attributes these to Dorothy Pound, whom Ezra married in 1914, but they are addressed to Mrs. O. Shakespear, her mother who was with Ezra when he first saw Gaudier's work at the Allied Artists' exhibition in 1913, and who sent Gaudier parcels at the front (referred to by Sophie in *Matka*; see G. Raffles, p. 109)
19.1.15 Postcard	Kitty Smith	Tate		Related he has been fighting since 20 September and is now Corporal. Admits left London 5 September having been there for past 4 years
21.1.15	Edward Wadsworth	Archive of Modern Conflict, London	Pound, p. 74 (wrongly dated 26.1.15)	Written from Craonne in Aisne Valley. Expresses sorrow at news of death of Segonzac
27.1.15	Ezra Pound	Y	Pound, pp. 59–61	
1.2.15	Edward Wadsworth	Archive of Modern Conflict, London		Postcard 'Le Grand Guerre'. Requests copy of Joseph Conrad's *Typhoon* and looks forward to seeing Wadsworth's woodcut of the subject
2.2.15	Kitty Smith	Tate	O'Keeffe, p. 278	
4.2.15	Mrs. Olivia Shakespear	WU	Pound, p. 66, excerpt	
4.2.15	Stanislawa de Karlowska (Mrs. Robert Bevan)	Tate	Cit. Ede, *Life*, p. 188; *SM*, p. 202	Refers to recently sent postcard saying all well. Pleased at good news of de Karlowska's family. Refers to own luck so far. On a week's rest behind lines. Sounds weary 'one forgets self sacrifice and self denial'. Wishes for general attack to shorten campaign. Heard from Hulme three weeks back. Season of attacks approaches, so asks if no news for six week to contact his CO, Capt. Ménager, 'to send to my sister.'
14.2.15	Edward Wadsworth	Archive of Modern Conflict, London	Cole (1979). pp. 43 and 44, note 12	Reference to receiving 2 woodcuts after 14 days in trenches. Instructs Wadsworth to get *Singer* and smaller better alabaster [*Imp*] from T.E. Hulme for forthcoming exhibition and specifies prices. Still awaits [book?] *Typhoon*
16.2.15	Ezra Pound	Y	Pound, p. 61, as part of 27.1.15	

Date	Correspondent	Archive	Published reference	Notes
18.2.15 [and undated fragment]	Edward Wadsworth	Archive of Modern Conflict, London	Pound, pp. 73–74, dated 18.2.15; Cole (1995), p. 101 (as 12.1.15)	Sends 2 drawings
26.2.15	Sydney Schiff	Orléans	Ede, *Life*, p. 187–88; *SM*, p. 201	
27.2.15 Postcard	M. Gaudier	Orléans	Paris, illus. p. 231	
Undated [late February 15] Postcard	Stanisława de Karlowska (Mrs. Robert Bevan)	PC, promised to Tate Archive	Cole (1979), p. 45; Cole (1995), p. 101	Refers to news about forthcoming London Group show about which Wadsworth has already written: 'I believe he'll exhibit several statuettes that I've sent him'. Requests news from Hulme
1.3.15	Mrs. Olivia Shakespear	WU	Pound, pp. 66–67	Headed 'before Craonne'
10.3.15	Sydney Schiff	Orléans		
14.3.15	Ezra Pound	Y	Pound, pp. 61–62	During 3 weeks of officer training
19.3.15	Mrs. Olivia Shakespear	WU	Pound, pp. 61–62	
19.3.15	Mrs. Olivia Shakespear	WU	Pound, pp. 67–68	From Bourgogne (Marne)
20.3.15	Ezra Pound	Y	Pound, p. 62	Refers to big sculpture of sleeping woman, which Pound has not seen. Discusses works (*Doorknocker* and *Paperweight*) available for London Group show. Sketches priapic shape of captive balloon
20.3.15 Postcard	Kitty Smith	Tate		Re: current officer training
26.3.15 Postcard	Ezra Pound	Y	Pound, p. 63	Re: *Stags* in care of Renée Finch
31.3.15 Postcard	Kitty Smith	Tate		Training complete. Photo with self in back row
6.4.15	Kitty Smith	Tate		
7.4.15 Postcard	Ezra Pound	Y	Pound, p. 63	

Date / Type	Recipient	Repository	Reference	Description
7.5.[4?].15 Postcard	Sydney Schiff	Orléans	Paris, illus. p. 232	
11.4.15	Dorothy Shakespear		Pound, p. 68; Cole (1995). p. 102	Reference to doing more Mlle G (*Torso* owned by Pound) when he returns; 'I am getting convinced slowly it is not much use going further in the research of planes, forms, etc.'
14.4.15 Postcard	T. Leman Hare	Archive of Modern Conflict, London		Refers to news that Mr. Hare drilling in the guard. Wonders whether Captain Macfall will also come over and fight and states will write to him
17.4.15 Postcard	Haldane Macfall	V&A		Hears Macfall back in uniform. Asks after Smythies. Clearly first letter to Macfall since joining, since he refers to Leman Hare reporting on Gaudier's joining up and action since 20 September
19.4.15 Postcard	Ezra Pound	Y		Postcard of Rheims Cathedral. Re: requests to Pound to send tobacco etc. in parcel
10.5.15 Postcard	Ezra Pound	Y	Pound, ref. p. 63	
10.5.15	Kitty Smith	Tate		
14.5.15	Mrs. Olivia Shakespear	WU	Pound, p. 69	
22.5.15 Postcard	Kitty Smith	Tate		View of Belfry, Amiens
22.5.15	Ezra Pound	Y	Pound, p. 63 (dated 25.5.15)	
24.5.15	Kitty Smith	Tate		Near Arras in reserve
29.5.15 Postcard	Kitty Smith	Tate		Rheims Cathedral pre-bombardment
29.5.15	Mrs. Olivia Shakespear	WU	Pound, pp. 69–71	
3.6.15	Ezra Pound	Y	Pound, pp. 63–64; Cole (1995). pp. 104–05	Dated 3.5.15, but postmarked 3.6.15 according to Pound

Appendix 3

Selected omissions from Henri Gaudier's letters

Below are the four passages from Gaudier's letters announced in Ede's footnotes as omitted. They are followed by a group of omissions selected by Evelyn Silber in support to her essay, which represent only a small portion of the text Ede edited out of the original sources included in the book. The translations from the French are by Julia Miller and Marie-Claude Harrison.

23 April 1911

After '... Donde vá mamà?' (p. 46):

Or else a mocking devil bowing to the reader and stretching his arm towards the sated monks – saying with his thumb in the mouth: *Ya es hora* (now is the time) – naked old vagabond witches beneath the stars saying to each other: *Si amanece, nos vamos* (we will leave at dawn).

Followed by 'The words he uses ...'

After '... bowled over with admiration' (p. 46):

It was after seeing the *Caprichos* that Gavarni made his drawings – I remember now an enraged woman, holding her son's shirt in her teeth; with one hand he was pulling down his trousers and with the other he was brandishing a shoe, giving him an awful smack on his 'poor bum'. The shrew gave as an excuse 'Si quebró el cantaro' (yes, the pig has broken the jug). And also a monk and a nun, whispering, after an act against the vow of celibacy (the nun still has the shirt under her chin), 'Nadie nos ha visto' (no one saw us). Further on, 'Ysele quema la casa' (Ysele is burning the house), is one of the most humorous, one of the funniest engravings that I have ever seen. Imagine a completely bare room, an old drunk peasant readjusting his trousers, after the big event, next to a single chair upon which he has placed the candle. The candle sets fire to the chair and thus Ysele has burnt down the house. I will make a copy and send it to you. In *Caprichos* there is such keen satire against the monks that Goya was banished from Spain, and he died in Bordeaux. After the publication of these etchings the number of monks began to decrease in Spain, so they have had their use.

Desastres is a collection of 86 etchings about Napoleon's invasion of Spain, in which we see the behaviour of the French soldiers.

'Las mujeres dan valor' – 'women are valiant' (very ambiguous – because word for word it is: 'women give value'): one gives herself to two soldiers whilst the other kills them with knife blows to the back. Then there are about ten engravings dedicated solely to the brutality of the soldiers against the Spanish women, then piles of dead bodies and there is always a Spaniard who shouts a witty remark before dying. I remember one who says 'Para eso habeis nacido' (it's for this that you were born) and heaps of other things. Then the French arrive and rob the dead. One thing they seem to have enjoyed much was to cut off the Spaniard's little man with their sabres. Further on there are about twenty Castilians dressed in black greatcoats, with barrettes that have a white cross and whom the French have strangled because they were carrying knives or matches with them, and then others who were executed, and others who were hung. These Spaniards are vengeful. They hang a Frenchman, who is so heavy that they have trouble hoisting him up on the scaffold – below it reads: 'duro es el paso!' (hard is the way). They have attached another one, who is completely naked, on the back and hit him on the stomach with big sticks shouting 'Tu lo hay bien merecido' (you deserve this).

It is the women who surround him – he had obviously been nasty with them. Then come the real disasters – a 'hija d'Algo' (a noble girl) who, brought together with the poor and the injured, laments because she has been forced to beg – and then the women who are fleeing from the battle dragging with them everything they can – a house that is crumbling under the cannonballs, and inhabitants that are falling from the first floor, during the night – and then about twenty more engravings against priests who are treacherous or who profit from the war.
Followed by 'I tell you this, dear little Mamus …'

28 October 1912
After '… to get out of business' (p. 129):
As for means, I am starting to understand her and I will follow her instructions as well as I can – however I will not make any promises. Speaking of Dante, did you know that he fell in love at first sight with Beatrice – when they were both 9 – and that he wrote his best poems, 'Vita Nova', about his sublime love for her between the ages of 9 and 18?
About the war in the Balkans. The war is raging furiously – and the *bracie slowianie* [the Balkan League] have split in half the whole of Turkey.
Nikita Król Srnej-Gorej is near Tarabosh and Scutari in the south. After conquering 25 forts and taking 10,000 prisoners and many guns in the north, he invaded the old Serbia, took Berane, Bjelopolje and Sienitza in the Sanjak of Novibazar, where he met the Serbian army.
Karageorgevitch of Serbia defeated the Turks at Novibazar, Kotchana and Kumanova, a huge battle lasting two days, and entered Uskub, the capital of ancient Serbia, yesterday.

<u>The Greeks</u> have defeated the Turks at Elassona and Serfyszye and are marching towards Yanina to rejoin the Montenegrins on one side, and to Monastir to rejoin the Serbs and the Bulgarians on the other side, and then advance together to Thessalonica. <u>Dimitriev</u>, the Bulgarian general, has taken the very important forts of <u>Kirk-Kilisseh</u> with bayonets, made a huge turning movement, destroyed the centre of the Turkish army at Babaeski today, cut it in two, and cut off the retreat of the Turkish army from Andrinople, grappling with the Bulgarian general, Savoff. If it all continues this way, as it seems it will, the Slavs will enter Constantinople triumphantly in less than three weeks. The dirty Turks will be banished from Europe, as they deserve, because even German newspapers now recognise that Europe will not be able to prevent the division of the Ottoman Empire amongst the people of the Balkans.

The dirty crescent moon will be destroyed, and it is a good thing. The Turks always begin their battles by the light of the moon, but lose them at dawn.

Followed by a map of the Balkans and 'My little darling, a thousand kisses ...'

3 November 1912

After '... things in it that interested me' (p. 134):

In passing, 'La Vieille Heaulmière', which we thought had been inspired by Baudelaire's 'Petites Vieilles', actually came from [François] Villon's poem, 'The helmet-maker's old wife':

Oh! Old age, wicked and proud
Why have you battered me so?
Who cares for my anguish
Or if I die for all your blows?

When I think, alas, of the good times,
Of what I was, what I have become,
When I look at myself naked
And see myself so changed
Poor, dry, thin, worn away,
I almost forget myself in anger!

Where has my smooth brow gone
My blond hair...
The fine, slender shoulder blades
The small breasts, the broad hips
Full and firm, strongly built
to withstand all amorous games.

This is the fate of human beauty
Shrivelled arms, clenched hands,
Shoulders utterly hunched up
Breasts, what breasts? In full retreat
The hips too, same as the teats!

...As for the thighs,
They are thighs no more, but
Thighbones
Blotched and dry like sausages.

And Rodin says it is one of his greatest works because an infinite sadness emanates from it.

Art is about <u>character</u>, beings we call ugly have more art than others because the suffering, the evil forces, the languor, the pity that comes from them are so profound that they move the heart. A lively being, beautiful, strong, has theoretically less art because the emotion it releases flatters the senses, gaiety, voluptuousness, sensuality, and is therefore superficial.

(Very well, but all the same I believe that a man or a woman who is strong and beautiful and arouses love is also interesting.)

Rodin: 'It is true of drawing in art as it is of style in literature – a style that is mannered, that is stiff just to get noticed, is bad. The only good style is the one that is forgotten in order for the reader to concentrate his entire attention upon the subject in question, upon the emotions created.

There really is no beautiful style, nor beautiful drawing, nor beautiful colour; there is only one beauty, that of the truth which is revealed. When a truth, when a profound idea, when a powerful emotion bursts forth from a literary or artistic work, it is clear that the style or the colour or the drawing are excellent, but this quality does not come to them other than through the reflection of truth.

The great difficulty and the height of art is drawing, painting, writing with naturalness and simplicity.

You have just seen a painting, you have just read a page, you haven't paid attention to the drawing or the colouring, or the style, but you are moved to the core, don't fear that you are mistaken: the drawing, the colouring, the style have been executed perfectly.'

He is absolutely right, at first glance we can find counter arguments, but on second glance we see that it is true.

At the end of the book, there is a beautiful anecdote. In 1910, the book's editor, Paul Gsell, met Rodin and his two students, Bourdelle and Despiau in the *Salon de la Nationale*, in contemplation of Bourdelle's 'Hercules'.

Come midday Rodin was hungry. The restaurants on the Champs-Elysées are very chic, and since Rodin didn't know where to go Bourdelle began:

'I don't want to go to one of those places, there are waiters in uniform and it intimidates me.'

Despiau:

'Don't fret, Bourdelle, we'll go to a coachmen's café – there are no waiters, it is the owner who serves. In the big places they give you dubious dishes, I always go where you can eat cheaply.'

Rodin and Gsell follow. They enter.

Despiau:

'Help yourself, Bourdelle, you don't deserve to be served.'

'Why?'

'You are an artist, you are useless.'

'Ah, that's true, it always haunts me that we are good for nothing. So my dear old father was a quarry sawyer, I can still see him, this poor old man, on his worksite, in the wind, sawing rocks in all weather!'

'He was useful; he cut stones for people's houses.'

Rodin: 'Drink some Beaune, Bourdelle, that will cheer you up! I'm surprised that you have such conversations.'

It's true that nowadays we have a higher regard for a factory worker or an engineer than for an artist. This doesn't detract from the fact that the artist is the most useful of the three. The world has always been as it is today: it wants bodily pleasures and abandons those of the intellect; it ends being scared of all thought. The artist is the Redeemer, his work compels men, in spite of themselves, to think. He is always touched, even as he insults, and the overall effect is that art creates balance, it saves the world from ruin and from dying out.

Science is nothing next to art. Art is Mystery, the Unknown, the creative force that is at the source of life, and I would like modern society to understand it better than the others and eventually to consider an artist superior to a merchant.

Followed by 'All our sympathies are with Rodin …'

12 November 1912

After '… at that time "The Courtier"' (p. 140):

Perfect diplomat, always loyal, never a traitor, he served in turn people who exchanged compliments even if they were fierce enemies.

Servant to the Gonzagas of Mantua, they sent him to Guidobaldo, then to the Medicis, and then to the Borgias, then to Charles V, then to the Gonzagas. He served them all with zeal.

When he was with the Pope, in talks, he dictated to his wife letters that she should send him. The best known, which is in Latin, begins thus: 'I sigh because you are far from me, but the image that Raphael has made of you comforts me and I am as loyal to it as to you.' It was a strange way of imposing love. Arrigo Levasti would agree, naturally. Castiglione saw the Spanish seriousness as more fitting than French gaiety. For every day, black suits or beautiful colours, warmly

sombre, decorated with black furs, with a few jewels of a fine red gold and the white of a beautiful embroidered shirt, that is the clothing he dreams of. The cut of the garment should not have the fullness of French clothing, or the tightness of the Spanish, but be in between. For festivities, over the dazzling armour, he calls for pure coloured garments, purple and gold brocade, fabrics of red and orange silk – to give joy to those gathered. In a word, a man of wit, well balanced, neither a base materialist, nor an exalted mystic, virtuous with moderation, '<u>il perfetto Cortegiano</u>' [the perfect Courtier].
Followed by 'I feel compelled to tell all this …'

22 April 1911
After '… had a gay time' (p. 43):
Because of this, Rachel entered the Faubourg St. Germain, dethroned these women and was able to join the most prestigious circles – from which she profited financially, by helping out numerous Jewish relatives – the Felixes who swarmed like worms on rotten meat. Joinville seemed to love her, but she got rid of him pretty quickly, to acquire another character (now, now), that is, someone more in fashion: Count [Alexander Joseph Colonna] Walewski – the natural son of Napoleon I and of his Polish (like Mamus) mistress, [Marie] Walewska. Walewski thus restored his reputation, and gave her a palace and a son, and alms for the ever-growing tribe of the Felixes. Then came the great Alexander Dumas, who was ruthlessly rejected – and then Rachel was unfaithful to Walewski – as is her inclination, it seems. He married an Italian noble, Cristina di Ricci da Milano, and went to London as the French ambassador. Rachel was sorry – not for herself but for her father's tribe, ever hungry for money. She consoled herself with twenty or so other lovers, and met a Hector B. – rich, influential, who, without being especially brilliant, could continue magnificently the *dobry Geschäft* [convenient arrangement] begun with Joinville. She was then at the height of her glory, and when Hector disappeared she had already established herself sufficiently to support the Felixes and herself on her own, and to treat herself to fleeting romances from time to time. This is the summary of an article that I read in this month's *Fortnightly Review*, which magnifies the 'beautiful Jewish people' of whom the English seem very proud.
Followed by 'And now for our own affairs.'

28[?] May 1911
After '… relics of barbarism?' (p. 68):
The negroes of the Congo, the American Indians draw in lines that are as pure as the Greeks because they too are underdeveloped.
Followed by 'That the Greeks were entirely right …'

3 June 1911
After '... to express life", etc.' (p. 70):
And we cannot express it without fashioning it. A beautiful statue lives like an or-
ganised being. It is different according to the angle from which we see it, accord-
ing to the day and the hour. The expressions change and slip across its face and
its limbs according to the play of light and shadow. It is the mere observation of
the shapes that gives a regular and natural aspect to this play. The precise values
of the volumes give soft shadows. Hardness only comes from wrong relation-
ships. Everything consists of positioning the planes accurately.
'What young people should be wary of is to let themselves be tempted by literary
sculpture. One shouldn't try to express an idea through form. Make something
and the idea will follow afterwards. I (Rodin) work in front of nature, I create
such and such an aspect of it, and it is only then that I name the newly created
figure. Art critics will come along and say that I wanted to express this or that.
But they are wrong. What they have found in my work is there because they
have seen it. Others will see something else there, and one can almost say that
the greatness of a sculpture is in proportion to the strength and quantity of ideas
that it evokes, as long as no particular or preconceived idea has presided over
its birth. It is therefore not ideas that generate forms but it is forms that generate
ideas.'
This is what Pik has been trying to explain to you, dear Mamus. Will you believe
it now?
As for me, I am very happy, because Mamus's witty retorts caused me to doubt
and often I was caught. But sweet little Mamusienka is wrong, as I first thought,
and she must change her ideas??
I am not happy, actually, because I am of Rodin's opinion rather than yours, but,
now, being utterly certain that what I felt is really 'true' I will no longer wander
off into doubt but will work more. Do you see, kind sweetie, one must love all the
arts, but must not believe that the same laws apply to all of them. Here is another
expression: 'Every artist interprets and that's good – what is bad is to premeditate
the interpretation.'
Followed by 'I have just got your letter ...'

After '... you judge everything by your own little standards' (p. 70):
Rodin writes in the book that I am reading: 'They call me dreamer, idealist,
Christian, pagan etc. In reality I am none of these things – actually I am an ir-
repressible mathematician and I have not done a good statue unless it is geo-
metrical. It is certain that the geometrical statue evokes ideas, but it wasn't what
I intended – I only wanted the planes, and they give out the ideas. That's why I
am astonished before my work, just like the critics, and I might see there all they
can see.' It's frank and it refutes, and one must have faith in it, at least. 'Second,
«Inspiration»?! There isn't such a thing – no more than there is «creation» – we

observe, we see, and we interpret – interpret and nothing more.'
'They have built theories around all of my works – the 'Burghers of Calais' for example? They had commissioned a statue of one of them, 'Eustache de St. Pierre', and it so happened that I was busy studying six models; I made them walk around my studio out of pure pleasure, beggars, workers. And then I made a group of them, I tied some rope around their necks and I sent it all to Calais. I made the statues, no more, no less. I like them because they are square, the men of letters can do what they want with them to make people admire them, I don't mind.'
Followed by 'I shall always maintain tenaciously …'

After '… it should only have planes in the right place – no more' (p. 73):
Eventually one must understand that painting is the art of arranging colours according to certain values, that sculpture is the art of arranging planes according to certain values, that literature is the art of recounting the life of man and that music is the art of expressing inner feelings and the aspirations of man that are too vague to be written. If we want to mix it all together we get to 'academies, styles, periods etc.' and yet it is so easy to understand it all when we show goodwill.
Followed by 'You make a dreadful mistake …'

After '… universal colour, inspired genius?????!!!' (p. 75):
It is you who tells me nothing but stupid things that completely contradict your actions. You are human and if you want to write the story of man take man as you see him around you – and I am happy because that is all you do. You are nothing but an old criticizer; you don't have the right to say that the masterpieces of Shakespeare will never be equalled or surpassed, etc. Rid them of all this aristocratic nonsense, this royal decor with which they have been rigged. Compare them to the theatre of Balzac, of Maeterlinck, of Hauptmann and Ibsen, and it is all the same. The academic tradition carries the dead on diamond thrones. In Shakespeare's time they didn't compare him to Homer, now it is allowed because centuries separate us from them – but it is certain, mathematically irrefutable that beauty doesn't change, and there is no superiority between two men that have brought about this beauty. You get deeper into the mud instead of getting out of it. If Shakespeare hadn't chosen princesses, he would have chosen countesses etc. etc. This is what he did: he then called them princes, just like Rodin baptised 'St John' after having made it.
Molière has only contemporaries, all the great artists have only contemporaries. It's the minor ones who have no taste, the vermin, the worms that eat the carcasses and the old drapes of times past. Art is Life and Life is all around us, and he who looks for art in the past is ignorant or cowardly. You misread Shakespeare, confusing stylistic necessity with hyperbole.
Followed by 'In Art one must exaggerate …'

24 October 1912
After '... gay, strong, alert' (p. 124):
They all hate the whore, who <u>by the way</u>, is 33 and not 23, and was one of the <u>girls</u> in the harem of a famous publisher, a certain Granville – hence, of course, the flat, the piano, the carpet etc. etc. They say that Murry is sick of her and that he would do anything to get rid of her if she wasn't expecting <u>a child</u> – you do remember her awful brunch.
Followed by 'In spite of all Sisik may say ...'

After '... no one knows exactly what has happened' (p. 124):
Swift left with the money – all his debts were with W.H. Smith & Co., who, if they continue with *Rhythm*, will have all the profits and won't pay anyone until the entire debt is paid off – and so Murry won't have a penny from it. Basically everyone agrees that *Rhythm* is on its last legs – that each issue is an absurd repetition of the one before and that no one will buy it any more.
Followed by 'Macfall has produced a hideous article ...'

After '... and I gave him about sixty' (p. 124):
Fraser – with whom I am very cold, don't worry – is all over me. He has just given me tickets to the zoo for Sunday, with the promise of more when those have run out. I'm keeping my distance, in spite of all his stupid ideas about shells, and I'll have the tickets.
Followed in the original (but not in the book; the intervening passage is Ede's invention) by 'The Lousadas come back next Sunday evening ...'

28 October 1912
After '... and leads to the absurd' (p. 125):
– a good example: 'nothing exists'. Bergson says: nothing is the negation of everything. An idea, a feeling always applies to something, and an idea that applies to nothing is not a non-idea, because it is itself something.
The idea can refer to the absence of something in relationship to the rest of things.
If the idea imagines the remainder of absent things the body of the individual who has this idea finds itself suddenly in deep contemplation, facing the void outside itself. This is irrational – so the idea of nothingness is an illusion pushed to the extreme.
This shows that intuition solves the problem of life by assimilating it into time and...
Followed by 'To make this clearer for you ...'

After '... working at my own personal ideas' (p. 128):
A rotten devil – a friend of Macfall, whose portrait I am enclosing – red hair, and who owns a beautiful bookshop on Charing Cross Road, came to see me about some statuettes of the Ballets Russes, ten centimetres in height, of which he wants half of the profits, and after that the copyright – in a word, robbery. It proves that the statuettes will sell well (the Russians are returning in January) and I will do them, but on my own. I spoke about it all with Tomy [Hare] this evening as well.
Followed by 'Wulfsberg has promised ...'

12 November 1912
After '... sin against our love' (p. 140):
Good, be well darling, enjoy the wonderful Sun and being in nature, take as inspiration the delicate work of Hindu weavers, the hard idealistic work of the poor bricklayer, and do likewise, hard but delicate.
See the hand of God, the rocky, chaotic world, in the great hand that reaches out of infinity to guide all things. And in this world, so bitter, what a beautiful vision of love, of gentleness, of confidence and beauty.
There we see that Rodin is a greater genius than the poor bricklayer, because he understands the sources of Creation and sees more profoundly, because he is more civilised, but basically they are alike, because they translate to the best of their abilities what they feel, and that is Art: the precise translation of feelings, never perfect, because the hand doesn't respond skilfully to the speed of the vision when it is so deeply moved.
Followed by 'I read that the place left empty ...'

14 November 1912
After 'I am still enchanted with it all' (p. 142):
Naturally, we spoke of Murry. Marsh was very surprised about what I told him regarding the young madam. He kept saying: 'Oh! Well, it would be a good job for him to go if she's as bad as you say.' What actually happened was this: out of stupidity they signed Swift's contracts without reading them and the idiots are responsible for all of the journal's expenses and debts. One night whilst they were keeping their bodies entertained in their cottage, they received a letter from the bailiff asking them to appear in court for a debt of £180 – the printing of *Rhythm* – so they came to London to find that Swift had fled. Now they have had to leave the cottage, they are staying in London again, at Chancery Lane, a horrible stinking little street in the City.
Marsh says they live in extreme poverty and worries that they don't have enough to eat.
Murry is at a loss, disheartened – she is cheerful, it seems. In the end Martin Secker reissued *Rhythm*, but he is only giving his name and the employment of his clerks in exchange for three quarters of the profits.

Murry and his young madam not only have to cover the current expenses and those to come, but have to continue at their own cost the distribution of those issues for people who have a year's subscription who haven't yet received all twelve issues – plus £180 for the printing. Where they're going to get all that from is a mystery, because, it seems, according to Lousada, that Fergusson himself doesn't know about it. In short, they have been properly punished for all of their mess. They put my ad for Heal's at the front, but I probably will not see any of the £2.20 if they are starving – they didn't even send me the journal, I had to buy it at Bob's [Rider's bookshop]. There were two interesting articles: one about Utamaro, and the other on Joseph Conrad, a Pole who writes in English, probably in America, because his name seems unknown here.

Murry is the bastard son of an important civil servant. He is in touch with his father, who makes his life easier. When he was just a child, his mother came and took him from Mother Thompson in the countryside and put him in a school in Winchester. The people in the house where he lived – he was 10 years old – were arrested for sodomy and the poor little devil with them. The dirty slut of a mother made his life miserable ever since, putting him in and out of numerous schools for something of which he was innocent. Now she is a 'respectable lady in the suburbs'. The poor devil has therefore had a hard life from the beginning and he is exhausted by it. Marsh fears that he might commit suicide in a moment of great depression.

All the same, they have been too ignorant and too cowardly and without any discrimination, either of them. You will see his drawings of Yeats, Peploe, whom they have introduced in *Rhythm*, yuck!!

A certain George [Banks], an admirer of *Rhythm*, had invited a hundred other admirers to an enormous tea. Murry and George were there, but the hundred guests never came. This shows that *Rhythm,* because of their idiotic ploys, isn't liked that much. Even Marsh thinks that neither he nor she know how to write well enough to publish their scribbles, especially she, who is full of affectations. The famous Boris Petrovski doesn't exist; she is the original author of those famous Russian poems. Oh, the dirty bitch! I'll write to them asking for our books back, promising in receipt theirs – because they have no willpower (unless it is bad) and really you can't trust a word they say.

Followed by 'I went with Marsh to see Gibson …'

17 November 1912
After '… and acts in the evenings and on Sundays' (p. 148):

He gave me about twenty beautiful steel engravings. They are beautiful because of their technique, though the subjects are pitiful: English statues by Flaxman etc. I gave him some drawings in exchange and he gave me another present, the nicest one: a sweet little Wedgwood cameo in lapis lazuli. In his pocket he had a wonderful little French fifteenth-century gold jewel: a beautiful woman seated

in a decorated bathtub. The back opens and you can see the woman's bum and her legs all beautifully enamelled in pink [small sketch on the margin]. The end result is a ravishing jewel. As we were leaving, we bumped into the fool, Clouser. I hate this devil who runs after me in that way. Since Harris wasn't coming, I told him all the same to come along today. He disturbed me whilst I was painting. I attempted his portrait, but he is so silly and stupid, such an abominable idler and pessimist according to fashion, preaching that women are far behind men intellectually, close to animals and made for slavery, preaching hatred of love and I don't know what other foolish notions, and I couldn't really do anything because he was annoying me so much. Finally, to get away, I pretended that I had to go to a client at 4 o' clock, and thank God the bastard left. To save the honour of my Sunday, I painted a little windmill in a storm, but I would have preferred to have worked all day.

By the way, I learnt that the statue of Charles I that I like so much in Trafalgar Square was made by [Hubert] Le Sueur, a French sculptor. I thought that it had been made by a Dutchman.

In the past few days there has been an International Suffrage Fair in Chelsea – as I was tired last night, I went there to relax. I was strolling along when someone pulled me by the clothes: it was Hare's sister. She attached herself to Pik the whole time he was there, and introduced me to another of Hare's sisters whom I had never met – my goodness, the most beautiful – also a school teacher and an old spinster. This Tommie only seems to have sisters. I learnt that 'fips' is Toots's stepbrother – I find all of this funny.

Followed by 'I went to the class again on Friday ...'

22 November 1912

After '... the poor bee gives her very guts to provide it' (p. 150):

There is no way of approaching Murry, absolutely no way, not even by letter. I made my resolution, I will wait until the next time I see him by chance. In the meantime, I still need to have drawings in this *Rhythm* – those two issues did me a lot of good. Two Russians who came recently from Moscow and met up with Fraser speak very highly of me – because of *Rhythm* – I'll see them one of these days. I will send some drawings to Martin Secker's shop, with a little note so that we can get our books back.

Sisik, don't preach to me about the drawings – it's pointless. I feel very hostile towards this dirty bitch, but work comes before pride and all small personal feelings. That's why I don't see Castiglione the same way as you do. I admire him for being aware of his value, the way in which he works – as a diplomat.

I must tell you off. You agree with me that the head of Harris by Fergusson is a masterpiece, and then you are annoyed with me for buying *Rhythm*. It doesn't make sense. I will keep buying it just for Fergusson's drawings. As for *Art Chronicle*, it is for my monkey which sits enthroned imposingly in the article.

Never mind your moral reasons, if I wanted to follow them they would lead to idleness and the confiscation of all my belongings. Say what you want, Zosisik, I will never listen to you about that.

I am pleased to move out; I will make a few sculptures in wood and hurrah!

The rotten Clouser annoys me so much. He came last Sunday and the result is that now I am losing everything: I lost the key to the coal cellar (a key for the padlock of your big trunk); as you have three more, please send me one, Zosiunis, it would be very kind of you.

Followed in the original (but not in the book; the intervening passage is Ede's invention) by 'Poor darling, I haven't even a little sovereign …'

24 November 1912

After '… so don't worry about me' (p. 150):

The hideous Clouser really pissed me off last Sunday, Harris didn't come and then Lousadziny [Lousada] with the bronze, everything contributed and I hated the whole world, including Tomsy and Chuquie [the Hares] – for no real reason. Chuquie is looking for a studio for me. Tommy keeps insisting and because he is an odd fellow I am happy to let him do it. He said to me that if each month I did 'something' for a business firm, it would pay my rent – I sense that he wants to give me work but only if I take the studio he wants – and Chuquie too, so that she can stick her nose in from time to time – and brighten up her existence with some variety – so I let him do it, after all I do trust him. I told you that I met an actor at Bob's [Rider], who gave me some engravings. He is an affable fellow, I like him – he is lively, joyful, even though he is married with three kids at 25. He says: 'I have given hostages to Fortune'. He isn't very faithful to his wife, he likes different little actresses, it goes with the job it seems.

Followed by 'Wheeler came yesterday to help me take …'

After '… woman with her arms above her head' (Monday, p. 153):

His moulder, an Italian from Battersea, Feltrini, casts him badly, like Parlanti when it takes him. Parlanti went to see him, asking for work.

Followed by 'We smoked together …'

28 November 1912

After '… we parted the best of friends' (p. 157):

Smythies is coming along. As he sees that his face has no chance at Burlington House for the Academy and since he heard that I was going to try the head of Macfall at the International he has proposed the International to me. Czukie [Thérèse Hare] came at 9.30 and took me with her in the taxi at 10.30. She is a funny kind of *lapatczka*, she seems to be protecting me a lot now, all she did was talk about me at Mac's, full of little considerations, asks me if I look after myself, if I eat etc. etc. etc. Lord blow mee guts that at 40 years of age some people are so

stupid, it is not surprising that the world is going bad *Zosik mała* [little Zosik]!! *Najdrozejsza córka i Kochanka* [my dear daughter and love], when will we be able to retire at least six months of the year in a retreat deep in the mountains? Zosiunio, darling. Czukie is looking for a studio for me but she hasn't managed yet, so I'll also start looking – I won't be able to take it until the first of January at the start of the term – when everything will be all cleaned, aired, repainted.

Once she got home, she went out again to see some neighbours and I stayed with Tommy. We mostly talked about the size of *worki* [vaginas] and the length of *kuśki* [penises]. Tommy saw a devil whose *kuśka* reached his knees – we also spoke of the charms of *pani* [ladies] – and of sculpture in general, because all this only came up through speaking of Epstein, in particular the Oscar Wilde.

At [Beatrice von] Holthoir's there was a devil, a certain Atkinson whom she calls her 'little one' and with whom she speaks familiarly. He also thinks that Fraser is a bad version of Oscar Wilde, that he is quite affected etc., but the funny thing is that Atkinson is just as affected but in a different way.

Whilst waiting for something better, I will only give you my news tomorrow, because I don't have any more at the moment, unless I tell you about my visit to the British Museum this afternoon.

Followed by 'I looked particularly at all the primitive statues ...'

3 December 1912

After '... we spoke of Murry' (Friday, p. 160):

and the whore – we'll try and talk about it to Murry, that is to say, Lunn will try

Followed by 'but I don't want to see him again ...'

10 October 1913 (misdated by Ede '13 October')

After 'Harris says he has owed him' (p. 183):

£80 since June, and that the other day he threw him out because he insulted him for not lending him more. Harris also found out that in exchange for £5 a month Rider had sold all his things to an editor from New York. Because of this Harris has lost several hundreds of pounds. He is furious with Rider.

Followed by: 'As for Brodzky ...'

Index of names

Savage Messiah
A biography of the sculptor Henri Gaudier-Brzeska
by H.S. Ede

with new texts, endnotes and appendices by
Sebastiano Barassi, Evelyn Silber and Jon Wood

Edited by Sebastiano Barassi and Jon Wood
Editorial and illustration assistance: Kirstie Gregory

Published in 2011 by
Kettle's Yard and the Henry Moore Institute

Kettle's Yard
University of Cambridge
Castle Street
Cambridge CB3 0AQ

www.kettlesyard.co.uk

Henry Moore Institute
74 The Headrow
Leeds LS1 3AH

The Henry Moore Institute is part of The Henry Moore Foundation which was set
up by the artist Henry Moore in 1977 to encourage appreciation of the visual arts,
especially sculpture. The Foundation's responsibilities are preserving Moore's legacy
at his Hertfordshire home and in exhibitions worldwide, funding exhibitions and
research at the Institute and awarding grants to arts organisations across the UK.

www.henry-moore.org

ISBN 978-1-905462-34-6

Photography: Norman Taylor, Leeds, England
Design: Groundwork, Skipton, England
Print: Graphicom, Verona, Italy

Henry Moore
Institute

The Henry Moore
Foundation